BEST PRACTICES IN **SUSTAINABLE BUILDING DESIGN**

Shahin Vassigh
Ebru Özer
Thomas Spiegelhalter

Copyright ©2013 by J. Ross Publishing

ISBN: 978-1-60427-068-6

Printed and bound in the U.S.A. Printed on acid-free paper

10 9 8 7 6 5 4 3 2 1

Library of Congress Cataloging-in-Publication Data

Vassigh, Shahin.
 Best practices in sustainable building design / by Shahin Vassigh, Ebru
Vzer, and Thomas Spiegelhalter.
 pages cm
 Includes bibliographical references and index.
 ISBN 978-1-60427-068-6 (hardcover : alk. paper) 1. Sustainable buildings—Design and construction. I. Vzer, Ebru, 1976- II. Spiegelhalter,
Thomas, 1959- III. Title.
 TH880.V37 2012
 720'.47--dc23
 2012017645

Disclaimer

The contents of this book were developed under a grant from the U.S. Department of Education. However, those contents do not necessarily represent the policy of the U.S. Department of Education, and you should not assume endorsement by the federal government.

All the drawings produced for this book were developed by the authors, research assistants and students. The information presented in the book was researched and developed in good faith. The authors and publisher have credited resources and references to the best of their abilities. The authors and publisher do not warrant or guarantee the information in this book. This book is presented solely for educational purposes and is not intended as a definitive source for professional use and judgment.

This publication contains information obtained from authentic and highly regarded sources. Reprinted material is used with permission, and sources are indicated. Reasonable effort has been made to publish reliable data and information, but the author and the publisher cannot assume responsibility for the validity of all materials or for the consequences of their use.

All rights reserved. Neither this publication nor any part thereof may be reproduced, stored in a retrieval system or transmitted in any form or by any means, electronic, me-chanical, photocopying, recording or otherwise, without the prior written permission of the publisher.

The copyright owner's consent does not extend to copying for general distribution for promotion, for creating new works, or for resale. Specific permission must be obtained from J. Ross Publishing for such purposes.

Direct all inquiries to: J. Ross Publishing, Inc.,
300 S. Pine Island Rd., Suite 305, Plantation, Florida 33324.
Phone: (954) 727-9333 Fax: (561) 892-0700
Web: www.jrosspub.com

Acknowledgments and Credits

ACKNOWLEDGMENTS The authors thank all who have contributed to the text, the production of the diagrams and the accompanying DVD. Special thanks should be given to Silvana Herrera, Fiorella Mavares, Julian Sandoval, Paolo Arce and Joanna Ibarra who contributed their passion, careful thought and great skills to produce this book. Without their hard work, this publication would not exist.

We thank our chairs, John Stuart and Adam Drisin, for cultivating a collaborative working environment as well as for their continuous support of the project. We also thank Dean Brian Schriner for his administrative support.

We also thank Kenneth MacKay and Annette LeCuyer at University at Buffalo, the State University of New York for their contributions at the initial stages of the project. We thank Jason Chandler and Malik Benjamin for their input, advice, and involvement with the project.

CREDITS The contents of this book were developed under a grant from the U.S. Department of Education, Fund for Improvement of Postsecondary Education Comprehensive Program, and a Paul Cejas Faculty Initiative Endowment grant from Florida International University.

Final drawings, layout and design were produced by the following group of research assistants: Silvana Herrera, Fiorella Mavares, Paolo Arce, Julian Sandoval, Joanna Ibarra, Veronica Scharf, Louis Bardi, Javier Cuevas, Basil Valderrama, Jordan Johnson, Cassandra Strauss, Tanaz Haghighi, Matin Jadidi, and Jasbir Singh Ubhi.

Author Biographies

SHAHIN VASSIGH

Shahin Vassigh is a professor and co-director of the Environmental and Structural Technology Lab in the Department of Architecture at Florida International University. She teaches courses in structures and building technologies. Ms. Vassigh has built a nationally recognized body of research focused on improving building technology and sustainable building design education by developing alternative teaching pedagogies. She is a recipient of two major federal grants for "A Comprehensive Approach to Teaching Structures" and "Building Literacy: The Integration of Building Technology and Design in Architectural Education." Both projects developed interactive learning environments using state-of-the-art computing technology. She is the author of *Interactive Structures: Visualizing Structural Behavior* (2008) and a co-author of *Building Systems Integration for Enhanced Environmental Performance* (2011). She has a Master of Architecture, a Master in Urban Planning and a Bachelor of Science in Civil Engineering from University at Buffalo, the State University of New York.

EBRU ÖZER

Ebru Özer is an assistant professor in the Department of Landscape Architecture at Florida International University and teaches courses in landscape architectural design, landscape technology and construction, and advanced digital representation. As a professional with experience in both landscape architecture and architecture, her research includes developing a holistic approach to environmentally sustainable design that integrates current architectural design theories with landscape design theories. Her research has been supported by grants from The Andrew W. Mellon Foundation and the U.S. Department of Education. She has a Master of Landscape Architecture degree from Louisiana State University, a Bachelor of Architecture degree from Dokuz Eylul University, Turkey, and a Physics degree from Ege University, Turkey.

THOMAS SPIEGELHALTER

Thomas Spiegelhalter is Co-Director of the Environmental and Structural Technology Lab (ESTL) in the Department of Architecture at Florida International University. He teaches Sustainability Graduate Studio and Environmental Systems. Mr. Spiegelhalter has developed numerous solar, zero-fossil-energy and low-energy buildings in Europe and the U.S. Many of his completed projects have been published in international anthologies of architecture such as Architectural Record magazine (Design Vanguard Award 2003) and in the monograph *Adaptable Technologies - Le tecnologie adattabili nelle architetture di Thomas Spiegelhalter*. He has received 42 honors, prizes and awards for his design work in competitions and applied research at national and international levels. Mr. Spiegelhalter has a Master and a Bachelor degree in Design and Architecture from the University of the Arts in Berlin and a Bachelor degree in Architecture and Engineering from the University of Applied Sciences in Bremen, Germany.

Contents

ACKNOWLEDGMENTS AND CREDITS	iii
AUTHOR BIOGRAPHIES	v
INTRODUCTION	1

1. BUILDING FORM — 3

1.1 CONCEPTS — 4
- Plan Geometry — 4
- Building Orientation — 4
- Surface Area-to-Volume Ratio — 4
- Natural Lighting — 5
- Mass and Service Core — 5
- Natural Ventilation — 5

1.2 PLAN SHAPES — 6
- Rectangular Plan — 6
- Square Plan — 6
- O-Plan — 7
- C-Plan — 7
- L-Plan — 7

1.3 CLIMATIC CONTEXT — 8
- Hot and Humid — 8
- Hot and Arid — 10
- Temperate — 12
- Cold — 14

2. BUILDING ENVELOPES — 17

2.1 CONCEPTS — 18
- Environmental Impact — 18
- Material Thermal Properties — 20
- Enclosure Materials — 24
- Insulation Materials — 30
- Thermal Materials — 34

2.2 WALL SYSTEMS — 36
- Cavity Wall — 36
- Glass Curtain Wall — 41
- Concrete Masonry Unit Wall — 44
- Concrete Wall — 48
- Metal Veneer Wall — 52
- Precast Concrete Wall — 56
- Stone Panel Wall — 60

2.3 CLIMATE-RESPONSIVE FAÇADES — 64
- Double-Skin Façades — 64
- Shading Devices — 68
- Photovoltaic Façades — 69

3. STRUCTURE — 71

3.1 STRUCTURAL MATERIALS — 72
- Wood — 72
- Reinforced Concrete — 73
- Prestressed Concrete — 73
- Masonry Products — 75
- Steel — 75

3.2 HORIZONTAL SPANNING SYSTEMS	76
One-Way Systems	76
Two-Way Systems	76
Noncomposite Steel Frame (One-Way System)	77
Composite Steel Frame (One-Way System)	78
Concrete Frame (One-Way System)	79
Pan Joist or Ribbed Slab (One-Way System)	80
Hollow-Core Slabs (One-Way System)	82
Flat Plates and Flat Slabs (Two-Way System)	83
Slabs with Beams (Two-Way System)	84
Waffle Slabs (Two-Way System)	85
Bubble Decks (Two-Way System)	87
3.3 VERTICAL SPANNING ELEMENTS	88
Columns	88
Load-Bearing Walls	89
Shear Walls	90
3.4 STRUCTURAL FRAMES	91
Wood Frames	91
Concrete Frames	91
Steel Frames	92

4. CLIMATE CONTROL 93

4.1 CONCEPTS	94
Climate	94
Degree Days	94
Building Occupancy Codes	95
Psychrometrics/Thermal Comfort	96
Heat Forms	98
Heat Flow	99
Carbon-Neutral Design	100
4.2 PASSIVE SYSTEMS	106
Natural Systems	106
Solar Heating	109
Passive Cooling	110
Phase-Change Materials	114
4.3 ACTIVE SYSTEMS	116
Space Conditioning	116
Distribution Medium	118
Refrigeration Cycles	123
Heat Pumps	125
Chillers	130
Evaporative Cooling	135
Mechanical Heating	137
District Heating and Cooling	140
Ventilation	141
Heat Energy-Recovery Systems	143
Distribution and Terminal Systems	145

5. RENEWABLE ENERGY 153

5.1 ENERGY SOURCES AND STORAGE	154
Solar Energy	154
Photovoltaic Systems	156

Contents

Wind Energy	158
Geothermal Energy	159
Biomass, Hydropower and Hydrogen Energy	159
Energy Storage Systems	160

6. LIGHTING — 163

6.1 CONCEPTS — 164
- Measuring Light — 164
- Light Transmittance — 168
- Lighting Design — 170

— 172
- Solar Radiation — 172
- Climatic Zones and Sunlighting — 173
- Glass — 174
- Glass Types — 175
- Design with Natural Lighting — 176
- Side Lighting — 178
- Light Shelves — 180
- Top Lighting — 182
- Natural Light Filtering and Redirection — 183

6.3 ARTIFICIAL LIGHTING — 185
- Luminairs — 185
- Light Sources — 186
- Incandescent Light Sources — 186
- Discharge Sources — 187
- Solid-State Lighting Sources — 189
- Lighting Control Systems — 191

7. LANDSCAPE — 193

7.1 CONCEPTS — 194
- Plant Classification — 194
- Plant Processes — 199
- Hydrology — 203
- Climate — 206

7.2 THERMAL EFFICIENCY — 210
- Solar Heat Moderation — 210
- Thermal Insulation — 215
- Wind Protection and Control — 217
- Prototypical Designs for Climatic Regions — 220

7.3 HYDROLOGICAL EFFICIENCY — 224
- Water Conservation — 224
- Runoff Mitigation and Pollution Control — 227
- Wastewater Management — 233

7.4 CASE STUDIES — 236
- Council House 2 — 236
- California Academy of Sciences — 239
- Sidwell Friends School — 242

BIBLIOGRAPHY — 247

INDEX — 253

Foreword

Steffen Lehmann

There is no doubt that today we stand at a crossroads in architectural design and urban development, contemplating how we want our cities to develop and grow in future. *Best Practices in Sustainable Building Design* is an important book that offers answers and solutions. It is for architects, designers, planners, engineers—for both students and educators—and everyone who is passionate about or interested in ways to improve our built environment.

Architectural education is increasingly taking climate responsive design principles into account and integrating sustainable building design as a necessity for the future of the architectural profession, so that "best practice" will trigger an emerging "next practice". The only choice we have is to make our buildings greener, more energy and material efficient, and more sustainable by increasing their durability and lifecycle, making them plus-energy and carbon neutral, without compromising either comfort or architectural design integrity.

Best Practices in Sustainable Building Design is clearly structured into learning modules, allowing the reader to quickly grasp the various concepts of passive and active strategies influenced by building form, envelopes, structural systems, technical control systems, and other elements, ensuring a very accessible, step-by-step learning process.

I congratulate the three authors on their marvelous achievement, publishing this work as both a book and an interactive interface (DVD). It is my hope that by studying this relevant and timely material and by analyzing the clear illustrations, diagrams, and charts, the reader will be inspired to design buildings that will further change the way you, dear reader, will approach your future work and implement the wide-ranging knowledge contained within these learning aids.

PROFESSOR STEFFEN LEHMANN PhD. AADip, is the Director of the Zero Waste Research Centre for Sustainable Design and Behavior (sd+b Centre) and the Chair in Sustainable Design at the University of South Australia, Adelaide. He also holds the UNESCO Chair in Sustainable Urban Development for Asia and the Pacific, has published fourteen books, is Editor-in-Chief of the Journal of Green Building, and is the Editor of the Earthscan Book Series on Sustainable Design (Routledge). His latest book, Designing for Zero Waste: Consumption, Technologies and the Built Environment, offers a new view of material efficiency, modular prefabrication, and construction without waste.

Introduction

This book and the accompanying software comprise an educational platform developed to advance climate-responsive and ecologically sustainable buildings. The principal idea for developing this platform was to create a resource for both architecture students and educators that can serve a variety of learning styles and needs. Although this platform is primarily designed for architecture students, it includes a wide range of information from a number of related fields and can be helpful for architects and anyone with an interest in sustainable building design and development.

Both the software and book are organized into seven content areas: building form, building envelopes, structure, climate control, renewable energy, lighting, and landscape. Each content area is subdivided into learning modules that introduce building concepts, construction materials, and operational systems, all explained with a specific focus on energy-efficiency and carbon-neutral design. The content has been developed to integrate information from various building design disciplines into a comprehensive format.

The printed book component utilizes a highly graphical approach to visually demonstrate the concepts described in the text. These diagrams demonstrate critical processes in building design and relate important details to holistic functions. The materials presented in the book do not require an in-depth knowledge of the subject and engage most topics at an introductory level.

The software component of the educational framework has been developed as an immersive and integrated learning environment, delivering the content in an interactive format. Harnessing the capabilities of advanced media, such as dynamic modeling, animation, interactive diagrams, and hypertext, the software-generated environment helps to visualize and engage concepts and topics that may be difficult to grasp in traditional learning formats. The interactive content aims to engage and compel users to participate actively in the learning process. The inclusion of the software component also responds to the proclivity of the new generation of students who are more accustomed to accessing information in such environments. The software content is organized under a graphical user interface system that serves as a vehicle for learning on demand, linking to proper information quickly and easily.

The content of the book is cross-referenced to the accompanying software with graphic icons at important reference points. The icons are used to inform the reader that there are interactive diagrams, charts, and animations explaining the subject in greater depth in the accompanying software.

Building Form

Building form relates to the shape, volume, mass, scale, and configuration of a building as well as the occupancy type and the users activities. Although building form may often be determined based on a number of concerns outside energy efficiency and sustainability, selecting the proper form is one of the most important steps in sustainable design. Building form impacts the amount of construction materials and energy requirements of the building. A properly conceived building form will mitigate the external climate in order to provide comfortable interior conditions, thereby reducing cooling, heating, ventilation, and electrical lighting requirements.

1. Building Form

1.1 Concepts

A building's environmental performance in relation to its formal configuration can be determined based on a number of factors, including plan geometry, surface area-to-volume ratio, orientation, access to natural light and natural ventilation, user activity, and the location of the structural core and circulation spaces. In addition, climate has a substantial influence on the performance of the building form. A properly selected form for a specific climate may perform poorly in another climatic condition. The following sections examine some of these important factors in the selection of building form.

Plan Geometry

A building's plan geometry can be studied based on its aspect ratio, which is the proportion of the short side to the long side of the floor plan dimensions. A building with a square footprint has a 1:1 aspect ratio and a building twice as long as it is wide has a 1:2 aspect ratio. The optimal building aspect ratio varies with orientation, climatic conditions, latitude, longitude and altitude. In general, elongated plans with aspect ratios 1:1.3 to 1:1.7 with the short sides facing an east-west direction perform well in hot climates. In cold climates, building plans that are almost square, with aspect ratios close to 1:1.1, are considered to be optimal because they have minimal surfaces exposure to the cold.

Building Orientation

Building orientation is an important factor in a building's thermal performance. The built form should be oriented in relation to the influences of the surrounding environment, including the sun's path and prevailing winds. In general, to maximize passive solar heat gain, the long axis of the built form should be oriented east-west so that the elongated sides of the building face north-south. Windows placed in the north wall in hot climatic zones allow diffused light into the building and reduce heat gain. In cool climates, openings should be placed in the south wall to maximize sun penetration into the building.

Surface Area-to-Volume Ratio

A building's exposed surface area-to-volume ratio is a key element for determining heat transmission through the skin. An efficient building form has a low surface area-to-volume ratio, enclosing the maximum amount of space with the minimum skin exposure. Therefore, in cold climates using a compact building with a square floor plan is beneficial because the building will have a minimum of exposed surface area to the cold while providing maximum volume for occupancy.

Tall buildings with multiple units also tend to be more compact than low-rise buildings. Buildings that have many façade protrusions have a larger surface area and are not considered compact. The optimal surface area-to-volume ratio is often determined by utilizing simulation software.

PLAN GEOMETRY

CLIMATIC ZONE	ASPECT RATIO
Hot and Humid	1:1.3
Hot and Arid	1:1.3 - 1:1.7
Temperate	1:1.6
Cool	1:1.1

Source: Victor Olgyay and Aladár Olgyay, Design with Climate: Bioclimatic Approach to Architectural Regionalism (Princeton: Princeton University Press, 1963). P. 89

Fig. 1.1-1 Approximate Aspect Ratio for Ideal Thermal Performance Based on Climatic Zones

BUILDING ORIENTATION

CLIMATIC ZONE	BUILDING ORIENTATION
Hot and Humid	E-W axis 5' north of east
Hot and Arid	E-W axis 25' north of east
Temperate	E-W axis 18' north of east
Cool	E-W axis facing south

Source: Ken Yeang, The Green Skyscraper: The Basis for Designing Sustainable Intensive Buildings (New York: Prestel, 1999). P. 210

Fig. 1.1-2 Approximate Building Orientations for Ideal Thermal Performance

SURFACE TO VOLUME RATIO

BUILDING FORM		SURFACE AREA FT² (m²)		VOLUME FT³ (m³)		S A/V RATIO
Rectangle		112	(10.4)	64	(1.8)	1.75
Square		96	(8.9)	64	(1.8)	1.5
C-Shape		128	(11.9)	64	(1.8)	2.0
O-Shape		160	(14.8)	64	(1.8)	2.5
L-Shape		112	(10.4)	64	(1.8)	1.75

Fig. 1.1-3 Surface Area-to-Volume Ratio for Ideal Thermal Performance of Various Geometries with the Same Volume

Concepts

Natural Lighting

Natural lighting can significantly decrease a building's energy consumption by reducing the need for electric lighting. Narrow floor plans can access adequate light for general illumination with proper openings and solar orientation. Deeper floor plans may require larger portions of the floor area to be artificially lit. Because admitting sunlight for natural lighting is often accompanied with solar heat gain, selecting the proper orientation, glazing type, window location, and using architectural devices (such as roof overhangs and daylight-redirecting systems) can be considerably effective in mitigating thermal gains. For a detailed discussion of natural lighting use in buildings, refer to Section 6.2.

Mass and Service Core

The location of building elements, such as shear walls and service cores, play an important role in the building's energy performance. In cold climates, placing the structural mass at the center of the building volume will facilitate solar energy absorption from the perimeter, thus minimizing the energy required for active heating. In warm climatic zones, the structural mass can be placed in the east and west sides to block the most intense solar heat gain and provide shading for the building.

Natural Ventilation

Natural ventilation is a key element for sustainable design because it can significantly reduce the energy requirements for mechanical ventilation and air conditioning. Natural ventilation is most effective when the building is shaped and oriented to optimize the impact of prevailing winds. Narrow floor plans facilitate air flow and cross-ventilation through the building. Deep floor plans are problematic because fresh air can become contaminated before it is exhausted out of the building. An analysis of local wind directions and pressure differences at various times of the year is necessary to determine the best locations for façade openings to catch and funnel cool breezes through the building.

NATURAL LIGHTING

CLIMATIC ZONE	BUILDING ORIENTATION	MAIN GLAZING LOCATION
Hot and Arid	E-W axis 25' north of east	North
Hot and Humid	E-W axis 5' north of east	North
Temperate	E-W axis 18' north of east	North-South
Cool	E-W axis facing south	North-South

Source: Ken Yeang, The Green Skyscraper: The Basis for Designing Sustainable Intensive Buildings (New York: Prestel, 1999). P. 227–229

Fig. 1.1-4 Approximate Building Orientation for Utilizing Natural Lighting

MASS AND SERVICE CORE

CLIMATIC ZONE	CORE CONFIGURATION	CORE ORIENTATION	CIRCULATION ORIENTATION
Hot and Arid	Double Core	East-West	North-South
Hot and Humid	Double Core	East-West	North-South
Temperate	Single Sided Core	North	North
Cool	Central Core	Center	North

Source: Ken Yeang, The Green Skyscraper: The Basis for Designing Sustainable Intensive Buildings (New York: Prestel, 1999). P. 207

Fig. 1.1-5 Approximate Mass and Service Core Location and Orientation

NATURAL VENTILATION

CLIMATIC ZONE	PREVAILING WINDS (over heated periods) SUMMER	PREVAILING WINDS (over heated periods) WINTER
Hot and Arid	E,W (6.9 mph)	E (5.2 mph)
Hot and Humid	S,SE (8.1 mph)	N (9.3 mph)
Temperate	SW (8.4 mph)	S,SW (9.6 mph)
Cool	S,SE (9.9 mph)	NW (10.5 mph)

Source: "NOAA Satellite and Information Service," National Oceanic and Atmospheric Administration, August 20, 2008. http://www.ncdc.noaa.gov/oa/climate/online/ccd/avgwind.html.

Fig. 1.1-6 Approximate Building Orientation for Utilizing Natural Ventilation

1. Building Form

1.2 Plan Shapes

A building's plan geometry affects the energy performance of a building and responds to particular climatic conditions in different ways. Plan shapes can influence the received amount of solar radiation, thermal transfer, natural light, and natural ventilation, thus affecting the overall indoor environments in buildings. The following sections examine various plan shapes, configurations and orientations in different climatic zones.

Rectangular Plan

A building with a rectangular plan performs well in the hot climates at lower latitudes. Because the east and west sides of the building receive the most intense heat from the sun, minimizing the plan dimensions in these façades can reduce solar heat gain significantly. In addition, placing shear walls and service cores along the east and west sides will provide shaded zones, thus reducing heat gain and the building's temperature. Admitting diffused light from the north in a narrow floor plan can provide ample natural light, reducing the need for artificial lighting. Perpendicular orientation of window openings to the prevailing winds facilitates cross-ventilation.

A rectangular plan shape is not efficient in cold climatic zones because a high aspect ratio produces higher thermal losses during the winter months. However, a narrow rectangular floor plan, with its longer sides aligned with the east and west axis, can generate passive heat gain from the south and admit ample diffused natural light from the north. When the prevailing winds are perpendicular to the long side of the building, cross-ventilation can be an effective means for passive cooling in the summer months.

Square Plan

Compact geometric forms close to a cube shape have smaller surface area-to-volume ratios when compared to elongated shapes. Although less exposed surface area reduces heat exchange with the external environment, a square building provides equal exposure to solar radiation in all directions. In large buildings with square footprints, access to natural light is limited to the building periphery and areas located close to window openings, leaving the internal portions of the floor area dependent on artificial lighting. Introducing daylight from skylights can eliminate this problem. In addition, natural ventilation in square buildings is only effective when the building's floor area is small and air can cross the building easily.

In hot climates, it is always preferable to reduce solar radiation on the east and west sides of a square building. Placing shear walls and the service cores on the east and west sides can provide shaded areas and reduce solar heat gain. A square building configuration can be an efficient shape in the temperate and cold climatic zones. When the building volume uses small openings, the form can preserve heat during the winter months and remain cool during the summer months. Placing shear walls and the building's service core along the center or the north side of the building will allow passive heat gain from the periphery where the sun has some intensity during the winter months.

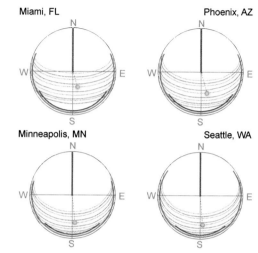

Fig. 1.2-1 Cities' Sun Path
— Summer Sun's Ecliptic
— Winter Sun's Ecliptic

Fig. 1.2-2 Square Section on Minneapolis, Minnesota Climatic Zone

Fig. 1.2-3 Square Section on Minneapolis, Minnesota Climatic Zone

Plan Shapes

O-Plan

A rectangular plan with a central courtyard provides a larger exposed surface area that can lead to significant heat exchange through the building's skin. However, the courtyard configuration divides the plan into narrow sections, providing opportunities for passive cooling and heating, natural ventilation and natural lighting.

The east and west sides of the building receive the most intense heat from the sun. Minimizing the plan dimensions on the east and west sides can reduce heat gain significantly in hot climatic regions. In addition, placing the mass of the building's service cores along the east and west sides will reduce heat gain and the building's temperature.

The O-plan shape is not an efficient configuration in cold climatic zones because the central open space provides a large exposed surface area. Although the plan increases the potential for both natural lighting and cross-ventilation during the summer months, it can have significant heat loss through the building's skin during the winter season.

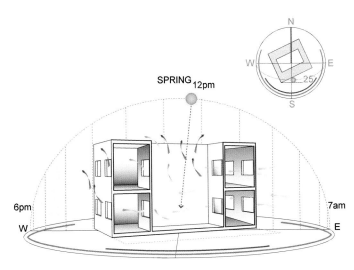

Fig. 1.2-4 O-Plan Section on Phoenix, Arizona Climatic Zone

C-Plan

The addition of two wings extending from a central rectangle increases the exposed surface area to solar radiation. However, the distinct advantage of this plan shape is the shallow depth of the floor plate throughout the plan, providing an increased opportunity for efficient distribution of side lighting and cross-ventilation.

In hot climatic zones, the C-plan provides a better chance for night cooling and cross-ventilation. Circulation spaces are best located on the north side of the building where the sun does not penetrate significantly into the interior space.

In temperate and cold climatic zones, the large surface area of the C-plan produces higher thermal losses through the building skin during the winter months. However, this configuration provides an opportunity for passive cooling in the summer months. Buildings located in the northern hemisphere should have the largest surface area facing south to maximize passive heating during the winter months.

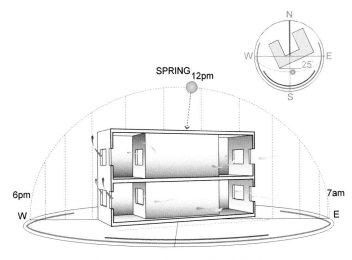

Fig. 1.2-5 C-Plan Section on Phoenix, Arizona Climatic Zone

L-Plan

A rectangular plan can be expanded with the addition of one wing. This floor plan configuration increases the surface area, providing an increased opportunity for natural ventilation and natural lighting. The building side with the larger surface area should be oriented facing north to reduce solar exposure and to minimize heat gain in the hot climatic regions. The location of core and circulation spaces within the building can mitigate heat gains through the building envelope.

In temperate and cold climates, the increased surface area of the L-plan increases the surface area-to-volume ratio, thus reducing the floor plan efficiency in these climates. However, this plan shape provides an opportunity for both natural lighting and natural ventilation.

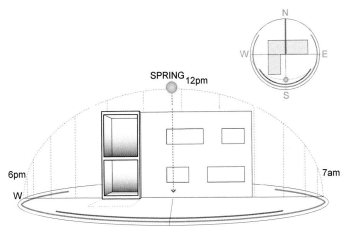

Fig. 1.2-6 L-Plan Section on Seattle, Washington Climatic Zone

1. Building Form

1.3 Climatic Context

In order to examine the response of building form to climatic conditions, the following describes the world climatic zones according to the Köppen Classification System. This system is the most commonly used system and classifies the world's climates into five main zones of Hot and Humid, Hot and Arid, Temperate, Cold, and Polar based on the annual and monthly average temperatures and precipitation. Each zone is further divided into subclimates. The Polar zone and the subclimates are not discussed here because architectural strategies for designing buildings in these climates will not be significantly different.

Hot and Humid

The hot and humid climates are classified into tropical and subtropical zones. Tropical conditions are found in lower latitudes between 15° north and 15° south of the equator, and subtropical climates are located between 15°-23.5° north and 15°-23.5° south of the equator.

Hot and humid climates are mostly identified by the lack of seasonal variation and intense solar radiation for most of the year. These climates are dominated by monthly average temperatures exceeding 64°F (18°C) and have high precipitation and humidity, producing climate conditions outside the comfort zone for the majority of the year. In this climate, the east and west sides of a building receive low altitude sun rays that produce large heat gains. This is a result of the incident sun striking the building's surface with close to right angles on the east and west. To reduce heat gain, it is best to minimize the building's dimensions on these sides.

Using diffused light from the north side can reduce glare in addition to minimizing solar heat gain. Proper overhangs on southern glazing will allow the admission of low-angle winter sunlight for daylighting and exclude excessive higher angle solar radiation in the warmer summer months.

Average wind speeds are generally low and less frequent in hot and humid climates, and the prevailing winds are from the south and southeast during overheated periods. Because humidity levels are very high, evaporative cooling is not effective in this zone, and mass cooling is a preferred passive strategy.

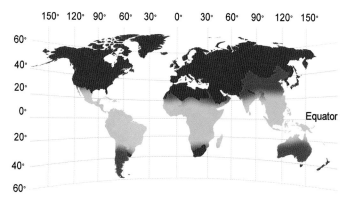

Fig. 1.3-1 *World Map Depicting Hot and Humid Zone*

PLAN	Buildings with elongated footprints perform well in the hot climates at lower latitudes.
GEOMETRY AND ORIENTATION	Minimizing the plan dimensions in the east and west can reduce solar heat gain significantly. Plan geometries that form shallow floor depths are ideal in this climatic zone because they maximize cross-ventilation and provide ample access to natural light.
MASS AND CORE	Placing the building's service core along the east and west sides will reduce heat gain by providing shaded zones, thus reducing the temperature.
SURFACE - VOLUME RATIO	A large surface area-to-volume ratio can lead to significant heat exchange through the building's skin. Admitting diffused light from the north will provide natural lighting, reducing the energy required for artificial lighting.
NATURAL VENTILATION	Window openings perpendicular to the prevailing wind's direction, as well as pressure differences between the inside and outside facilitate cross-ventilation.

Fig. 1.3-2 *Plan Shape Considerations for Hot and Humid Climates*

Climatic Context

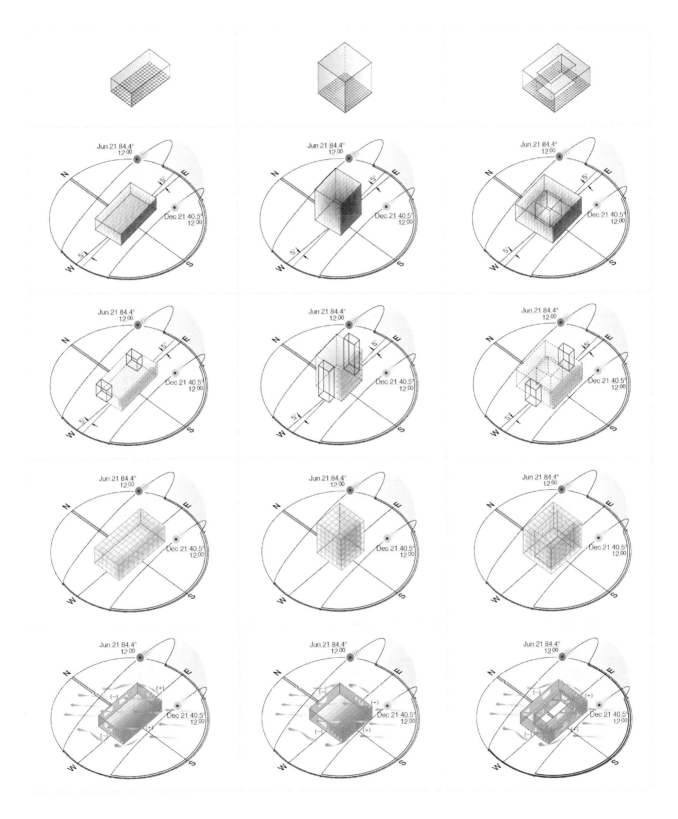

1. Building Form

Hot and Arid

Hot and arid climates are characterized with high temperatures, lack of humidity, and great changes in the daily temperatures. These climates are mostly located between 15°-37° north and south of the equator. The areas located further from the equator have cooler climates and the areas closer to the equator have some periods with humidity. Hot and arid climates receive little precipitation and typically have daily temperatures that are higher than night time temperatures.

Similar to hot and humid climates, plan geometries that form shallow floor depths are ideal in this climatic zone because they maximize cross-ventilation, allow for night cooling, and provide ample access to natural light. A building orientation with the short sides facing east and west is most effective in reducing exposure to intense solar radiation.

With predominantly clear blue skies and bright ground surfaces in the hot and arid climatic zones, it is best to admit diffused light or reflected light from the ground or louver surfaces. Admitting light from the north reduces solar heat gain as well as glare. Utilizing proper overhangs on southern glazing will allow low-angle winter sunlight for daylighting and reflect the intense high angle sunlight in the warmer summer months. Whenever possible, it is best to avoid glazing, and to place shear walls or service cores on the hot east and west sides of the building. When placed in the periphery, the core spaces serve as thermal buffers reducing solar penetration into the interior of the building. Circulation spaces can also create buffer zones to protect the building from excessive sun penetration.

Evaporative cooling or mist cooling is an effective cooling strategy in hot and arid climates. This process produces cooler temperatures by moving dry air through moisture. Because there is often a great difference between the daily and nightly temperatures, night cooling can remove much of the daily generated heat, leading to lower early morning interior temperatures. The prevailing winds in hot and arid climates are from the east and west directions during the over-heated periods.

PLAN	Buildings with elongated footprints perform well in the hot climates at lower latitudes.
GEOMETRY AND ORIENTATION	Minimizing the plan dimensions in the east and west can reduce solar heat gain significantly. Plan geometries that form shallow floor depths are ideal in this climatic zone because they maximize cross-ventilation, allow for night cooling, and provide ample access to natural light.
MASS AND CORE	Placing the building's service core along the east and west sides will provide shaded zones, reducing heat gain and the building's temperature.
SURFACE - VOLUME RATIO	Large surface-to-volume ratio can lead to significant heat exchange through the building's skin. Admitting diffused light or reflected light from the north will provide natural lighting, reducing the energy required for artificial lighting.
NATURAL VENTILATION	Perpendicular orientation of window openings to the prevailing winds as well as pressure differences between inside and outside facilitate cross-ventilation. Evaporative cooling and night cooling are effective methods to lower air temperatures in hot and arid climates.

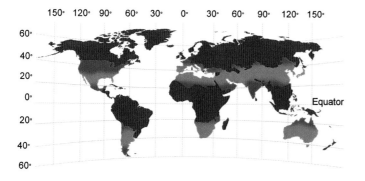

Fig. 1.3-3 World Map Depicting Hot and Arid Zone

Fig. 1.3-4 Plan Shape Considerations for Hot and Humid Climates

Climatic Context

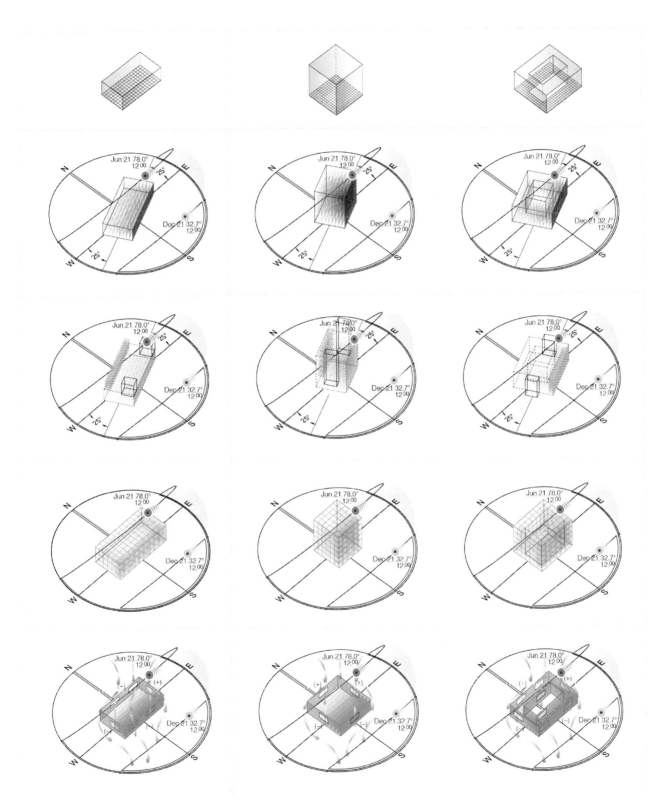

1. Building Form

Temperate

Temperate climates do not have extreme temperatures or precipitation and are characterized by warm and dry summers, leading to cool and wet winters. They are generally located in latitudes between 30°-55° north and south of the equator. These climates have an average temperature above 10°C (50 °F) in their warmest months (April to September in the northern hemisphere) and a coldest month average between −3°C (27°F) and 18°C (64°F).

The moderate temperatures, light winds and four distinctively marked seasons of temperate climates provide more flexibility in the selection of the building form. The implementation of passive strategies, maximizing heat gain during winter months and minimizing heat gain during the summer, can be very effective in these climates. Because the larger the surface area of a building has the greatest potential for heat exchange with the exterior environment, orienting the long surfaces of the building to the south will provide direct passive heating in winter months. Placing windows on the south side can facilitate access to high levels of illumination and reduce the energy required for artificial lighting.

Because the prevailing winds are from mostly from the west and southwest, window openings are best located on the windward façades to facilitate cross-ventilation during summer months. However, it is best to restrict incoming fresh air during the winter. The difference in temperature between the interior of the building and the exterior environment allows a stack effect to draw in fresh air. Shear walls, service cores and circulation spaces are best located on the north side of the building to reduce heat loss.

PLAN	Elongation of the form along the east and west axis is preferable because it provides a larger exposed surface for passive heating on the south side of the building during the spring and winter.
GEOMETRY AND ORIENTATION	The long surfaces of the building should be oriented toward the south to capture solar energy. Admitting light from south-facing glass walls provides ample natural light in addition to providing passive heating. However, direct sunlight through the southern façade should be controlled to minimize glare.
MASS AND CORE	Shear walls, service core, and circulation spaces are best located on the north side of the building to reduce heat loss.
SURFACE - VOLUME RATIO	Large surface area-to-volume ratios can lead to significant heat loss through the building's skin. Large surface areas should be oriented toward the south to capture solar energy for passive heating during the winter.
NATURAL VENTILATION	Window openings on the windward south and southwest sides, and the leeward north and northeast sides will facilitate cross-ventilation. Pressure differences between inside and outside facilitate cross-ventilation.

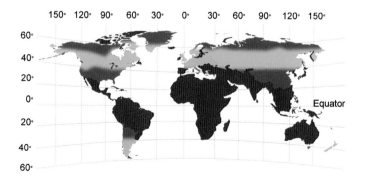

Fig. 1.3-5 World Map Depicting Temperate Zone

Fig. 1.3-6 Plan Shape Considerations for Temperate Climates

Climatic Context

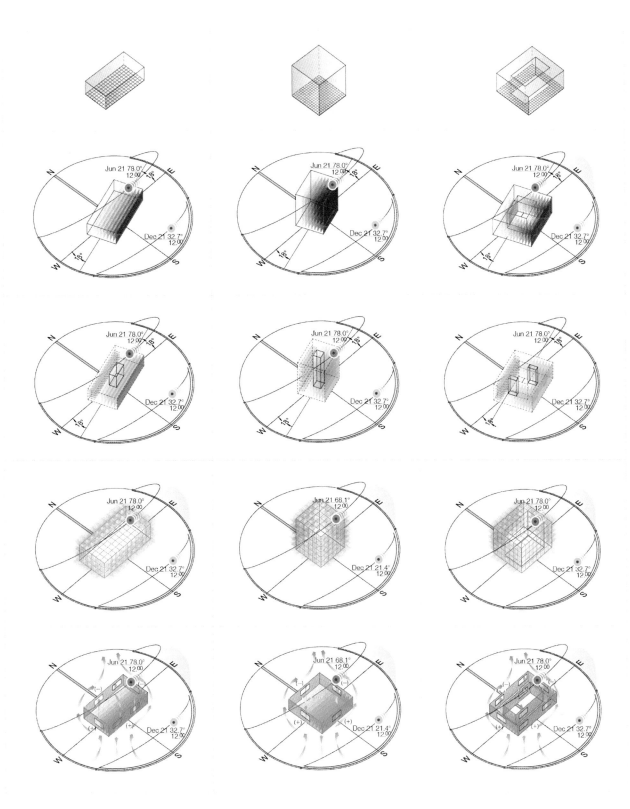

1. Building Form

Cold

Cool climate zones are located generally in higher latitudes, ranging from 50°-70° north and south of the equator in the interior regions of large land masses. They are characterized by cool-to-cold winter temperatures and short summers that range from hot in the south to cool in the north. Cold climates receive less sunlight and receive moderate precipitation in summer, with well-defined summer and winter seasons.

In the higher latitudes of the northern hemisphere with colder climates, it is best to minimize the surface exposed to the cold winter winds and reduce heat loss. In these climates, buildings are best oriented to receive maximum solar radiation. In general, aligning the long axis of the built form along the east-west axis provides maximum solar exposure on the south façade, maximizing passive heat gain.

Direct sunlight can be an excellent source of lighting in cold climates if efficiently distributed throughout the building. However, direct sunlight through the southern façade should be controlled to minimize glare and visual discomfort.

In these climates, service cores should be located at the center of the building to allow solar penetration from the perimeter for passive heating. The circulation spaces are best located on the north side of the building to provide a thermal buffer that mitigates exterior lower temperatures.

Natural ventilation can be achieved using wind pressure or stack effects. Adequate air exchange through small openings is preferable to maintain comfortable interior temperatures and avoid excessive heat loss. The prevailing winds come from the northwest during the winter months and from the south and southeast during the heated period. Cross-ventilation during the summer months can be effective to reduce significantly the energy required for mechanical cooling systems.

PLAN	Elongation of the form along the east and west axis is preferable because it provides larger exposure in the south side of the building for passive heating.
GEOMETRY AND ORIENTATION	The long surfaces of the building should be oriented toward the south to capture solar energy. Admitting light from south-facing exposed glass walls can provide ample natural light and passive heating. However, direct sunlight through the southern façade should be controlled in order to minimize glare.
MASS AND CORE	Shear walls and service cores are best located at the center of the building to allow solar penetration from the perimeter for passive heating. The circulation spaces are best located on the north side of the building to provide a thermal buffer that mitigates exterior lower temperatures.
SURFACE - VOLUME RATIO	Large surface-to-volume ratios can lead to significant heat exchange through the building's skin. Large surface areas should be oriented toward the south to capture solar energy for passive heating.
NATURAL VENTILATION	Natural ventilation can be achieved using wind pressure or stack effects. Adequate air exchange through small openings is preferable to maintain comfortable interior temperatures and avoid excessive heat loss. Window openings on the windward northwest sides and the leeward southeast sides will facilitate cross-ventilation.

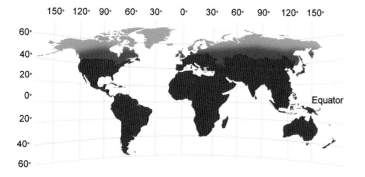

Fig. 1.3-7 World Map Depicting Cold Zone

Fig. 1.3-8 Plan Shape Considerations for Cold Climates

Climatic Context

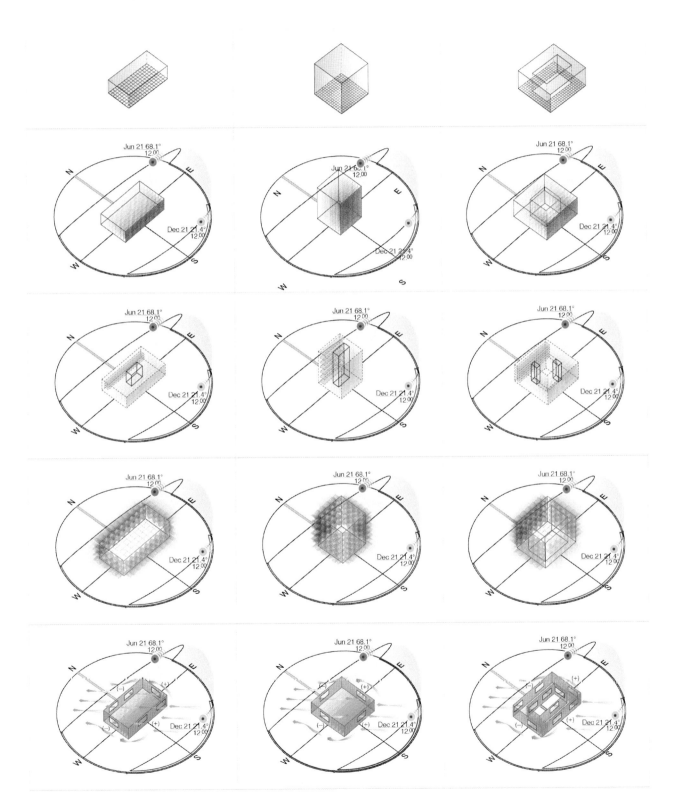

Building Envelopes

The building envelope is the primary interface of a building with the exterior surroundings. As a result, the building envelope plays a critical role in the energy management and sustainability of the built environment. The proper selection of walls, roof and floor systems, construction materials and a rigorous, detailed development of connections and structural joinery are important components of energy saving strategies. In addition, thermal and moisture control, sound and fire insulation, and natural lighting strategies can significantly reduce dependence on mechanical climate control systems. The following sections will introduce concepts, principles, and strategies for the selection and evaluation of building enclosures with respect to their environmental performance.

2. Building Envelopes

2.1 Concepts

An informed process of selecting materials utilized in building envelopes can lead to significant improvements and reduce the environmental impact of buildings. An investigation of a material in terms of natural resource extraction and properties such as thermal resistance, thermal transmittance and insulation capabilities can be a useful vehicle for gauging various enclosure alternatives. The following sections describe some of the critical concepts required for understanding building enclosure materials, function, performance and sustainability.

Environmental Impact

The use of materials for building construction causes major impacts on the environment, including significant water consumption and resource and energy usage as well as greenhouse gas emissions. These materials consume energy and water in their removal, manufacturing, transportation, maintenance and recycling and produce hazardous emissions during these processes. Approximate indicators of a material's environmental impact are embodied energy, embodied water and carbon footprint. Designing buildings with improved environmental performance should go beyond decreasing the operational energy and aim at reducing embodied energy, embodied water and carbon footprint during the life cycle of building materials.

EMBODIED ENERGY Embodied energy is the amount of energy used to extract, produce, and distribute a material to the location of use. In general, the embodied energy of building materials contributes about 15 to 20 percent to the energy used by a building over a 50-year period.[1] This percentage is expected to increase as buildings become more energy efficient. The units for embodied energy may be expressed as Megajoules (MJ) or Btu per unit of weight (kg or lb) or per unit area (square meter or square foot).

The embodied energy for an enclosure system can be arrived at by the summation of the embodied energy values of each individual material used in the system or the assembly. Although the use of different methodologies and data sets for calculating embodied energy can result in different measurements, these measurements still provide an indication of resource depletion and energy utilization in the construction of a building.

The strategies and recommendations below provide a framework for selecting materials and construction methods for the design of building envelopes:

• Investigate the embodied energy values of materials prior to construction to select materials with lower embodied energy.

• When possible, to save water, use salvaged materials with high recycled content to reduce embodied energy, construction waste and air pollution.

• When possible, use regional construction materials to decrease the transportation distances to reduce embodied energy.

EMBODIED WATER Although the demand for water consumption has increased significantly over the last century, the infrastructure capacity to harvest adequate water to serve the Earth's growing population has not grown accordingly, and in many parts of the world, water scarcity is becoming a critical issue. In addition to the daily operation of buildings, water is used in the production of building materials. The amount of water used to manufacture and deliver materials to their final destination is called embodied water.

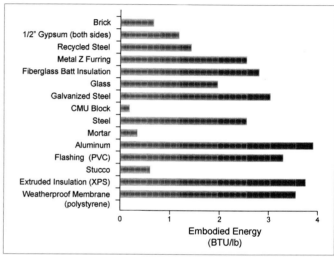

Fig. 2.1-1 Embodied Energy of Building Materials (BTU/lb)

EMBODIED ENERGY		
MATERIAL	EMBODIED ENERGY BTU/lb	EMBODIED ENERGY MJ/Kg
CMU Block	305.89	0.71
Mortar	603.16	1.40
Stucco	947.82	2.20
Brick	1,292.48	3.00
1/2" Gypsum Wallboard (both sides)	2,908.08	6.75
Recycled Steel	3,791.28	8.80
Glass	6,462.41	15.00
Steel	10,512.19	24.40
Metal Z Furring	10,512.19	24.40
Fiberglass Batt Insulation	12,063.16	28.00
Galvanized Steel	16,802.26	39.00
Flashing (PVC)	33,259.87	77.20
Weatherproof Membrane (polystyrene)	37,309.64	86.60
Extruded Insulation	38,171.30	88.60
Aluminum	66,778.23	155.00

Fig. 2.1-2 Embodied Energy of Building Materials (BTU/lb) vs. (MJ/Kg)

Source: Geoff Hammond and Craig Jones, "Inventory of Carbon and Energy (ICE)," Sustainable Energy Research Team (SERT), Department of Mechanical Engineering, University of Bath, UK, 2008. http://people.bath.ac.uk/cj219/

Concepts

There is a growing body of research using various methodologies to estimate the embodied water values for various materials. Based on a study conducted by the Royal Institute of Australian Architects,[2] there is a close relationship between embodied water and embodied energy. As a result, the study concludes that the strategies used to reduce the embodied energy in buildings will be effective for reducing the embodied water.

CARBON FOOTPRINT Carbon footprint refers to the amount of carbon dioxide and other greenhouse gas emissions associated with an activity, a process, or a product. Building materials cause greenhouse emissions throughout their life cycles because they require energy for their production and disposal. Building materials with high embodied energy generate considerable amounts of greenhouse gas emissions. Steel generates 26 percent more greenhouse gases and concrete 31 percent more, than wood.[3] Reducing a material's carbon footprint will minimize embodied energy and mitigate its environmental impact.

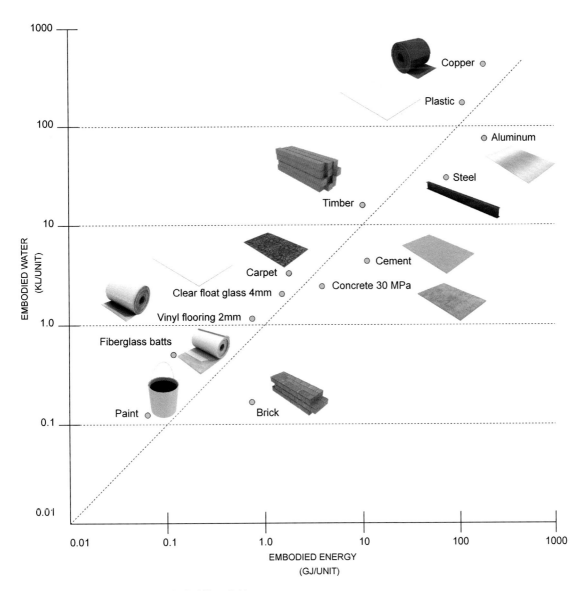

Fig. 2.1-3 Embodied Energy and Embodied Water Table

Source: Graham Treloar, Michael McCormack, Laurence Palmowski and Roger Fay, "Embodied water of construction," BEDP Environment Design Guide Vol. GEN 58, pp.1–8, Royal Australian Institute of Architects, Melbourne (2004–2005)

2. Building Envelopes

Material Thermal Properties

Designing efficient building envelopes requires an understanding of the thermal performance of utilized materials. Reducing the envelope energy loss is critical, particularly where significant heating or cooling is required to provide thermal comfort. In general, thermal transmittance and thermal resistance are the two most important properties for understanding the conductive performance of building materials.

THERMAL RESISTANCE (R-VALUE) Thermal resistance is the capacity of a material to resist heat transfer through conduction, convection, and radiation. It is a measure of insulation value and is largely a function of the number and size of cavity spaces in a material. Thermal resistance is expressed as R-value which has units of $ft^2 \cdot °F \cdot h/Btu$ (square feet-Fahrenheit hour per Btu), $m^2 \cdot K/W$ (square meter—kelvin per watt), or $m^2 \cdot °C/W$ (square meter—Celsius per watt). To show the thermal resistance of a material, the symbol R is usually placed before the numerical value, as in R-20. The R-value for building assemblies composed of various elements can be found by the summation of all individual element's R-values.

THERMAL TRANSMITTANCE (U-VALUE) Thermal transmittance is the rate of heat loss or heat transfer through a material and is expressed by the U-value. Thermal transmittance measures the capacity of a material with a certain thickness to transmit heat through conduction, convection and radiation. The units of U-value are $Btu/hr \cdot ft^2 \cdot °F$ (Btu per hour per square foot per degree Fahrenheit) or W/m^2K (watts per square meter per kelvin). The U-value of a building assembly, such as a wall system, is calculated from the reciprocal of the combined thermal resistances of the materials in the wall assembly ($U = 1/R$).

THERMAL CONDUCTIVITY Thermal conductivity is the ability of a material to transmit heat. Conductivity is a result of direct molecular interaction for transferring heat when there is a temperature difference in the material. Thermal conductivity is expressed by k or λ and is measured as $Btu/hr°F \cdot ft$ (Btu per hour per foot per degree Fahrenheit) or $W/m \cdot K$ (watts per meter per kelvin). Thermal conductivity and thermal transmittance are closely related. However, thermal conductivity does not take into account heat transfer due

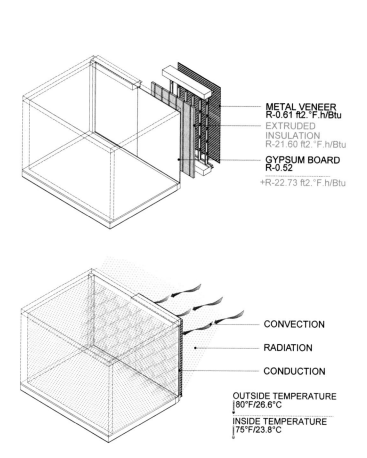

Fig. 2.1-4 Thermal Resistance (R-Value)

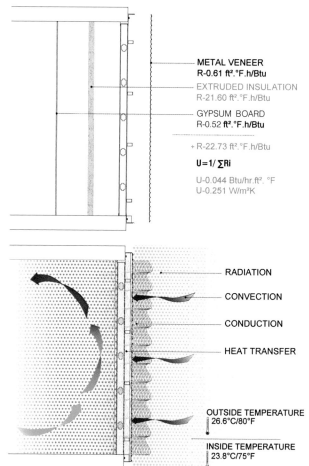

Fig. 2.1-5 Thermal Transmittance (U-Value)

Concepts

to radiation and convection, or the material thickness.

THERMAL BRIDGING A thermal bridge is the part of the building envelope where heat transfer occurs at a significantly higher rate than the surrounding areas of the envelope. Thermal bridging and air leakages happen when relatively highly thermal conductive materials (such as steel and concrete) are used without airtight insulation in transitional spaces, thus creating vulnerable locations for heat loss or heat transfer. These locations include the periphery of windows and doors and connection areas between the envelope components and structural elements.

Thermal bridges are more critical in cold climates or in hot and humid climates when the indoor-outdoor temperature differences are the greatest. Without adequate insulation, the cool air and the warm air meet through thermal bridges on the surface of the envelope, creating condensation and built-up moisture. Moisture decreases the envelope's R-value, creates water leakage and deteriorates the building envelope. Thermal bridging is best addressed during the design process for new buildings. For existing buildings with mandatory energy saving ordinances, various testing methods can determine the exact location and to some extent the magnitude of thermal bridges. The U.S. ENERGY STAR Qualified Homes Thermal Bypass Inspection Checklist includes two methods of infrared thermography (thermal imaging) and blower

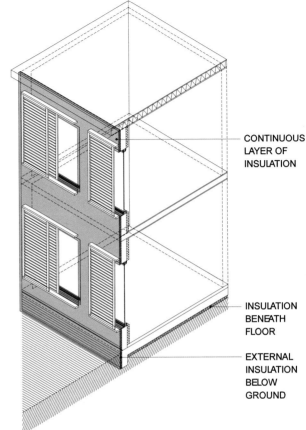

CONTINUOUS LAYER OF INSULATION

INSULATION BENEATH FLOOR

EXTERNAL INSULATION BELOW GROUND

Fig. 2.1-7 Thermal Bridge Free Façade with Continued Insulation

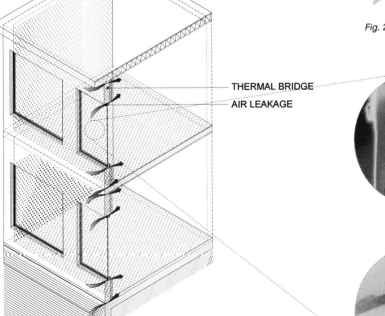

THERMAL BRIDGE
AIR LEAKAGE

OUTDOOR AIR TEMPERATURE 79°F (26.1°C)
INDOOR AIR TEMPERATURE 68°F (20°C)
HEAT TRANSFER

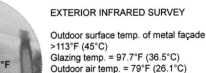

EXTERIOR INFRARED SURVEY

Outdoor surface temp. of metal façade >113°F (45°C)
Glazing temp. = 97.7°F (36.5°C)
Outdoor air temp. = 79°F (26.1°C)
Relative humidity = 78%
Wind speed = 15 mph (24.1 km/h)

INTERIOR INFRARED SURVEY

Indoor surface temp. of metal window mullion > 76.6°F (24.8°C)
Interior wall surface temp. = 74°F (23.3°C)
Indoor air supply temp. = 68°F (20°C)

The window mullion has no thermal break to stop the heat transfer from exterior to interior; therefore, a thermal bridge is created.

Fig. 2.1-6 Thermal Bridge Detection through Infrared Camera in Hot and Humid Climate

2. Building Envelopes

door test inspections.

SOLAR HEAT GAIN COEFFICIENT & SHADING COEFFICIENT Glazed openings on buildings can be a major source of heat gain by solar radiation. Solar heat gain is a function of glazing material properties and is measured by the shading coefficient (SC). SC is the ratio between the solar heat gain for a particular type of glass and that of a single clear float glass. SC is expressed as a number between 0.0 and 1.0. A lower SC indicates a lower heat gain value and a better capacity to block solar radiation. Clear glass has a SC of 1.0.

Shading coefficient is being replaced by the solar heat gain coefficient (SHGC). The SHGC is a measure of how well glass blocks heat from sunlight. The SHGC is the fraction of solar radiation that is admitted through glass and is expressed as a number between

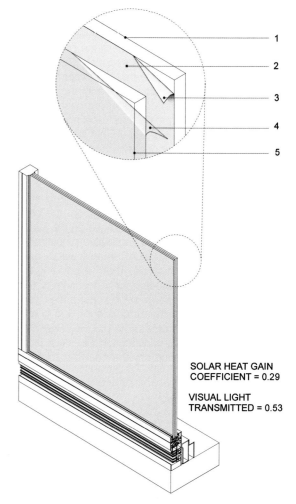

SOLAR HEAT GAIN COEFFICIENT = 0.29

VISUAL LIGHT TRANSMITTED = 0.53

1. 1/4" (6.3 mm) Thick Clear Window Glass
2. 1/2" (12.6 mm) Air Gap
3. Low Emissivity Coating Layer
4. Spectrally Selectic Tint Film
5. 1/4" (6.3 mm) Thick Clear Window Glass

Fig. 2.1-8 Solar Heat Gain Coefficient

Concepts

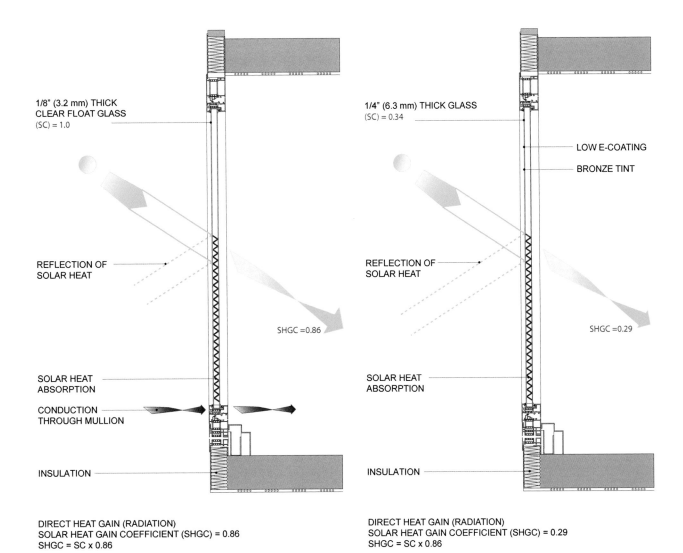

Fig. 2.1-9 *Solar Heat Gain Coefficient and Shading Coefficient*

2. Building Envelopes

Enclosure Materials

Building enclosures serve a multitude of critical functions by providing thermal comfort, natural lighting, air movement, humidity and moisture control, views, sound insulation, pollution and fire resistance. In addition, building enclosures can function as load-bearing walls or roof systems that provide lateral resistance to wind and seismic loads. Selecting enclosure materials that can best integrate these functions is a substantial step to reducing resource and energy demand and the carbon footprint of buildings throughout their life cycle.

Wood

Due to the extensive availability and ease of fabrication, wood has been widely used as a building enclosure material. Although wood is often considered renewable, unsustainable forest management causes soil erosion and bio-diversity loss. However, when wood resources are managed and certified properly, the benefits of using wood in construction may exceed that of concrete and metals.

In order to ensure long-life service, a number of factors must be considered when using wood in buildings. Moisture control is one of the most critical concerns because a high level of moisture content will lead to decay. Termite and fire control are also important factors when designing with wood. Wood can be recycled and, when designed properly, is a durable construction material. Wood has a low embodied energy, is biodegradable and has a better thermal efficiency when compared to most metals.

ENGINEERED WOOD PRODUCTS Almost all enclosure applications require engineered wood products. These are composite elements manufactured with precise design specifications to produce wood components with consistent properties, better efficiency, and improved performance.

Engineered wood products utilize smaller trees that can grow and be replaced faster. However, the manufacturing process consumes more energy, and some of the adhesives used are toxic. In addition, recycling engineered wood is more difficult than sawn lumber. Engineered wood products are used for stiffening and covering floors, walls, partitions and sheathings, and for backings for special veneers and coatings.

Plywood
Plywood is composed of thin sheets or plies of wood veneers oriented at cross-grain and bonded together under heat and pressure.

Oriented Strand Board (OSB)
OSB is composed of wood strands aligned at 90 degrees and glued together with waterproof adhesives.

Laminated Veneer Lumber (LVL)
Laminated veneer lumber is manufactured from thin peeled layers of wood veneer that are aligned with the length of the member and glued with a strong adhesive.

PHYSICAL APPEARANCE	NAME AND DESCRIPTION
	Plywood Composed of thin sheets or plies of wood veneers oriented at cross grain and bonded together under heat and pressure.
	Oriented Strand Board (OSB) Composed of wood strands aligned at 90 degrees and glued together with waterproof adhesives.
	Laminated Veneer Lumber (LVL) Manufactured from thin peeled layers of wood veneer aligned with the length of the member and glued with a stron adhesive.

Fig. 2.1-10 Wood Enclosure Materials

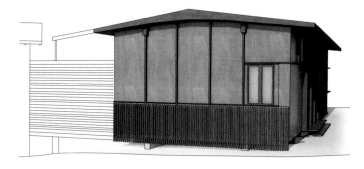

Fig. 2.1-11 Example of Using Plywood as a Building Envelope; "Plywood House" by Herzog & De Meuron, Basel, Switzerland

Concepts

Masonry Products

Masonry products are commonly used in building construction because of their modular nature. Traditionally, these products have been used as a load-bearing element. However, due to increased cost, most masonry products (with the exception of concrete masonry units) are currently used as cladding materials only. Masonry building materials are easy to produce, transport and assemble. They require low maintenance and can be recycled at the end of their use.

In addition, masonry products have good thermal properties: they can store solar energy during the winter for passive heating and store cool energy in the summer to provide passive cooling. Masonry products can be classified into natural units which consist of stones and man-made units, including clay bricks and concrete masonry units.

NATURAL UNIT: STONE Stone masonry is one of the oldest materials utilized in building construction. Stone products are currently used as cladding materials only because their construction methods are not efficient when compared to other available structural materials. Stone products require extremely labor-intensive processes that are harmful to the site of their extraction. They are also expensive to transport and manipulate, thus having a high embodied energy. For building enclosure applications, the most commonly used stones are granite, an igneous rock created from deposits in molten state; limestone, a sedimentary rock transformed by the action of water; and marble, a metamorphic rock which can be either sedimentary or igneous rock transformed by heat and pressure.

MAN-MADE UNITS: CLAY BRICK AND CONCRETE MASONRY UNITS (CMUs) Man-made masonry products are among the most commonly used materials in building construction. They have low embodied energy because they are fabricated under a controlled environment, reducing time and material use effectively. They are durable and can be recycled for other uses. Unused, broken units can be returned to the manufacturing process to produce new ones. Man-made units are formed and shaped by the action of steam and pressure. They can be made of clay, shale, soft slate, calcium silicate and concrete. Some manufacturers fabricate masonry units for cladding applications made of sludge or petroleum-contaminated soil, thus further reducing embodied energy and water.

Clay Bricks
Clay bricks are generally utilized in cladding applications for aesthetic purposes and ease of fabrication. Brick walls can be constructed off-site in a metal frame system and assembled on the construction-site, where they are welded together into place.

Concrete Masonry Units (CMUs)
CMUs are utilized for both structural and cladding applications. When used as load bearing walls, the hollow space within the units are utilized for placing steel reinforcing bars and are filled with concrete. The hollow space in CMUs can also be used to hold electrical or plumbing elements.

PHYSICAL APPEARANCE	NAME AND DESCRIPTION
	Stone — Utilized in cladding materials only because they require extremely labor-intensive processes and expensive transportation.
	Clay Bricks — Utilized in cladding applications for aesthetic purposes and ease of fabrication. Clay bricks have very low embodied energy.
	Concrete Masonry Units — Utilized for both structural and cladding applications. When used as load-bearing walls, the hollow space within the units are utilized for placing steel reinforcing bars and are filled with concrete.

Fig. 2.1-12 Masonry Enclosure Materials

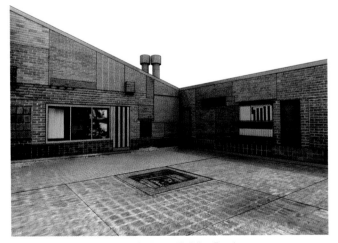

Fig. 2.1-13 Example of Using Brick as a Building Envelope; "Experimental House" by Alvar Aalto, Muuratsalo, Finland

2. Building Envelopes

Reinforced Concrete

Concrete is composed of cement, aggregate, water, and a number of additives to control properties such as strength, workability, curing time, etc. Cement production accounts for 7 percent of worldwide CO_2 annual emissions. These emissions can be reduced by replacing a portion of cement in the mix with waste by-products from power plants, steel mills, and other manufacturing facilities. In addition, using recycled concrete, recycled glass, tire scraps, and other materials as aggregate can reduce concrete's embodied energy significantly. Concrete has many applications for building enclosures including architectural panels, bearing walls and shear walls.

STEEL-REINFORCED CONCRETE Because concrete is brittle and has a very low capacity to carry tension forces, almost all elements used in building construction include reinforcing steel bars or wires. Architectural precast wall panels, commonly used for building enclosures, include steel reinforcement to increase the concrete's capacity in tension. However, when reinforced concrete is used for structural purposes, a much larger percentage of steel reinforcement must be included.

FIBER-REINFORCED CONCRETE In nonstructural applications of concrete, reinforcement to increase concrete's compressive capacity can be added in the form of discrete fiber particles of glass, steel or plastic. The addition of these fibers creates a lightweight concrete with improved moisture resistance, energy absorption and fire resistance.

LIGHTWEIGHT CONCRETE Lightweight concrete, also known as foamed concrete or cellular concrete, is composed of lightweight concrete with improved thermal efficiency. Adding stable foam to the concrete mix introduces small air bubbles, making it lighter. This type of concrete can be used in nonstructural wall and floor panels.

PHYSICAL APPEARANCE	NAME AND DESCRIPTION
	Steel-reinforced Concrete Architectural precast wall panels used for building enclosures include steel reinforcement to increase the concrete capacity in tension.
	Fiber-reinforced Concrete Discrete fiber particles of glass, steel or plastic can be added to the concrete mix to increase its capacity in tension.
	Lightweight Concrete Adding stable foam to the concrete mix introduces small air bubbles, making concrete lighter.

Fig. 2.1-14 Concrete Enclousure Materials

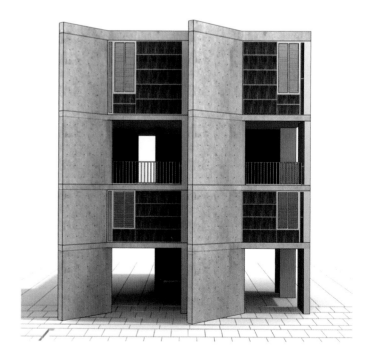

Fig. 2.1-15 Example of Using Reinforced Concrete as a Building Envelope; "Salk Institute" by Louis Kahn, San Diego, California

Concepts

Metals

Metals that are widely used as building enclosure materials include steel, stainless steel, copper, titanium, zinc, brass, and aluminum. Metals offer a long-lasting and lightweight alternative for cladding buildings. Most metals are highly recyclable without any loss in property or performance, and on-site metal construction often leaves little waste. However, metals in general have high embodied energy and embodied water, and do not provide adequate thermal insulation. In addition, because the production of metals requires significant input of raw materials and energy, it often results in output of hazardous emission, water pollution and solid waste.

STEEL Steel is a high strength metal, but it is vulnerable to moisture and corrodes easily. Steel must be covered with a protective layer when exposed to the environment. Using COR-TEN steel or weathering steel can provide an alternative to the application of rust-proofing material. This type of steel forms a stable outer layer of brown/orange rust when exposed to air. This layer protects the steel from further rusting.

STAINLESS STEEL Stainless steel is an iron alloy that contains chromium which is a corrosion-resistant element, making stainless steel an extremely durable cladding material. It can be 100 percent recycled with a high scrap value, eliminating much of the construction waste. However, stainless steel is an expensive construction material with high embodied energy.

ALUMINUM Aluminum is relatively useful because it is long lasting, corrosion resistant, lightweight and 100 percent recyclable. However, aluminum has a negative impact on the environment because its manufacturing processes (including extraction, refinement, smelting and modeling) require a large amount of energy. Aluminum's embodied energy is 126 times higher than that of wood.

ZINC Zinc is a long-lasting, flexible material that can be used for building enclosure applications. It generally contains a large percentage of recycled content and has little to no maintenance requirements. Zinc's carbon footprint is lower than that of other metals.

TITANIUM Titanium is a long-lasting, lightweight metal. It is mostly used in automotive, motorcycle and sporting applications because of its light weight and its high strength and rigidity. Titanium does not corrode and as a result does not release toxic materials generated by corrosion. Titanium has a long life cycle and a large percentage of recycled content. It has a smaller thermal expansion and shrinkage than stainless steel.

PHYSICAL APPEARANCE	NAME AND DESCRIPTION
	Steel High-strength and durable cladding material when treated against corrosion.
	Stainless Steel Contains chromium which is a corrosion-resistant element, making stainless steel an extremely durable cladding material.
	Aluminum Long-lasting, corrosion-resistant, lightweight and 100 percent recyclable material.
	Zinc Long-lasting, corrosion-resistant and mildew-resistant material, recyclable and reduces heat gain.
	Titanium Corrosion-resistant, lightweight, easily worked into complex shapes, low coefficient of expansion.

Fig. 2.1-16 Metal Enclosure Materials

2. Building Envelopes

Glass

Glass is composed of a mixture of sand, soda ash (hydroxide or sodium carbonate) and added heat. When glass was first used in architecture and construction, it had many limitations, including cost and labor-intensive fabrication processes. Today, architectural glass has become a favored building material because it is relatively inexpensive and it offers versatility. When utilized for cladding purposes, glass has a profound impact in the aesthetics and energy efficiency of a building. Glass can be reflective, refractive, transparent, translucent and opaque. It can control glare as it filters light and can provide sound and fire protection. Glass has been the focus of intensive research and development among scientists and engineers to enhance its two most efficient traits, the ability to transmit natural light and block excessive heat.

ANNEALED GLASS is the most common type of window glass; however it can break into large, sharp pieces causing serious injuries.

TEMPERED GLASS has increased strength and if it breaks, it will usually shatter in small pieces.

LAMINATED GLASS is impact proof because it is composed of two layers of temperate glass sandwiched together with an invisible mesh of polyvinyl butyral.

SPANDREL GLASS is a portion of opaque glass used in exterior curtain wall systems to hide the mechanical system between floor slabs.

FRITTED GLASS is used as a light-diffusing element in buildings. It can be used as an energy-saving strategy to maximize daylight penetration while reducing heat gain.

TINTED GLASS is a type of tempered glass that has been treated with a film or coating to reduce the transmission of light and heat into a space.

INSULATED GLASS is composed of two or three separate layers of glass with air space in between. These layers provide good thermal insulation to minimize heat gain or heat loss through the building envelope. Insulated glass is required by law for cladding applications in many countries.

SOUND INSULATION glass consists of multiple glass panes that prevent sound waves from entering interior spaces.

FIRE PROTECTION GLASS consists of multiple glass layers with wire mesh or special fireproofing foil in between. Utilizing this type of glass provides adequate time for evacuation before damage by fire.

PHOTOVOLTAIC GLASS consists of two glass layers embedded with solar cells that collect and convert solar energy into electricity. The energy generation is dependent on the enclosure orientation and the amount of solar exposure.

SMART GLASS also known as E-glass or switchable glass is a type of glass that can control the amount of light transmitted into a space. It can also block UV rays by transforming its appearance from a transparent surface to a translucent surface.

ELECTROCHROMIC GLASS consists of glass treated with an electrochromic layer to control the amount of light passing through. It is an energy-saving device because it changes opacity and color when exposed to solar radiation to reduce heat gain.

Composites

A composite material refers to a single material that occurs naturally or is engineered from two or more materials with significantly different properties. Composite materials range from translucent concrete to colored photovoltaic units. Composites are often used when lighter weight is an important consideration.

PLASTICS are highly functional engineered materials for architectural applications. Innovative, technical developments are constantly improving their material properties, and plastics are becoming increasingly prevalent in the construction industry. Some common applications in building construction include insulation, piping, and window framing and cladding. Plastic insulation has high thermal efficiency and improves energy performance.

Concepts

PHYSICAL APPEARANCE	NAME AND DESCRIPTION
1	**Annealed Glass** Annealed glass is produced by gradually cooling glass to decrease its brittleness and likelihood of cracking. However, annealed glass can break into large, sharp pieces causing serious injuries.
2	**Tempered or Safety Glass** Safety glass is tempered to increase strength and resistance to impact. When tempered glass breaks, it shatters into very small pieces that are held together, making it less of an injury hazard.
3	**Laminated Glass** Laminated glass is impact resistant because it is composed of two or more layers of temperate glass, sandwiched together with an invisible mesh of resin.
4	**Spandrel Glass** Spandrel glass is opaque glass often used in exterior curtain walls to conceal the mechanical and structural systems between floor slabs.
5	**Fritted Glass** Fritted glass is produced by printing an image, color or a pattern onto the glass surface during the manufacturing process. It can be utilized to control daylight and solar heat gain.
6	**Tinted Glass** Tinted glass is tempered glass that has been treated with a film or coating in order to reduce the transmission of light and heat.
7	**Insulated Glass** Insulated glass is composed of two or three separate layers of glass with an air space in between. These layers provide thermal insulation and minimize heat transfer.
8	**Sound Insulation or Acoustic Glass** Sound insulation glass consists of multiple glass panes or laminated glass that reduce sound transmission.
9	**Fire Protection Glass** Fire protection glass consists of multiple glass layers with wire mesh in between. Utilizing this type of glass provides adequate time for evacuation before damage by fire.
10	**Photovoltaic Glass** Photovoltaic glass consists of two glass layers embedded with solar cells that collect and convert solar energy into electricity.
11	**Smart Glass** Smart glass also known as E-Glass utilizes a smart film to transition from transparent to darkened or reflective surface, thus controlling the amount of light transmitted into a space.
12	**Electrochromic Glass** Electrochromic glass consists of glass treated with an electro-chromic layer to control the amount of light passing through. This type of glass changes opacity to reduce heat gain.

Fig. 2.1-17 Glass Enclosure Materials

2. Building Envelopes

Insulation Materials

The insulation of a building envelope consists of many layers of materials that are critical in meeting thermal, acoustical, and fire-resistant requirements. Insulation materials can be either organic (raw materials such as cork, mineral fiber, cotton, etc.) or inorganic (synthetic materials such as polyurethane rigid foam or polystyrene).

Thermal insulation is used to reduce the rate of heat transfer through the building enclosure and protects against moisture-related damage. Thermal insulation plays a critical role in the energy efficiency of buildings because it mitigates energy exchange between the interior of the building and the exterior environment. The thermal energy transfer through a material is dependent on its thermal conductivity. A material with less conductivity will have smaller energy exchange with the external environment, therefore creating a better insulation. In addition, materials with less density have a better insulation quality because they have higher air content. Air and some inert gases such as xenon, krypton and argon are good insulators and are often used as insulation between glass panels.[4]

RIGID INSULATION Rigid Insulation is a lightweight material used to provide thermal insulation for the building envelope. It is composed of extruded plastic foam (polystyrene or polyurethane), or a fibrous material such as fiberglass, rock, and slag wool. Rigid insulation is most effective in reducing heat exchange by conduction. There are three types of rigid insulation: polystyrene, bead board and polyisocyanurate.

STRUCTURAL INSULATED PANELS Structural insulated panels (SIP) are composed of rigid foam core insulation (polystyrene or polyurethane) laminated by structurally oriented strand boards on either

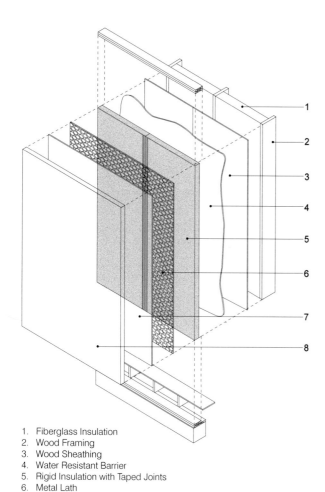

1. Fiberglass Insulation
2. Wood Framing
3. Wood Sheathing
4. Water Resistant Barrier
5. Rigid Insulation with Taped Joints
6. Metal Lath
7. Mortar
8. Exterior Cladding

Fig. 2.1-18 Rigid Insulation

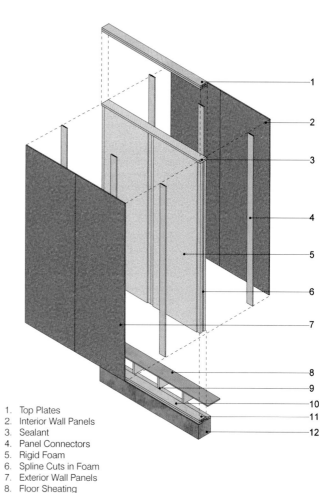

1. Top Plates
2. Interior Wall Panels
3. Sealant
4. Panel Connectors
5. Rigid Foam
6. Spline Cuts in Foam
7. Exterior Wall Panels
8. Floor Sheating
9. Floor Joists
10. Nailer
11. Sill Treated Plate
12. Foundation

Fig. 2.1-19 Structural Insulated Panels

Concepts

side. These panels can act as a structural system in lightweight construction where the building loads are relatively low, thus functioning as both structure and insulation. SIP provide high R-values and have significantly reduced levels of air infiltration. They are commonly available in panels 4 feet (1.2 m) wide by 8–24 feet (2.4–7.3 m) long, and a thickness range of 2–12 inches (3.5–5 cm).

VACUUM INSULATION PANELS Vacuum insulation panels (VIPs) provide higher thermal resistance than conventional insulation materials by utilizing the insulating effect of a vacuum (convection cannot occur in a vacuum). VIPs are generally composed of a porous core material such as polystyrene which could be evacuated and sealed with an airtight metal foil skin.

Although the thermal resistance of VIPs is five to ten times better than conventional insulation of the same thickness,[5] the long-term performance of VIPs is based on adequate protection of the skin against damage and puncture that could lead to loss of the vacuum. VIPs have been used as refrigerator insulation for a long time, but they are becoming increasingly utilized for building construction, replacing conventional insulation materials.

SYNTHETIC INSULATION Building materials such as concrete or masonry can meet the requirements for building insulation depending on the climatic zone and thickness of the building envelope. Load-bearing materials such as CMU can be permeated with air-filled pores that satisfy sufficient load-carrying capacity, with the air captured in the pores providing an insulation effect, increasing the R-value. Building materials that are porous must be protected against moisture to avoid the insulating factor being significantly reduced.

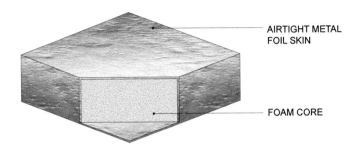

Fig. 2.1-20 Vacuum Insulated Panel Detail

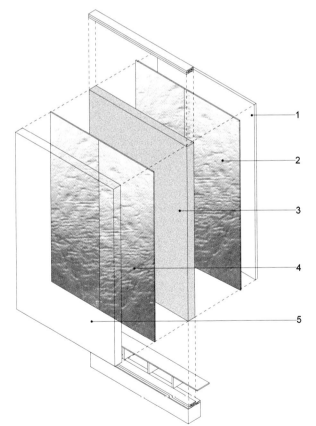

1. Interior Gypsum Board
2. Airtight Metal Foil Skin
3. Foam Core (Expanded Polystyrene EPS Rigid Foam)
4. Airtight Metal Foil Skin
5. Exterior Wall

Fig. 2.1-21 Vacuum Insulated Panels

2. Building Envelopes

SOUND INSULATION Sound insulation is an important aspect of building performance. Sound insulation can be achieved by using a wide range of materials that can be used for both sound and thermal insulation. Sound insulation is measured based on how well the building envelope attenuates airborne sound. Sound transmission class (STC) is widely used in the United States to evaluate the insulation's effectiveness. The higher the STC number, the more effective the material is in providing adequate sound insulation.

OTHER INSULATION MATERIALS Building construction uses a wide range of synthetic or natural and organic or inorganic insulation materials manufactured from fossil fuel byproducts or silica and plant cellulose material. Almost all synthetic insulation products provide good resistance to water permeability. Natural insulation materials contain continuous air gaps and require a special vapor barrier for water protection.

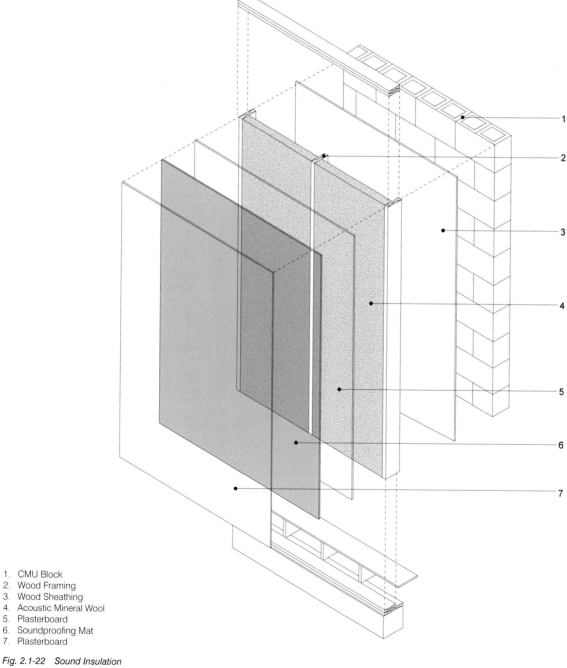

1. CMU Block
2. Wood Framing
3. Wood Sheathing
4. Acoustic Mineral Wool
5. Plasterboard
6. Soundproofing Mat
7. Plasterboard

Fig. 2.1-22 Sound Insulation

Concepts

PHYSICAL APPEARANCE	NAME	THERMAL PROPERTIES	REMARKS
	Cellulose fibers	Thermal Conductivity (k) 0.022 - 0.023 Btu/hr.ft.°F 0.038 - 0.040 W/m.°K R-Value per inch R = 3.6 - 3.8	Mostly made of recycled newspaper Harmful dust inhalation Recyclable
	Cork	Thermal Conductivity (k) 0.022 - 0.029 Btu/hr.ft.°F 0.038 - 0.050 W/m.°K R-Value per inch R = 3.0 - 3.1	Made from renewable resources (cork forests) Harmful dust inhalation Recyclable and waterproof

ORGANIC NATURAL RAW INSULATING MATERIAL

PHYSICAL APPEARANCE	NAME	THERMAL PROPERTIES	REMARKS
	Expanded polystyrene (EPS)	Thermal Conductivity (k) 0.018 - 0.023 Btu/hr.ft.°F 0.032 - 0.040 W/m.°K R-Value per inch R = 3.5 - 4.5	Can be reused Pollution risks from oil and plastic production Recyclable
	Extruded polystyrene (XPS)	Thermal Conductivity (k) 0.017 - 0.021 Btu/hr.ft.°F 0.028 - 0.036 W/m.°K R-Value per inch R = 5.0 - 5.4	Can be reused Pollution risks from oil and plastic production Recyclable

PHYSICAL APPEARANCE	NAME	THERMAL PROPERTIES	REMARKS
	Expanded clay	Thermal Conductivity (k) 0.018 - 0.023 Btu/hr.ft.°F 0.031 - 0.040 W/m.°K R-Value per inch R = 2.0 - 2.2	Lightweight Does not contain harmful substances Moisture resistant

PHYSICAL APPEARANCE	NAME	THERMAL PROPERTIES	REMARKS
	Cellular glass	Thermal Conductivity (k) 0.022 - 0.028 Btu/hr.ft.°F 0.037 - 0.048 W/m.°K R-Value per inch R = 3.4 - 3.5	Contains glass waste Landscape degradation caused by extraction of material Recyclable
	Glass mineral wool	Thermal Conductivity (k) 0.018 - 0.023 Btu/hr.ft.°F 0.031 - 0.040 W/m.°K R-Value per inch R = 3.1 - 4.3	Contains about 30 to 60% post-consumer waste Landscape degradation caused by extraction of material Recyclable

Fig. 2.1-23 Other Insulation Materials' Properties

2. Building Envelopes

Thermal Materials

Building materials with significant mass such as concrete can act as a thermal storage areas in climates where there is a significant difference between the day and nighttime temperatures. A number of newly developed materials can store energy without requiring a great mass. Because these materials are being further developed, tested and improved, their use in building construction is becoming more prevalent.

THERMAL MASS Concrete, masonry, and stone are good thermal materials. When properly used, they can absorb excess energy deep into their mass during high thermal loads and gradually release it from their surface when the thermal loads are low. Materials such as wood and steel are not thermal materials. Wood does not have an adequate emissive quality. The location of the thermal mass in a building is critical to its performance. To effectively mitigate the interior temperatures, the exterior thermal mass should be well insulated.

PHASE CHANGE MATERIALS Like thermal mass, phase change materials (PCMs) have the capacity to store energy and release it at a later time. PCMs can be incorporated in wallboards, roofs, ceiling, and floors to passively cool or heat buildings. When utilized for passive heating, PCMs absorb surplus heat energy during the day, and release the stored heat when the ambient temperature drops at night. PCMs are also utilized for space cooling in hot climates to reduce the energy requirement for mechanical air conditioning systems. For a detailed disscussion of PCMs, refer to Section 4.2.

TRANSPARENT THERMAL INSULATION Transparent insulation (TI) can transform the heat loss of massive building walls to solar heating elements. TI is composed of small transparent plastic or glass honeycomb tubes with small openings. TI is usually installed in front of a dark, and preferably matt surface, and is backed by a high-density concrete wall. The insulation is then protected from the outside with a single glass pane. When facing sunlight, the solar radiation passes through the TI and is absorbed by the dark material, thus warming up the concrete and storing heat in the wall's mass. The stored heat is then gradually emitted for space heating. In overcast skies, the insulation capacity of TI prevents heat loss through the wall, creating a superior thermal mass. Some TI systems have integrated shading systems to avoid overheating of the dark absorbering material during the hot summer season.

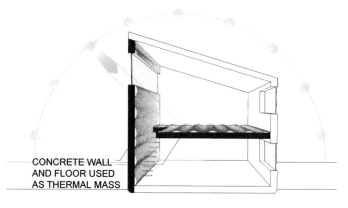

Fig. 2.1-24 *Thermal Mass absorbs solar energy and release heat*

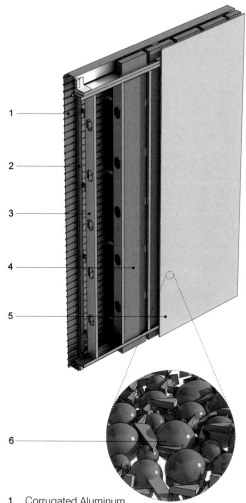

1. Corrugated Aluminum
2. Aluminum Channel System
3. Lightweight Steel Framing System
4. Insulation
5. Gypsum Board
6. Microscopic View of PCM Embedded in the Gypsum Board

Fig. 2.1-25 *PCM Embedded Wall Detail*

Concepts

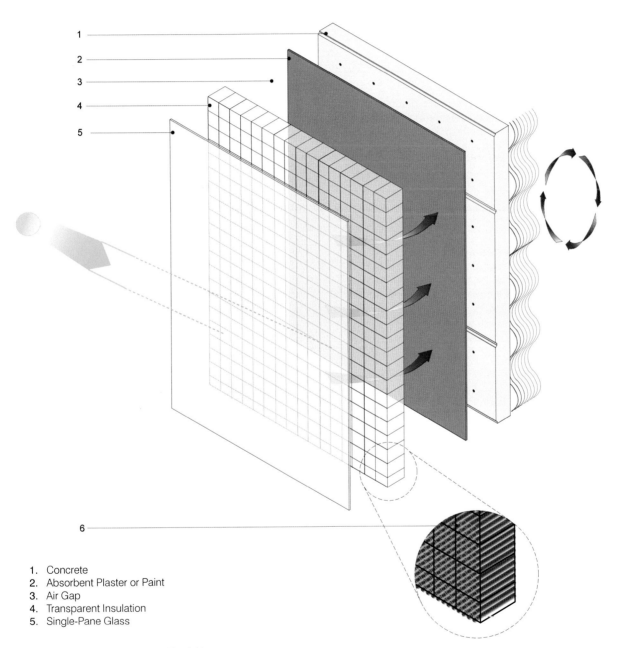

1. Concrete
2. Absorbent Plaster or Paint
3. Air Gap
4. Transparent Insulation
5. Single-Pane Glass

Fig. 2.1-26 Transparent Thermal Insulaltion

2. Building Envelopes

2.2. Wall Systems

The design and technology used in exterior walls entail the use of diverse materials. In general, wall systems can be designed as a monolithic construction or a multi-layered system. In monolithic wall construction, the protective insulation and the structural system are all integrated into the same layer. Multilayer walls carry these functions in separate layers. The capacity of walls to function as structural systems is dependent on the material and construction type. Walls can serve as the primary or secondary load-bearing structure, or not perform any structural function at all.

The following sections will introduce a number of commonly used wall types, their components, construction and assembly methods, and their sustainability properties. Each wall will be accompanied by tabulated property values for standard construction as well as for green construction. The values listed for green construction are based on the use of alternative materials with improved environmental performance.

Cavity Wall

A cavity wall consists of two unbonded wythes of masonry separated by an air space. The primary purpose of the cavity is to prevent water from reaching the inner wythe. Cavity walls can be load bearing or nonload-bearing. For load-bearing constructions, the floor and roof loads of the building are carried by the inner wythe. For nonload-bearing assemblies, another primary structure such as steel or concrete carries roofs and floors. The cavity wall carries only its own weight.

Wall Components

INNER WYTHE In load-bearing assemblies, the inner wythe is structural. All floor and roof loads are transferred into the inner wythe, which transmits those loads down to the foundations. The inner wythe is typically made of concrete masonry units (CMUs) and can vary in thickness. In load-bearing assemblies, several thicknesses of block might be used in the same building, typically 8-inch (20.2 cm) CMUs on upper floors and 12- or 16-inch (30.5 – 40.6 cm) CMUs on lower floors where accumulated loads are greater.

The most commonly used device where floor and roof loads are transferred into a CMU wall is a bond beam: U-shaped blocks placed in a section without intermediate webs. The trough formed is filled with steel reinforcement and grout, which ties the blocks together to create what is effectively a reinforced concrete beam embedded in the wall, making a strong bearing beam to transfer/distribute floor and roof loads into the wall.

Masonry is strong in compression and effective in resisting gravity loads, but has no strength in tension. To deal with wind loads, which introduce tensile forces in walls, the cavity wall may require reinforcing. This is typically accomplished by horizontal joint reinforcement and/or vertical rebar grouted solid within the cells of the CMU inner wythe. In nonload-bearing assemblies, the inner wythe is an infill within another primary structure, such as a steel or concrete frame. In this case, the inner wythe sits on the slab,

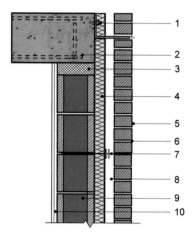

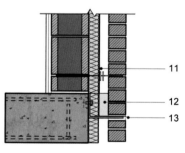

1. Steel Nut and Bolt on Steel Angle
2. Reinforced Concrete Floor
3. Compressible Foam Filler
4. Insulation
5. Brick Face
6. Mortar Joint
7. Metal Tie
8. Air Space
9. CMU
10. Drywall on Furring
11. Vapor Barrier (Required Based on Climatic Conditions)
12. Mortar Dropping Control
13. Aluminum Flashing

Fig. 2.2-1 Section of a Cavity Wall

Wall Systems

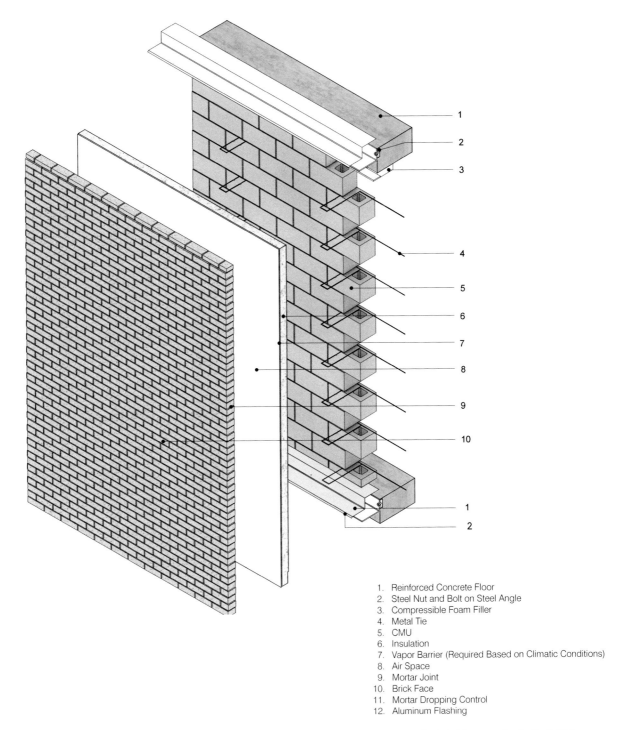

1. Reinforced Concrete Floor
2. Steel Nut and Bolt on Steel Angle
3. Compressible Foam Filler
4. Metal Tie
5. CMU
6. Insulation
7. Vapor Barrier (Required Based on Climatic Conditions)
8. Air Space
9. Mortar Joint
10. Brick Face
11. Mortar Dropping Control
12. Aluminum Flashing

Fig. 2.2-2 Exploded Axonometric of a Cavity Wall

2. Building Envelopes

and its weight is carried by the primary structure. Typically, the outer face of the inner wythe is flushed with the edge of the slab to ensure a continuous cavity.

OUTER WYTHE The outer wythe of a cavity wall is nonstructural. The primary functions of the outer wythe are to determine the appearance of the wall, keep most liquid water out (not all), and transfer lateral wind loads to the inner wythe through the cavity ties.

In small scale construction, the outer wythe transmits its own load directly down to the foundations. In larger scale construction, the outer wythe is typically carried by a shelf angle, which is bolted to the edge of the floor slab. At each floor level, this angle transfers the weight of the outer wythe to the primary structure. Ideally, the shelf angle is stainless steel. Less costly galvanized steel angles may be used, but these carry the risk of corrosion. The shelf angle, typically bolted to an insert cast into the edge of the slab, has slotted holes for tolerance and leveling.

CAVITY The role of the cavity is primarily to provide a capillary break against water penetration. The secondary benefits are that it allows for differential movement of the inner and outer wythes, and enhances the insulation value of the wall. The dimension of the cavity varies depending on how much additional insulation is placed within the cavity. As a rule of thumb, the cavity must retain a minimum clear dimension of 2 inches (50 mm) to work effectively. A narrower cavity is too easily bridged by mortar, which can squeeze out of joints or drop down inside the cavity, or by insulation, which has been unevenly placed. Any such bridging in the cavity must be avoided because it provides a path for water to pass into the inner wythe.

CAVITY TIES Because the two wythes of a cavity wall are not bonded, they must be connected by cavity ties, which are inserted in the bed (horizontal) joints of both wythes at the spacing specified by the manufacturer. Made of metal, plastic sheet or wire, cavity ties are flexible and allow differential movement between wythes. Because cavity ties must bridge the cavity, most are designed with a drip detail to prevent the passage of water across the cavity. As the width of the cavity increases, cavity ties become more expensive. The most durable and costly cavity ties are stainless steel. Galvanized steel ties are less expensive, but carry the risk of corrosion.

INSULATION The air space of the cavity itself contributes to the insulation value of the wall. However, it is rarely sufficient to provide the required level of thermal, acoustical, and fire safety performance, so insulation is typically added to the assembly. A common location for insulation is within the cavity, where it is fixed to the outer face of the inner wythe. Because insulation within the cavity will get wet from time to time, it is important to specify products that will not degrade under wet conditions. Another location for insulation systems are outside on the walls. They are called exterior insulation and finish systems (EIFS). These systems are added to bricks, concrete or other thermal mass materials to provide a layer of continuous exterior insulation that protects from temperature fluctuations and keeps interiors more comfortable. In addition, by placing the insulation layer on the exterior of the building, heat loss or heat transfer caused by thermal bridging is reduced.[6] The thickness of insulation can be varied to enhance the thermal performance of the wall. This improved performance must be weighed against increased costs of insulation cavity ties and flashings for thicker assemblies. However, higher initial costs for better insulation can also help to save energy with significant pay back.

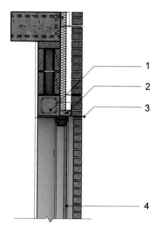
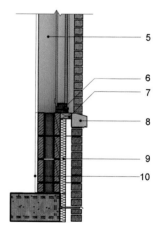

1. Precast Concrete Lintel
2. Rough Head
3. Aluminum Flashing
4. Double Glazed Window System
5. Window Casing
6. Aluminum Window Frame with Thermal Break
7. Rough Jamb
8. Window Sill
9. Insulation
10. Drywall on Furring

Fig. 2.2-3 Section of a Cavity Wall with Punched Window

Wall Systems

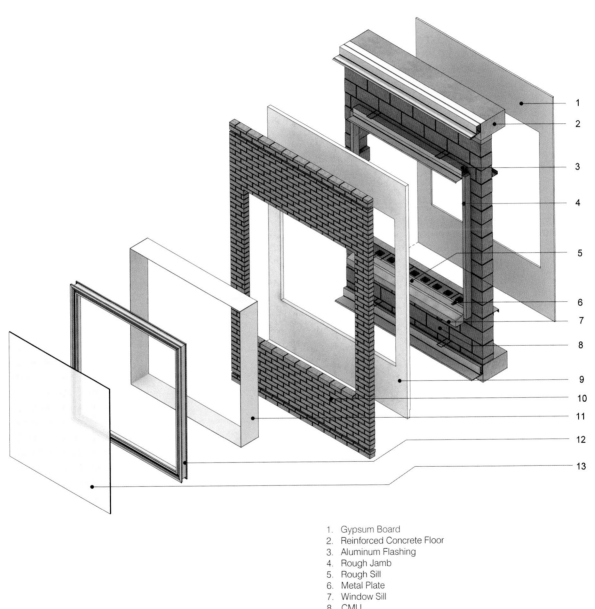

1. Gypsum Board
2. Reinforced Concrete Floor
3. Aluminum Flashing
4. Rough Jamb
5. Rough Sill
6. Metal Plate
7. Window Sill
8. CMU
9. Insulation
10. Brick Face
11. Window Casing
12. Aluminum Window Frame with Thermal Break
13. Double-Glazed Window System

Fig. 2.2-4 Exploded Axonometric of a Cavity Wall with Punched Window

2. Building Envelopes

VAPOR BARRIER Although the outer wythe and the cavity prevent the ingress of water in liquid form, a barrier is required to resist the passage of water vapor through the wall. Vapor pressure always seeks to equalize on both sides of a wall. Warm air has a higher moisture content/vapor pressure than cool air, so vapor will seek to move from warm to cool areas to equalize pressure. As it does so, moisture-laden air cools and, if it reaches the dew point, causes condensation problems within buildings. In general, the vapor barrier is located on the warm side of the insulation to prevent the moisture in warm air to cool and become condensate. A vapor barrier is made of plastic or foil and can be a separate membrane or, more commonly, an integral layer laminated to the insulation. The vapor barrier may also be a liquid cementitious or asphalt-based coating applied by brush.

INTERIOR FINISH If the inner face of the inner wythe will not be seen in the completed building, a finish is required. This might be gypsum board (dry wall), wet plaster, tile/stone, or wood/metal paneling. Typically, wood or metal furring strips/channels are required. The furring strips are screwed to the inner wythe and can be shimmed to provide a level surface. The finish is in turn screwed to the furring strips. The space created (1–2 inches or 2.5-5.1 cm) between the inner wythe and the finish may be used for concealing pipes, electrical conduit and wiring.

FLASHINGS A flashing is a continuous sheet of thin, impervious material used as a barrier against the passage of water. There are two broad categories: external flashings, which keep water out of the cavity, and internal flashings which take water from the cavity and direct it out.

Examples of locations where external flashings are required are at the top of a wall or at the junction of a flat roof and a parapet wall. External flashings are not always hidden and could be exposed, such as a sheet metal coping/flashing at the top of a wall or the counter-flashing at a roof/wall junction.

Internal flashings, which are also called cavity trays, are required whenever anything interrupts, projects into, or bridges the cavity. The only exceptions are cavity ties, which do not need to be flashed. Locations where internal flashings are required include at floor levels where shelf angles are used to support the outer wythe; at openings such as windows or doors, which must be flashed at the top, the sides and at the sill; and at the base of a wall where the cavity terminates. Instead of extending horizontally through the wall, a cavity tray must be stepped 6–8 inches or 15.2-20.3 cm down toward the outer wythe, so that any water in the cavity is naturally directed down and out.

CONSTRUCTION AND SUSTAINABILITY The construction of a cavity wall requires highly skilled labor. Because of the mortar, a cavity wall is a form of wet construction, which is more time consuming and site labor intensive than dry forms of construction, which can be prefabricated and more quickly assembled on-site. Cavity wall construction is weather dependent. In extremely hot weather, mortar hydrates too quickly, which reduces its strength. If temperatures drop below freezing, mortar will not hydrate. Work must either be delayed or heating within temporary enclosures provided to enable work to continue. Masonry is a long-life material that requires relatively little maintenance. The primary maintenance issue is renewal of mortar pointing, which may be required at 50-year intervals.

STANDARD CONSTRUCTION

Cavity Wall Punched Window	R-VALUE	EMBODIED ENERGY	RECYCLED CONTENT
Steel Connections	N/A	10,512	8.20%
Weatherproof Membrane (Polystyrene)	N/A	37,310	0.00%
Flashing (PVC)	N/A	33,260	0.00%
Compressible Filler (CMU)	N/A	47,323	0.00%
CMU	0.66	306	0.00%
1/2" Gypsum Wallboard (Both Sides)	0.41	1,292	0.00%
Brick	0.36	47,323	0.00%
Compressible Filler (Brick)	N/A	2,908	0.00%
Extruded Insulation (XPS)	5.00	38,171	0.00%
1/8" Uncoated Double Glazing	0.53	6,462	0.00%
Aluminum Frame	N/A	66,778	0.99%
Per Square Foot of Wall	**6.95**	**291,646**	**9.20%**

GREEN CONSTRUCTION

Cavity Wall Punched Window	R-VALUE	EMBODIED ENERGY	RECYCLED CONTENT
Steel Connections	N/A	10,512	8.20%
Weatherproof Membrane (Polystyrene)	N/A	37,310	0.00%
1/2" Gypsum Wallboard (Both Sides)	0.41	1,292	0.00%
Flashing (PVC)	N/A	33,260	0.00%
Compressible Filler (CMU)	N/A	47,323	0.00%
CMU (Recycled/Reused)	0.66	306	21.64%
Brick (Reclaimed 10% Energy)	0.36	1,292	29.67%
Compressible Filler (Brick)	N/A	47,323	0.00%
Extruded Insulation (Polyisocyanurate)	4.28	30,373	0.02%
1/8" Low-E Double Glazing	0.68	6,462	0.51%
Aluminum Frame	N/A	12,408	2.65%
Per Square Foot of Wall	**6.37**	**227,862**	**62.70%**

STANDARD CONSTRUCTION
GREEN CONSTRUCTION

R-VALUE ($ft^2 \cdot °F \cdot h/BTU$) 0–50

MATERIAL WEIGHT (lbs/ft^2) 0–150

EMBODIED ENERGY (BTU/lb) 0–300,000

RECYCLED CONTENT (% lbs/ft^2) 0–100

COST 0–100

Estimated properties and values are based on the addition of attributes of each component of an 8'x12' (2.4 m x 3.6 m) wall panel.

Wall Systems

Glass Curtain Wall

A glass curtain wall is a nonload-bearing external wall that is supported by the structural frame of the building. The most common association is with fully glazed building envelopes, but curtain walls may also be made of metal, stone, concrete or other materials. Standard glazed curtain wall systems typically use aluminum frames because they are lightweight and strong, can be easily formed into complex shapes by the process of extrusion, and readily accept a wide range of finishes. Glazed curtain wall systems are designed to be glazed either from the outside or the inside.

Wall Components

MULLIONS These complex extruded box sections of aluminum incorporate housings for either screw or snap-on fixings. Vertical mullions are typically continuous from floor to floor and support discontinuous horizontal mullions. In standard systems, vertical and horizontal mullions have the same depth. However, depths may differ for structural, thermal, visual or aesthetic reasons.

SETTING BLOCKS Made of synthetic rubber, setting blocks carry the weight of the glass on the horizontal mullions, isolate the glass from the frame on both horizontal and vertical mullions, and enable the glass to expand and contract within the frame.

THERMAL BREAK Made of extruded plastic, the thermal break fits into the screw slot on the mullion. It separates the external metal components of the frame from the mullion to prevent hot and cold bridging.

GLAZING GASKETS Made of rubber or neoprene, glazing gaskets fit into housings on the mullion and the pressure plate. Glazing gaskets are attached prior to placing the glass. They isolate the glass from the frame and make a weather-tight seal.

GLAZING Prefabricated units of single, double or triple glazing are connected to the aluminum frame from the exterior.

PRESSURE PLATE The pressure plate, an aluminum extrusion, is screwed to the projecting spines on the mullions to hold the glass in place.

SNAP CAP The snap cap, an aluminum extrusion, which snaps into housings in the pressure plate, covers the screw fixings. It provides the external profile of the curtain wall framing and can vary in depth for visual or aesthetic purposes.

STANDARD CONSTRUCTION

Glass Curtain Wall (8'x12')	R-VALUE	EMBODIED ENERGY	RECYCLED CONTENT
Aluminum Frame & Firewall	0.00	12,408	2.00%
Double Glass (Volume Less Airspace)	1.73	6,462	0.00%
Spandrel Glass (Double)	0.13	6,462	0.00%
Fire Retardant Batt (Fiberglass)	0.73	12,063	0.15%
Steel Channel & Connectors	N/A	10,512	26.44%
Per Square Foot of Wall	**2.60**	**47,907**	**28.62%**

GREEN CONSTRUCTION

Glass Curtain Wall (8'x12')	R-VALUE	EMBODIED ENERGY	RECYCLED CONTENT
Aluminum Frame & Firewall	0.00	12,408	5.43%
Double Glass w/Mod SG Low-E (Volume Less Airspace)	3.20	6,462	14.93%
Spandrel Glass	0.13	6,462	1.25%
Fire Retardant Batt (Mineral Wool)	0.73	7,152	0.44%
Steel Channel & Connectors	N/A	4,093	26.44%
Per Square Foot of Wall	**4.07**	**36,577**	**48.48%**

STANDARD CONSTRUCTION
GREEN CONSTRUCTION

- R-VALUE ($ft^2 \cdot °F \cdot h/BTU$) 0–50
- MATERIAL WEIGHT (lbs/ft^2) 0–150
- EMBODIED ENERGY (BTU/lb) 0–300,000
- RECYCLED CONTENT (% lbs/ft^2) 0–100
- COST 0–100

Estimated properties and values are based on the addition of attributes of each component of an 8'x12' (2.4 m x 3.6 m) wall panel.

2. Building Envelopes

CONSTRUCTION AND SUSTAINABILITY Standard glazed curtain wall systems are typically stick-built or are prefabricated panels. In stick-built systems, metal frame components are assembled and glazed on-site. Prefabricated panels are more costly to purchase and transport, but they are typically of very high quality. Because prefabricated panels can be quickly placed on-site with comparatively little site labor, using them can shorten the construction time. In addition to glass, curtain walls can incorporate louvers, vents and solid infill panels of metal, wood, translucent thermal insulation, air collectors, and photovoltaics or other materials. Enhanced thermal performance of curtain walls can be achieved by combining single- and double-glazed leaves with an air space in between that may vary from several inches to several feet, depending on the servicing strategy for the building. Materials used in the construction of curtain walls (i.e., metal and glass) tend to have high embodied energy.

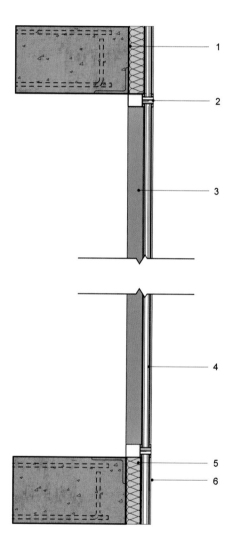

1. Reinforced Concrete Floor
2. Glazing Gasket with Thermal Break
3. Aluminum Window Frame System with Thermal Break
4. Double-Glazed Window System
5. Insulation
6. Spandrel Glass

Fig. 2.2-5 Section of a Glass Curtain Wall

Wall Systems

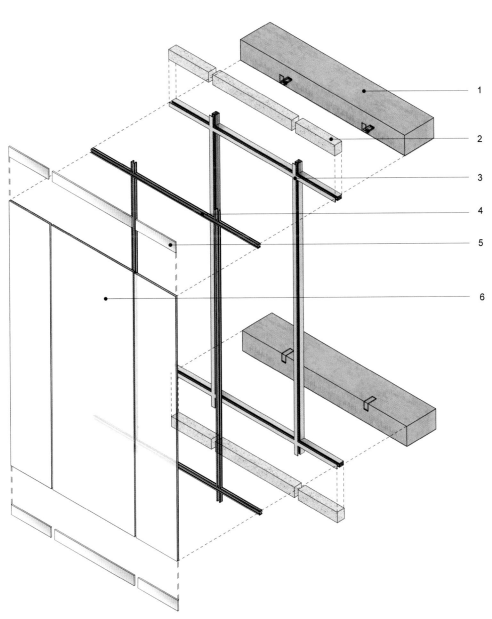

1. Reinforced Concrete Floor
2. Insulation
3. Aluminum Window Frame System with Thermal Break
4. Glazing Gasket with Thermal Break
5. Spandrel Glass
6. Double-Glazed Window System

Fig. 2.2-6 Exploded Axonometric of Glass Curtain Wall

2. Building Envelopes

Concrete Masonry Unit Wall

The concrete masonry unit (CMU) wall is a prevalent building component that is both simple to construct and durable over time. It is composed of hollow elements that allow for expediency and alterability during and after assembly. The voids of the CMUs serve as forms for cast-in-place reinforced concrete columns and beams and can accommodate other building systems such as insulation, plumbing and conduits.

Wall Components

CMU The CMU is a factory-produced item. Although there are a variety of shapes available to address particular wall conditions, the standard American CMU block is 8 in x 8 in x 16 in (20.3 cm x 20.3 cm x 40.6 cm). The standard block is hollowed out with two vertical cells.

MORTAR The mortar or grout of CMU walls unifies the individual masonry units into a monolithic system. Because the concrete masonry units are hollow, the mortar is applied only to the outer edges of the block. The mortar used in a CMU wall has more water in it than typical concrete because the mortar needs to be a workable material capable of being easily modified on-site.

HORIZONTAL JOINT REINFORCEMENT Horizontal joint reinforcement provides lateral strength to the CMU wall. The size and frequency of horizontal joint reinforcement depends on the structural loads on the wall. Typically, joint reinforcement is placed at every other horizontal joint line. This reinforcement is composed of "ladder types" or "truss types" that span from the center lines of the block faces.

VERTICAL REINFORCEMENT Vertical reinforcement provides the CMU wall with the required compressive strength. This reinforcement is composed of reinforcing steel bars sized to the structural design loads. The reinforcement, combined with grout-filled cells, forms load-bearing columns embedded in the wall.

STUCCO Because a concrete masonry unit is porous, a waterproofing surface is needed. Stucco serves as an inexpensive material that waterproofs a CMU wall and hides imperfections. The surface of the stucco can be smooth or textured and can be scored. For stucco to serve as an effective waterproofing agent, its surface should not to be pierced or disrupted.

CONSTRUCTION AND SUSTAINABILITY The CMU wall has been a prevalent building enclosure because of its forgiving nature and adaptability. Because it is hollow, a CMU wall is easy to cut and break to conform to specific dimensional requirements. If errors occur on-site, it is a system that can be easily modified and rebuilt. This malleability makes it cost effective and requires a moderate skill level. In addition, the hollow cells can absorb a variety of building complements and adapt to a wide range of structural capacities. CMU walls are quite durable. Their weakness is porosity, therefore waterproofing this building system requires special attention.

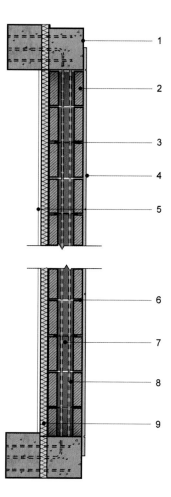

1. Reinforced Concrete Floor
2. CMU Block
3. Horizontal Reinforcement
4. Stucco (Impermeable Medium)
5. Gypsum Board
6. Mortar
7. CMU Grout
8. Vertical Reinforcement
9. Insulation

Fig. 2.2-7 Section of a CMU Wall

Note: Insulation Detail based on Schock Isokorb, "Schock Innovative Building Solutions." http://www.schoeck.co.uk/upload/files/download/100113_TI_IK_GB_rz_web_EBA_type_K_5B2736_5D[2736].pdf.

Wall Systems

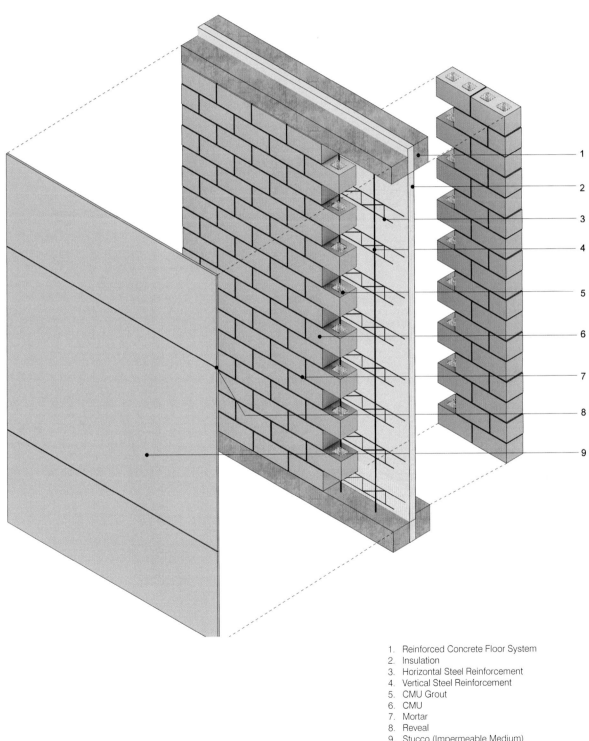

1. Reinforced Concrete Floor System
2. Insulation
3. Horizontal Steel Reinforcement
4. Vertical Steel Reinforcement
5. CMU Grout
6. CMU
7. Mortar
8. Reveal
9. Stucco (Impermeable Medium)

Fig. 2.2-8 Exploded Axonometric of a CMU Wall

45

2. Building Envelopes

STANDARD CONSTRUCTION

CMU Wall (8'x12') Punched Window	R-VALUE	EMBODIED ENERGY	RECYCLED CONTENT
CMU Block	1.11	306	0.00%
3/4" Stucco	0.15	948	0.00%
Steel Reinforcement	N/A	3,791	0.30%
Mortar	N/A	603	0.00%
Metal Z Furring	N/A	10,512	0.00%
1/2" Gypsum Wallboard	0.45	1,292	0.00%
Extruded Insulation (XPS)	15.00	38,171	0.00%
Glass Double (1/4", 1/2", 1/4")	0.53	6,462	0.00%
Aluminum Frame	N/A	66,778	1.44%
Per Square Foot of Wall	**17.24**	**128,865**	**1.74%**

GREEN CONSTRUCTION

CMU Wall (8'x12') Punched Window	R-VALUE	EMBODIED ENERGY	RECYCLED CONTENT
CMU (Recycled/Reused)	1.11	306	30.75%
3/4" Stucco	0.15	948	0.00%
Steel Reinforcement	N/A	3,791	0.30%
Mortar	N/A	603	0.00%
Metal Z Furring	N/A	10,512	0.00%
1/2" Gypsum Wallboard	0.45	1,292	0.00%
Extruded Insulation (Polyisocyanurate)	21.60	30,373	0.06%
Glass Double (1/4", 1/2", 1/4")	0.68	6,462	0.75%
Aluminum Frame	N/A	12,408	3.84%
Per Square Foot of Wall	**23.99**	**66,696**	**35.70%**

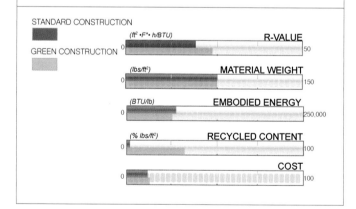

Estimated properties and values are based on the addition of attributes of each component of an 8'x12' (2.4m x 3.6m) wall panel.

If left unprotected, the CMUs can act like sponges and absorb a great deal of water. In addition, because the CMU is an intensely site-built system, the assembly of a CMU wall is exposed to human error and the realities of weather and site conditions.

Concrete is a tremendously energy-consumptive material. Although CMU blocks are made quickly, additional energy is required to speed up the curing process. In spite of this, CMU walls require little maintenance over time.

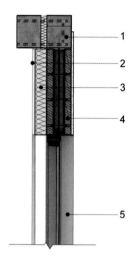
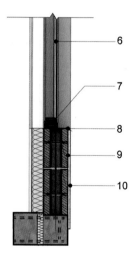

1. Reinforced Concrete Floor
2. Gypsum Board
3. Insulation
4. CMU
5. Window Casing
6. Double-Glazed Window System
7. Aluminum Window Frame
8. Aluminum Flashing
9. Base Coat
10. Stucco (Impermeable Medium)

Fig. 2.2-9 Section of a CMU Wall with Punched Window

Note: Insulation Detail based on Schock Isokorb, "Schock Innovative Building Solutions." http://www.schoeck.co.uk/upload/files/download/100113_TI_IK_GB_rz_web_EBA_type_K_5B2736_5D[2736].pdf.

Wall Systems

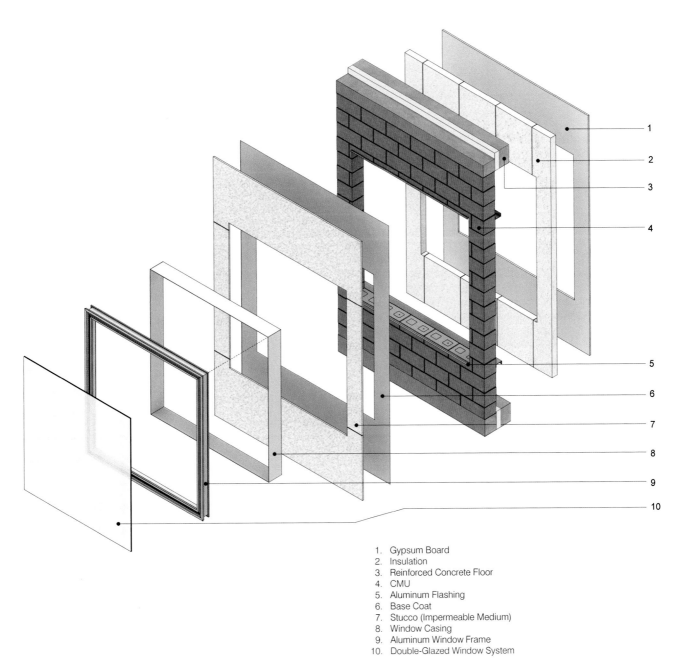

1. Gypsum Board
2. Insulation
3. Reinforced Concrete Floor
4. CMU
5. Aluminum Flashing
6. Base Coat
7. Stucco (Impermeable Medium)
8. Window Casing
9. Aluminum Window Frame
10. Double-Glazed Window System

Fig. 2.2-10 Exploded Axonometric of a CMU Wall with Punched Window

2. Building Envelopes

Concrete Wall

Concrete has been used since the times of the Romans and continues to be a major building material. Concrete is a durable enclosure material and once it has been properly installed, it lasts for many years. Its nature as a fluid that becomes a solid allows for limitless spatial possibilities, ranging from simple cubic forms to complex curves.

Wall Components

CONCRETE Concrete is a mixture of water, Portland cement, aggregate and sand. Upon adding water, the mixture undergoes a process of hydration (curing), which transforms the liquid material into a solid mass. This is not a drying process, rather it is a process in which water combines with cement to form concrete. Concrete has tremendous compressive strength, but very low tensile strength.

STEEL REINFORCEMENT Steel reinforcement provides concrete with tensile strength, allowing it to span distances without an arch form. Standard reinforcing takes the form of hot-rolled steel bars. These bars are ribbed to allow the steel to grip the surrounding concrete. Steel reinforcement can also be in form of wires or strands and be pulled in tension to squeeze concrete into compression to produce more efficient spans. The tension force applied to strands can occur before the concrete has cured (pretensioned) or after it has cured (posttensioned).

FORMWORK Formwork is required to create the shape of the final concrete element. Typically, formwork is a temporary structure that is assembled to support the weight of concrete while it cures and is removed once the concrete has reached sufficient strength. The inside of a formwork surface can be manipulated to produce patterns, lines and reveals on the exterior of the finished concrete wall. Due to the weight of concrete, engineering of the structure of the formwork is often required.

FORM TIES Form ties are used to hold the walls of formwork at a specified distance from one another. When the concrete is poured into the cavity of the formwork, the form ties prevent the walls from separating and failing.

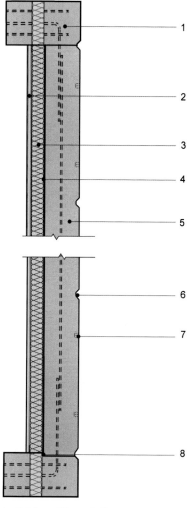

1. Reinforced Concrete Floor
2. Gypsum Board
3. Insulation
4. Metal Furring
5. Concrete Panel
6. Reveal
7. Form Tie
8. Cold Joint

Fig. 2.2-11 Section of a Concrete Wall

Note: Insulation Detail based on Schock Isokorb, "Schock Innovative Building Solutions." http://www.schoeck.co.uk/upload/files/download/100113_TI_IK_GB_rz_web_EBA_type_K_5B2736_5D[2736].pdf.

Wall Systems

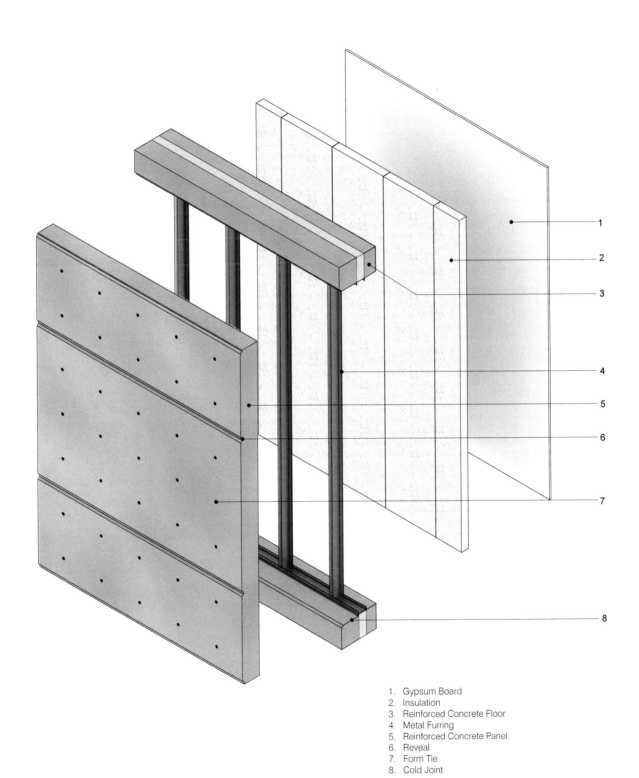

1. Gypsum Board
2. Insulation
3. Reinforced Concrete Floor
4. Metal Furring
5. Reinforced Concrete Panel
6. Reveal
7. Form Tie
8. Cold Joint

Fig. 2.2-12 Exploded Axonometric of a Concrete Wall

2. Building Envelopes

STANDARD CONSTRUCTION

Concrete Wall (8'x12') Punched Window	R-VALUE	EMBODIED ENERGY	RECYCLED CONTENT
Concrete	0.60	409	0.00%
Steel Reinforcement	N/A	3,791	0.22%
Metal Z Furring	N/A	10,512	0.00%
1/2" Gypsum Wallboard	0.45	1,292	0.00%
Extruded Insulation (XPS)	15.00	38,171	0.00%
Glass double (1/4", 1/2", 1/4")	0.53	6,462	0.00%
Aluminum Frame	N/A	66,778	1.05%
Per Square Foot of Wall	**16.58**	**127,417**	**1.27%**

GREEN CONSTRUCTION

Concrete Wall (8'x12') Punched Window	R-VALUE	EMBODIED ENERGY	RECYCLED CONTENT
Concrete (50% Fly Ash)	0.60	280	5.22%
Steel Reinforcement	N/A	3,791	0.22%
Metal Z Furring	N/A	10,512	0.00%
1/2" Gypsum Wallboard	0.45	1,292	0.00%
Extruded Insulation (Polyisocyanurate)	21.60	30,373	0.04%
Glass double (1/4", 1/2", 1/4") w/mod Low-E	0.68	6,462	0.55%
Aluminum Frame	N/A	12,408	2.81%
Per Square Foot of Wall	**23.33**	**65,120**	**8.84%**

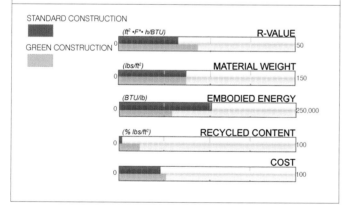

Estimated properties and values are based on the addition of attributes of each component of an 8'x12' (2.4m x 3.6m) wall panel.

CONSTRUCTION AND SUSTAINABILITY When concrete is in its wet state, great care is required in assembling the formwork to prevent leaks and failures. The water-to-cement ratio must be managed and checked to ensure correct mixture. Concrete is a heavy material. During the curing process, engineered shoring for formwork is required. Once concrete has cured, it is quite labor intensive to correct errors. Concrete is tremendously energy consumptive and produces CO_2 gas emissions in its production process. In spite of this, concrete walls are durable and require little maintenance

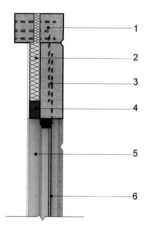

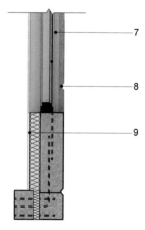

1. Reinforced Concrete Floor
2. Insulation
3. Reinforced Concrete Panel
4. Metal Furring
5. Window Casing
6. Double-Glazed Window System
7. Aluminum Window Frame
8. Reinforced Concrete Panel Reveal
9. Gypsum Board

Fig. 2.2-13 Section of a Concrete Wall with Punched Window

Note: Insulation Detail based on Schock Isokorb, "Schock Innovative Building Solutions." http://www.schoeck.co.uk/upload/files/download/100113_TI_IK_GB_rz_web_EBA_type_K_5B2736_5D[2736].pdf.

Wall Systems

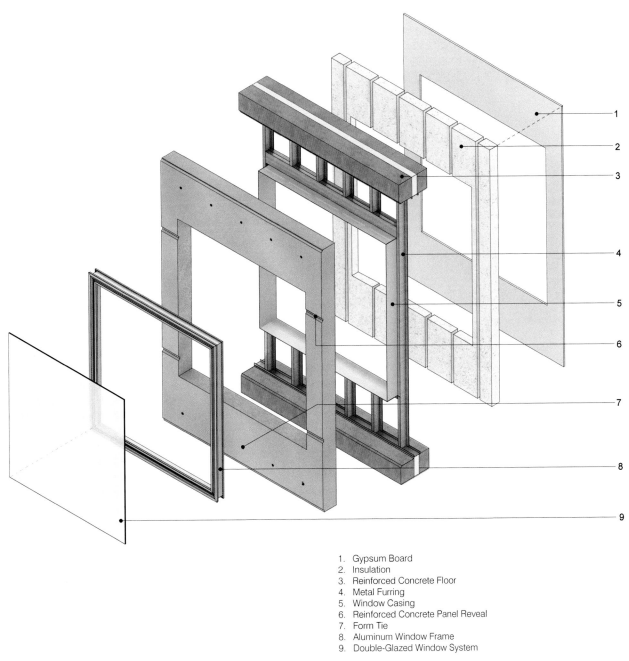

1. Gypsum Board
2. Insulation
3. Reinforced Concrete Floor
4. Metal Furring
5. Window Casing
6. Reinforced Concrete Panel Reveal
7. Form Tie
8. Aluminum Window Frame
9. Double-Glazed Window System

Fig. 2.2-14 Exploded Axonometric of a Concrete Wall with Punched Window

2. Building Envelopes

Metal Veneer Wall

A metal veneer wall is a nonload-bearing curtain wall that is supported by the building's primary structure. Different metals used for cladding systems include aluminum, steel, lead, copper, lead-coated copper, bronze, stainless steel and titanium. As with all building systems, the evolution of metal cladding has focused on reducing the amount of metal in order to reduce the cost, not only of the cladding itself, but also of the supporting structure. The most common metal cladding assemblies are metal sheet panels and composite panels.

Wall Components

METAL CLADDING The appearance of the building is determined by the metal sheets or panels. These may be flat or corrugated or be composite panels in which metal is bonded to another material. Sheet metal requires a continuous substrate of support, while corrugated metal and composite metal panels can span between supports.

SUPPORT STRUCTURE Metal cladding is fixed to a support structure, comprising vertical and/or horizontal framework. This framing spans floor to floor and is fixed to the building's primary support structure by cleats bolted to fixings cast into the edge or face of the concrete slab.

JOINTS Metal cladding may be joined by overlapping, interlocking or the incorporation of a jointing material such as silicone or a neoprene gasket.

THERMAL INSULATION There are several methods of incorporating thermal insulation into a metal cladding system. Insulation may be (a) loose laid on the rear of the panel, either in the factory or on-site, (b) bonded to the metal in a composite panel, and/or (c) incorporated in a separate backup wall.

BACKUP WALL A backup wall is a nonstructural wall constructed on-site that spans from slab to slab. The most typical construction is light-gauge metal studs with insulation between the studs and a gypsum board, wood or veneered plywood interior finish. A backup wall also carries and conceals pipework and electrical services.

METAL CLADDING ASSEMBLIES A flat metal sheet is thin, has no stiffness, and therefore requires a continuous supporting substrate (plywood, etc.). A flat metal sheet that spans without support, is typically at least ¼ inch (6.4 mm) thick and therefore is heavier and requires a more robust support structure. Alternatively, thin sheet metal can be corrugated to enable it to span. Typically, a corrugated sheet of 2–3 inches (51–67 mm) deep can span 5–8 feet (1.5–2.4 m). Thin sheet metal panels are typically joined by interlocking standing or flat seams for flat sheets or overlapping joints for corrugated sheets.

COMPOSITE PANELS To reduce the amount of metal used, composite panel cladding systems may be used. In this system, very thin sheet metal is bonded to another material, which is typically rigid insulation. The insulation stiffens the metal, enabling panels to span up to 12 feet (3.6 m). Composite panels were developed in the 1970s in response to the energy crisis, when insulation and thermal performance of buildings first became a real concern. Joints in composite metal cladding systems are typically sealed by silicone, metal connectors, or neoprene gaskets.

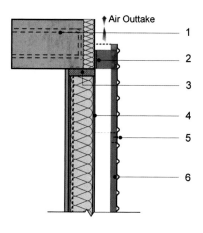
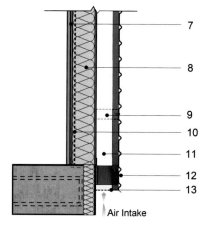

1. Reinforced Concrete Floor
2. Steel Angle
3. Compressible Foam Filler
4. Lightweight Steel Framing System
5. Channel Bolted with a Bolt and Washer
6. Aluminum Channel System
7. Gypsum Board
8. Insulation
9. Aluminum Mounting Profile
10. Vapor Barrier (Cold Climate)
11. Air Space (Beyond)
12. Corrugated Aluminum
13. Ventilation Screen

Fig. 2.2-15 Section of a Metal Veneer Wall

Wall Systems

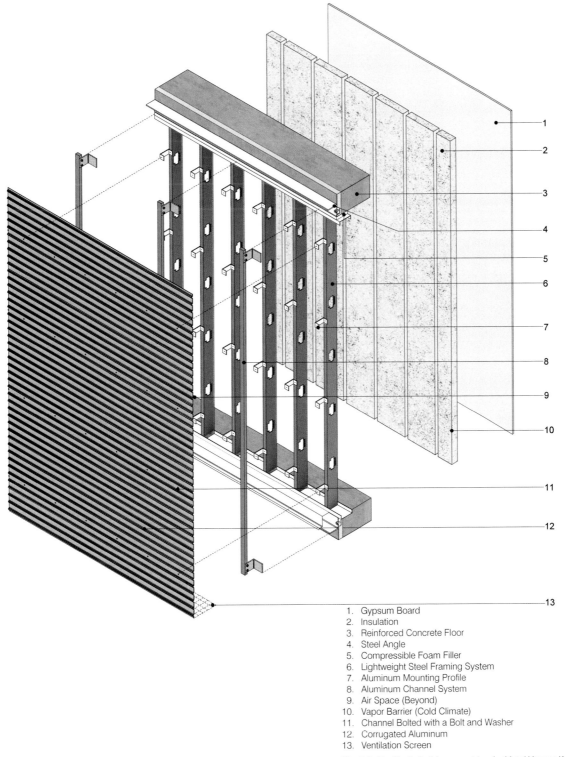

1. Gypsum Board
2. Insulation
3. Reinforced Concrete Floor
4. Steel Angle
5. Compressible Foam Filler
6. Lightweight Steel Framing System
7. Aluminum Mounting Profile
8. Aluminum Channel System
9. Air Space (Beyond)
10. Vapor Barrier (Cold Climate)
11. Channel Bolted with a Bolt and Washer
12. Corrugated Aluminum
13. Ventilation Screen

Fig. 2.2-16 Exploded Axonometric of a Metal Veneer Wall

2. Building Envelopes

STANDARD CONSTRUCTION

Metal Veneer Wall (8'x12') Punched Window

	R-VALUE	EMBODIED ENERGY	RECYCLED CONTENT
Metal Veneer (Galv Steel)	0.36	16,802	10.34%
Metal Tiebacks (Galv Steel)	N/A	10,512	0.50%
Weatherproof Membrane (Polystyrene)	N/A	37,310	0.00%
Extruded Insulation (XPS)	8.91	38,171	0.00%
Steel Framing (Studs BOF)	N/A	10,512	5.27%
Fiberglass Batt Insulation	8.81	12,063	0.66%
Compressable Filler w/Sealant	N/A	47,323	0.00%
Gypsum Board	0.52	1,292	0.00%
1/8" Uncoated Double Glazing	0.53	6,462	0.00%
Aluminum Frame	N/A	66,778	5.57%
Per Square Foot of Wall	**19.14**	**247,227**	**22.34%**

GREEN CONSTRUCTION

Metal Veneer Wall (8'x12') Punched Window

	R-VALUE	EMBODIED ENERGY	RECYCLED CONTENT
Metal Veneer (Galv Steel)	0.36	16,802	10.34%
Metal Tiebacks (Galv Steel)	N/A	10,512	0.50%
Weatherproof Membrane (Polystyrene)	N/A	37,310	0.00%
Extruded Insulation (Polyisocyanurate)	12.83	30,373	0.25%
Steel Framing (Studs BOF)	N/A	10,512	5.27%
Mineral Wool Batt Insulation	8.81	7,152	1.99%
Compressable Filler w/Sealant	0.52	1,292	0.00%
Gypsum Board	N/A	47,327	0.00%
1/8" Low-E Double-Glazing, Low-E=0.1 on surface 2	0.68	6,462	2.87%
Aluminum Frame	N/A	12,408	14.84%
Per Square Foot of Wall	**23.20**	**180,147**	**36.07%**

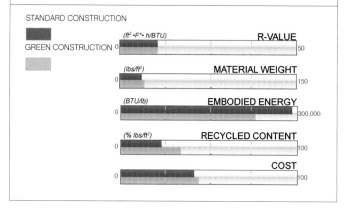

Estimated properties and values are based on the addition of attributes of each component of an 8'x12' (2.4m x 3.6m) wall panel.

CONSTRUCTION ISSUES SUSTAINABILITY Metal cladding systems range from very inexpensive, such as thin steel sheet that is printed with a texture to simulate wood and vinyl coated, to very expensive, such as titanium. Less costly systems are entirely factory made, whereas custom or variable systems typically require a high level of skilled labor on-site.

Metal extraction from the earth typically causes environmental damage, including erosion and pollution of groundwater. Metal manufacturing has high embodied energy, requiring large amounts of water and heat; however, transportation of metal cladding components to site is not as expensive as concrete or masonry systems because metal cladding is typically much lighter in weight. Metal cladding does not have any inherent fire resistance (unlike concrete or masonry cladding for example); therefore, if fire resistance is required, it must be achieved through a backup

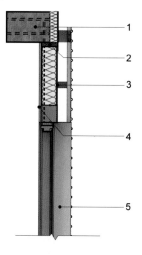
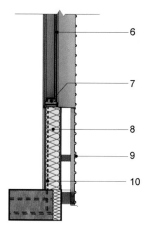

1. Reinforced Concrete Floor
2. Compressible Foam Filler
3. Aluminum Framing System
4. Gypsum Board
5. Window Casing
6. Double-Glazed Window System
7. Aluminum Window Frame
8. Insulation
9. Corrugated Aluminum
10. Vapor Barrier (Cold Climate)

Fig. 2.2-17 Section of a Metal Veneer Wall with Punched Window

Wall Systems

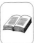

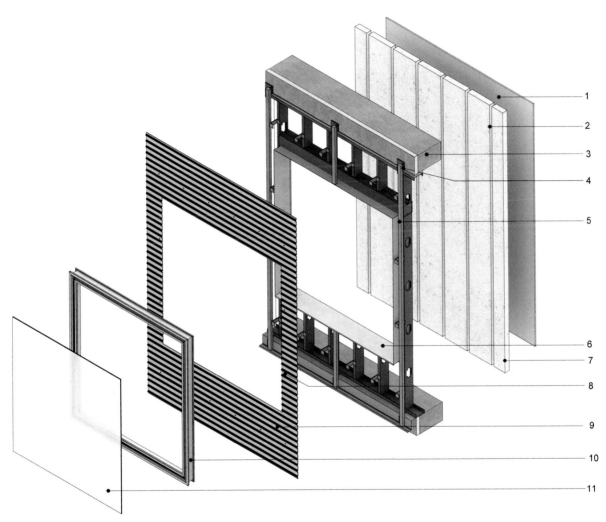

1. Gypsum Board
2. Insulation
3. Reinforced Concrete Floor
4. Compressible Foam Filler
5. Aluminum Framing System
6. Window Casing
7. Vapor Barrier (Cold Climate)
8. Channel Bolted with a Bolt and Washer
9. Corrugated Aluminum
10. Aluminum Window Frame
11. Double-Glazed Window System

Fig. 2.2-18 Exploded Axonometric of a Metal Veneer Wall with Punched Window

2. Building Envelopes

Precast Concrete Wall

Precast concrete cladding for large scale buildings is typically a nonload-bearing curtain wall that is supported by the structural frame of the building. Precast concrete cladding panel sizes are governed by the 10–12 foot (3.0 –3.6 m) width of typical factory casting beds and by the limited dimensions of road, rail or ship transportation from factory to site.

Precast concrete cladding can achieve a variety of textures and colors by varying the concrete mix, particularly the aggregate. A wide range of finishes may also be developed through (a) manipulation of the formwork, (b) incorporation of other facing materials such as ceramic tiles, thin bricks or thin stone, either by incorporation in the formwork or application to the surface of the precast panel, and (c) manual manipulation of the surface either during or after the curing process.

Wall Components

PRECAST CONCRETE PANELS Precast concrete panels are fabricated in factories with high-quality, reusable formwork. Panels are typically 3–6 inches (76–152 mm) thick, 10–12 feet (3.0 –3.6m) wide and 1–2 stories high.

PANEL FIXINGS Made of stainless steel, panel fixings transfer the weight of the panel into the building's primary structural frame. Panels are typically fixed at the top and bottom edges to angles bolted to a steel frame or to anchors cast into the edge or face of a concrete slab. The anchors, which have slotted holes to allow for adjustment, carry bolts that slot into holes cast into the back face of the precast panels.

PANEL JOINTS Precast cladding is typically used to create a sealed building envelope in which joints are made weathertight by the insertion of a compressible backer for mastic sealant.

THERMAL INSULATION There are several methods of incorporating thermal insulation into a precast cladding system. Insulation may be (a) sandwiched between layers of concrete during the casting process, (b) fixed to the rear face of the panel, either in the factory or on-site, and/or (c) incorporated in a separate backup wall.

BACKUP WALL A nonstructural backup wall is constructed on-site and spans from slab to slab. The most typical construction is light-gauge metal studs with insulation between the studs and a gypsum board, wood or veneered plywood interior finish. The backup wall also carries and conceals pipe work and electrical services.

CONSTRUCTION AND SUSTAINABILITY The advantages of using pre-casting include high quality, reduced time on-site, and economy. Factory production, which is independent of weather conditions, enables the concrete mix and curing conditions

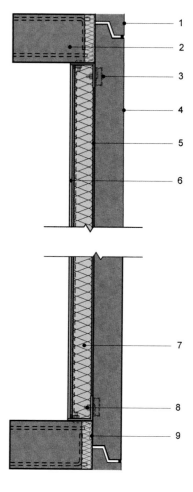

1. Sealant
2. Reinforced Concrete Slab
3. Wedge Anchor Insert
4. Precast Concrete Wall Panel
5. Metal Stud
6. Gypsum Board
7. Insulation
8. Steel Nut and Bolt
9. Fire/Thermal/Acoustic Stop

Fig. 2.2-19 Section of a Precast Concrete Wall

Wall Systems

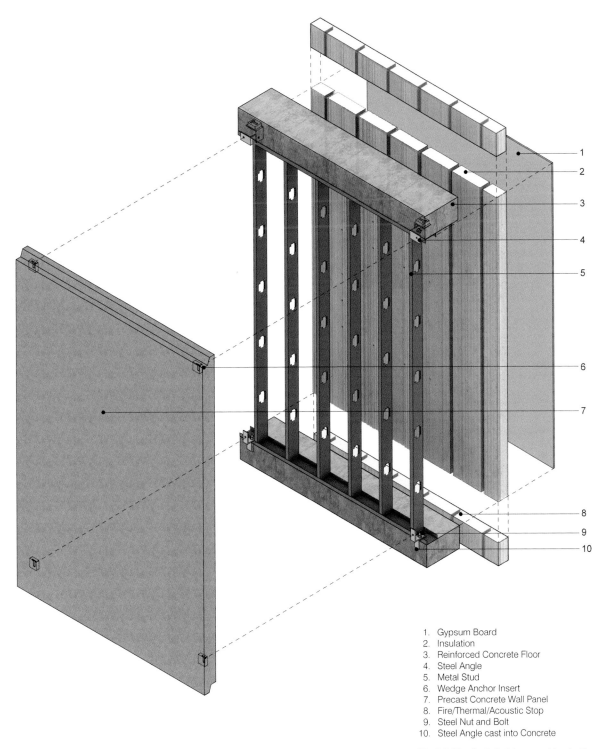

1. Gypsum Board
2. Insulation
3. Reinforced Concrete Floor
4. Steel Angle
5. Metal Stud
6. Wedge Anchor Insert
7. Precast Concrete Wall Panel
8. Fire/Thermal/Acoustic Stop
9. Steel Nut and Bolt
10. Steel Angle cast into Concrete

Fig. 2.2-20 Exploded Axonometric of a Precast Concrete Wall

2. Building Envelopes

STANDARD CONSTRUCTION

Precast Concrete Wall (8'x12') Punched Window	R-VALUE	EMBODIED ENERGY	RECYCLED CONTENT
Concrete	0.27	409	0.00%
Steel Connections	N/A	10,512	0.65%
Weatherproof Membrane (Polystyrene)	N/A	37,310	0.00%
1/2" Gypsum Wallboard (One Side)	0.27	1,292	0.00%
Steel Frame (Studs BOF) (58'10"LF)	N/A	10,512	1.12%
Fiber Glass Insulation (Batts)	8.81	12,063	0.14%
1/8" Uncoated Double Glazing	0.53	6,462	0.00%
Aluminum Frame	N/A	66,778	0.47%
Per Square Foot of Wall	**9.89**	**145,340**	**2.38%**

GREEN CONSTRUCTION

Precast Concrete Wall (8'x12') Punched Window	R-VALUE	EMBODIED ENERGY	RECYCLED CONTENT
Concrete (50% Fly Ash)	0.27	280	5.43%
Steel Connections	N/A	10,512	0.65%
Weatherproof Membrane (Polystyrene)	N/A	37,310	0.00%
1/2" Gypsum Wallboard (One Side)	0.27	1,292	0.00%
Steel Frame (Studs BOF)	N/A	10,512	1.12%
Mineral Wool Insulation (Batts)	8.81	7,152	0.42%
1/8" Low-E Double glazing, Low-E=0.1 on surface 2	0.68	6,462	0.59%
Aluminum Frame	N/A	12,408	1.25%
Per Square Foot of Wall	**10.03**	**85,928**	**9.46%**

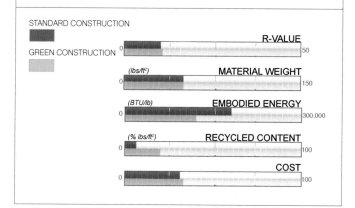

Estimated properties and values are based on the addition of attributes of each component of an 8'x12' (2.4m x 3.6m) wall panel.

to be highly controlled. Precasting has typically benefited from an economy of scale, that is, it is most economical when there is a high degree of repetition of elements.

Concrete, after aluminum and steel, has high levels of embodied energy and produces CO_2 gas emission, both in its manufacturing and its transport. Concrete is a huge consumer of natural resources, whose extraction causes environmental degradation and requires large amounts of water and heat in the process of manufacturing. These factors can be mitigated by using fly ash or other forms of industrial waste in place of Portland cement or by using ground up concrete or other durable recycled materials as aggregate. Reusable formwork also helps to minimize the considerable resources needed for concrete construction.

Precast cladding units are typically large and very heavy and therefore are costly to transport. The most sustainable strategy is to minimize the transportation distance from factory to site. Well-detailed concrete cladding is a long-life material that requires little maintenance.

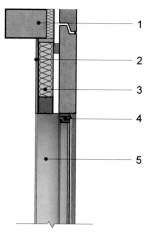
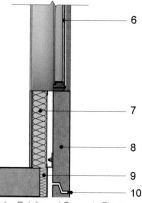

1. Reinforced Concrete Floor
2. Gypsum Board
3. Metal Stud
4. Aluminum Window Frame
5. Window Casing
6. Double-Glazed Window System
7. Insulation
8. Precast Concrete Wall Panel
9. Fire/Thermal/Acoustic Stop
10. Sealant

Fig. 2.2-21 Section of a Precast Concrete Wall with Punched Window

Wall Systems

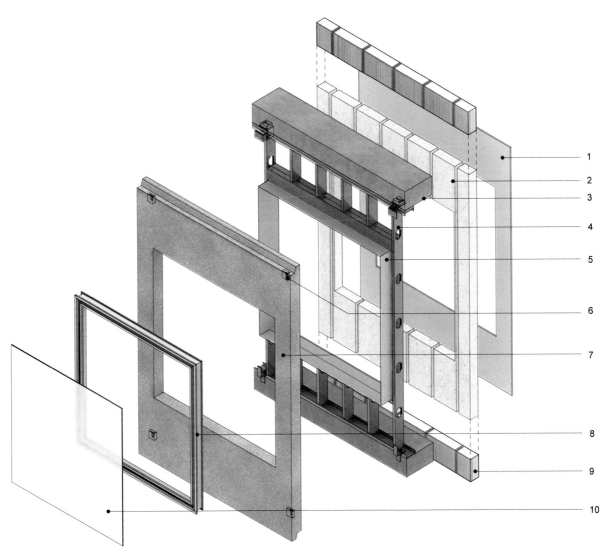

1. Gypsum Board
2. Insulation
3. Reinforced Concrete Floor
4. Metal Stud
5. Window Casing
6. Wedge Anchor Insert
7. Precast Concrete Wall Panel
8. Aluminum Window Frame
9. Fire/ Thermal/Acoustic Stop
10. Double Glazed Window System

Fig. 2.2-22 Exploded Axonometric of a Precast Concrete Wall with Punched Window

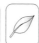

2. Building Envelopes

Stone Panel Wall

Stone cladding for large-scale buildings is typically a nonload-bearing curtain wall that is supported by the structural frame of the building. Because of their appearance, durability and weather resistance, granite, limestone and marble are the most widely used types of stone for external cladding.

Wall Components

STONE PANELS The thickness of stone cladding panels is governed by the panel size and the type of stone. Smaller stone panels are usually supported by a steel subframe that spans vertically from floor to floor. The larger story-height panels are fixed directly to the building's primary structure. The recommended minimum thickness for panels of up to 20 square feet (6 square meters) is 1 ¼ inches (31.7 mm) for granite and 2 inches (50.8 mm) for limestone or marble. The type of stone determines the color and patterning of the cladding. A wide range of textures can be achieved, including sawn, honed, polished, flame cut, bush-hammered and split-face finishes.

PANEL FIXINGS Stainless steel fixings transfer the dead load of the stone panel and lateral wind loads into the building's primary structural frame. The simplest fixings are combined dead-load and tie-back anchors. Story-height panels are typically fixed to angles bolted to a steel frame or to anchors cast into the edge or face of a concrete slab. Smaller panels are fixed to a steel subframe that spans vertically from floor to floor. The anchors, which have slotted holes to allow for adjustment, fit into kerfs (grooves) cut into the top and bottom edges of each stone panel. Panel joints for a sealed building envelope are made weather-tight by the insertion of a compressible backer for mastic sealant.

THERMAL INSULATION Thermal insulation is incorporated in a separate backup wall.

BACKUP WALL A nonstructural backup wall is constructed on-site and spans from slab to slab. The most typical construction is light-gauge metal studs with insulation between the studs and a gypsum board, wood or veneered plywood interior finish. The backup wall also carries and conceals pipe work and electrical services.

CONSTRUCTION AND SUSTAINABILITY Stone cladding is expensive relative to many other materials. The detailing of stone cladding and its highly specialized fixings is typically done by the stone subcontractor, who provides shop drawings for approval by the design team. Fabrication and installation are carried out by highly skilled labor. Each piece of stone is prefabricated in a shop and marked with a code to identify its precise location in the building envelope. Because stone is robust and durable, it typically requires minimal protective measures, such as wrapping, either in the shop or on the building site.

1. Reinforced Concrete Floor
2. Compressible Foam Filler
3. Steel Bolt with Nuts
4. Lightweight Steel Framing System
5. Insulation
6. Gypsum Board
7. Steel Tube
8. Caulk
9. Stone Veneer System
10. Vapor Barrier
11. Air Space
12. Fire/Thermal/Acoustic Stop
13. Metal Ties

Fig. 2.2-23 Section of a Stone Panel Wall

Wall Systems

 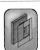

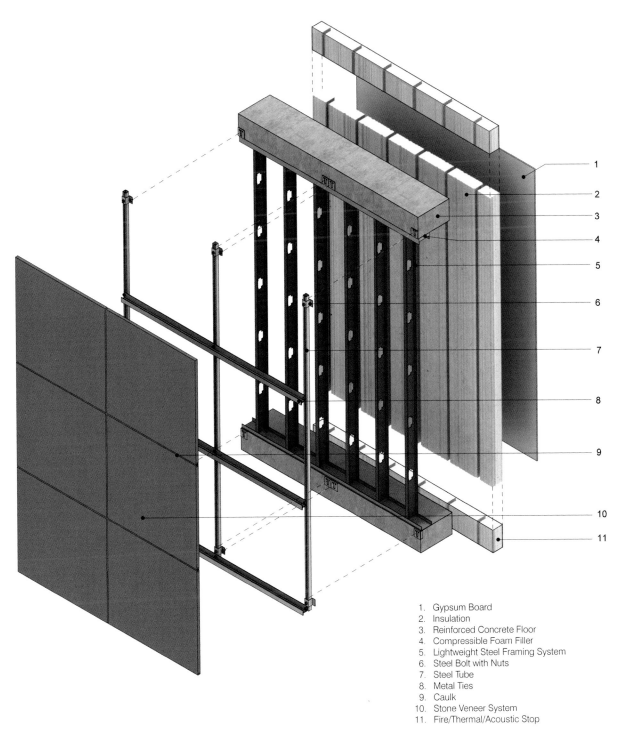

1. Gypsum Board
2. Insulation
3. Reinforced Concrete Floor
4. Compressible Foam Filler
5. Lightweight Steel Framing System
6. Steel Bolt with Nuts
7. Steel Tube
8. Metal Ties
9. Caulk
10. Stone Veneer System
11. Fire/Thermal/Acoustic Stop

Fig. 2.2-24 Exploded Axonometric of a Stone Panel Wall

2. Building Envelopes

STANDARD CONSTRUCTION

Stone Panel Wall (8'x12') Punched Window	R-VALUE	EMBODIED ENERGY	RECYCLED CONTENT
Stone (Imported)	0.05	431	0.00%
Compressable Filler w/ Sealant	N/A	47,323	0.00%
Weatherproof Membrane (Polystyrene)	N/A	37,310	0.00%
1/2" Gypsum Wallboard (Both Sides)	0.44	1,292	0.00%
Steel Frame (Wall Studs/BOF)	N/A	10,512	2.18%
Fiber Glass Insulation	8.81	12,063	0.37%
Steel Frame (Stone Studs/BOF)	N/A	10,512	4.47%
Extruded Insulation (XPS)	5.00	38,171	0.00%
1/8" Uncoated Double Glazing	0.53	6,462	0.00%
Aluminum Frame	N/A	66,778	3.07%
Per Square Foot of Wall	**14.84**	**230,855**	**10.09%**

GREEN CONSTRUCTION

Stone Panel Wall (8'x12') Punched Window	R-VALUE	EMBODIED ENERGY	RECYCLED CONTENT
Stone (Domestic)	0.05	431	0.00%
Compressable Filler w/ Sealant	N/A	47,323	0.00%
Weatherproof Membrane (Polystyrene)	N/A	37,310	0.00%
1/2" Gypsum Wallboard (Both Sides)	0.44	1,292	0.00%
Steel Frame (Wall Studs/BOF)	N/A	10,512	2.18%
Mineral Wool Insulation	8.81	7,152	1.10%
Steel Frame (Stone Studs/BOF)	N/A	10,512	4.47%
Extruded Insulation (Polyisocyanurate)	5.34	30,373	0.14%
1/8" Low-E Double Glazing, (E=0.1)	5.34	6,462	1.58%
Aluminum Frame	N/A	12,408	8.18%
Per Square Foot of Wall	**15.33**	**163,776**	**17.65%**

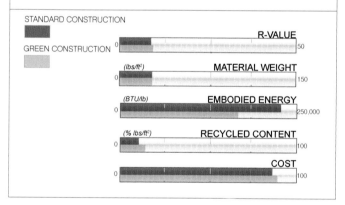

Estimated properties and values are based on the addition of attributes of each component of an 8'x12' (2.4m x 3.6m) wall panel.

Stone has low levels of embodied energy in its manufacture. Large blocks of stone are quarried and transported to workshops where the stone is cut and finished. Although water is required continuously during cutting and finishing to cool the equipment, the amount of this water is minimal relative to other materials such as concrete. However, stone quarries disfigure the landscape.

The embodied energy in stone, related to transportation, is significant because stone is transported globally. In some cases, international shipping and foreign labor add up to less than domestic labor and transportation by truck. Well-detailed stone cladding is a long-life material that requires little maintenance.

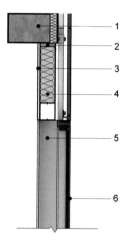
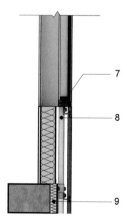

1. Reinforced Concrete Floor
2. Compressible Foam Filler
3. Gypsum Board
4. Insulation
5. Window Casing
6. Double-Glazed Window System
7. Aluminum Window Frame
8. Steel Tube
9. Fire/Thermal/Acoustic Stop

Fig. 2.2-25 Section of a Stone Panel Wall with Punched Window

Wall Systems

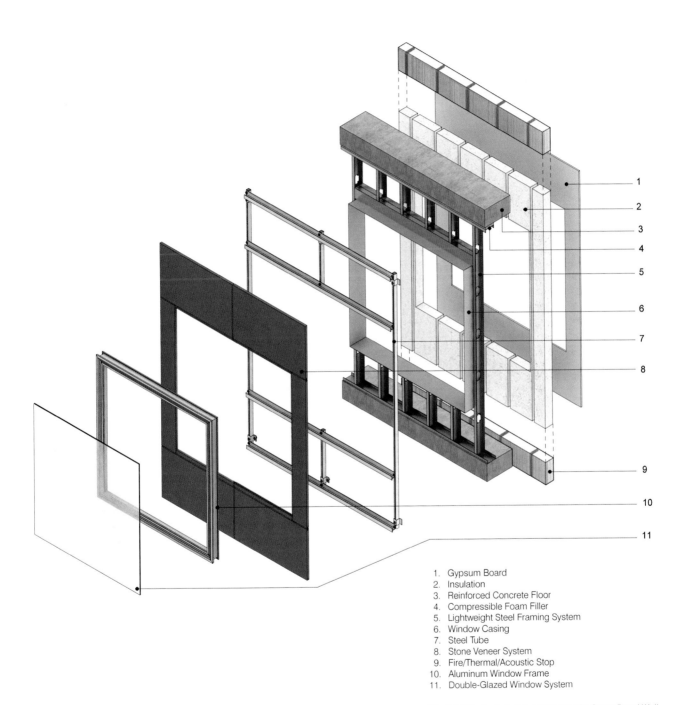

1. Gypsum Board
2. Insulation
3. Reinforced Concrete Floor
4. Compressible Foam Filler
5. Lightweight Steel Framing System
6. Window Casing
7. Steel Tube
8. Stone Veneer System
9. Fire/Thermal/Acoustic Stop
10. Aluminum Window Frame
11. Double-Glazed Window System

Fig. 2.2-26 Exploded Axonometric of a Stone Panel Wall with Punched Window

2. Building Envelopes

2.3 Climate-Responsive Façades

Beyond the functions of providing shelter, form, views, and image, the building façade plays a critical role in the thermal behavior and the overall building's energy consumption. Advanced technologies in façade construction are enabling buildings to respond to the environment effectively and take advantage of the site forces to develop passive strategies. These façade systems have the potential to capture, filter, and redirect daylight, provide natural ventilation and control solar radiation and glare, and to significantly improve the buildings' energy performance. Some of these systems include double-skin façades for thermal comfort, shading devices for solar control, and façade-integrated photovoltaics for electricity generation.

Double-Skin Façades

Double-skin façades are generally composed of two layers of glazing separated by an air cavity that performs as insulation against extreme temperatures. The exterior layer is usually composed of hardened single glazing that mediates climatic conditions to reduce the building's overall energy consumption. The interior layer is usually a double-glazed window that seals and insulates the building. The air cavity between the two layers of glazing can be totally natural, fan supported or mechanically ventilated. A double-skin façade can incorporate integrated sun-shading devices, natural ventilation systems, and thermal, acoustical, and fire safety insulation materials. In general, there are three types of double-skin façades: the extract-air system, the buffer system, and the twin-face system. There are also hybrid double façades that include opaque, translucent or screen elements as an alternative to single glazing on the outer skin to control solar heat gains, glare, and daylighting levels.

AIR EXTRACT SYSTEM An air extract system is utilized in areas where natural ventilation through operable windows is not possible. In an air extract system, the cavity between the two skins is part of the heating, ventilation and air conditioning (HVAC) systems. Exhaust air is mechanically removed through openings in the interior skin to the cavity where it is drawn out of the building, often through a heat-energy recovery system. This façade system utilizes automated dampers at the top and bottom of the wall to ventilate the cavity.

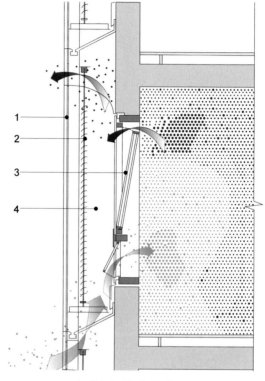

1. Exterior Single Glazing
2. Integrated Sun-Shading Devices
3. Interior Double Glazing (Low-E Glass)
4. Air Cavity

Fig. 2.3-1 Double-Skin Façade

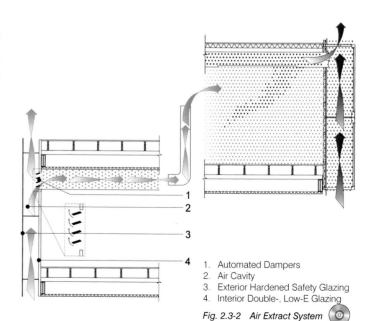

1. Automated Dampers
2. Air Cavity
3. Exterior Hardened Safety Glazing
4. Interior Double-, Low-E Glazing

Fig. 2.3-2 Air Extract System

Source: Shahin Vassigh and Jason Chandler. *Building Systems Integration for Enhanced Environmental Performance* (Fort Lauderdale: J. Ross Publishing, 2011). P. 56

Climate Responsive Façades

BUFFER SYSTEM A buffer system utilizes two sealed layers of glazing spaced from 10 inches (25.5 cm) to 3 feet (91.5 cm) apart. The exterior layer is usually single safety glazing whereas the interior layer is often low-E double glazing. Buffer systems usually incorporate shading and daylight control devices between the two layers to provide solar protection. The buffer façade may include automated dampers at the top and bottom of the cavity to allow ventilation and prevent overheating during the summer. These dampers perform as a thermal buffer during cold winters by maintaining the interior cavity closed, acting as solar thermal air collectors with heat exchangers for heating the interior.

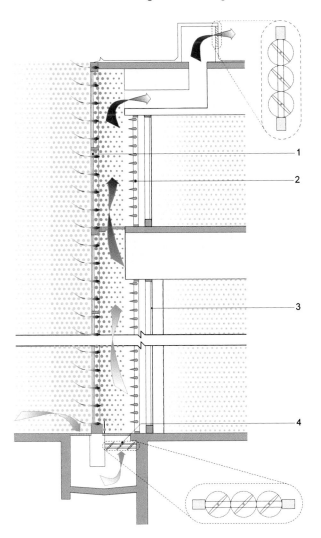
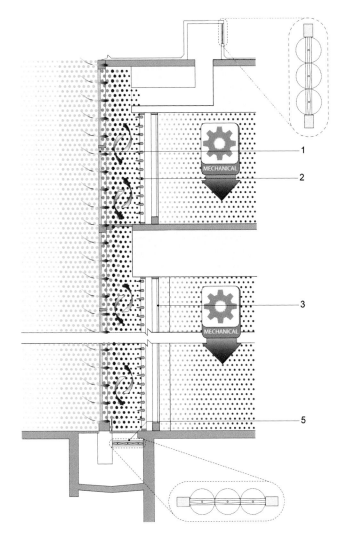

1. Exterior Hardened Safety Glazing
2. Metal Louvers
3. Interior Double-, Low-E Glazing
4. Motorized Open Dampers
5. Motorized Closed Dampers

Fig. 2.3-3 Buffer System. Thermal Buffer for Winter Climates

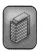

2. Building Envelopes

TWIN-FACE SYSTEM A twin-faced façade system consists of two layers of single safety glazing and low-E double glazing separated by an air cavity extending at least 2 feet (61 cm). Both the interior and exterior skins include operable windows to allow natural ventilation inside the building. These windows are generally controlled by the building management system with a manual override. The twin-face system allows nighttime cooling through automated purge windows.

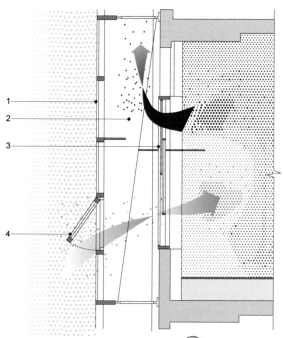

Fig. 2.3-4 Twin-Face System (Summer: Day Ventilation)

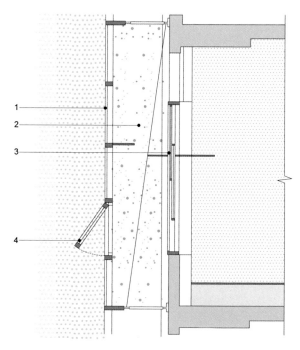

Fig. 2.3-6 Twin-Face System (Winter: Thermal Buffer)

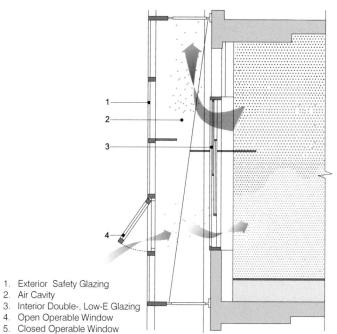

1. Exterior Safety Glazing
2. Air Cavity
3. Interior Double-, Low-E Glazing
4. Open Operable Window
5. Closed Operable Window

Fig. 2.3-5 Twin-Face System (Summer: Night Cooling)

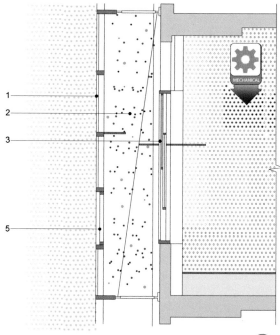

Climate Responsive Façades

HYBRID SYSTEM A hybrid system includes double-skin façades that do not utilize an additional layer of glazing as the secondary skin. The hybrid double-skin façade usually incorporates a layer of screens or opaque elements to control excessive heat gains.

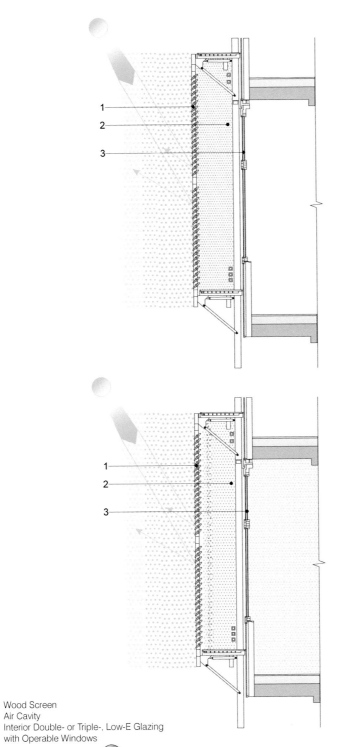

1. Wood Screen
2. Air Cavity
3. Interior Double- or Triple-, Low-E Glazing with Operable Windows

Fig. 2.3-7 Hybrid System

2. Building Envelopes

Shading Devices

Shading systems are a passive method to control solar heat gains and glare while providing ample daylight and views to the outside. Shading devices are often attached to the building's cladding frame or mounted directly to the building structure. They can be manually operated or automatically controlled by a building management system. External louvers generally consist of glass fins, perforated metal louvers, or wood slats utilized to control solar radiation and glare based on the façade orientation. Horizontal louvers are efficient in southern façades whereas vertical louvers respond effectively to the low summer sun striking the east and west façades, as well as sun in the higher latitudes on the northeast and northwest façades. When used in combination with double-skin façades, the shading devices can be incorporated into maintenance walkways attached or integrated in the façade cavity.

HORIZONTAL SHADING DEVICES Horizontal screening is highly efficient in the southern façades to reduce the amount of solar radiation entering the building from a steep angle. Horizontal shading devices allow diffused natural light inside the building while reducing excessive heat gains and the need for artificial lighting.

VERTICAL SHADING DEVICES Vertical shading devices work effectively on the east, west and north façades. They minimize heat gains by screening direct solar radiation from the low summer sun while allowing daylight entry and views to the outside.

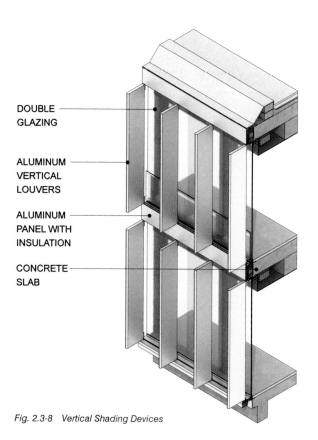

Fig. 2.3-8 Vertical Shading Devices

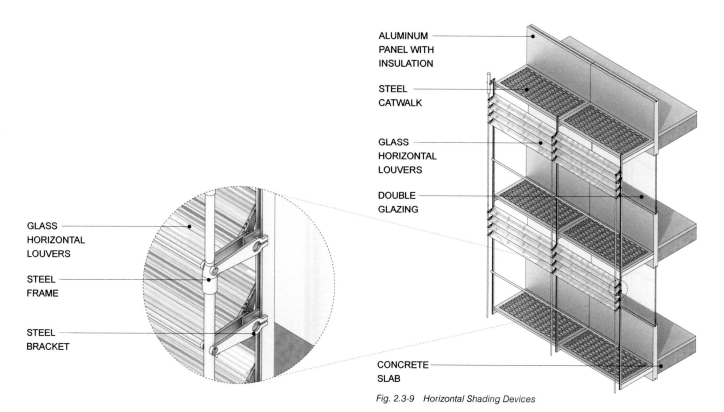

Fig. 2.3-9 Horizontal Shading Devices

Climate Responsive Façades

 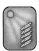

Photovoltaic Façades

Photovoltaic (PV) systems can be integrated into the building's façade to generate electricity and reduce reliance on fossil fuels, while minimizing green house gas emissions. PV systems may be utilized as the external wall finishing or as part of the façade to provide shading. The optimum orientation and correct tilt angle of the PV installation are fundamental in the solar access and the potential electrical output of the system. Photovoltaic façades on the northern hemisphere should be oriented south and tilted at an angle 15 degrees higher than the site latitude for maximum efficiency.

EXTERNAL BUILDING WALLS PV systems utilized as external building walls are generally made of safety-glass to allow some light penetration. They consist of double-glazed panels with PV cells in between. The PV glazed panels can be manufactured in any form and size to match the dimensions and visual attributes of conventional glazing.

SHADING SYSTEMS PV systems utilized as external louvers to provide shading are generally more effective because they block solar radiation while allowing views to the outside. These systems replace the conventional shading devices and combine two functions of providing solar control and collecting solar energy. They may be fixed or automatically controlled to track the sun's path and optimize both the solar shading effect and the energy collection strategy.

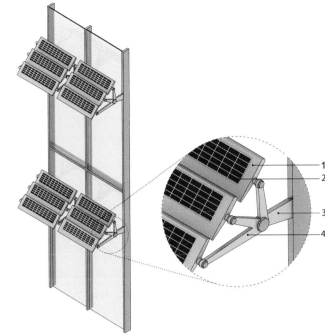

1. Louver
2. Photovoltaic Laminate
3. Strut Anchor
4. Strut Arm

Fig. 2.3-10 Photovoltaic Shading System

REFERENCES

1. Transit Green House Gas Emissions Management Compendium, U.S. Department of Transportation, Federal Transit Administration, p.104; http://www.fta.dot.gov/documents/GHGCompendGTv2.pdf

2. Treloar, G., McCormack, M., Palmowski, L., Fay, R. (2004) Embodied water of construction. In Royal Australian Institute of Architects. BDP Environment design guide (pp.1-8). Royal Australian Institute of Architects

3. Maureen Puettmann. WoodLife, "Carbon Footprint of Renewable and Nonrenewable Materials." October, 18, 2009. http://www.corrim.org/presentations/2009/Puettmann_WEI.pdf

4. Klaus Daniel and Ralph Hammann. *Energy Design for Tomorrow*, (Stuttgart: Edition Axel Menges, 2009).

5. Simmler, Hans, Samuel Brunner, and Ulrich Heinemann. "Vacuum Insulation Panels—Study on VIP-Components and Panels for Service Life Prediction of VIP in Building Applications." HiPTI—High Performance Thermal Insulation IEA/ECBCS Annex 39. no. September (2005). http://www.ecbcs.org/docs/Annex_39_Report_Subtask-A.pdf.

6. Sto Corp, "Exterior Insulated Finish Systems (EIFS)." http://www.stocorp.com/index.php/component/option,com_catalog2/Itemid,1%2096/catID,1/catLevel,2/subCatID,15/

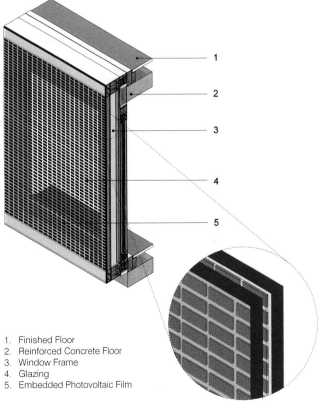

1. Finished Floor
2. Reinforced Concrete Floor
3. Window Frame
4. Glazing
5. Embedded Photovoltaic Film

Fig. 2.3-11 Photovoltaic External Building Walls

Structure

Designing and selecting structural materials and systems for buildings is often based on material efficiency and reducing the structural components to the smallest possible size without compromising safety. Although this process promotes effective use of natural resources, other strategies that utilize materials with high recycled content and reduced impact on the environment are significant ways in which the design of a structure can contribute to minimizing a building's carbon footprint.

3. Structure

3.1 Structural Materials

Because structure constitutes the most massive and permanent part of a building, the selection of structural materials with an understanding of resource extraction and their environmental impact is becoming increasingly important. Common building materials used for structural purposes are structural wood, reinforced concrete, masonry and steel. The following sections briefly explain the structural capacity, types, and environmental impact of these materials.

Wood

Most wood structures are composed of linear elements used as beams or joists to frame building floors and roofs. These frames are often supported by wood columns, masonry bearing walls, or closely spaced studs enclosed by plywood. Because wood has limited strength and spanning capacity, it is mostly used in residential and small-scale construction. Because utilizing wood involves harvesting forests, using wood from managed and certified resources is critical. Recycling and reusing wood structural components are other important considerations in sustainable wood construction.

SOLID SAWN LUMBER Solid sawn lumber members are wood members that are produced directly from the cutting of a log. Solid sawn members are often used as beams, columns and trusses in small-scale construction. Using solid sawn lumber members that are greater than 2 in x 10 in (5 cm x 25 cm) requires cutting large trees that take a long time to grow and be replenished.

ENGINEERED WOOD When larger wood members are required, engineered wood products may offer a viable alternative to solid sawn lumber because they are designed to be more efficient. Engineered wood products can perform structural functions with smaller sizes manufactured from smaller trees that can be replaced by rapidly growing trees. To manufacture engineered wood products, wood strands and particles are bonded together with adhesives under controlled conditions to maximize the natural strength and capacity of wood. As a result, these products can span larger distances with less material.

Structural Wood Panels

Plywood, oriented strand board (OSB) and laminated veneer lumber (LVL) are three types of structural wood panels that are often used in a variety of applications, such as walls, floors, roof sheathing and concrete formwork. OSB and LVL are also used as web elements in the construction of I-joists.

Wood I-Joists

Wood I-joists are composed of horizontal members or flanges connected to the top and bottom of a vertical member called a web. The flanges are often composed of swan wood. The web members are often composed of LVL or OSB.

Glue-Laminated Wood

Glulams are manufactured from individual pieces of wood arranged in horizontal layers joined together to produce high capacity structural members. Glulams are used as beams, columns and arches and can be manufactured in larger sizes.

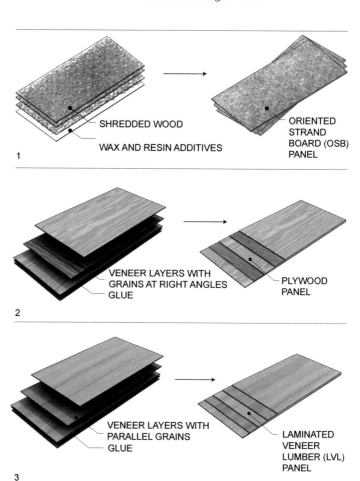

Fig. 3.1-1 Engineered Wood Products

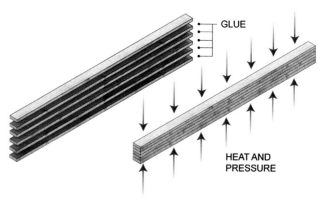

Fig. 3.1-2 Glue-Laminated Wood

Structural Materials

Reinforced Concrete

Concrete is a commonly used building material with a high capacity to carry compression forces, but very small strength to resist tension forces. Adding reinforcing steel bars or wires to concrete provides tensile strength, making it suitable for structural purposes. Because the production process of cement used in concrete causes significant CO_2 emissions, replacing 15–40 percent of cement with fly ash in the concrete mixture is becoming a common practice. Fly ash is a by-product from the combustion of coal electric power generation plants. Fly ash has a low embodied energy and it is lighter than cement.

Prestressed Concrete

Prestressing concrete is a process by which external forces are deliberately applied to concrete in order to counteract expected stresses on the structural members during their service life. Controlling stresses in the structural members results in smaller elements with larger spanning capability. Although prestressed members use much less concrete, they require high-strength steel, resulting in higher cost. Prestressing concrete can be achieved by pretensioning or posttensioning.

PRETENSIONED CONCRETE In pretensioned concrete, the steel cables placed in the casting beds are tensioned prior to the casting of the concrete. Once the concrete is cast and hardened, it bonds to the steel cables. When the concrete reaches the required strength, the tension forces in the cables are released and transferred to the concrete through the bond, thus placing the concrete in compression. In many cases, transferring the cable forces to the concrete creates a camber and bends the concrete member in the opposite direction of the anticipated deflection due to applied loads. Once the load is applied, the camber flattens, thus minimizing the beam deflection. Pretensioned members are often produced as prefabricated elements in concrete plants under controlled environment.

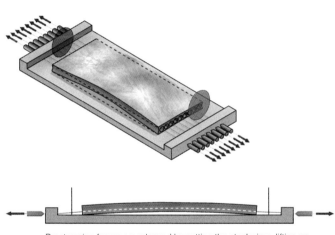

Applying prestressing forces to concrete by tensioning the steel wire or strands.

Prestressing forces are released by cutting the steel wires, lifting up the concrete and producing a camber.

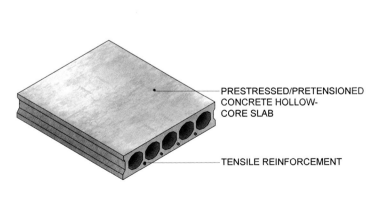

— PRESTRESSED/PRETENSIONED CONCRETE HOLLOW-CORE SLAB

— TENSILE REINFORCEMENT

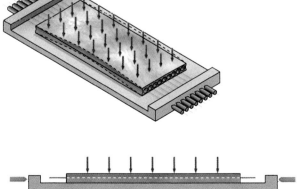

Once the load is applied the concrete becomes flat and the camber disappears resulting in reduced deflection.

Fig. 3.1-3 Prestressed, Pretensioned Concrete Hollow Core Slab

73

3. Structure

POSTTENSIONED CONCRETE In posttensioned concrete, cables are threaded through hollow conduits in the concrete to prevent bonds between the steel and concrete. Once the concrete is cast and it has reached the required strength, the tension force is applied by hydraulic jacks and the cables are anchored at their ends. The result of this force is a bending in the opposite direction of the anticipated deflection of the beam.

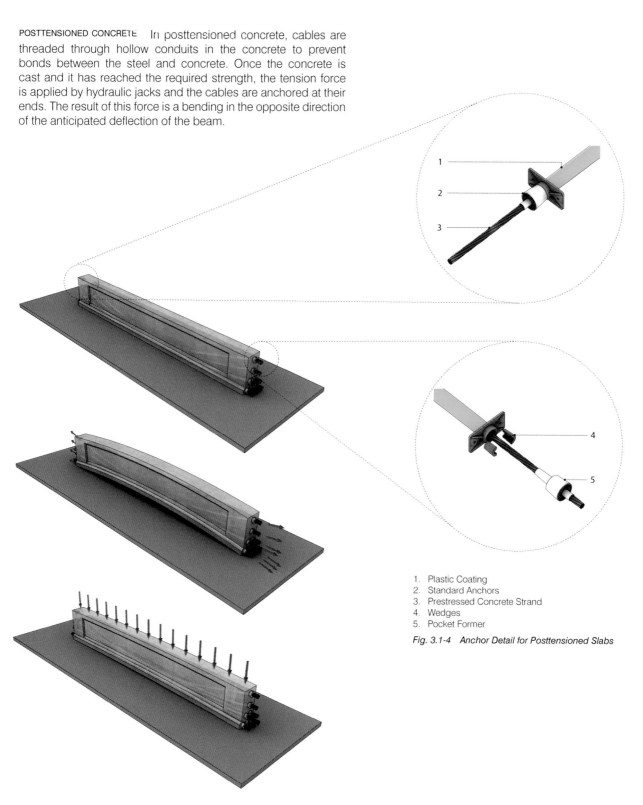

1. Plastic Coating
2. Standard Anchors
3. Prestressed Concrete Strand
4. Wedges
5. Pocket Former

Fig. 3.1-4 Anchor Detail for Posttensioned Slabs

Fig. 3.1-5 Beam Post-Tensioning

Structural Materials

Masonry Products

The most common masonry product used for building structures is concrete masonry units (CMUs). Because masonry products have very low tensile strength, their use is often limited to construction of load-bearing walls and columns. CMUs used for structural purposes are reinforced with steel bars. Brick masonry is another product with structural applications. In addition to wall and column construction, brick masonry has been traditionally used in the construction of arches and lintels.

Steel

Steel has a wide range of structural applications, such as beams, columns, decks, connection plates, fasteners and reinforcing bars, which are commonly used in both small- and large-scale construction. Because steel is strong in carrying both tension and compression forces, structural elements made of steel have smaller cross-sections and can span longer distances with less material, often making steel structural elements an efficient structural choice.

Steel has high embodied energy and embodied water because the process to produce steel requires a significant input of raw materials and energy. In addition, steel fabrication produces hazardous emissions, water pollution and solid waste. However, steel is highly recyclable and produces little waste on the construction site. Steel is vulnerable to moisture and corrodes easily, therefore, it must be covered with a protective layer when exposed to the environment.

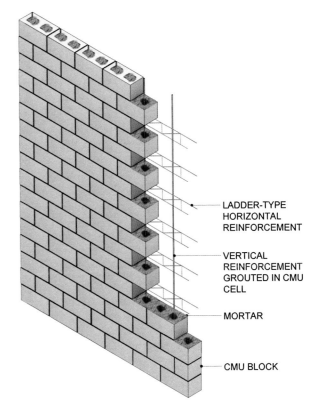

Fig. 3.1-6 Concrete Masonry Unit (CMU) Wall

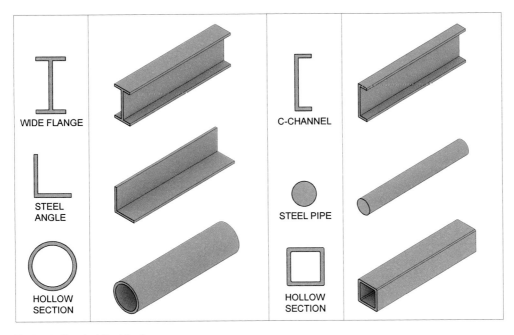

Fig. 3.1-7 Standard Steel Sections

3. Structure

3.2 Horizontal Spanning Systems

Horizontal structural systems can be designed as slabs, beams, girders and trusses. In general, limiting the horizontal span of a floor or a roof system will lead to a more efficient structure. This can be achieved by placing the vertical supports closer to each other. Shorter spans lead to shallower depths, reduced deflections, and material savings.

Horizontal spanning systems used for floors and roofs can be treated the same although there are some differences in their load-carrying capacity. In general, roof systems are subjected to smaller loads, and depending on the building's geographical location, they may be subjected to wind and snow loads. Horizontal spanning systems can be organized based on their structural behavior into two categories: one-way and two-way systems.

One-Way Systems

One-way systems or slabs are utilized when the structural bays form a rectangular or near rectangular shape. One-way systems are designed as a system of beams, girders, or trusses that support the deck slab. In one-way systems, the slab carries loads by bending in only one direction, redirecting loads to the supporting structural elements located at the two longer opposite sides or edges. It is preferable to span the beams in the short direction in order to keep beam deflection and sizes small, thus achieving maximum efficiency.

Two-Way Systems

Two-way horizontal spanning systems are utilized when the structural bays form square or near square bays. Two-way systems can be designed as a system of beams, girders or trusses that support a deck slab. In the two-way system, the slab carries the load by bending in two directions, redirecting loads to the supporting structural elements located at four sides or four edges.

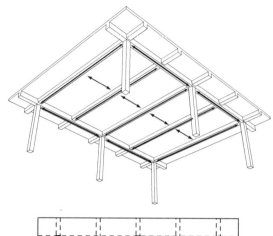

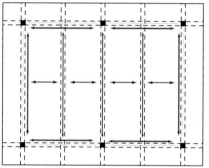

Fig. 3.2-1 One-Way System Load Distribution Direction

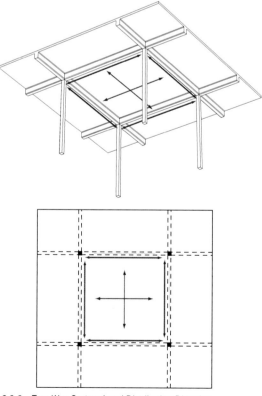

Fig. 3.2-2 Two-Way System Load Distribution Direction

3.2 Horizontal Spanning Systems

Noncomposite Steel Frame (One-Way System)

A noncomposite steel frame system is composed of a series of parallel steel beams that extend in the short direction to frame a floor or a roof structure. The concrete deck slab is continuously supported by resting on the beams without any additional structural connection. This comprises a one-way system that is most efficient for spanning rectangular bays.

Frame Components

CONCRETE DECK SLAB In noncomposite construction, the concrete slab rests on the steel frame with no connection to the steel beams. It acts independently from the supporting steel frame. As a result, there is no mechanism to transfer the horizontal shear forces to the frame, and the deck slab cannot assist in carrying bending moment to the frame. The deck acts as dead load placed on the steel frame, therefore, the concrete slab must be designed to carry its own weight.

STEEL BEAMS Wide-flange steel beams run parallel to form rectangular bays that support the reinforced concrete deck slab. The beams are all connected to girders at their ends, where they transfer loads to other structural elements. Smaller steel beams may be used to provide bracing for the beams.

STEEL DECK In noncomposite construction, the deck functions as a form for normal-weight, structural lightweight or insulating concrete. The steel deck is constructed from thin sheet metal and comes in a variety of corrugated profiles and thicknesses. The corrugations increase the stiffness of the deck. The deck thickness determines the spanning capacity. The steel deck has a high strength-to-weight ratio, making it an economically viable choice.

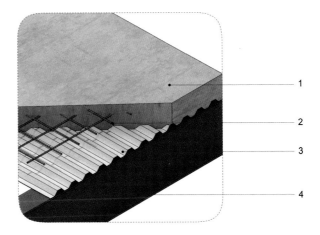

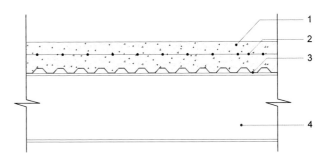

1. Concrete Slab
2. Reinforcement
3. Corrugated Metal Deck
4. Steel Beam

Fig. 3.2-3 Noncomposite Frame Components and Section Detail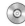

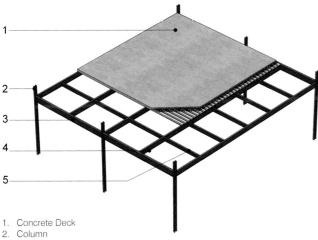

1. Concrete Deck
2. Column
3. Girder
4. Beam
5. Cross-Bracing

Fig. 3.2-4 Noncomposite Frame with Bracing

Fig. 3.2-5 Noncomposite Frame without Bracing

3. Structure

Composite Steel Frame (One-Way System)

Similar to the noncomposite steel frames, a composite steel frame system utilizes a series of parallel steel beams extending in the short direction that carry the deck slab. However, in the composite steel frame system the concrete deck slab is connected to the beams via structural connections called shear studs. This comprises a one-way system that is most efficient for spanning rectangular bays.

Frame Components

CONCRETE DECK SLAB In composite construction, the integral connection of the concrete deck slab and the steel framing provides resistance to the slippage of the concrete slab relative to the beams. As a result, the deck slab and the steel beams act in unison to resist the loads and the horizontal shear forces. In this monolithic construction, the deck slab is no longer considered as a dead load resting on the beam, but as a load-carrying component of the entire assembly.

STEEL BEAMS Wide-flange beams run in parallel to form rectangular bays that support the reinforced concrete deck slab. The beams are all connected to girders at their ends where they transfer the loads to other structural elements. Smaller steel beams may be used to provide bracing.

In composite construction, the steel beams and the concrete deck slab are connected by the use of shear studs. Shear studs are often welded to the top of the beam flanges and are embedded in concrete to create an integral system for resisting loads. They provide interlock between the concrete deck and the steel beams.

STEEL DECK A composite steel deck consists of a profiled steel decking that provides a permanent form for the cast-in-place concrete deck. In this type of construction, the deck is considered a component of the overall load-bearing deck assembly. During construction, the steel deck supports the weight of the wet concrete, steel reinforcement, and any temporary loads associated with the construction process. Once construction is complete, the composite action is obtained by the interlock between the concrete and the decking via shear studs.

The monolithic action provided by connecting steel and concrete via shear studs utilizes both materials to their fullest capacity and achieves significant strength. Composite deck assemblies have greater stiffness than noncomposite assemblies. They can carry larger loads or similar loads with smaller sections. This leads to a 20–30 percent savings in the weight and size of the primary steel structure. Consequently foundation sizes can also be reduced. In addition, the composite deck system allows for service integration through utilization of the space between the ribs and the decking. The system provides a one hour fire rating without adding any fire protection.

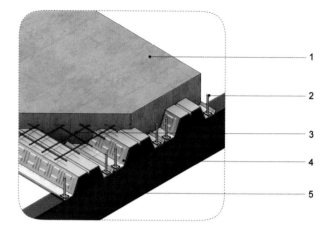

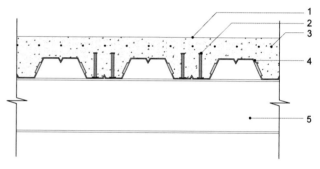

1. Concrete Slab
2. Shear Stud
3. Steel Reinforcement
4. Corrugated Deck Slab
5. Steel Beam

Fig. 3.2-6 Composite Frame Components and Section Detail

3.2 Horizontal Spanning Systems

Concrete Frame (One-Way System)

Concrete can be designed as a one-way system comprised of parallel concrete beams supporting a reinforced concrete slab. To increase the efficiency of this system, the beams and the slab can be connected to act as a monolithic system. In this case, the beams may consist of a series of connecting T-beams that create the slab.

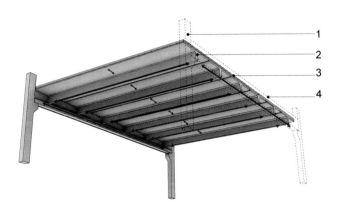

1. Column
2. T-Beam
3. Concrete Floor Slab
4. Girder

Fig. 3.2-7 One-Way Concrete Floor System with T-Beams

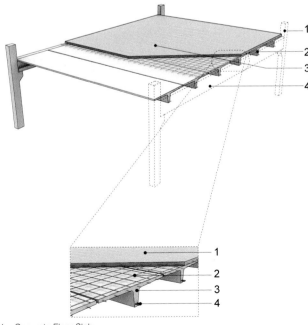

1. Concrete Floor Slab
2. Steel Reinforcement Mesh
3. T-Beam
4. Steel Reinforcement

Fig. 3.2-8 Detail of One-Way Concrete Floor System with T-Beams

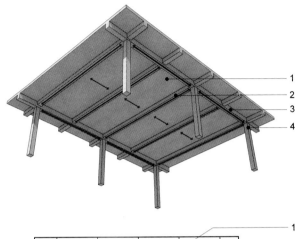

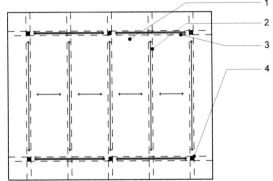

1. Concrete Deck
2. Beam
3. Girder
4. Column

Fig. 3.2-9 One-Way Concrete Floor System with Rectangular Beams

79

3. Structure

Pan Joist or Ribbed Slab (One-Way System)

The pan joist or ribbed slab system is an integrated or a monolithic beam-slab system composed of evenly spaced, parallel, reinforced concrete joists or beams, and a cast-in-place concrete deck. The joists are spaced at close intervals and are framed into beams that are supported by columns. Pan joist constitutes a one-way system. Like all one-way systems, it is preferable to span the joists in the short direction to achieve maximum efficiency.

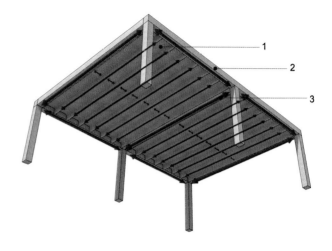

1. Pan Joists (Monolithic Floor System)
2. Framing System
3. Load Distribution Direction

Fig. 3.2-11 Pan Joist Load Distribution

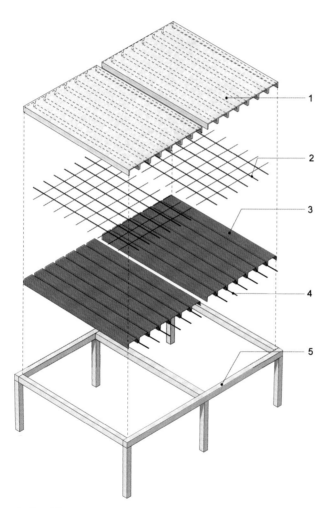

1. Pan Joists
2. Shrinkage and Temperature Reinforcement
3. Pan Forms
4. Tensile Reinforcement
5. Framing System

Fig. 3.2-10 Pan Joist System Components

3.2 Horizontal Spanning Systems

Frame Components

CONCRETE DECK SLAB The reinforced concrete slab is cast and integrated with the beams to produce a monolithic floor system. This type of construction leads to relatively thin concrete slabs, with typical thickness ranging between 2–4 inches (5–10 centimeters). Standard joist spacing is about 30 inches (76 centimeters) and can span distances of 40–60 feet (12–18 meters). The reinforced concrete slab system uses removable metal pans to form joists. Although the formwork can become expensive, it achieves economy through the reuse of standard forming pans.

The pan joist floor system comprises a relatively lightweight system that spans large distances and can resist larger loads. This efficient system utilizes less concrete in construction and the reusable pan forms produce less wasted material. Furthermore, pan joist systems do not require additional fire proofing because concrete provides adequate fire resistance.

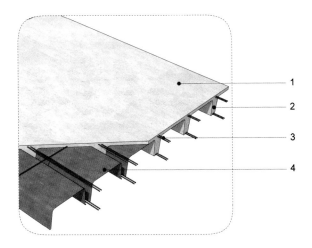

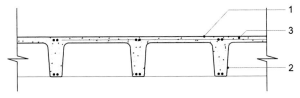

1. Concrete Slab
2. Pan Joists
3. Reinforcement
4. Pan Form

Fig. 3.2-12 Pan Joist Components and Section Detail

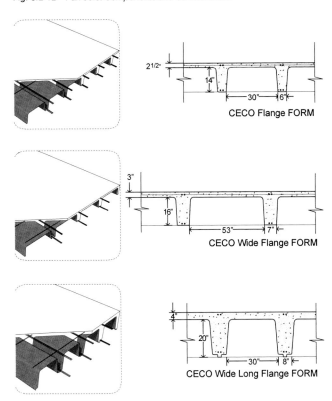

Fig. 3.2-13 Example of Pan Joist Types and Section Details

3. Structure

Hollow-Core Slabs (One-Way System)

Hollow-core slabs are modular prestressed members cast with continuous voids to remove concrete mass in order to produce lighter members. The voids in the slab are introduced to replace nonfunctional or ineffective concrete, thereby increasing the slab's strength-to-weight ratio.

Hollow-core slabs are designed and constructed as one-way systems that span in the direction of hollow cores. The slabs are cast as prestressed members in a plant or a controlled environment and brought to the site as individual units. Once in place, they are connected and grouted together at keyways and are topped with concrete to produce a monolithic slab.

Hollow-core slabs can be actively used as a thermal mass for saving energy. Studies show that integrating the thermal mass of hollow-core and air conditioning systems can save about 50 percent of cooling and 4–10 percent of heating energy.[1] The voids in the slab allow for the integration of electrical wiring or mechanical ducts.

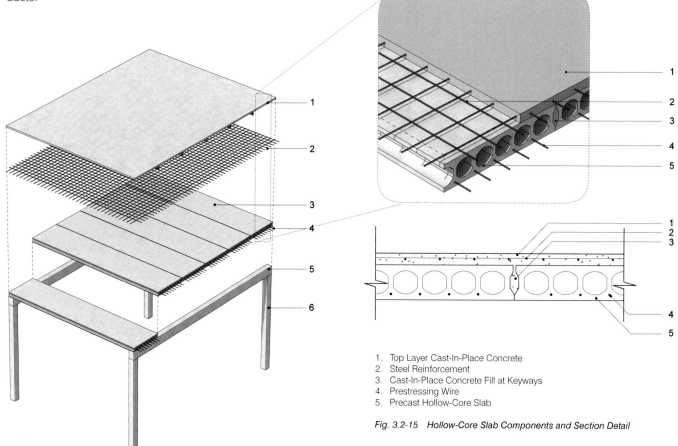

1. Top Layer Cast-In-Place Concrete
2. Steel Reinforcement
3. Cast-In-Place Concrete Fill at Keyways
4. Prestressing Wire
5. Precast Hollow-Core Slab

Fig. 3.2-15 Hollow-Core Slab Components and Section Detail

1. Top Layer Cast-In-Place Concrete
2. Steel Reinforcement
3. Hollow-Core Slab
4. Prestressing Wire
5. Beam
6. Column

Fig. 3.2-14 Hollow-Core Slab Axonometric

3.2 Horizontal Spanning Systems

Flat Plates and Flat Slabs (Two-Way System)

Flat plates are two-way slabs that transfer loads directly to the vertical supporting elements without using beams or girders. This construction is unique to reinforced concrete and is often used for supporting light loads such as floor loads in apartment buildings.

For supporting larger loads, such as those in industrial buildings, thickening of the floor plate around the columns aids in transferring loads to the columns and reduces the possibility of columns puncturing through the plates. The thickening of the slab can be accomplished by adding drop panels and column capitals. This system is referred to as a flat slab. These slabs often have slight cantilevers on all sides in order to reduce the bending of the slab at the center, thus increasing their efficiency.

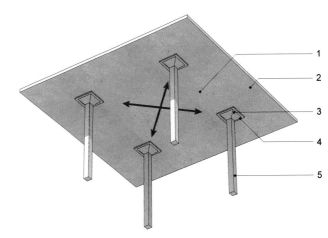

1. Load Distribution Direction
2. Concrete Slab
3. Column Capital
4. Drop Panel
5. Columns

Fig. 3.2-16 Flat Slab Load Distribution

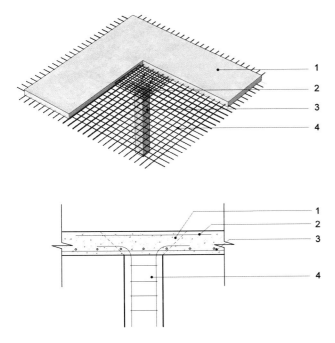

1. Concrete Slab
2. Tensile Reinforcement
3. Shrinkage and Temperature Reinforcement
4. Column

Fig. 3.2-17 Flat Plate Components and Section Detail

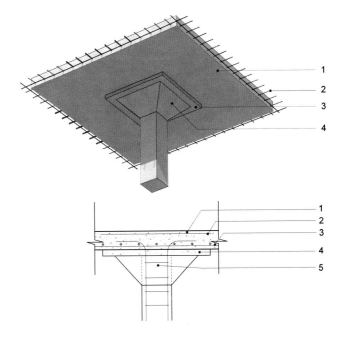

1. Concrete Slab
2. Tensile Reinforcement
3. Shrinkage and Temperature Reinforcement
4. Drop Panel
5. Capital

Fig. 3.2-18 Flat Slab Components and Section Detail

3. Structure

Slabs with Beams (Two-Way System)

When a slab is supported by orthogonal beams located in the perimeter of a square bay, rather than directly on columns, it produces a two-way slab system. This system permits thinner slabs and is one of the most economical reinforced concrete systems. These slabs often have slight cantilevers on all sides in order to reduce the bending of the slab at the center, thus increasing its efficiency even further.

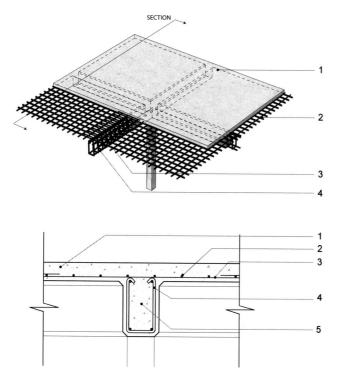

1. Concrete Slab
2. Shrinkage and Temperature Reinforcement
3. Tensile Reinforcement
4. Beam Reinforcement
5. Concrete Beam

Fig. 3.2-19 Two-Way Slabs with Beams

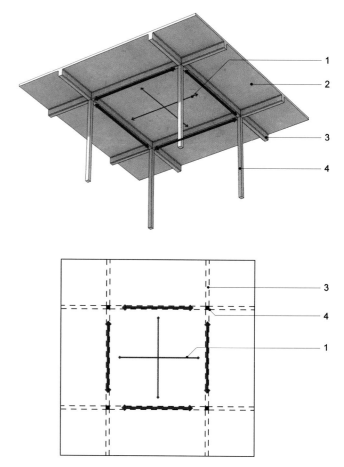

1. Load Distribution direction
2. Concrete Slab
3. Beam
4. Column

Fig. 3.2-20 Two-Way Slabs with Beams Load Distribution

3.2 Horizontal Spanning Systems

Waffle Slabs (Two-Way System)

When slabs are required to span larger distances and support heavier loads, the slab thickness must be increased. However, the increase in the slab thickness does not have to be uniform throughout the slab, because the full thickness is not utilized evenly across the entire slab.

Waffle slabs are designed with variable thickness to achieve maximum efficiency by removing material from inactive parts of the concrete. To save materials where forces are not critical, a series of voids are introduced to the slab while keeping it at full depth in the vicinity of the columns.

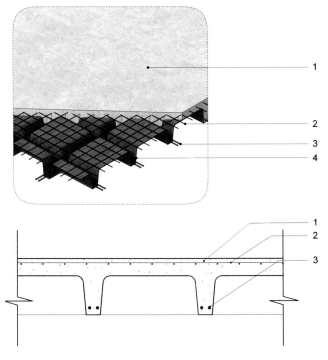

1. Concrete Floor Slab
2. Shrinkage and Temperature Reinforcement
3. Tensile Reinforcement
4. Waffle Form

Fig. 3.2-21 Waffle Slab Components and Section Detail

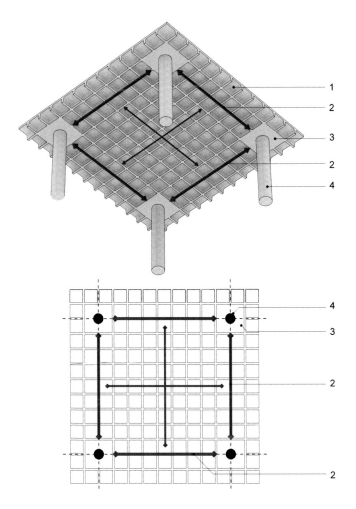

1. Concrete Floor Slab
2. Load Distribution Direction
3. Column Capital
4. Column

Fig. 3.2-22 Waffle Slab Load Distribution

3. Structure

Waffle slab construction utilizes removable metal or fiberglass domes to form a grid of voids in the slab. The voids can be shaped by using standard square forms that are tapered for easy removal. Triangular forms or other customized forms can also be used to provide architectural expression and finishes.

Waffle slabs are suitable for spanning medium-to-long spans and carry larger loads with a lighter weight. Although waffle slab form work can be expensive, it can be composed of recycled plastic and be reused to save materials and produce less waste.

Most waffle slabs have deeper sections leading to deeper floors; however, the void space can be utilized for mechanical and life-safety features creating an integrated system. Like other two-way slab systems, cantilevering the deck slab over columns increases efficiency of the systems.

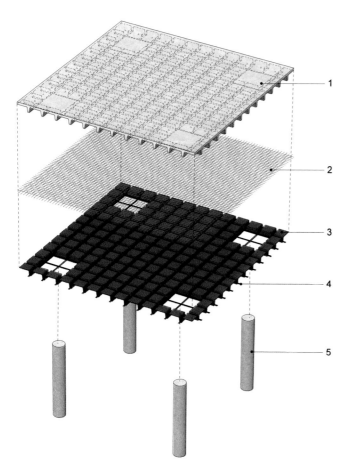

1. Concrete Floor Slab
2. Shrinkage and Temperature Reinforcement
3. Waffle Forms
4. Tensile Reinforcement
5. Columns

Fig. 3.2-23 Waffle Slab Components

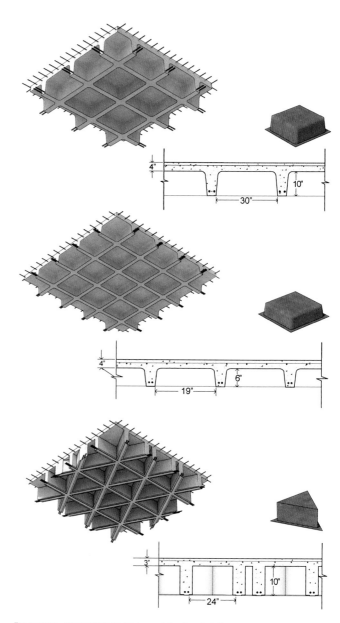

Fig. 3.2-24 Typical Waffle Slabs and Section Details

3.2 Horizontal Spanning Systems

Bubble Decks (Two-Way System)

Bubble decks are flat slabs with significantly reduced weight. The reduced weight is a result of embedding hollow plastic balls within the slab to create voids.[2] Bubble decks are partially prefabricated and equipped with auxiliary support. The semicast units are brought to the site with the lower layer of steel reinforcement in place. The upper steel reinforcement bars are placed on-site and concrete is added to complete the deck.

The incorporation of the plastic balls into the deck slab reduces its weight by almost 35–50 percent without any major reduction in the load-carrying capacity of the deck. The significant weight reduction leads to further material savings as it transfers smaller loads to the supporting columns and foundation. The adverse environmental impact of this deck type is relatively lower than other horizontal spanning systems because it uses recycled plastic for producing the balls. The material efficiency of the systems contributes to lower embodied energy and smaller carbon emissions.

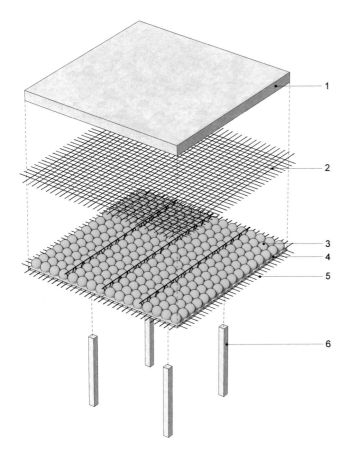

1. Cast-In-Place Concrete Slab
2. Top Reinforcement Mat Placed On-site
3. Plastic Hollow Bubbles
4. Semi-Precast Slab
5. Bottom Slab Reinforcement
6. Column

Fig. 3.2-25 Bubble Deck Components

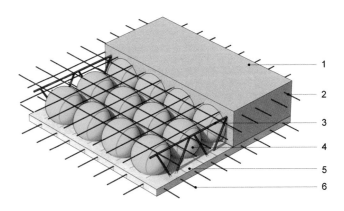

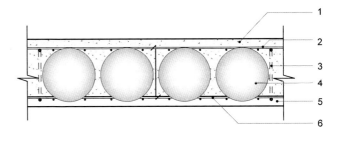

1. Cast-In-Place Concrete Slab
2. Top Reinforcement Mat Placed On-site
3. Lattice Trusses to Hold Bubble in Place
4. Plastic Hollow Bubbles
5. Semi-Precast Slab
6. Bottom Slab Reinforcement

Fig. 3.2-26 Bubble Deck Components and Section Detail

3. Structure

3.3 Vertical Spanning Elements

Vertical spanning systems can be identified as columns or bearing walls that collect loads from horizontal spanning systems and transfer them to the foundation or other adjacent structural elements. Columns and bearing walls are subjected to axial compression loads in addition to their own weight. Shear walls are vertical elements that provide lateral stiffness to the structural frame and transfer lateral loads to the connecting structural elements.

Columns

Column nomenclature can vary based on size, location and structural function. Smaller-sized vertical elements are often referred to as posts or struts. Large columns are often called pylons, piers or masts. Material choice for columns involves several factors, including construction type, loading size, height, shape, frequency of the columns, and economic and availability considerations.

In general, because wood columns have a smaller load-carrying capacity and span shorter distances, they are often used in residential and small-scale construction. The most common use of wood columns is in the form of 2 in x 4 in (5.1 cm x 10.2 cm) studs utilized in wall systems of light frame construction. Single wood columns are larger (at least 4 in x 4 in or 10.2 cm x 10.2 cm) and can be made in square, rectangular and circular cross sections.

Steel and concrete columns have a much larger load capacity. As a result they can be designed with smaller cross-sectional elements, extend longer distances and be placed further apart. When comparing steel and concrete columns, the larger load capacity of steel provides for the design of more slender columns. The typical steel column occupies significantly less floor space than an equivalent concrete column.[3] In addition, because steel beams can span long distances, the number of columns can be reduced, leading to the use of less steel and the creation of more flexible spaces. Steel columns can be made in a variety of shapes. The most commonly used steel columns have a hollow square section or are composed of wide flanges.

Concrete columns can be classified as tied or spiral. In tied columns the longitudinal main steel reinforcement bars are tied with smaller bars at certain intervals along the length of the columns. Tied columns can be constructed in many shapes. In spiral columns, the longitudinal main steel reinforcement bars are tied with a single spiral bar. The spiral bar is used to contain column failure. It is mostly used in seismic areas where the column may suddenly fail. Spiral columns are mostly circular in shape.

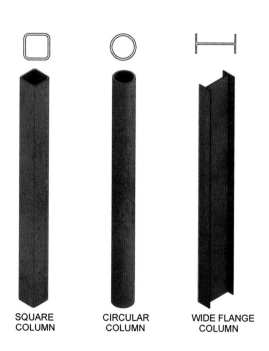

Fig. 3.3-1 Steel Columns

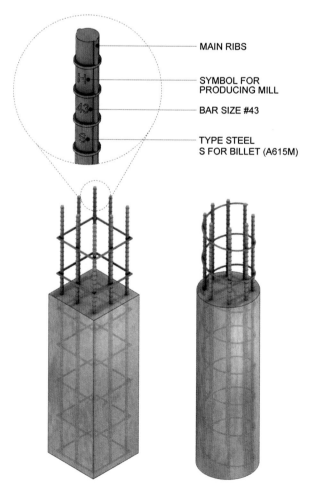

Fig. 3.3-2 Concrete Tied and Spiral Columns

3.3 Vertical Spanning Systems

Load-Bearing Walls

Load-bearing walls are structural components of a building that can be used as exterior or interior walls. These walls carry loads from roofs, floors and lateral load-resisting systems to the foundation. Exterior load-bearing walls are often composed of multi-layers, including load-bearing materials, insulation and connectors. The thickness of bearing walls is a function of the height and the amount of load they must carry. Load-bearing walls can be composed of wood, metal, brick, concrete block or reinforced concrete.

Wood stud walls are often composed of 2 in x 4 in (5.1 cm x 10.2 cm) or 2 in x 6 in (5.1 cm x 15.2 cm) studs closely spaced and held in place by board material such as plywood. They are best suited for small-scale construction with one to three floors.

Masonry walls are used for medium-size construction and are suitable for buildings of up to ten stories. Reinforced concrete walls can be constructed as solid or as containing cavity space. Masonry walls are thinner than masonry walls and can extend further.

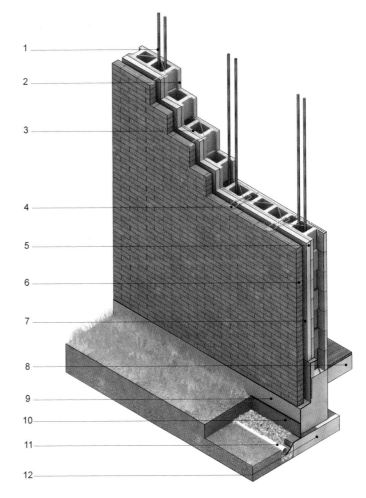

1. Steel Reinforcing Bars
2. CMU Block
3. Ladder Reinforcement
4. Wall Ties
5. Insulation
6. Brick Veneer
7. Cavity Space
8. Concrete Slab
9. Dampproofing
10. Waterproofing
11. Footing Pipe
12. Concrete Footing

Fig. 3.3-3 Masonry Load-Bearing Wall

3. Structure

Shear Walls

Shear walls are vertical spanning elements that are used to resist wind load and earthquake forces. Because shear walls utilize their stiffness to carry lateral loads, they can have very few openings in order to keep their rigidity intact. To increase the efficiency of the structural system, shear walls are often incorporated into the building core where the building circulation and mechanical systems are located.

Most shear walls are composed of reinforced concrete. Wall thickness varies from 5.5 inches to 20 inches (140 mm to 500 mm), depending on the number of stories, building age, and thermal insulation requirements. Steel shear walls are less common in building construction; however, in recent years their use has increased because they offer more efficient use of materials. When compared to concrete shear walls, steel walls are significantly less thick. Steel shear walls are composed of a steel plate that is welded to beams and columns at its perimeter.

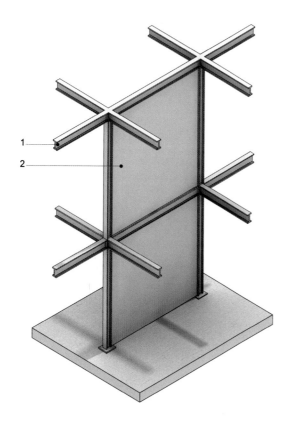

1. Steel Frame
2. Steel Plate Panel

Fig. 3.3-4 Steel Shear Wall

1. Steel Reinforcement
2. Concrete Wall
3. Floor Slab

Fig. 3.3-5 Concrete Shear Wall

Structural Frames

3.4 Structural Frames

Structural frames are among the most common building systems used in construction. Although most frames are composed of horizontal spanning and vertical bearing elements, their ability to carry loads varies considerably with the connecting joinery.

In simple post and beam frames, the horizontal and vertical spanning elements are connected with simple joints and transfer loads independently of each other. Simple frames are easier to construct because the joints do not have to be rigidly connected. In this type of frame, the deflection is only carried by the horizontal elements. In rigid frames, the members are connected with rigid, moment resisting joints that prevent the independent action of horizontal and vertical spanning elements. Rigid frames are more efficient because the rigid connection between horizontal and vertical elements enables the entire frame to deflect as a single entity.

Wood Frames

Wood frames can be composed of light or heavy timber. Heavy timber framing uses large beam and girder elements spaced 2–10 feet (0.6 meters to 3 meters) apart that are at least 6 inches (15 centimeters) wide x 10 inches (25 centimeters) deep and columns that are at least 8 x 8 inches (20 x 20 centimeters). Light woodframe construction employs smaller and more closely spaced elements. Light wood framing has evolved from the balloon frame, in which studs span from the foundation to the roof, to the widely used platform frame. Most wood frames are constructed with simple connections.

Concrete Frames

Concrete frames can be either cast into forms on the building site or precast at the manufacturing plant. Site casting is usually done when the forms are too large or geometrically complex to be done at the plant. Site casting includes one- and two-way slabs, caissons and spread footings. Precast elements include hollow core slabs, beams, T-beams, girders and columns. Concrete frames can be constructed with simple frame connections.

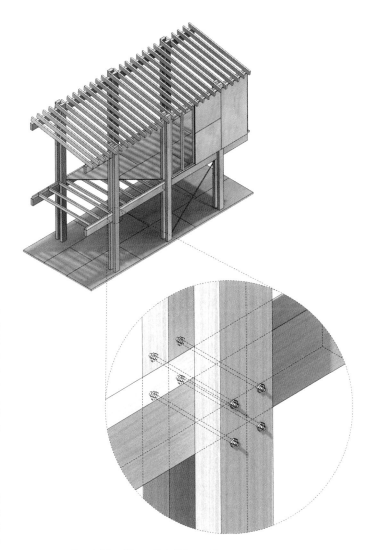

Fig. 3.4-1 Simple Wood Frame Detail Connection

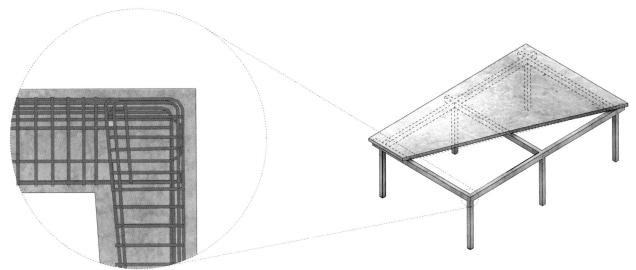

Fig. 3.4-2 Simple Concrete Frame Detail Connection

3. Structure

Steel Frames

Steel frames can be composed of light or heavy members. Light-gauge steel members are produced by cold forming and usually consist of channels and short-span open-web joists. Light-gauge steel framing is often utilized for small-scale residential or commercial structures due to its low cost, fire resistance, and the need to preserve natural wood resources. Heavy steel frames are used in mid- to large-scale structures and use hot-formed, rolled-steel sections such as wide flanges, T-beams, and composite sections for the primary structural members. Steel frames can be constructed with simple frame connections.

REFERENCES

1. Piia Sormunen, Tuomas Laine, Juhani Laine and Mikko Saari "The Active Utilization of Thermal Mass of Hollow-Core Slabs," Proceedings of Clima 2007 Well Being Indoors, VTT Technical Research Centre of Finland Espoo, Finland (2007). www.rehva.eu/projects/clima2007/SPs/D04B1190.pdf.

2. BubbleDeck Structure Solutions, CI/SfB, (23) Eq4. Part 1 (September 2008), http://www.bubbledeck-uk.com/pdf/Product%20Information%20_final_20070219.pdf.

3. "Structural Steel Solutions," American Institute of Steel Construction, http://www.aisc.org/content.aspx?id=3792

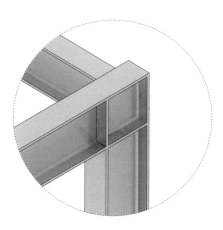

Fig. 3.4-3 Rigid Steel Frame Construction

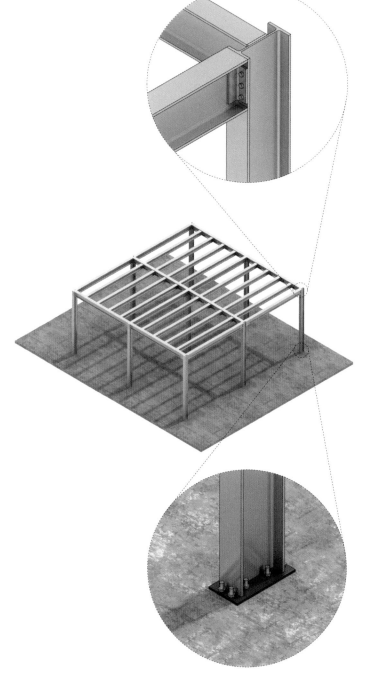

Fig. 3.4-4 Simple Steel Frame Construction

Climate Control

Designing resource-efficient buildings with active, passive or hybrid means of achieving comfort requires a thorough understanding of the climate, site conditions, building occupancy types, and the availability of energy resources. Although a wide range of mechanical systems exists for controlling the interior conditions of buildings, mechanical systems present significant drawbacks to natural resources and the environment. Although it may be unrealistic to completely move away from the active methods for climate control, considering passive means of heating, cooling and ventilation is becoming increasingly critical.

4. Climate Control

4.1 Concepts

One of the critical functions of a building is to provide a comfortable thermal environment that ensures human well-being. Thermal comfort can be achieved by passive means using natural systems; by active means using mechanical heating, ventilation and air conditioning systems; or a combination of both. In each case, a clear understanding of the local site and climatic conditions, comfort standards, the relationship between air and surface temperature and humidity, and the influence of these factors on thermal comfort are not only key aspects of energy efficient building design, but also essential for designing pleasant and livable buildings.

Climate

Designing buildings based on climate-appropriate strategies entails utilizing, analyzing and interpreting climatic data properly. Data collected based on climatic zones provide a vast range of information on air temperature, humidity, precipitation, solar radiation, natural light, wind, and vegetation. Making informed early-stage design decisions based on this data is critical in evaluating alternative climate responsive strategies that can lead to superior building energy performance. The following sections briefly describe how climatic information can be utilized in the building design process.

Degree Days

Degree days is a quantitative index used to estimate the energy demand of a building for heating and cooling. This index helps designers relate daily outdoor temperatures to the amount of energy required for space conditioning in order to provide thermal comfort. Degree days shows the difference between the average daily temperatures and a base temperature representing human comfort.

HEATING DEGREE DAYS Heating degree days (HDD) indicates how much (in degrees), and for how long (in days), outside air temperature drops below a specific base temperature of 65°F (18°C).[1] In other words, HDD shows the number of total degrees that the average temperature has been below the base temperature. HDD is used for estimating the building's heating requirement and can be accessed from a wide range of resources that gather data from weather stations across the country.

COOLING DEGREE DAYS Cooling degree days (CDD) designates how much (in degrees), and for how long (in days), outside air temperature has been above a specific base temperature of 65°F (18°C). CDD indicates the number of total degrees that the average temperature has been above the base temperature. CDD is used to estimate the building's cooling requirement and is available from a wide range of resources that gather data from weather stations across the country.

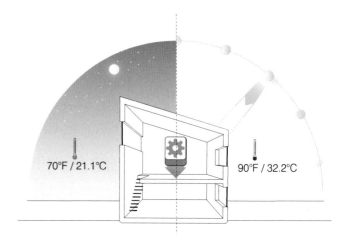

DEGREE DAYS FOR ONE DAY

STEP 1

HIGH TEMPERATURE 90°F / 32.2°C + LOW TEMPERATURE 70°F / 21.1°C ÷ 2 = AVERAGE TEMPERATURE 80°F / 26.6°C

STEP 2

AVERAGE TEMPERATURE 80°F / 26.6°C − BASE TEMPERATURE 65°F / 18.3°C = COOLING DEGREE DAY (CDD) 15°F / -9.4°C

Fig. 4.1-1 Example CDD Calculation for One Day

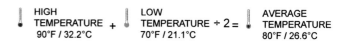

MONTHLY DEGREE DAYS
MIAMI, FL

	JAN	FEB	MAR	APR	MAY	JUN
HDD	88.0	51.0	14.0	0.0	0.0	0.0
CDD	156	149	221	306	425	492

	JUL	AUG	SEP	OCT	NOV	DEC	ANNUAL
	0.0	0.0	0.0	0.0	6.0	41.0	200
	546	552	507	412	264	168	4198

Fig. 4.1-2 Typical Monthly Degree Days in a Hot and Humid Zone (Miami, FL)

Source: EIA Independent Statistics and Analysis, U.S. Energy Information Administration, "Energy Units and Calculators Explained."
http://www.eia.gov/energyexplained/index.cfm?page=about_degree_days

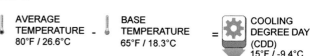

Concepts

Building Occupancy Codes

Building occupancy codes categorize buildings based on the occupancy type, building function and operations. The codes dictate a range of requirements for occupant safety, thermal comfort, and expected resource and energy usage of the building. Awareness of these code categories is important in providing an accurate estimate of the building's energy demand and designing the environmental control systems properly.

BUILDING THERMAL LOADS Building thermal load calculations are conducted to estimate the total annual energy requirements to condition a building. Load calculations assist designers in determining both the type and size of the environmental systems. Thermal loads refer to the quantity of heat that must be added or removed from a space to meet the occupancy needs, thermal comfort, and air-quality requirements. Thermal loads take into consideration both external and internal loads. External loads include the impact of solar radiation, wind, precipitation, humidity, thermal bridges, heat, and moisture infiltration on the building enclosure. Internal loads include heat generated from electrical appliances, lighting systems, and the waste heat and moisture caused by the various activity levels of the building's occupants.

Building thermal loads are often accessed from various software applications. Most software allows designers to accurately simulate the building and predict its energy consumption by compiling typical design load data based on particular climatic conditions, occupancy classification and schedules, and building enclosure type. Most simulation software utilizes building thermal loads to model the building's behavior at the early design and planning stage.

OCCUPANCY TYPES The most commonly used building occupancy classification code in the United States is based on the International Building Code (IBC). IBC classifies buildings into the following groups:

Assembly (Group A)
Gathering places for entertainment and worship, including churches, restaurants (with 50 or more possible occupants), theaters, and stadiums.

Business (Group B)
Places where services are provided, including banks, insurance agencies, government buildings (police and fire stations), and doctor's offices.

Educational (Group E)
Schools and day care centers.

Factory (Group F)
Places where goods are manufactured or repaired (unless considered "high-hazard"), including factories and dry cleaners.

High-Hazard (Group H)
Places involving production or storage of highly flammable or toxic materials and explosives, including fireworks, hydrogen peroxide, and cyanide.

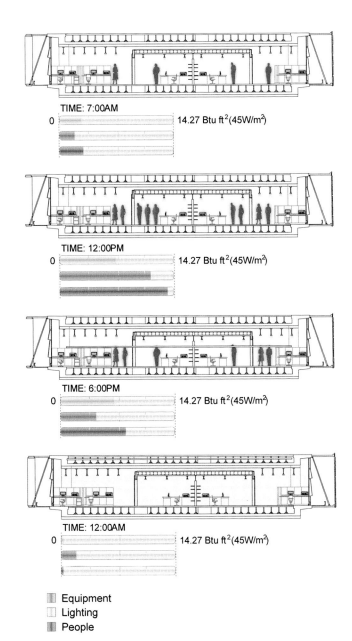

Fig. 4.1-3 Example of Building Thermal Loads for a Single Day

4. Climate Control

Institutional (Group I)
Places where people are physically unable to live without assistance, including hospitals, nursing homes, and prisons.

Mercantile (Group M)
Places where goods are displayed and sold, including grocery stores, department stores, and gas stations.

Residential (Group R)
Places providing accommodations for overnight stay (excluding Institutional), including houses, apartment buildings, hotels, and motels.

Storage (Group S)
Places where items are stored (unless considered high-hazard), including warehouses and parking garages.

Utility and Miscellaneous (Group U)
Water towers, barns, towers.

Psychrometrics/Thermal Comfort

One of the main goals of building design is to provide comfortable indoor spaces for living and working. All indoor environments should be designed and controlled to assure thermal comfort, air quality, safety and health for the occupants.

HUMAN BODY The human body has the capacity for regulating its temperature between 98°F (36.6 °C) and 100°F (37.8 °C). This presumes a nude body and dry air. The external heat transfer mechanisms for the human body include radiation, conduction, convection, and evaporation of perspiration. However, these processes are not passive operations. The human body takes a very active role in regulating its temperature. During physical activity, the human body produces waste heat, and the amount is mostly a function of the activity being performed. The following list represents environmental conditions in which the human body can dissipate heat and remain at comfort:

- Air temperature range of 68°F to 78°F (20°C–25°C).

- Relative humidity range of 20 to 80 percent in the winter and 20 to 60 percent in the summer.

- Air velocity range of 20 to 60 feet per minute (0.1 to 0.3 meters per second).

PSYCHROMETRIC CHARTS Climate analysis with weather data files is the initial step for any climate-responsive design and evaluation of sustainable strategies. Psychrometric charts show designers a variety of graphical representations of hourly climate data for a chosen location. These charts visually demonstrate the unique patterns and subtle details that characterize various climatic conditions. Without the help of these charts, valuable information could be overlooked. The psychrometric charts aid in understanding the relationships between the exterior environment and the required indoor conditions for the occupants' thermal comfort. They also help to identify passive and active strategies for space conditioning while matching the thermal comfort zone requirements to the building codes. The distribution of heating and cooling degree days, daily or hourly air temperatures, dew point temperature, and

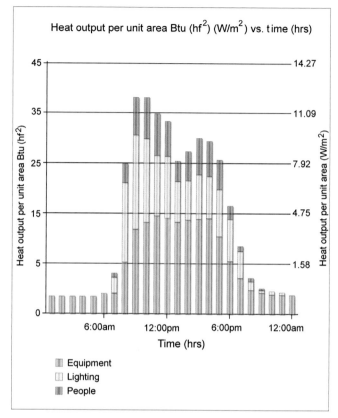

Fig. 4.1-4 *Approximate Building Thermal Loads for a Single Day*

Source: Manfred Hegger, Matthias Fuchs, Thomas Stark and Martin Zeumer, Energy Manual: Sustainable Architecture, Detail Edition, (Basel: Birkhäuser, 2008)

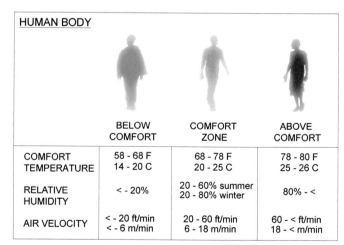

Fig. 4.1-5 *Average Temperature Regulation of the Human Body*

Concepts

relative humidity changes over an entire year can be shown by plotting the climatic data in a psychrometric chart with a determined thermal comfort zone defined by a particular building code.

THERMAL COMFORT STANDARDS Current thermal comfort standards, such as the International Standard Organization for Standardization (ISO) 7030 and the American National Standard Institute/American Society of Heating, Refrigerating and Air-Conditioning Engineers (ANSI/ASHRAE) Standard 55-2011, specify a thermal comfort zone by representing the optimal range and combinations of the thermal factors listed to the right:

- air temperature
- radiant temperature
- air velocity
- humidity
- personal factors
- clothing
- activity level

With these factors in the optimal range, a minimum of 80 percent of the predicted mean vote (PMV) of the building occupants are expected to express satisfaction.[2]

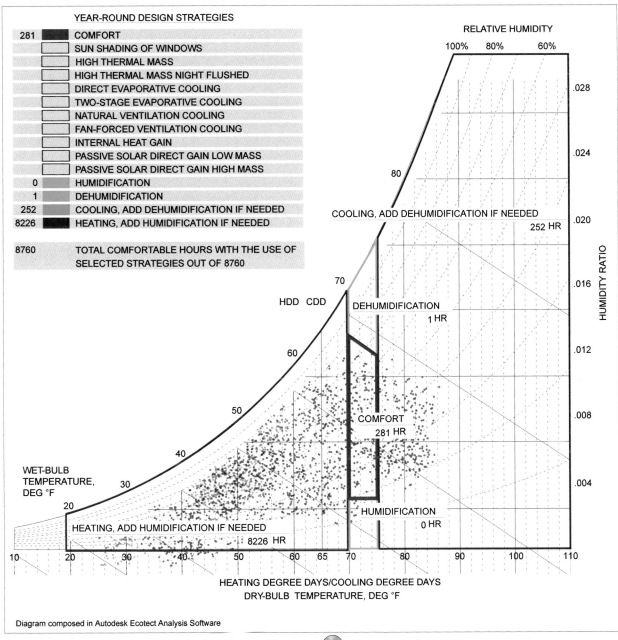

Fig. 4.1-6 Psychrometric Chart with Comfort Strategies for Minneapolis, MN

4. Climate Control

Heat Forms

A significant portion of energy consumption and discomfort in buildings is a result of unwanted heat exchange through the envelope. The analysis of heat exchange through building envelopes requires an understanding of heat forms and heat exchange mechanisms. The following sections present some essential concepts for explaining the interaction of the building skin with the exterior environment.

LATENT HEAT Latent heat is the amount of required energy to change the physical state of a material (i.e, solid, liquid, or gas) without changing its temperature. In other words, latent heat is the amount of energy absorbed or given-off when a material changes its state. Because this form of heat does not cause a change in temperature, it cannot be measured with a thermometer. Latent heat can be used to provide evaporative cooling in buildings.

SENSIBLE HEAT Sensible heat is the amount of heat energy required to change a material's temperature without changing its physical state. Because sensible heat results in changing the material temperature, it can be sensed or measured by a thermometer.

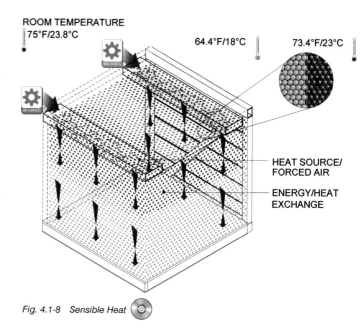

Fig. 4.1-8 Sensible Heat

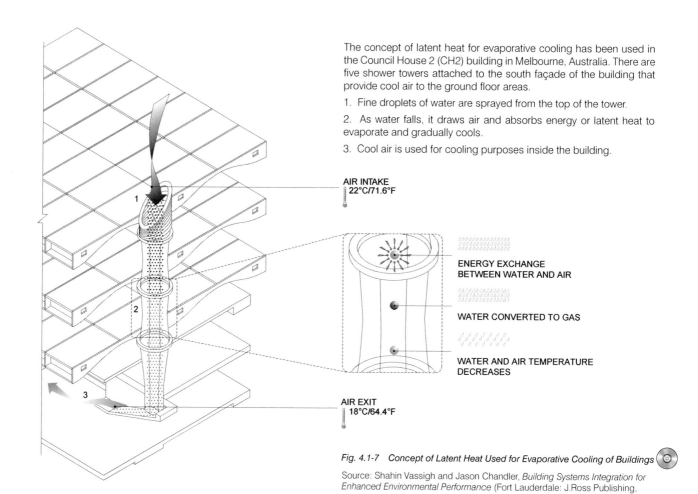

The concept of latent heat for evaporative cooling has been used in the Council House 2 (CH2) building in Melbourne, Australia. There are five shower towers attached to the south façade of the building that provide cool air to the ground floor areas.

1. Fine droplets of water are sprayed from the top of the tower.

2. As water falls, it draws air and absorbs energy or latent heat to evaporate and gradually cools.

3. Cool air is used for cooling purposes inside the building.

Fig. 4.1-7 Concept of Latent Heat Used for Evaporative Cooling of Buildings

Source: Shahin Vassigh and Jason Chandler, *Building Systems Integration for Enhanced Environmental Performance* (Fort Lauderdale: J.Ross Publishing,

Concepts

Heat Flow

Heat flows from the material with a higher temperature to the material with the lower temperature, often leading to a temperature reduction in the hotter material and a gain in temperature of the cooler material. However, there are some materials that can absorb heat without a significant change in their temperature (referred to as phase-change materials). All building materials, including structures and the envelope systems, transfer heat by one or a combination of the following three mechanisms:

CONDUCTION Conduction is the process of heat transfer in a material from a high-temperature region to a lower-temperature region through direct interaction and collision between adjacent molecules. The ability of a material to transfer heat is called thermal conductivity. Some metals such as copper have good thermal conductivity. Poor conductors are called insulators.

RADIATION Radiation is the transfer of heat from a heat source by electromagnetic waves. Heat transfer by radiation does not require contact between the heat source and the heated material. The most common form of electromagnetic long wave is the infrared heat radiated by the sun.

CONVECTION Convection is the flow of heat through a moving stream of liquid or gas. Convection occurs when higher-temperature areas of a liquid or gas rise to the areas with lower temperatures. As lower-temperature gas or liquid moves to take the place of the high-temperature areas, a current is created. An example of convection is the movement of air due to the temperature difference in a room, which is often used as a passive strategy to ventilate and cool buildings.

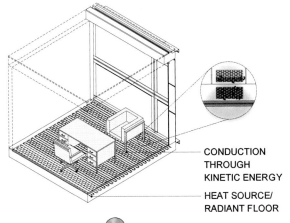

Fig. 4.1-9 Conduction

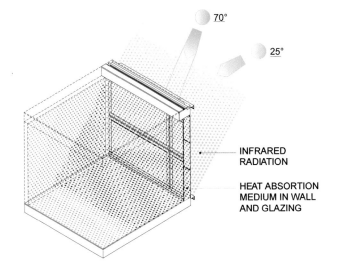

Fig. 4.1-10 Radiation

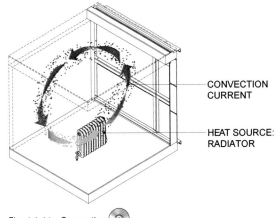

Fig. 4.1-11 Convection

99

4. Climate Control

Carbon-Neutral Design

Carbon-neutral design or carbon neutrality is a general term referring to a building achieving zero net energy consumption and zero carbon emissions. However, a common global definition for carbon-neutral buildings, or a standardized method to benchmark all resource inputs and outputs of a building, is still deficient. Carbon neutrality with respect to operational energy means that no fossil fuel, greenhouse gases, or hazardous-emitting energy sources are used to operate the building. Building operation includes heating, cooling, electrical lighting and appliance use and service energy. Carbon-neutral design can be accomplished by implementing innovative design strategies, generating on-site renewable power, purchasing renewable energy, and utilizing certified renewable energy credits.

Carbon neutrality is also based on embodied energy. As buildings become more energy efficient, the ratio of the embodied energy to the lifecycle of the building become more important. Clearly, for green buildings aiming to be "carbon neutral," "zero-fossil-energy" or "autonomous," the energy used in construction, operation and maintenance, and final disposal, reuse, or recycling, takes on a new significance.

SUSTAINABLE BUILDINGS There are many definitions for a sustainable or a green building. The most common understanding refers to buildings that are environmentally responsible and resource efficient throughout their life cycle. This includes the entire design process and the building life cycle, beginning from site selection to design, construction, operation, maintenance, renovation, deconstruction, reuse, and recycling of the building components. This practice expands the standard building design concerns significantly. Although new technologies are constantly developing to advance current practices for achieving sustainable building design, the common objective is to reduce the impact on the built environment and human health while providing comfort for building occupants.

LOW-ENERGY BUILDINGS Low-energy buildings utilize low-energy design strategies for space heating and cooling to keep the energy consumption of the building in the approximate range of 6,300 to 15,850 Btu/ft²/yr (20kWh/m²/yr to 50kWh/m²/yr) for residential buildings.[3] The energy required to operate and provide comfort for the occupants of low-energy buildings is often provided by renewable on-site energy production or through purchasing renewable energy from the public energy grid. Worldwide, national standards for low-energy buildings vary considerably. A low-energy building in one country may not meet the standards in another country.

PASSIVE HOUSE Originated in 1988 in Sweden and Germany, the term "passive house" refers to the rigorous Passivhaus Standard for energy efficiency with highly insulated buildings, solid-state lighting (LEDs), and energy efficient appliances. Passive house is an ultra-low-energy building that requires little energy for space heating or cooling. Since 1994, a comparable standard, called MINERGIE-P, has been used in Switzerland. The standard is not confined to residential properties alone, other buildings such as office buildings, schools, kindergartens, and supermarkets are also constructed to the standard. In a passive house, the passive strategies represent an integrated design process utilizing approaches such as optimal building orientation to harness natural resources, high insulation standards, phase-changing materials, etc.

Heat gain from internal sources such as radiated heat from electrical appliances, lighting, and body heat play an important role in passive buildings. Heat gain can be collected and utilized as an energy source through heat energy recovery and heat pump systems for both cooling and heating in different zones. This approach has been mostly practiced in new buildings, but conservation techniques with new insulation and heat energy-recovery systems are increasingly used for energy efficient retrofitting of the existing building stock. Estimates on the number of passive houses around the world range from 15,000 to 20,000 as of December 2009 with the majority built in German-speaking countries and Scandinavia, as well as some in the U.S.[4]

Concepts

LOW-ENERGY BUILDING FOR HOT AND HUMID CLIMATES
Example Location: Miami
Latitude: 25°46'26.004" N
Longitude: 80°11'38.004" W

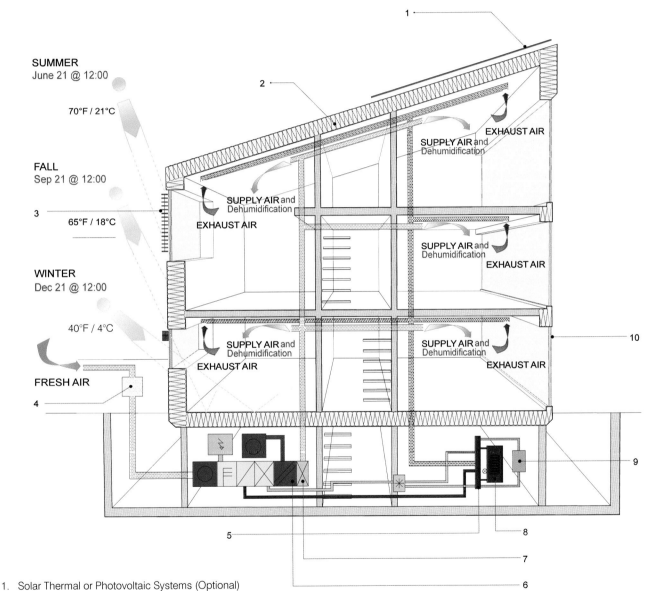

1. Solar Thermal or Photovoltaic Systems (Optional)
2. Low-Energy Insulation: U≤0.28 R≥20
3. Operable Daylight Shading Systems
4. Air Intake with Filter
5. Heat Energy Recovery Systems
6. Summer-Air-Cooling/Dehumidification
7. Air Handling Unit
8. Boiler/Warm Water Tank with Heat Energy Recovery
9. Combined Heat and Power
10. Double-Low-E-Glazing: U≤1.1 W/m²K R≥5.3

Fig. 4.1-12 Low-Energy Building for Hot and Humid Climates

4. Climate Control

PASSIVE HOUSE FOR HOT AND HUMID CLIMATES
Example Location: Miami
Latitude: 25°46'26.004" N
Longitude: 80°11'38.004" W

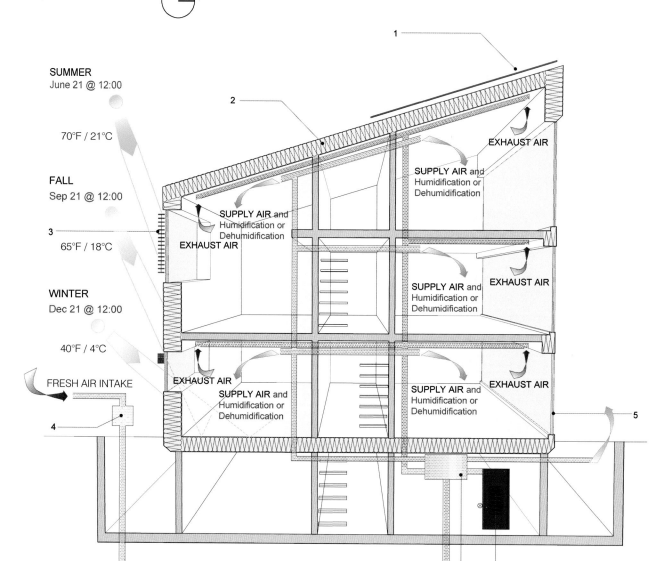

1. Solar Thermal or Photovoltaic Systems (Optional)
2. Super Insulation: $U \leq 0.11$ W/m^2K $R \geq 50$
3. Daylight Shading Systems
4. Air Intake with Filter
5. Operable 3-Pane Low-E Glazing: $U \leq 0.7$ W/m^2K $R > 8$
6. Boiler/Warm Water Tank with Heat Energy Recovery
7. Air-to-Air Heat Exchanger or Heat Energy Recovery System

Fig. 4.1-13 Passive House for Hot and Humid Climates

Concepts

ZERO-FOSSIL-ENERGY BUILDINGS A zero-fossil-energy building or a zero-net-energy building offsets its annual energy consumption from utility sources by emission-free renewable energy sources (such as solar, wind, biomass, hydroelectric, and geothermal). During the operation of these buildings, greenhouse gas emissions released into to the environment are minimized or eliminated.

Because buildings are one of the largest consumers of energy and significant contributors to the climate change, moving toward zero-net-energy buildings as the standard practice in building design has become a global agenda. In November 2009, the European Parliament, the Council of the European Union, and the European Commission made an agreement on the recast of the Energy Performance of Building's Directive (EPBD) to make it mandatory that all new buildings in the European Union must become nearly zero-fossil energy by 2020. In the United States, the voluntary American Institute of Architects (AIA) 2030 challenge aims to reduce fossil fuel consumption for all new buildings by 90 percent in 2025 and become carbon-neutral by 2030. This goal can be accomplished through innovative design strategies, highly insulated buildings, solid-state lighting (LED), energy-efficient appliances, and application of on-site renewable technologies.

PLUS-ENERGY BUILDINGS A plus-energy building, or energy-plus-building, produces on average more energy from renewable on-site or integrated building energy sources than it consumes during its operation in a year. The harnessed annual energy surplus, achieved by using appropriate strategies and innovative technologies, is sold to the public infrastructure grid. Passive solar building design, high insulation, very low U-values for the entire building envelope, efficient daylighting, natural ventilation systems, energy-heat recovery systems, careful site selection and orientation to capture available natural resources are among the plus-energy building techniques.

Most often a combination of renewable, energy generation systems, super-insulation systems, triple glazing and advanced phase-changing materials, solid-state lighting, and energy efficient appliances are also utilized to achieve a plus energy building. The styles of built plus-energy buildings around the world are almost indistinguishable from traditional architecture, since they simply use the most energy-efficient solutions. Plus-energy buildings can be designed, constructed, and operated in any climatic zone.

4. Climate Control

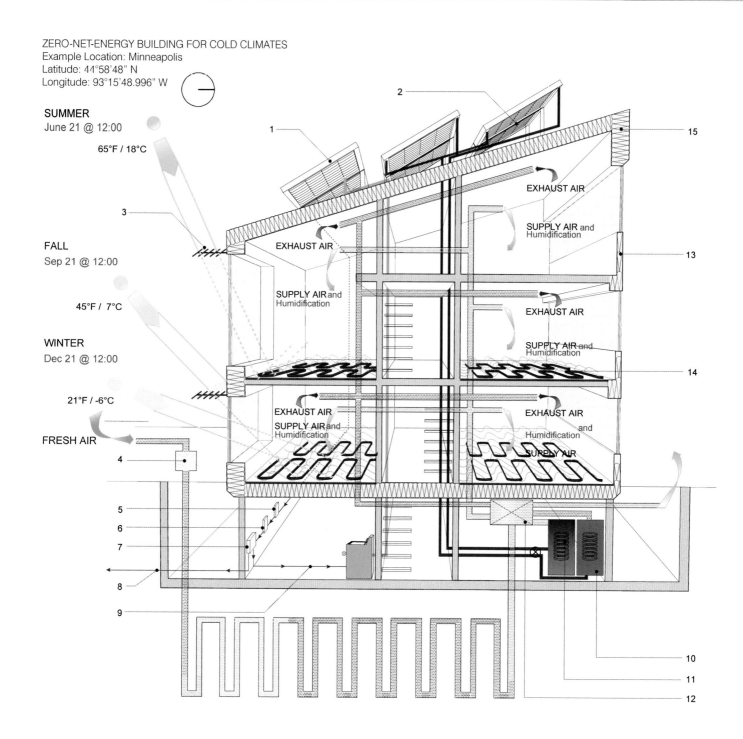

ZERO-NET-ENERGY BUILDING FOR COLD CLIMATES
Example Location: Minneapolis
Latitude: 44°58'48" N
Longitude: 93°15'48.996" W

SUMMER
June 21 @ 12:00
65°F / 18°C

FALL
Sep 21 @ 12:00
45°F / 7°C

WINTER
Dec 21 @ 12:00
21°F / -6°C

FRESH AIR

1. Photovoltaic Systems
2. Solar Thermal
3. Adjustable Photovoltaic Shades
4. Air Intake with Filter
5. Inverter AC/DC
6. Photovoltaic Generation Meter
7. Main Fusebox
8. Public Energy Grid
9. Lights and Appliances
10. Chilled Water Cooling Tank
11. Warm Water Heating Tank
12. Air-to-Air Heat Exchanger or Heat Energy Recovery System
13. Operable 3-Pane Low-E Glazing
14. Radiant Heating
15. Air-Tight Envelope with Super Insulation: U≤0,15 W/(m2K) R>50

— Photovoltaic Wiring
— Solar Thermal Cold Water Suppy Pipe with Glycol
— Solar Thermal Hot Water Return Pipe with Glycol

Fig. 4.1-14 Zero-Net-Energy Building for Cold Climates

Concepts

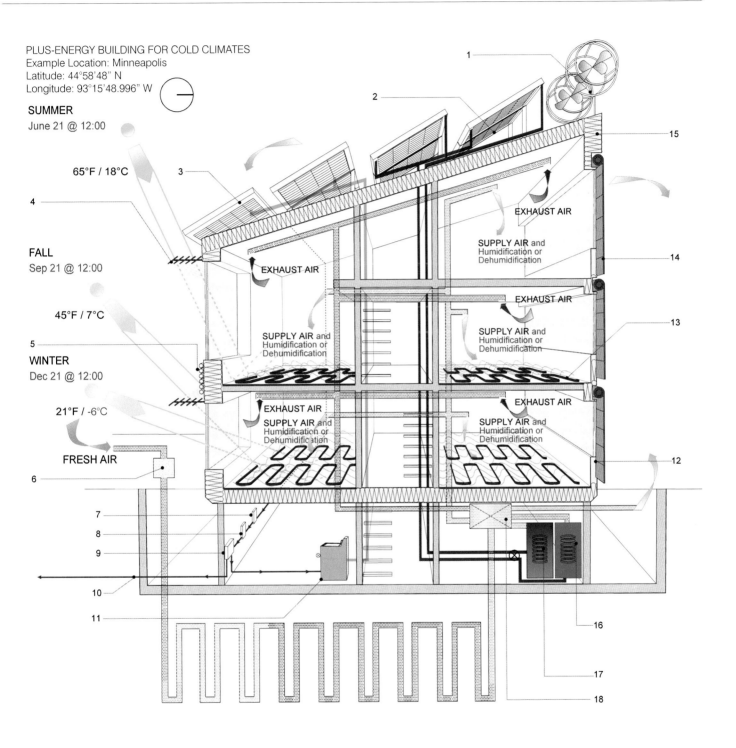

PLUS-ENERGY BUILDING FOR COLD CLIMATES
Example Location: Minneapolis
Latitude: 44°58'48" N
Longitude: 93°15'48.996" W

SUMMER
June 21 @ 12:00

65°F / 18°C

FALL
Sep 21 @ 12:00

45°F / 7°C

WINTER
Dec 21 @ 12:00

21°F / -6°C

FRESH AIR

1. Aeroturbine Energy Generator
2. Solar Thermal
3. Photovoltaic Systems
4. Adjustable Photovoltaic Shades
5. Solar Vacuum Collectors
6. Air Intake with Filter
7. Inverter AC/DC
8. Photo Volteic Generation Meter
9. Main Fuse Box
10. Public Energy Grid
11. Lights and Appliances
12. Operable 3-Pane Low-E Glazing: U≤0.7 W/m²K R>8
13. Radiant Heating
14. Operable Shutters
15. Air-tight Envelope with Super Insulation: U<0.11 W/(m2K) R>50
16. Chilled Water Cooling Tank
17. Warm Water Heating Tank
18. Air-to-Air Heat Exchanger or Heat Energy Recovery System

— Photovoltaic Wiring
— Solar Thermal Cold Water Suppy Pipe with Glycol
— Solar Thermal Hot Water Return Pipe with Glycol

Fig. 4.1-15 Plus-Energy Building for Cold Climates

4. Climate Control

4.2 Passive Systems

Because the energy conservation and sustainability of the built environment are rising to the top of the global agenda, passive building design presents an increasingly viable alternative for the building and construction industry. Passive design strategies utilize various forms of solar energy to augment or replace fossil fuels. In addition, passive design strategies employ sustainable methods to conserve energy through the use of proper materials, construction methods, and advanced technologies.

Natural Systems

A passive approach to building design takes advantage of natural systems to ventilate, daylight, and heat or cool buildings, thus eliminating the requirements for active mechanical systems and fossil fuel-based energy consumption. Passive design strategies are most effective when they are incorporated at the early stages of design because they impact building form, orientation, and space distribution. When buildings are completely adapted to the natural environment and are optimized for harnessing sun, wind, air, and landscape elements, their overall environmental performance is improved and the energy demand for operation and maintenance of the building is significantly diminished.

SUN Building orientation with respect to the position of sun is a significant factor in passive design. Sunlight can provide heat and daylight and thus reduce the need for artificial lighting and active heating. Passive solar design involves the knowledge of solar geometry, window technology and local climate. Solar geometry can be described by solar azimuth, which is the angle from due north, and solar altitude, which is the angular height of the sun measured from the horizon. Hourly solar altitude and azimuth are plotted on annual solar charts for different latitudes and longitudes. These plots can serve as effective tools in optimizing the building's orientation for passive design in various climatic regions.

LIGHT Using natural light for illumination of the building's interiors reduces the need for artificial lighting, minimizes building cooling load, diminishes glare, and provides visual comfort. There are a number of architectural strategies to channel and direct natural light to the building interior. When these strategies are integrated with building management systems and sensor technologies, they can reduce the energy requirement for electric lighting even more. For a detailed review of lighting concepts and strategies refer to Natural Lighting (Section 6.2).

AIR/WIND Air temperature and wind patterns are key elements for sustainable design. Air and wind can be utilized to provide natural ventilation and passive cooling, thus reducing energy demand. To provide adequate cooling and ventilation, it is important to consider the building's shape, orientation and the climatic conditions. For more information on natural ventilation in buildings, refer to Building Form (Section 1).

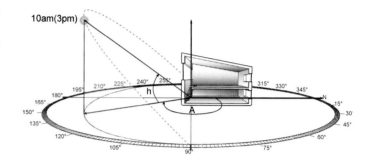

h= ELEVATION ANGLE: MEASURED UP FROM THE HORIZON
A = AZIMUTH ANGLE: MEASURED CLOCKWISE FROM NORTH

Fig. 4.2-1 Building Orientation with Respect to the Sun's Position

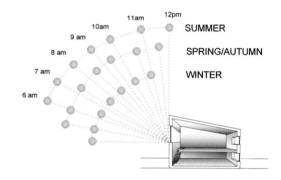

Fig. 4.2-2 Typical Sun Path in Hot and Humid Climatic Zones

Passive Systems

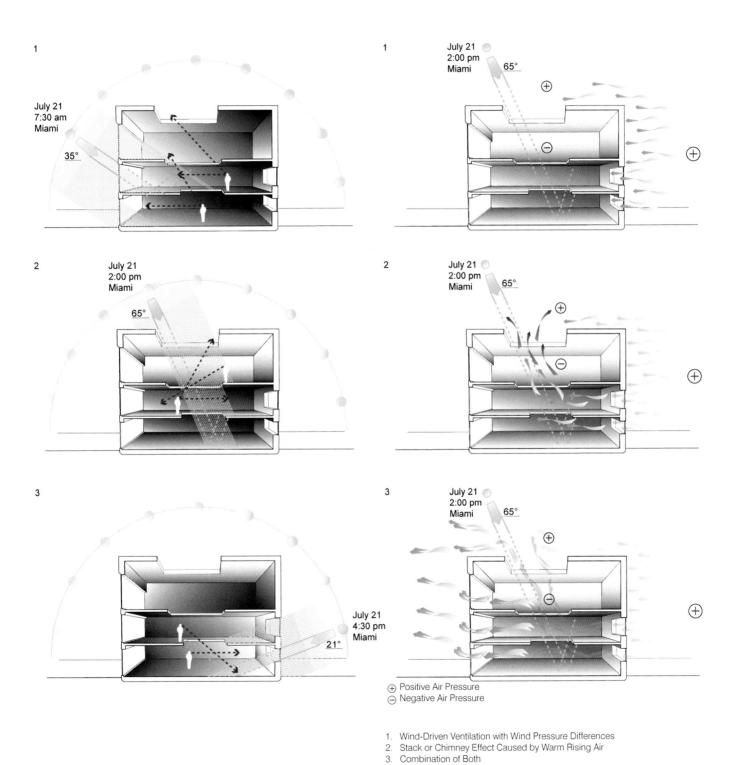

⊕ Positive Air Pressure
⊖ Negative Air Pressure

1. Wind-Driven Ventilation with Wind Pressure Differences
2. Stack or Chimney Effect Caused by Warm Rising Air
3. Combination of Both

Fig. 4.2-3 Natural Lighting Strategies Based on Miami's Sun Path *Fig. 4.2-4 Passive Ventilation in a Building*

4. Climate Control

LANDSCAPE Integrating landscape elements and systems can also lower energy demand and contribute to the overall health of the natural environment. Landscape elements improve air quality, contribute to the indoor and outdoor thermal comfort, and passively regulate air temperatures. A thoughtful selection of plant materials can create a natural screen to shield buildings from solar radiation and protect them against wind and precipitation. A green roof creates a natural insulation layer on the building, contributes to waterproofing and traps sound. The use of hydrologic landscape systems such as bioswales or constructed wetlands helps to filter, store and reuse water, thereby protecting and restoring the existing hydrology. A detailed discussion of landscape design strategies is addressed in Landscape (Section 7).

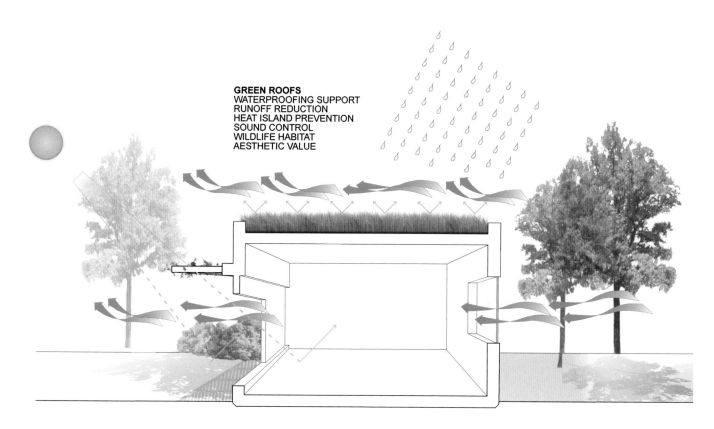

Fig. 4.2-5 General Considerations for Landscape/Building Integration

Passive Systems

 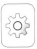

Solar Heating

Passive solar heating is achieved by positioning a building to harness, store, and distribute solar energy. The best orientation for capturing direct solar radiation is achieved by aligning the building's long axis in the east-west direction. This orientation maximizes the building's southern exposure and takes advantage of the low sun angles in the winter. Placing large glazed openings on the south façade will facilitate sun penetration into the interior space. Using roof overhangs, or other shading devices to block high sun angles in the summer months, can protect against overheating. In general, passive solar heating strategies rely on direct gain, indirect gain and isolated gain.

DIRECT GAIN Direct heat gain is the simplest form of passive heating. Direct heat gain utilizes south-facing windows or skylights to allow solar radiation to directly enter the zones to be heated.

Heat is stored by the building's mass, with materials such as concrete or masonry, and is released over time. To avoid overheating of the space during the summer months, adaptable shading devices can be used.

INDIRECT GAIN Indirect gain systems provide space heating through radiation, conduction, and convection. Indirect gain may be achieved by utilizing glazing elements with high thermal storage capacity. These glazing elements are designed to capture and store a large fraction of indirect radiation for subsequent release into the adjoining occupied space. Indirect gain can also be achieved by utilizing the mass of the wall material to hold and release heat over time. When walls are used to provide thermal storage, the indirect gain system is called a solar, a trombe or a mass wall.

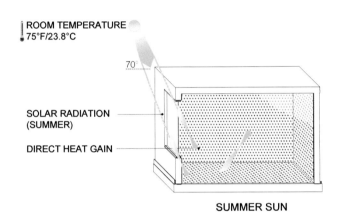

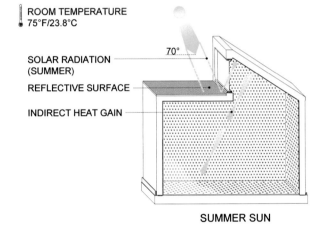

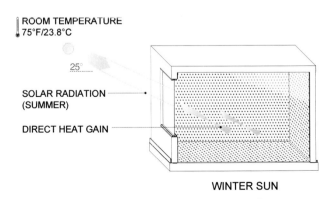

Fig. 4.2-6 Direct Heat Gain from South-Facing Glazing

Fig. 4.2-7 Indirect Heat Gain Glazing with Thermal Storage Capacity

4. Climate Control

ISOLATED GAIN Isolated gain systems are based on a thermal separation of the occupied area from solar heating and storage. The most commonly used isolated gain system is a sunroom. Sunrooms utilize thermal mass such as concrete or masonry for the walls and floors to absorb and store heat during the day. At night, the released heat can be distributed through openings such as vents, windows and doors. Sunrooms are most effective when they are well insulated.

Passive Cooling

Passive cooling design strategies utilize natural air and wind patterns to reduce energy consumption in buildings. These design strategies are significantly dependent on both regional and microclimates. The regional climatic data can be accessed and plotted on bioclimatic charts. Analyzing these data and charts will assist the designers to identify suitable strategies for a particular climatic zone. In addition to the regional climate, the microclimate surrounding a building is an important determinant of the cooling strategies. A building's microclimate may receive more sun, shade, wind, rain, snow, moisture, or dryness than the average local or regional conditions. If the building is located on a sunny southern slope, it may have a warmer microclimate, even if the larger regional context has more heating degree days than cooling degree days (refer to Climate Control, Concepts, Section 4.1). If the site is in a hot and humid region, the building may be situated in a comfortable microclimate because there is abundant shade and dry breezes. Nearby bodies of water could increase the site's humidity or decrease its air temperature. In general, microclimatic factors are another indicator of how air temperature and wind velocity change. They designate which cooling strategies might be successful.

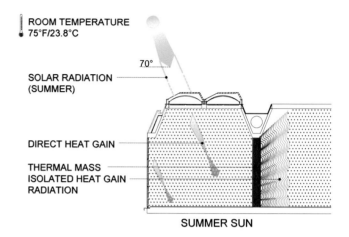

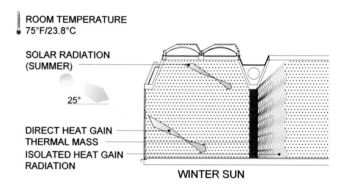

Fig. 4.2-8 Isolated Heat Gain

Passive Systems

CROSS-VENTILATION Natural cross-ventilation occurs when pressure differences to move fresh air from the cooler exterior environment through the building, carrying out the warmer interior air. Pressure differences can be the result of wind or the buoyancy effect created by temperature and humidity differences. In either case, the amount of ventilation will depend on the size and placement of openings and outlets in buildings. Openings between rooms such as transom windows, louvers, grills, clerestories, or open plans are vehicles to complete the airflow circuit through a building.

STACK VENTILATION Similar to cross-ventilation, stack ventilation capitalizes on temperature differences between the interior and exterior of the building. Stack ventilation can be achieved by placing a low and a high opening within the space to create a natural flow. When the interior air is warmer than the exterior air, warm air rises and is replaced by cooler exterior air entering the space through the lower opening. The higher the location of the exhaust opening, the greater the temperature difference it creates, resulting in more effective ventilation.

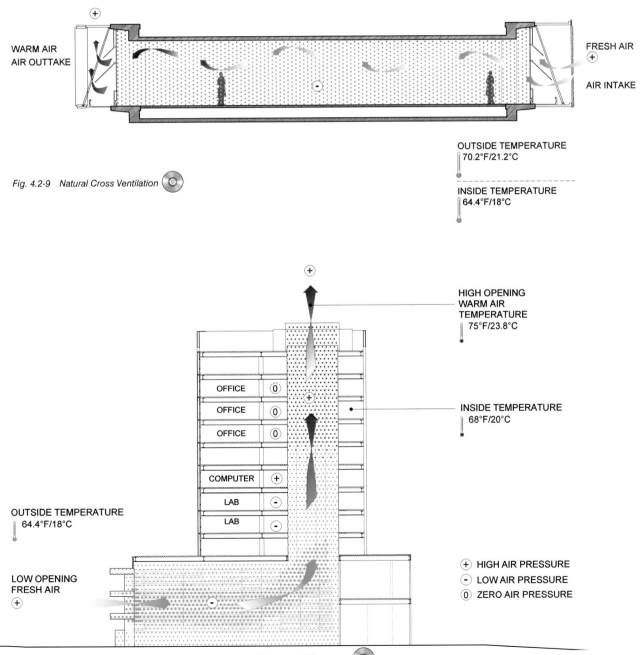

Fig. 4.2-9 Natural Cross Ventilation

Fig. 4.2-10 Stack Ventilation through Thermo Dynamics and Pressure Differences

4. Climate Control

THERMAL MASS COOLING WITH NIGHT VENTILATION Thermal mass cooling with night ventilation is an effective cooling strategy in climates where there is a significant change of temperature between days and nights. This strategy utilizes the mass of the building elements, such as floors, walls, and ceilings, to absorb heat during the day and slowly release it at night. At night, when the temperatures are much cooler, opening windows or vents will admit cool fresh air into the building and remove the released heat from the thermal mass to the exterior of the building. The thermal mass will be cooled and ready to absorb heat in the morning.

Courtyard-type buildings can use this cooling strategy effectively when the building floors and roofs can be protected with movable shading devices during the day that can be opened at night. The building can switch from a thermally closed condition by day to exclude sun and hot outdoor air, to an open condition at night to allow ventilation to cool the mass.

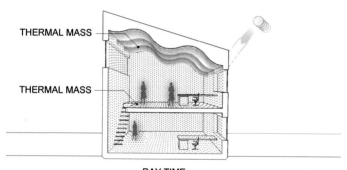

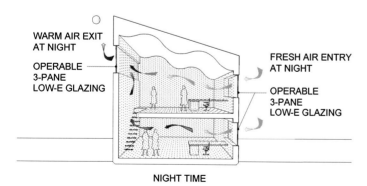

Fig. 4.2-11 Thermal Mass Cooling with Night Ventilation

Passive Systems

EVAPORATIVE COOLING Evaporative cooling is a climate control strategy used in hot and dry climates. Its operating principle is based on the same natural cooling that occurs near waterfalls and other bodies of water. When dry air comes in contact with water, the water is evaporated. The exchange of energy from liquid water to gas, or evaporation, leads to a drop in temperature.

Evaporative cooling in buildings is often achieved by producing a downdraft of cool air through dropping water from the top of a tower. As the water falls and draws air, it consumes energy to evaporate and it gradually cools, thus cooling the surrounding air. The cool and humid air at the base of the tower can be directed and utilized for cooling.

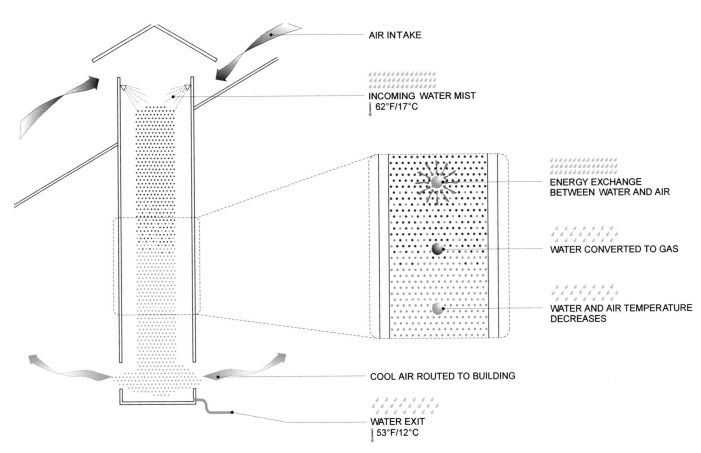

Fig. 4.2-12 Evaporative Cooling

4. Climate Control

Phase-Change Materials

Although phase-change materials (PCMs) are relatively new to the building industry, their use is rapidly increasing. PCMs are utilized in building construction because of their thermal capacity for storing latent and sensible heat. Incorporating PCMs into construction materials, such as concrete, plaster, gypsum board and other building enclosure materials, is an effective passive strategy to reduce the building's thermal load.

PCMs change their physical state or phase under small temperature changes; however, their phase change absorbs or releases significant amounts of heat. For example, when the ambient temperature rises, PCMs change from solid to liquid while absorbing heat. As the ambient temperature decreases, the material solidifies releasing heat energy back into the environment. The temperature of the material stays almost constant during the melting and solidification process. There are three types of PCMs: organic, inorganic and eutectic.

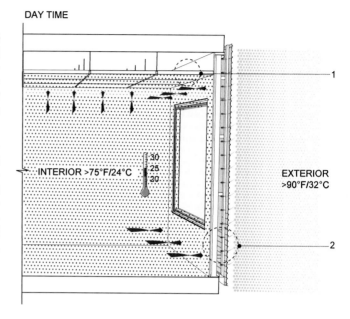

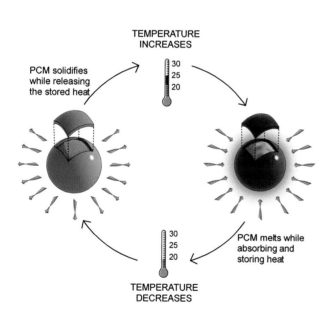

Fig. 4.2-13 Phase-Change Material (PCM) Behavior

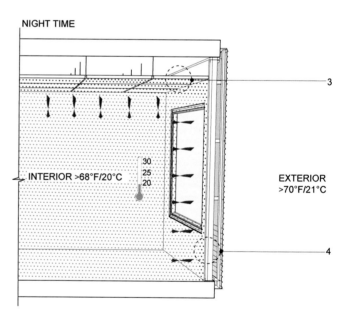

1. PCM (salt hydrate in liquid form) mounted in the ceiling, stores heat when ambient temperature increases.

2. Embedded PCM (paraffin) in the wall stores heat when ambient temperature increases.

3. PCM (salt hydrate in liquid form) mounted in the ceiling, releases the stored heat when ambient temperature drops.

4. Embedded PCM (paraffin) in the wall releases heat when ambient temperature drops.

Fig. 4.2-14 PCM Thermal Storage Behavior in Buildings

Passive Systems

ORGANIC PCM Organic PCMs consist of noncorrosive, chemically stable compounds with a high latent heat per unit weight. Organic PCMs are comprised of paraffin, fatty acids and polyalcohol. Paraffin is one of the most promising PCM because of its thermal storage capacity and its low cost. Paraffin can be incorporated in building materials such as plasters and gypsum boards. It can be securely encapsulated in a plastic shell and evenly spread in the building material.

INORGANIC PCM Inorganic PCMs include salt hydrates, salts, metals and alloys. Inorganic PCMs consist of nonflammable compounds with a higher latent heat per unit mass and volume when compared to organic PCM. They can also be encapsulated and placed in building components such as ceiling panels. Inorganic PCM decompose over time and can lose their phase-change properties.

EUTECTIC PCM Eutectic PCMs are comprised of a mixture of organic and inorganic compounds. Eutectic PCMs consist of nontoxic salts and materials with freezing temperatures above 32 degrees Fahrenheit (zero degrees Celsius). The freezing and melting points of eutectic PCM can be customized by adjusting the percentages of the mixing compounds. For example, eutectic PCM is used in the Council House 2 Building (CH2) located in Melbourne, Australia. The PCM is stored in 4-inch-diameter (100-mm) metallic balls in three tanks holding a total of 30,000 balls. Chilled water is added to the tanks, freezing the PCM, where it is stored for use when required.

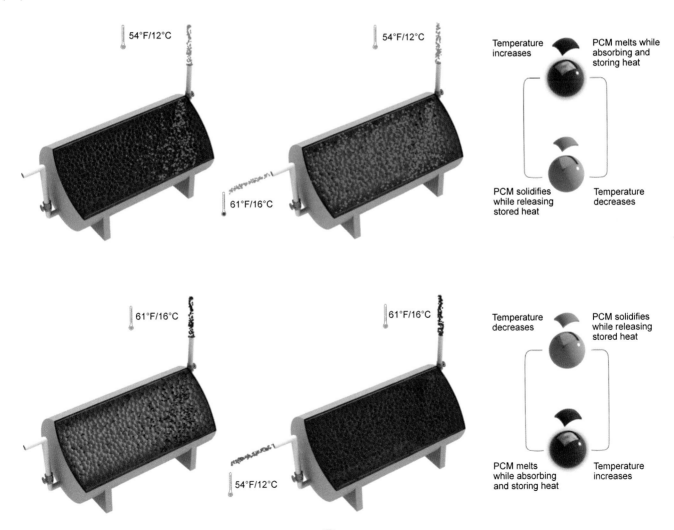

Fig. 4.2-15 Storage Mechanism with the Use of Eutectic PCM Filled Tanks

4. Climate Control

4.3 Active Systems

Heating, ventilation and air conditioning (HVAC) refers to the equipment, distribution network and terminal units utilized to control temperature, humidity, ventilation, filtration, and air movement in the occupied space. Ideally, on-site integrated building mechanical systems or active systems are required when all the passive design strategies utilized to reduce the internal building loads and operation loads are optimized and exploited. Building systems that embody both passive and active characteristics are often called hybrid systems. Hybrid systems are engineered to achieve the highest resource use and energy efficiency.

Space Conditioning

Space conditioning involves the processes of heating, cooling, and ventilating to maintain indoor air quality and provide thermal comfort. HVAC systems should provide adequate fresh air, humidity control, air-quality control, heating and cooling based on the thermal loads within a building and the exterior ambient conditions. Space conditioning equipment generally consists of boilers, furnaces, air-handling units, chillers and heat pumps. The selection of HVAC equipment for buildings involves a complex design decision that comprises a wide range of factors, including heating and cooling needs, humidity control, air quality, energy efficiency, codes, standards, life cycle and cost. Before selecting the HVAC equipment, a detailed, preliminary thermal load calculation must be conducted.

THERMAL LOADS Thermal loads on a building incorporate the impact of all external and internal factors, including building occupancy and climatic conditions. Thermal load calculations are conducted to determine the type and size of HVAC systems required to achieve adequate and economical thermal comfort. Thermal loads can be determined through a complex user and appliance demand analysis using energy performance software.

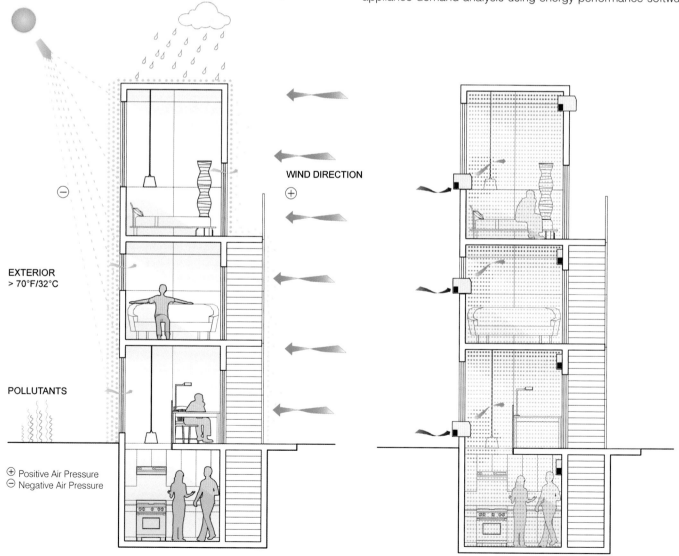

Fig. 4.3-1 Building Thermal Loads

Fig. 4.3-2 Space Conditioning: Mechanical Cooling with Single AC Units

Active Systems

The criteria used for thermal load calculations include the number of people, artificial lighting, and appliances for internal load calculations; activity levels and thermal zoning within the space, building envelope elements such as conductivity and thermal bridges; building configuration and orientation; and year-round microclimatic conditions, including temperature, vapor, humidity, air flows, and air exchange.

COOLING The cooling process consists of the removal of thermal energy or heat from the conditioned space by lowering the temperature or humidity levels of ambient air. Mechanical cooling can be achieved by air conditioners and air-handling units, chillers, evaporative coolers and heat pumps. The temperature and humidity of local climates will impact the amount of mechanical cooling required.

HEATING Heating consists of the addition of thermal energy to the conditioned space to raise or maintain an adequate temperature. Active mechanical heating can be achieved by solar thermal systems with thermal storage tanks, various types of heat pumps and heat energy-recovery systems with boilers or electrical furnaces, air conditioners, and air-handling units. The amount of mechanical heating required is based on the local climatic conditions, the use of passive systems, and available renewable energy sources.

VENTILATING Ventilating is the process that removes or supplies suitable quantities of fresh air to the conditioned space to maintain air quality. Ventilation includes air exchange, filtration, humidification, dehumidification, and air circulation within the building. To minimize the potential of adverse health effects, minimum ventilation and air exchange rates, CO_2 monitoring, energy control, and air-quality control are specified by the American Society of Heating, Refrigerating and Air-Contioning Engineers (ASHRAE) and the International Organization for Standardization (ISO).

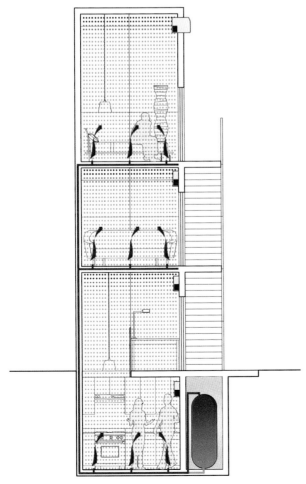

Fig. 4.3-3 Space Conditioning: Under-Floor Radiant Heating

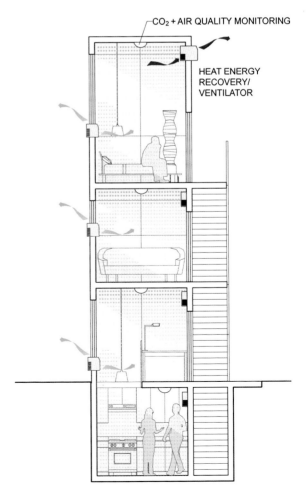

Fig. 4.3-4 Space Conditioning: Decentralized Mechanical Ventilation

4. Climate Control

Distribution Medium

HVAC systems may be classified based on the distribution media used to transfer cooling, ventilation, and heating. The most common carriers of heating, ventilation, and cooling for building applications are air, water and refrigerant. The major categories are refrigerant systems, all-air systems, all-water systems, air-water systems, and thermo active building systems.

REFRIGERANT SYSTEMS Direct refrigerant systems are usually utilized in small to medium-sized spaces or zones that require their own mechanical units. Refrigerant systems eliminate the distribution trees utilized by air or water HVAC systems and rely on a refrigeration machine, operating under the vapor compression refrigeration cycle, and fans adjacent to or within the space they serve. In this system, the refrigeration machine uses a refrigerant fluid that changes state to provide cooling or heating. In the cooling mode, room air is blown over the evaporator coil filled with cold, low-pressure refrigerant. In the heating mode, fresh air is blown over the condenser coils filled with warm, high-pressure refrigerant.

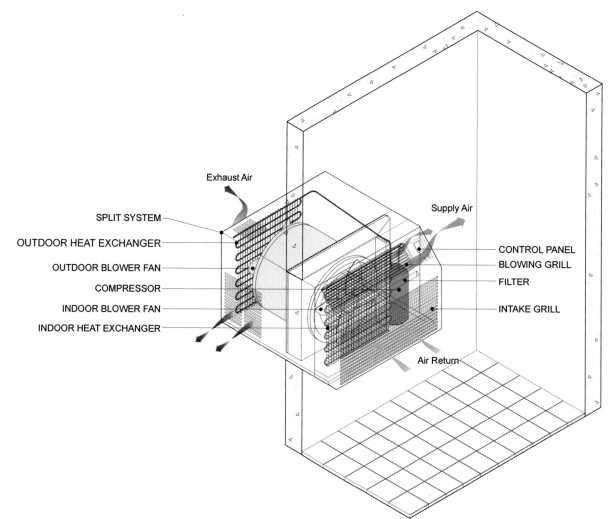

Fig. 4.3-5 Refrigerant System

Active Systems

ALL-AIR SYSTEMS All-air systems utilize air as the only heat transfer medium to provide sensible cooling and heating. In this system, air is moved through central station equipment to be cooled or heated, humidified or dehumidified, and filtered and freshened. Conditioned air is distributed from the central equipment to the zones it serves through distribution trees or ducts. Distribution ducts are generally thick and occupy significant amounts of space within the building when compared to those utilized in water systems or air-water systems with thermo active structural components or thermal mass.

Supply registers provide streams of conditioned air to the zones, while return grilles and a network of return air ducts transport air from the conditioned spaces back to the central equipment. Although the space requirements for ductwork are larger, all-air systems provide comfortable results for local control of zones and air quality because they regulate effectively temperature and humidity. All-air HVAC systems are comprised of an air-handling unit with fans and heat transfer coils to preheat, heat and cool the air passing through them. In addition, they also have filters to clean the air and other equipment to humidify and dehumidify the air.

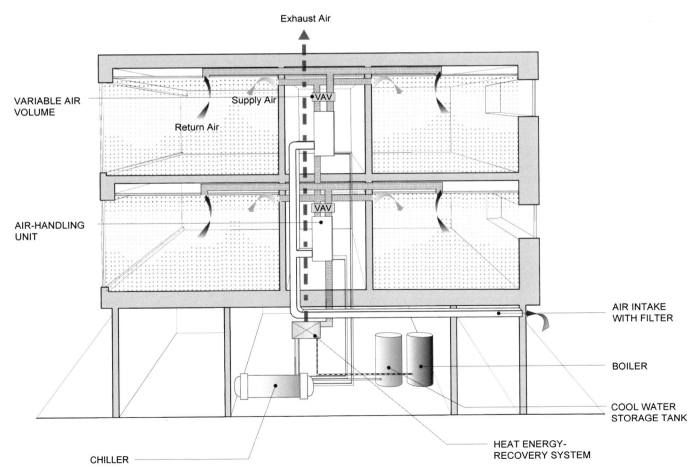

Fig. 4.3-6 *All-Air System*

4. Climate Control

ALL-WATER SYSTEMS All-water systems utilize water as the transfer medium for distributing heating and cooling. They utilize chilled or hot water from a central refrigeration or boiler plant to be distributed to terminal units located within or adjacent to the zones they serve. All-water systems provide radiant or sensible heating or cooling. They require less space for distribution elements because water utilizes much thinner distribution networks than air. Although all-water systems are generally more energy efficient than all-air systems, they deal with temperature control only and require a separate ventilation system and other equipment to control air quality and relative humidity. All-water systems are appropriate when a large amount of ventilation is not required or can be achieved by opening windows for controlled natural ventilation. When coupled with thermo active building systems, the efficiency of all-water systems is significantly improved.

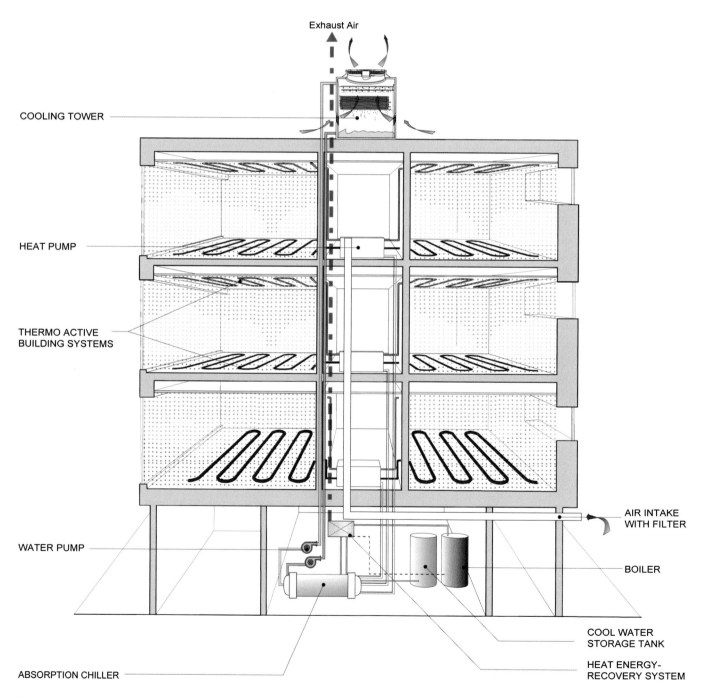

Fig. 4.3-7 All-Water System

Active Systems

AIR-WATER SYSTEMS Air-water HVAC systems utilize several distribution trees, including pipes and ducts that transport water and air to provide heating and cooling. In this system, most of the heating and cooling of each zone is achieved by water, which utilizes much thinner distribution trees that require less space than the ductwork needed by air. Water is heated in a boiler up to a temperature of 250°F (120°C) and is pumped through the heating coil during the heating mode. During the cooling mode, water is cooled by a chiller up to 50°F (10°C) and is pumped through the cooling coil. Conditioned water is pumped and piped to the terminal units which absorb or extract thermal energy. Air quality is accomplished via a separate central station that filters and humidifies or dehumidifies the total fresh air required. Exhaust air may be exhausted locally or it can be gathered in a return air duct system with an integrated heat energy-recovery system. Although there are several distribution trees required, air-water systems utilize less space than that required by all air-systems.

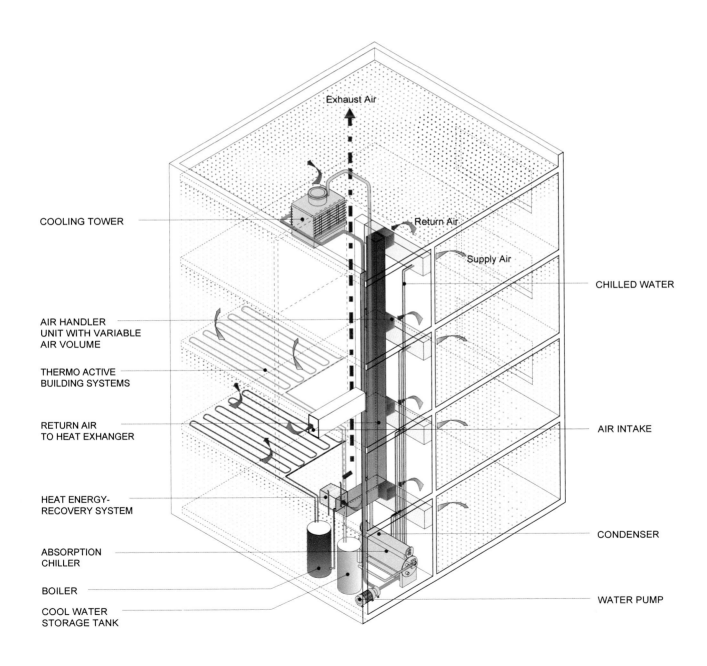

Fig. 4.3-8 Air-Water System

4. Climate Control

THERMO ACTIVE BUILDING SYSTEMS Thermo active building systems (TABS) are composed of water-carrying pipes embedded within the building structure to provide both heating and cooling. TABS utilize pipes as heat exchangers to cool or heat the thermal mass of the building in order to condition the interior environment. TABS are classified based on the location of the pipes in the building elements and can be integrated into ceilings, walls, or floors. TABS implemented in buildings with low heating and cooling requirements utilize energy for distribution only and not for generation. In order to meet higher heating and cooling requirements, the system can be supplemented by a wide range of heating and cooling equipment and can be combined with renewable energy to maximize the system's efficiency.

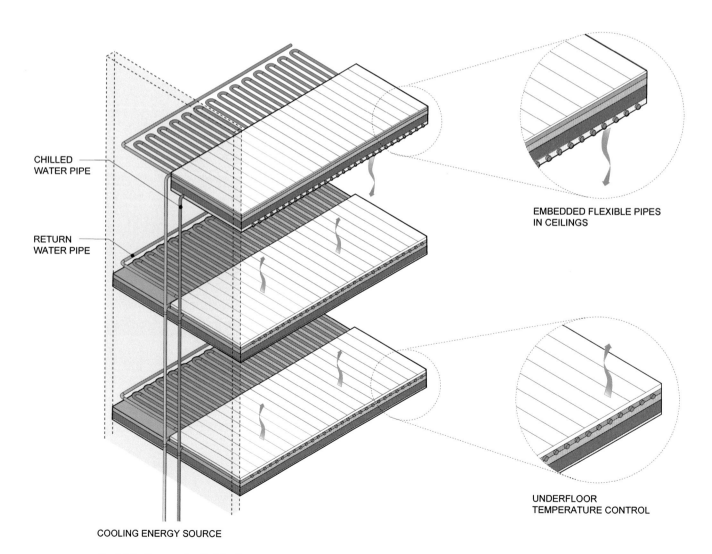

Fig. 4.3-9 Thermoactive Building Systems

Active Systems

Refrigeration Cycles

Mechanical equipment can rapidly produce heating or cooling on demand. The refrigeration cycle is a mechanical process utilized to produce cool or warm air within a building. The size of the refrigeration equipment depends on the calculated cooling loads, air exchange and treatment rate requirement. There are two basic methods of producing cooling for building applications: the vapor absorption refrigeration cycle and the vapor compression refrigeration cycle. When compression or absorption refrigeration machines are utilized to chill water and/or air, they are called chillers.

ABSORPTION CYCLE A vapor absorption refrigeration cycle utilizes heat sources such as district heating, solar thermal, waste heat recovery and natural gas to produce chilled water for cooling. A vapor absorption machine is composed of four interconnected chambers, a source of heat, chilled water and an absorber solution such as lithium bromide or ammonia. The process begins when water from one of the chambers evaporates and travels to the second chamber, where it is absorbed by the lithium bromide. As water evaporates, it removes heat from the chilled water coil utilized to cool the building. Once the lithium bromide becomes too diluted to absorb more water vapor, it travels to the third chamber, the regenerator. In this chamber, a heat source boils the water off the lithium bromide solution and the water vapor migrates to a condenser chamber, while the concentrated lithium bromide returns to its original compartment. In the condenser chamber, the hot water vapor becomes liquid and it returns to the first chamber to continue the cycle. The vapor absorption cycle becomes energy efficient when it utilizes renewable energy or other inexpensive sources of heat.

LITHIUM BROMIDE ABSORBS MOISTURE

HEAT SOURCE

WATER SEPARATED FROM LITHIUM BROMIDE

HOT WATER VAPOR
170°F/77°C

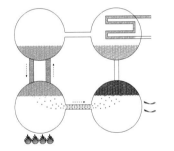

WARM WATER
120°F/48°C

HEAT IS RELEASED

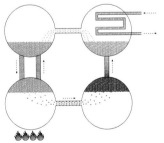

CHILLED WATER
45°F/7°C
RETURN WATER
55°F/13°C
COLD WATER VAPOR
40°F/4°C

Fig. 4.3-10 Absorption Cycle

4. Climate Control

COMPRESSION CYCLE A vapor compression refrigeration machine consists of an evaporator coil, compressor, condenser coil, expansion valve, and refrigerant. The cycle starts when the refrigerant fluid is compressed and pumped into the condenser coil. Once compressed, the refrigerant becomes a hot, high-pressure vapor and travels through the condenser coil where it condenses and becomes a warm, high-pressure liquid. The refrigerant passes through an expansion valve where it expands and gradually becomes a cold, low-pressure liquid. The expansion valve allows a small amount of the liquid refrigerant into the evaporator coil where it boils and evaporates due to the very low pressure. The evaporator coil cools to allow the refrigerant to change state and evaporate. A fan blows air through the evaporator coil, releasing cool air to the interior of the building. The cycle continues as the compressor pumps the refrigerant gas back into the condenser coil. The compression cycle can be inverted by a reversing valve that changes the direction of the refrigerant flow to provide heating or cooling on demand.

HOT VAPOR
HIGH PRESSURE
77°C/170°F

WARM LIQUID
HIGH PRESSURE
48°C/120°F

REFRIGERANT
EXPANDS

COLD LIQUID
LOW PRESSURE
2°C/35°F

REFRIGERANT
EVAPORATES

COLD VAPOR
LOW PRESSURE
4°C/40°F

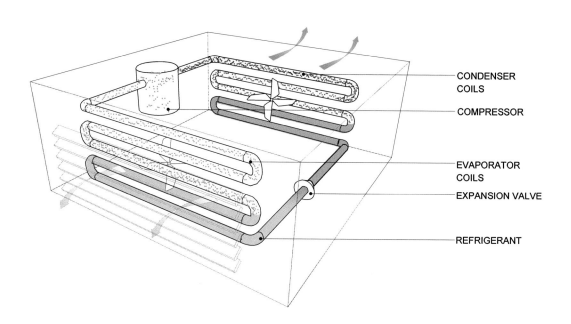

- CONDENSER COILS
- COMPRESSOR
- EVAPORATOR COILS
- EXPANSION VALVE
- REFRIGERANT

Fig. 4.3-11 Compression Cycle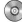

Active Systems

Heat Pumps

Heat pumps consist of refrigeration machines operating under an electric compression or thermal absorption cycle that is utilized for both heating and cooling. Because heat pumps transfer heat rather than generate it, they can deliver up to four times the amount of energy they consume. Heat pumps are considered an efficient method for climates with moderate heating and cooling needs because they utilize a reversing valve to change the direction of the refrigerant flow to provide heating or cooling on demand. When heat pumps utilize the ground or a body of water as an alternative to outdoor air, they are called geoexchange heat pumps.

The term "coefficient of performance" (COP) describes the energy efficiency of heat pumps. A typical Energy Star evaluation of the complete system is the Energy Efficiency Ratio (EER), which indicates the ratio of the thermal energy produced to the total amount of electrical energy consumed for a whole year. Another measure of efficiency in the cooling mode is the Seasonal Energy Efficiency Ratio (SEER) that measures the ratio of cooling capacity to electrical energy input. The higher the SEER value, the more efficient the heat pump's performance.

AIR-SOURCE HEAT PUMPS An air-source heat pump is a central heating and cooling system that uses outdoor air as a heat source during the winter or a heat sink during the summer. Like a compression refrigeration machine, heat pumps utilize electricity to pump heat from the evaporator coil to the condenser coil. During the cooling period, indoor air is cooled as it is blown across the cold evaporator coil, while outdoor air is heated as it passes through the condenser coil. During the heating period, the reversing valve changes the direction of the refrigerant flow and the outdoor coil becomes the cold evaporator while the indoor coil becomes the condenser. In this mode, the heat pump extracts heat from the exterior to warm the interior of the building. In hot and humid climates, highly efficient heat pumps reduce energy consumption significantly because they dehumidify better than standard central air conditioners.

Air-source heat pumps are most commonly used in small buildings. They may come in a single-package unit or as a split system. In a single-package unit, the heat pump transfers heat between the building's interior and outdoor air through a single piece of equipment. Single-package units are generally located on roofs because they require unlimited access to fresh air. In a split system, the air-source heat pump utilizes an outdoor unit containing the compressor and an indoor unit which treats and circulates indoor air. Split systems reduce the noise of the compressor and the air fan because they are located outdoors.

Fig. 4.3-12 Split System in Cooling Mode

 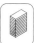

4. Climate Control

MINI-SPLIT HEAT PUMPS Air-source heat pumps are also available in a ductless version called a mini-split heat pump. Ductless, mini-split heat pumps are generally used as decentralized systems for room additions with non-ducted heating or cooling systems. Like standard air-source heat pumps, mini-splits have two main components: an outdoor compressor/condenser and an indoor terminal unit. In mini-split heat pumps, the refrigerant is compressed at the outdoor unit and transported via insulated refrigerant lines directly to the indoor units, where air is treated and blown by fans. Each room or zone may have its own thermostat to control air temperature. When compared to conventional systems, mini-split heat pumps are generally more energy efficient because they can provide restricted heating or cooling to specific zones.

ABSORPTION HEAT PUMPS Absorption heat pumps utilize heat as their energy source, rather than electricity, to provide heating or cooling. Absorption heat pumps operate the absorption refrigeration cycle utilizing an absorbent, such as lithium bromide or ammonia, instead of the refrigerant fluid. Absorption heat pumps of natural gas or solar thermal systems can be thermally driven by a variety of heat sources, such as internal heat energy from appliances and people, through heat energy recovery systems. Solar thermal systems are the most energy efficient option because they incorporate renewable energy technologies.

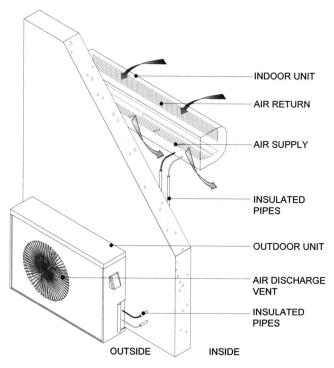

Fig. 4.3-13 Mini-Split Heat Pump

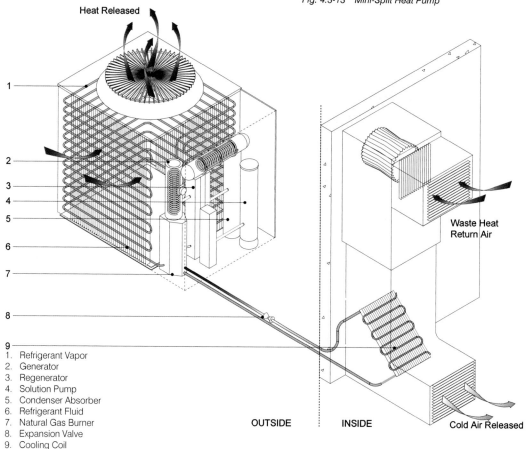

1. Refrigerant Vapor
2. Generator
3. Regenerator
4. Solution Pump
5. Condenser Absorber
6. Refrigerant Fluid
7. Natural Gas Burner
8. Expansion Valve
9. Cooling Coil

Fig. 4.3-14 Absorption Heat Pump

Active Systems

WATER-SOURCE HEAT PUMPS Water-source heat pumps utilize water as the heat transfer medium to provide heating or cooling. This system is generally used in buildings where both heating and cooling are simultaneously required. The heat pump either transfers heat from the water to the zone it serves, or cools the space by removing heat from the zone, absorbing it into the circulating water. The primary advantage of a water-source heat pump system is its ability to capture excess heat from spaces that require cooling and transfer it to spaces that require heating at the same time. In a closed-water-loop heat pump system, a continuous supply of water, maintained at a certain temperature, is pumped throughout the building. The pipe loop is connected to boilers for supplementary heat and to cooling towers for heat rejection.

GEOEXCHANGE HEAT PUMPS Geoexchange heat pumps are also known as geothermal heat pumps. They consist of a central heating and cooling device that utilizes water as the medium to transfer heat to or from the ground. Geoexchange heat pumps are among the most energy efficient and cost-effective solutions because they utilize stable ground and water temperatures for both heating and cooling. During the summer, the system utilizes the earth or a body of water as a heat sink. In the winter, the earth or the body of water become the heat source. There are four types of geoexchange systems: open loop, horizontal closed loop, vertical closed loop and pond/lake closed loop. The selection criteria are based on climate, soil conditions, available land, local codes, life-cycle costs and installation at the site.

Open-loop systems utilize moisture from the ground for heat exchange fluid as water circulates directly through the geoexchange heat pump system. Once the water has circulated through the system, it is returned to the ground through wells. This system is only effective when a clean supply of water is available and all the local codes and regulations dealing with groundwater discharge are met.

The horizontal, vertical and pond/lake heat pumps consist of closed-loop systems. Horizontal closed-loop installations are most commonly used for residential applications if sufficient land is available, because they require trenches of at least four feet deep. Vertical closed-loop systems are generally used in large commercial, educational and institutional buildings. They are often the best option for geoexchange because the deep ground is warmer during the winter and cooler during the summer. The pond/lake closed-loop system can only be used if there is a body of water at the site to be used as the heat source or heat sink. A closed-loop system is generally preferred over the open-loop system because it requires less pumping energy.

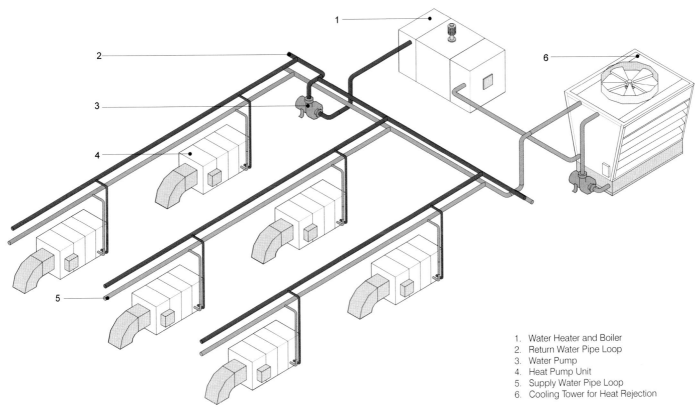

1. Water Heater and Boiler
2. Return Water Pipe Loop
3. Water Pump
4. Heat Pump Unit
5. Supply Water Pipe Loop
6. Cooling Tower for Heat Rejection

Fig. 4.3-15 Water-Source Heat Pump System

4. Climate Control

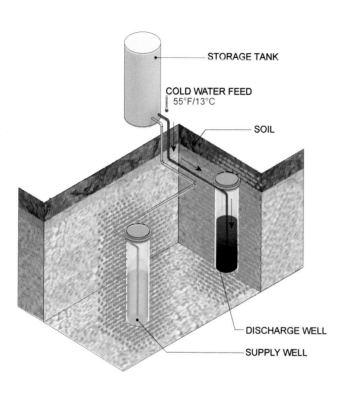
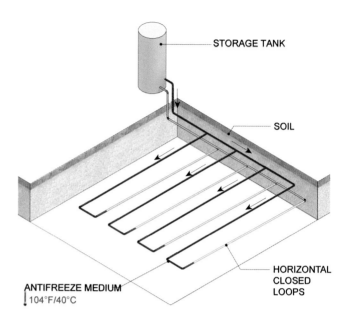
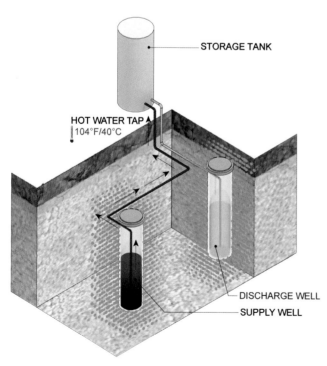
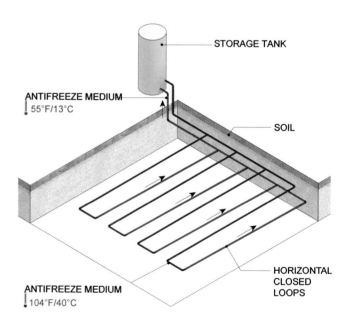

Fig. 4.3-16 Geothermal Heat Pump/Open Loop System

Fig. 4.3-17 Geothermal Heat Pump/Horizontal Closed Loop

Active Systems

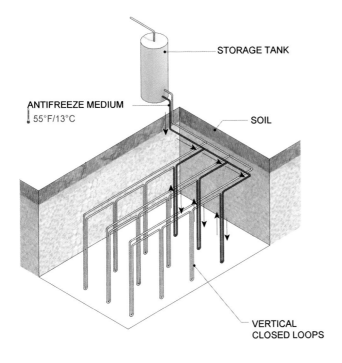
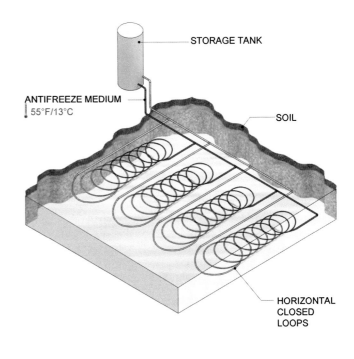
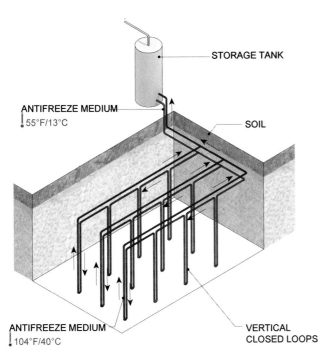
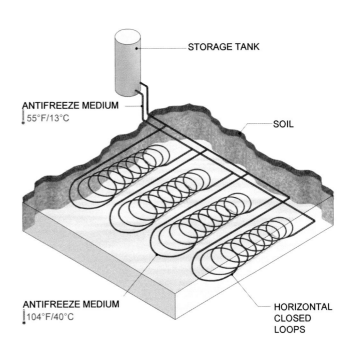

Fig. 4.3-18 Geothermal Heat Pump/Vertical Closed Loop

Fig. 4.3-19 Geothermal Heat Pump/Pond-Lake Closed Loop

4. Climate Control

Chillers

Active cooling is achieved by removing heat from a space via a mechanical device. In large buildings, a chilled-water air-conditioning system is utilized to transfer excess heat from the building to the outdoor air. A typical chilled-water air-conditioning system consists of one or more air handlers, a water chiller, circulating pumps, and a heat-rejection device. There are several variations to the application of this cooling system, including the integration of solar-assisted technologies that reduce energy consumption significantly.

CHILLED-WATER AIR-CONDITIONING SYSTEM A chilled-water air-conditioning system utilizes the vapor compression or absorption cycle to cool water and air. In this system, chilled water is pumped to cooling coils inside air handlers or fan coil units. The air handlers' cool fresh air is blown over the surface of the cooling coils. As a result, supply air leaves the air handler at a cooler temperature, while the water that passes through the coil leaves the unit at a warmer temperature. After gaining heat from the coils, tempered water is pumped back to the chiller where it is cooled again. Heat is transferred to a heat-rejection device that expels it to the atmosphere. The rejected heat from the cooling power-generation equipment (e.g., turbines, microturbines, and engines) can be reused with an absorption chiller to provide cooling.

WATER CHILLERS A water chiller is a key element of air-conditioning systems in large buildings. It is a cooling device utilized to remove heat from buildings using water as the heat-transfer medium. A water chiller consists of a compressor or generator, an evaporator and a condenser. The type of chiller used largely depends on the energy source and the cooling load required.

The two categories of water chillers used in HVAC systems are electric vapor compression chillers and thermally driven absorption chillers. The main difference between these two systems is their energy source. Compression chillers use electricity to operate a compressor used to raise the pressure of refrigerant vapors. Thermally driven absorption chillers use heat for compressing refrigerant vapors to a high pressure. The storage, distribution, and output of cooling energy is achieved through water and ice storage technologies or through the use of thermoactive building systems.

Small-scale and large-scale refrigeration machines and chillers are available from one to thousands of tons (3.5 kW – 3500 kW) of cooling capacity. Efficient waste heat control, heat recovery systems, mechanical room size and location, and acoustic separation are important considerations when installing chillers in buildings. Absorption chillers can also be driven by heat rejected from power-generation equipment (e.g., turbines, microturbines, and engines) and by solar thermal energy to generate cooling. Solar thermal-assisted chillers utilize solar energy provided through solar collectors such as flat plate collectors, solar concentrators and heat pipe collectors. Solar thermal air-conditioning has the potential to replace conventional cooling machines based on electricity.

Active Systems

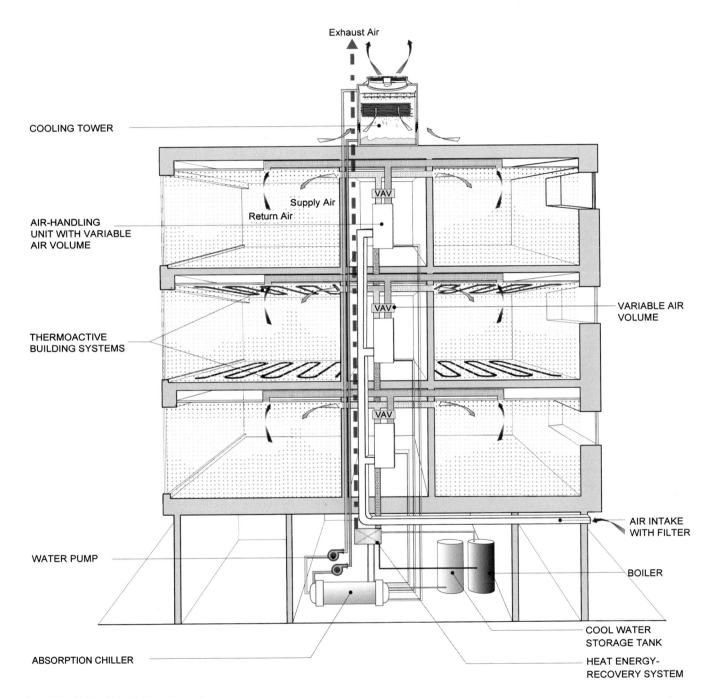

Fig. 4.3-20 Chilled-Water Air-Conditioning System

4. Climate Control

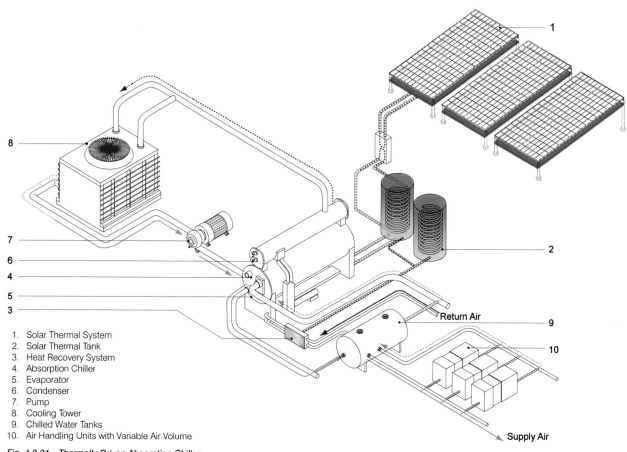

1. Solar Thermal System
2. Solar Thermal Tank
3. Heat Recovery System
4. Absorption Chiller
5. Evaporator
6. Condenser
7. Pump
8. Cooling Tower
9. Chilled Water Tanks
10. Air Handling Units with Variable Air Volume

Fig. 4.3-21 Thermally Driven Absorption Chiller

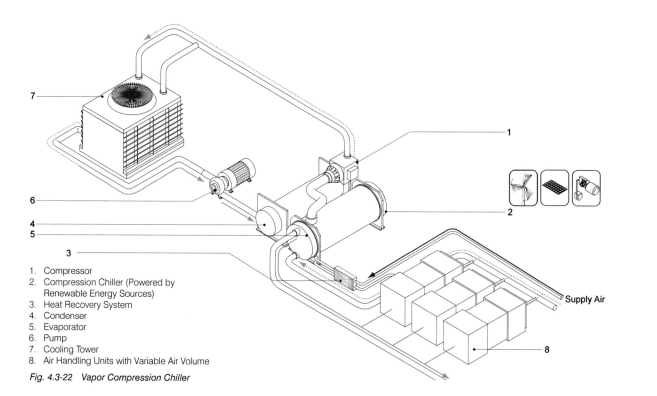

1. Compressor
2. Compression Chiller (Powered by Renewable Energy Sources)
3. Heat Recovery System
4. Condenser
5. Evaporator
6. Pump
7. Cooling Tower
8. Air Handling Units with Variable Air Volume

Fig. 4.3-22 Vapor Compression Chiller

Active Systems

CHILLED-WATER COIL A chilled-water coil transfers heat from recirculated air to circulated water. A chilled-water coil consists of several rows of copper tubes with copper or aluminum fins spaced along the length of the tube. Chilled water is circulated through the tubes, while air to be cooled is blown over the surface of the fins. The coil provides a large surface area for heat to be transferred from the warm air to the cool fins, causing the air to leave the coil at a cooler temperature while the water that has gained heat from the air leaves the coil at a higher temperature. Tempered water is returned to the chiller for recooling.

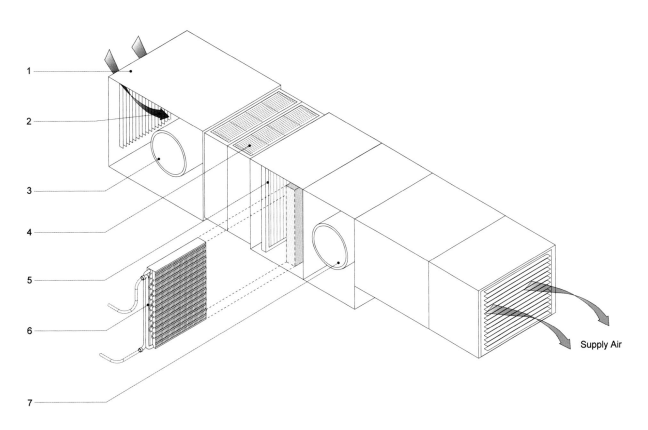

1. Air Handling Unit
2. Air Intake
3. Fan
4. Exhaust
5. Filter
6. Chilled Water Coil
7. Fan

Fig. 4.3-23 Chilled-Water Coil

4. Climate Control

COOLING TOWER A heat-rejection device is the part of an air-conditioning system that expels excess heat from a building to another medium. Outdoor air is the most common medium to which heat is rejected. Other mediums include bodies of water and the earth. Heat rejection is handled by the condensing system within refrigeration cycles. In larger buildings, when chillers are utilized, the condensing water system requirement is met by a cooling tower. A cooling tower removes heat from circulated water so that it can be recirculated and cooled by the chiller. In this process, tempered water is pumped to the top of the cooling tower at a higher temperature than outdoor air.

This water is sprayed over a large surface of plastic tubes or wood sheets called fill material. Water flows downward by gravity and is cooled by evaporation and convection as the outdoor air enters the cooling tower through louvers and is blown across the fill material. Streams of air utilized to cool the water may be generated by large fans or natural airflow patterns. When heat is transferred to the atmosphere through a heat exchange coil, water is returned to the chiller to cool the interior of the building.

HEAT ENERGY-RECOVERY SYSTEMS FOR COOLING TOWERS Heat recovery systems for cooling towers are increasingly employed to minimize the wasteful process of expelling heat into the atmosphere. In this system, latent heat can be reused to recover the rejected heat by cooling towers to generate low-temperature warm water for storage tanks, supplemental space or process heating, or to thermally drive heat recovery chillers. Heat recovery chillers may require the installation of additional heat exchangers and piping infrastructure.

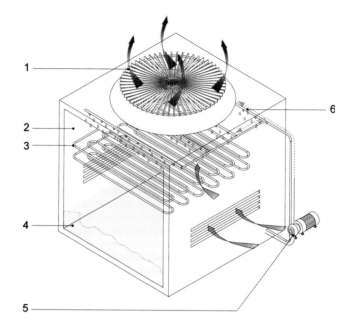

1. Heat-Rejection Device
2. Cooling Tower
3. Tube Fill Material
4. Cold Water
5. Pump
6. Water Sprinkles

Fig. 4.3-24 Cooling Tower

Active Systems

Evaporative Cooling

Evaporative cooling consists of the process of cooling through the evaporation of water. Evaporative cooling is most effective when utilized in hot and dry climates where the air temperature is high and the humidity levels are low. In some cases, it is not possible to implement evaporative cooling as a passive system, therefore mechanical equipment is introduced and evaporative coolers become part of the refrigeration system. Evaporative coolers, also known as swamp coolers, desert coolers, and wet air coolers, can reduce the peak mechanical refrigeration with low water and low energy requirements. Other advantages of evaporative coolers include significant cost savings and substantial reduction in the size of the mechanical refrigeration equipment. Evaporative coolers can be used for residential, commercial or industrial applications. There are three main types of evaporative coolers: direct evaporative, indirect evaporative and two-stage evaporative.

DIRECT EVAPORATIVE COOLER Direct evaporative coolers generally bring moist, cool air straight into the building. Direct evaporative coolers consist of a metal or plastic box with vents on both sides, enclosing a blower, electric motor, water pad, and water pump. In a direct evaporative cooler, ambient air is blown through a permeable, water-soaked pad. As warm air passes through the water pad, it cools and evaporates the water from the pad which is constantly redampened to continue the cooling process. Primary or supply air is cooled, filtered and humidified, to then be delivered to the building through vents on the roof or wall.

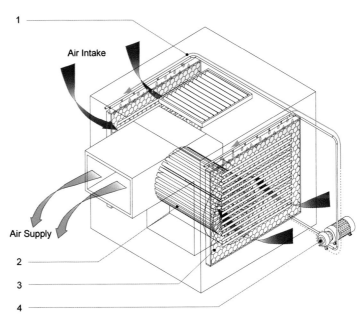

1. Water Distribution
2. Blower
3. Evaporative Pad
4. Pump

Fig. 4.3-25 Direct Evaporative Cooler

4. Climate Control

INDIRECT EVAPORATIVE COOLER Indirect evaporative coolers provide cool air without adding humidity to indoor air. In this system, outdoor air is evaporatively cooled to lower the temperature of a heat exchanger. Primary or supply air then passes through the surface of the heat exchanger and is sensibly cooled and delivered to the space. Indirect coolers generally operate at a lower efficiency and cost more than direct evaporative coolers, but they can be utilized in climatic zones and occupancies where direct evaporative cooling is not a viable choice.

TWO-STAGE INDIRECT-DIRECT EVAPORATIVE COOLER Two-stage systems involve the use of both direct and indirect evaporative cooling. In the first stage, indirect cooling is used to pre-cool air without adding moisture. Primary air leaves the first stage and enters the second stage to be directly evaporatively cooled. The pre-cooled air then passes through a water-soaked pad and picks up humidity as it cools to a lower temperature with the addition of less moisture. Supply air is then delivered to the occupied space.

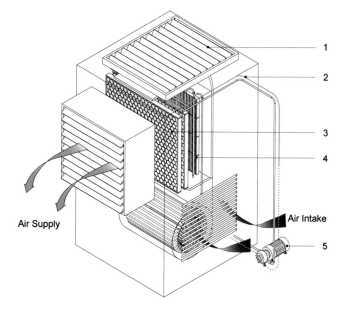

1. Exhaust Air
2. Water Distribution
3. Evaporative Media
4. Heat Exchanger
5. Pump

Fig. 4.3-27 Two-Stage Direct-Indirect Evaporative Cooler

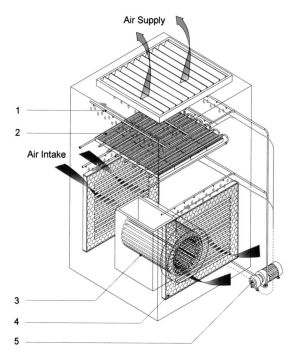

1. Water Distribution
2. Heat Exchanger
3. Blower
4. Evaporative Pad
5. Pump

Fig. 4.3-26 Indirect Evaporative Cooler

Active Systems

Mechanical Heating

Ideally, mechanical heating systems are required to provide thermal comfort when passive strategies are exploited and are not adequate. In large buildings, heat is generated at a central plant and is distributed through highly insulated ducts, or pipes, to radiators, convectors, or thermoactive building systems located at different parts of the building. Mechanical heating can be achieved by the use of solar heat, ambient heat via heat pumps, heat energy recovery (waste heat), hot water, steam or electricity. Heating equipment includes multiple types of heat pumps, heat-recovery systems, solar thermal systems with storage tanks and boilers, electrical furnaces and coil heating, and convectors. It is extremely important to select the heating equipment properly to minimize the cost and maximize energy efficiency.

BOILERS A boiler is a device that uses hot water tanks with integrated exchangers to heat water, for the purposes of building heating. There are several types of boilers. The type of boiler and energy source depends on the size of the heating load, available renewable fuels, and the desired operation. In solar-assisted heating systems, boilers are driven by photovoltaic, solar thermal energy and heat energy-recovery systems to reduce energy consumption.

Solar-assisted gas boilers require photovoltaic-driven electric pumps to circulate water through pipes to heating coils located in terminal units in radiators, finned tube radiation, and air-handling units. Heating coils transfer heat from the hot water or steam to the rooms and spaces to be heated. In buildings where both heating and cooling are simultaneously required, any emerging waste heat from the cooling system can be recaptured through heat energy-recovery systems directly into the hot water tank instead of releasing it to the exterior.

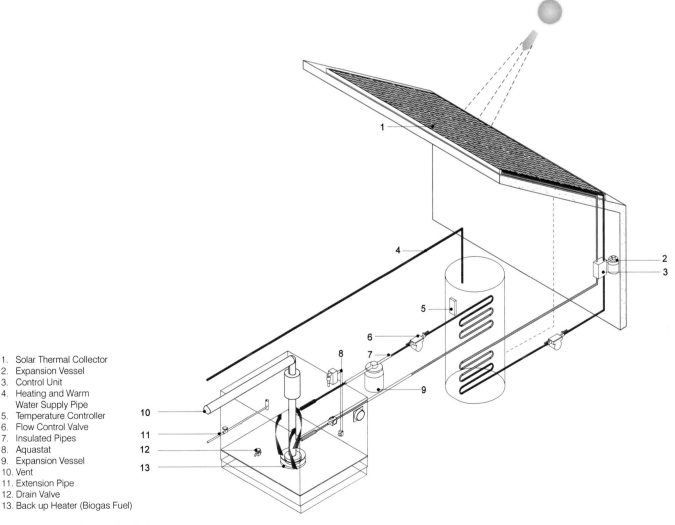

1. Solar Thermal Collector
2. Expansion Vessel
3. Control Unit
4. Heating and Warm Water Supply Pipe
5. Temperature Controller
6. Flow Control Valve
7. Insulated Pipes
8. Aquastat
9. Expansion Vessel
10. Vent
11. Extension Pipe
12. Drain Valve
13. Back up Heater (Biogas Fuel)

Fig. 4.3-28 Solar-Assisted Gas Boiler

4. Climate Control

FURNACES Furnaces use chemical energy from a fuel to heat air and warm the environment. The fuel source generally consists of natural gas, liquefied petroleum gas, fuel oil, coal or wood. The fuel source burns air in a combustion chamber to generate heat. Hot gases travel to a heat exchanger in the chimney, while air is forced around the surface of a heat exchanger to gain heat. Heated air is transported by a network of ducts to the building space being served. Furnaces are primarily used in residential and small office buildings, classrooms or industrial plants. When compared to boilers, furnaces are not a better option because they heat air, which is less efficient than transferring thermal energy with water. For residential buildings, Energy Star requires annual fuel utilization efficiency (AFUE) ratings of 85 to 90 percent or greater.

HEATING COIL Heating coils are essential components in most heating systems because they transfer heat from the source to the space being served. Heating coils are composed of copper tubes and thin aluminum fins that increase the heat transfer area and improve heat transfer rates. Heating coils may transport steam, high- or low-temperature water, refrigerant and combustion gas. The distribution medium, either air or water, is forced through the surface of the coils to capture thermal energy. The heated air or water is transported by a network of ducts or pipes and is delivered to the spaces that require heating.

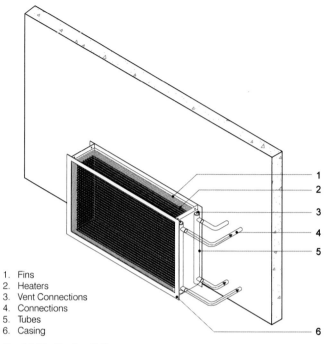

1. Fins
2. Heaters
3. Vent Connections
4. Connections
5. Tubes
6. Casing

Fig. 4.3-30 Heating Coil

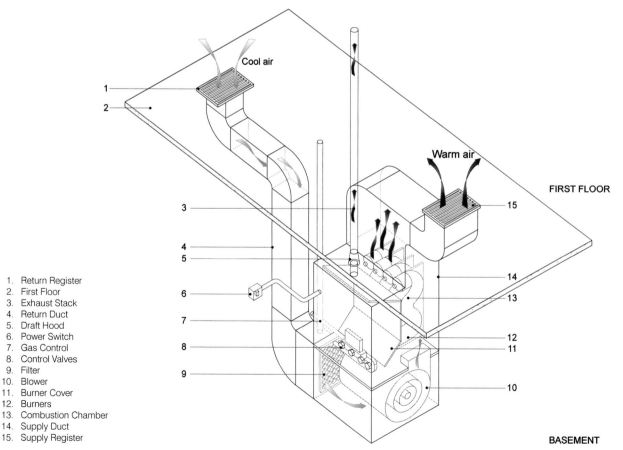

1. Return Register
2. First Floor
3. Exhaust Stack
4. Return Duct
5. Draft Hood
6. Power Switch
7. Gas Control
8. Control Valves
9. Filter
10. Blower
11. Burner Cover
12. Burners
13. Combustion Chamber
14. Supply Duct
15. Supply Register

Fig. 4.3-29 Basement Furnace

Active Systems

HEAT PUMPS Heat pumps can be used for both heating and cooling. When utilized for heating, they extract heat from the exterior and deliver it to the interior via the vapor compression cycle. In this mode, fresh air is blown across the surface of the warm condenser coil located within the indoor unit. Air captures heat from the coils and is delivered to the space being served. Exhaust air can be used to minimize the need to generate new heat by the use of heat energy-recovery systems. In order to reduce energy consumption, heat pumps may utilize stable ground and water temperatures as a heat sink or heat source. For detailed information on heat pumps, refer to Heat Pumps on page 125.

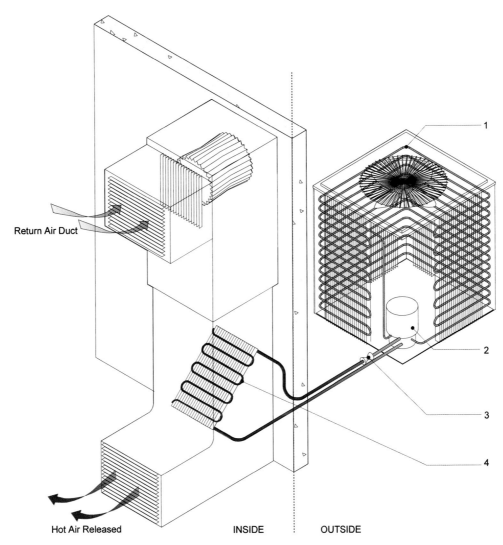

1. Condenser Coil
2. Compressor
3. Expansion Valve
4. Evaporator Coil

Fig. 4.3-31 Heat Pump

4. Climate Control

District Heating and Cooling

District heating and cooling (DHC) systems consist of city or neighborhood, centralized or building off-site, networks and are generally used to provide heating or cooling energy to individual buildings. DHC is an extremely flexible infrastructure technology that can use any fuel, including waste energy, renewable energy and combined heat and power (CHP). DHC networks offer increased opportunities for saving energy and minimizing environmental impact while replacing building heating/cooling generation plants.

DISTRICT COOLING SYSTEMS District cooling (DC) systems generate and distribute cooling energy to multiple buildings within a district or neighborhood. This system distributes chilled water through highly insulated pipes to the building's air-conditioning unit, lowering the temperature of air passing through the unit. DC plants can produce enough cooling energy to meet the cooling requirements of several buildings and can replace chiller systems that consume large amounts of energy.

DISTRICT HEATING SYSTEMS In district heating (DH) systems, thermal energy is generated in a central plant and distributed through a network of insulated pipes, in the form of hot water or steam, to heat multiple buildings and/or provide domestic hot water. DH can make use of waste heat from combined heat and power plants and other industrial processes. DH systems are also commonly used with heat-driven cooling technologies such as absorption chillers to provide cooling during the summer months.

COMBINED HEAT AND POWER Combined heat and power (CHP), also known as cogeneration, consists of the simultaneous generation of electric energy and thermal energy by capturing unused heat rejected from the production of electricity, to fulfill space heating. In this process, energy is used more efficiently because it recovers waste heat generated in the electric production process. CHP plants can be installed as part of DHC systems to significantly reduce energy consumption.

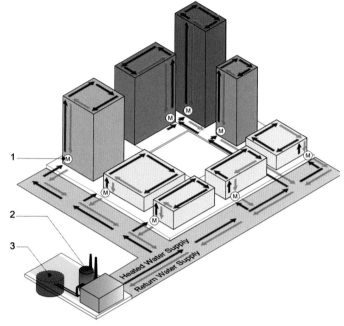

1. Meter
2. District Heating System Plant
3. Underground District Storage Tank

Fig. 4.3-32 District Heating System

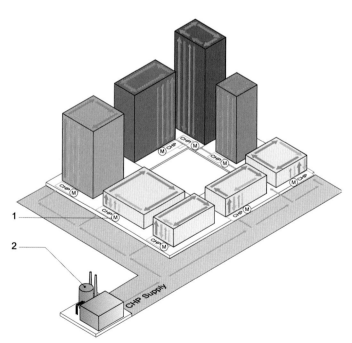

1. Meter
2. Combined Heat and Power System Plant

Fig. 4.3-33 Combined Heat and Power

Active Systems

Ventilation

A regular exchange of air via ventilation can be achieved by natural or mechanical means, or a combination of both, depending on the microclimate, location, and building occupancy type. Natural ventilation must be carefully planned and controlled because it is strongly dependent on the way thermal currents or differing wind pressures dominate a building site. Electric mechanical ventilation with the four types of technical air treatment, including cooling, heating, humidifying, and dehumidifying, is very energy consuming. On average, for 35 cubic feet (one cubic meter) of air per second, 8,524 Btu (2.5 kWh) is needed. Most commercial buildings in hot, arid and humid climates use electric mechanical ventilation to ensure that fresh air intake is filtered, conditioned, humidified or dehumidified and delivered at the right comfort temperature, relative humidity level, and required air quality. Controlled CO_2 content and air flow rates are other important parameters. Air-handling systems are responsible for supplying adequate amounts of fresh, clean air and maintaining good indoor air quality and thermal comfort. Air-handling equipment may come in many variations depending on the size of the building and the amount of air treated by the unit. Major energy-saving concerns are related to ventilation transmission losses. An energy-efficient ventilation system must have a controlled air supply and extract system, with an integrated heat exchanger to recover heat, cooling energy, and moisture.

AIR-HANDLING UNIT An air-handling unit (AHU) is composed of fans, coils, filters and other parts that are utilized to condition fresh air streams as a part of the HVAC system. AHUs are connected to ductwork that distributes and circulates the conditioned air throughout the building and returns it back to the unit. The AHU draws in fresh air and mixes it with return air from the building to reduce the cooling or heating loads. The size of an AHU varies greatly depending on the amount of air passing through the unit. In large buildings, AHUs are generally located in one central equipment room or in several separate, smaller mechanical rooms.

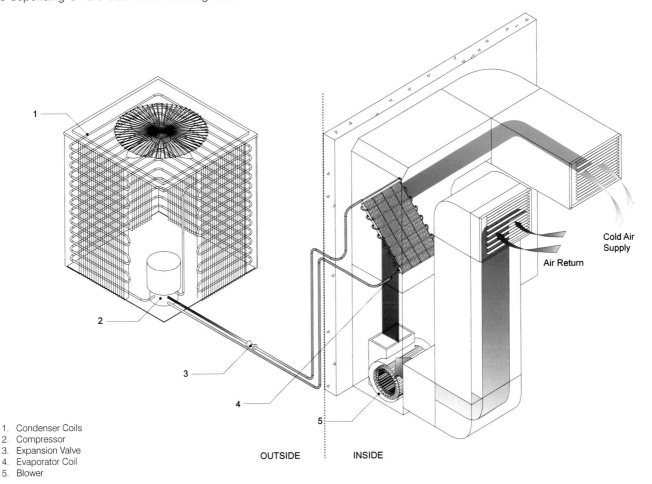

1. Condenser Coils
2. Compressor
3. Expansion Valve
4. Evaporator Coil
5. Blower

Fig. 4.3-34 Air Handling Unit

4. Climate Control

PACKAGE UNIT SYSTEM A package unit or rooftop unit is a self-contained AHU usually mounted on the exterior of a structure or at ground level on a concrete pad. Package units generally incorporate most of their components in a single unit and are fabricated in a factory. They are composed of a blower, filter, compressors, evaporator coil and an air-cooled condensing section. Package units are usually employed on large retail buildings, warehouses, and small commercial buildings. Package units provide air directly to the space being conditioned. The advantage of using a package unit is the cost and time savings from installation labor.

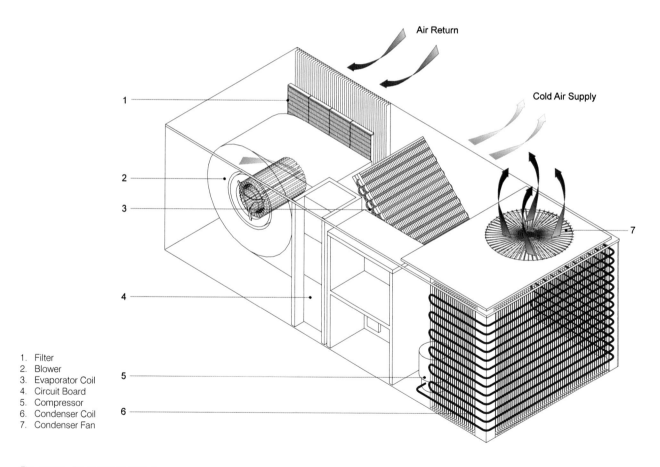

1. Filter
2. Blower
3. Evaporator Coil
4. Circuit Board
5. Compressor
6. Condenser Coil
7. Condenser Fan

Fig. 4.3-35 Package Unit System

Active Systems

Heat Energy-Recovery Systems

Energy recovery ventilation systems provide a controlled way of ventilating buildings while reducing heating or cooling requirements. They minimize energy consumption significantly by eliminating the need to generate new heat. Recovery systems capture waste heat, such as exhaust air, and transfer it to a fluid, either air or water. During the winter season, the cost of heating is reduced by transferring heat from the warm interior exhaust air to the chilly fresh air intake. During the summer months, the inside exhaust air cools the warmer incoming air to reduce ventilation and cooling costs. Recovery systems have the ability to meet the American Society of Heating, Refrigerating, and Air Conditioning Engineers (ASHRAE) ventilation and energy standards while improving climate control and indoor air quality. There are two types of recovery systems: heat-recovery ventilators and energy-recovery ventilators.

HEAT-RECOVERY VENTILATORS Heat-recovery ventilators (HRV) include a heat exchanger, fans, and climate controls. They use heat exchangers to extract heat from exhaust air and transfer it to the fresh air introduced into the building. These systems pre-heat or pre-cool incoming fresh air recapturing approximate 60 to 80 percent of the exhaust air temperatures that would otherwise be lost. Because exhaust air and fresh air do not mix, odors or water vapor are not transferred along with the heat. HRVs are available in different scales and configurations. They can be used in both,

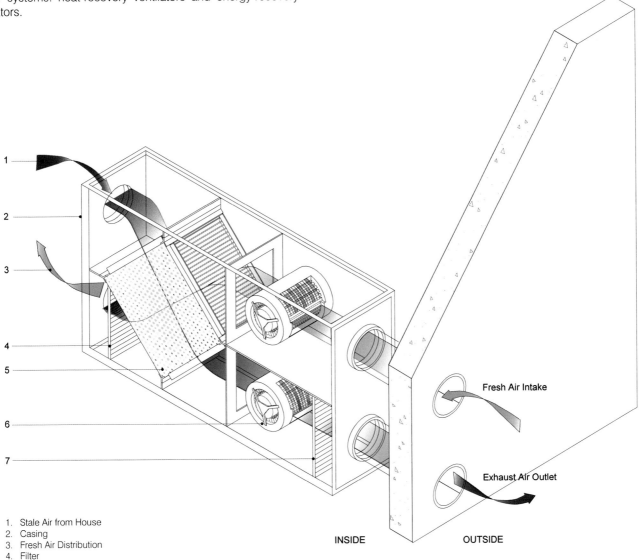

1. Stale Air from House
2. Casing
3. Fresh Air Distribution
4. Filter
5. Heat Exchange Core
6. Circulation Fan
7. Filter

Fig. 4.3-36 Heat Recovery Ventilator

4. Climate Control

residential and commercial HVAC systems.

ENERGY-RECOVERY VENTILATORS Energy recovery ventilators (ERVs) exchange energy contained in exhaust air and reuse it to pre-condition incoming outdoor air. EVRs transfer both sensible and latent heat. They transport heat and water vapor from exhaust air into the fresh air intake. In the summer months, ERVs pre-cool and dehumidify fresh air while in the cooler seasons they pre-heat and humidify incoming air. ERVs are recommended in hot and arid climates, where cooling loads place strong demands on HVAC systems. ERVs are not dehumidifiers, but they can limit the amount of moisture coming into the building. These systems can

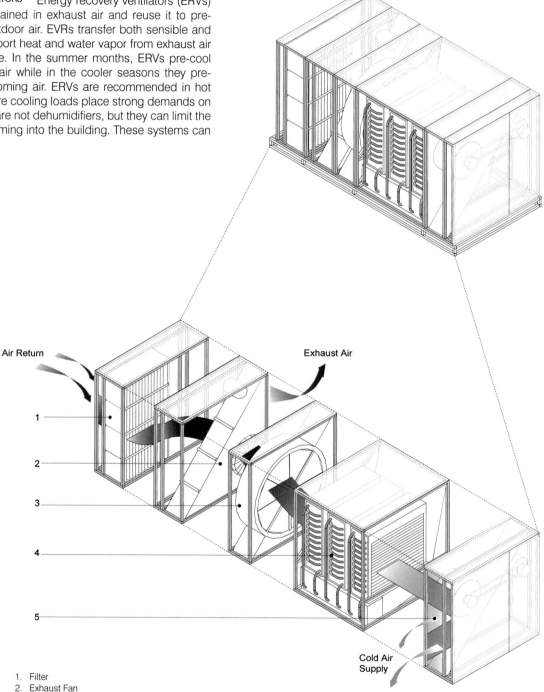

1. Filter
2. Exhaust Fan
3. Enthapy Wheel
4. Cooling Heating Coil
5. Supply Fan

Fig. 4.3-37 Heat Energy Recovery Ventilator

Active Systems

Distribution and Terminal Systems

Distribution systems are responsible for transporting heating or cooling fluids such as air, water or steam from the central equipment to the conditioned space. Distribution systems include networks of pipes, pumps, ducts or fans that transport the fluids to the terminal units. Terminal units vary depending on the type of system used to meet the cooling or heating requirements. All-air systems supply only conditioned air from the central equipment directly to the conditioned space. All-water systems require terminal units to circulate chilled or heated water within the conditioned space to provide cooling, heating, humidification or dehumidification. Air-water systems require terminal units in the conditioned space to meet the cooling, heating and ventilation requirements.

SINGLE-DUCT SYSTEMS Most all-air HVAC systems utilize a single network of supply air ducts to provide either warmed or cooled air to the zones they serve. Single-duct systems can serve as a single zone or as multiple zones to control temperature and humidity. A single-zone system is very energy efficient and inexpensive. It utilizes less energy to distribute conditioned air because the equipment is typically located within or adjacent to the space it serves. This system is typically used in smaller buildings and is controlled by a zone temperature sensor that regulates the required heating or cooling to achieve thermal comfort. A multiple-zone system works very similarly to a single-zone system with independent temperature sensors for each zone that regulate the volume and temperature of air discharged into the space. A multiple-zone system serves various zones in a building that might have different internal thermal loads or specific climate requirements.

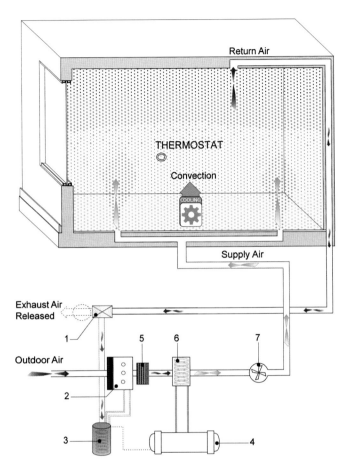

1. Heat Energy Recovery
2. Outdoor Air Inlet Preheater
3. Boiler
4. Chiller
5. Filter/Humidifier/Dehumidifier
6. Cooling Coils
7. Fan

Fig. 4.3-38 Single-Duct/Single-Zone System

4. Climate Control

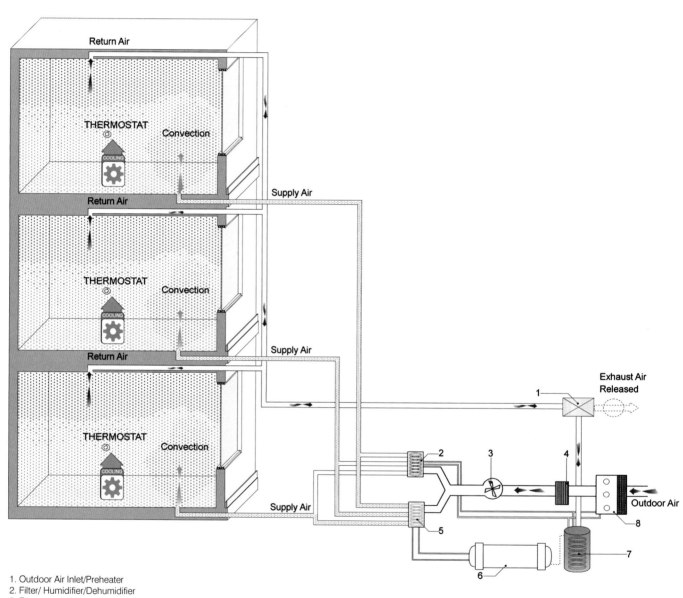

1. Outdoor Air Inlet/Preheater
2. Filter/ Humidifier/Dehumidifier
3. Fan
4. Heat Energy Recovery
5. Boiler
6. Chiller
7. Heating Coils
8. Cooling Coils

Fig. 4.3-39 Single-Duct/Multiple-Zone System

Active Systems

SINGLE-DUCT VARIABLE AIR VOLUME (VAV) Variable air volume (VAV) HVAC systems utilize a mixing box or terminal unit generally located above a suspended ceiling or below a raised floor within the zones it serves. The terminal unit is an energy-saving option because it controls the quantity of air supplied to each zone based on the thermal loads. In this system, the fan motors run at peak condition speed only during peak hours. The terminal unit also reduces noise and adjusts the velocity of air from the main duct to the distribution ducts.

DOUBLE-DUCT SYSTEMS The double-duct system has the greatest energy consumption of any all-air system. The double-duct option utilizes two separate distribution ductworks to supply warmed and cooled air. Warm and cold air ducts run parallel to each other, occupying a significant amount of space. During the summer peak, cool air is provided by the cool air duct, while the warm air duct provides heated air during the coldest winter days. Most of the time, supply air from the two networks is mixed at each zone's air terminals. The dual-duct system increases the required floor-to-floor height and the energy required for air distribution. Due to the high annual energy costs, this system is not commonly used.

1. Heat Energy Recovery
2. Preheater
3. Boiler
4. Filter/ Humidifier/ Dehumidifier
5. Cooling Coils
6. Fan
7. Chiller

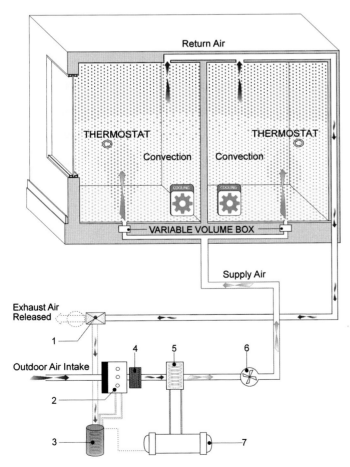

Fig. 4.3-40 Single-Duct Variable Air Volume System

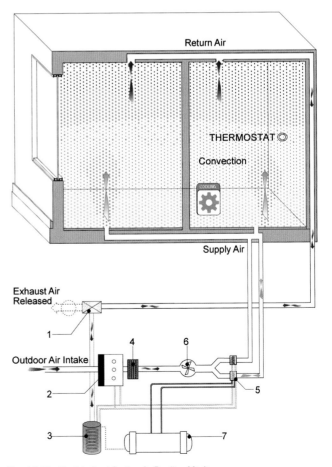

Fig. 4.3-41 Double-Duct System in Cooling Mode

4. Climate Control

UNDER-FLOOR DISTRIBUTION Under-floor distribution eliminates supply ductwork and introduces supply air through floor outlets using the under-floor area as a plenum. Under-floor distribution with displacement ventilation provides supply air at a very low velocity. Fresh air rises to the occupant level and is drawn upward by the stack effect, as are gains in heat from people, lighting, and other equipment. Under-floor distribution systems provide better thermal comfort by allowing the freshest air to be at the occupant level and the most stale air to be collected at the ceiling.

PERSONAL ENVIRONMENTAL MODULE Micro-zone systems are utilized in commercial buildings to provide a variety of individual controls in rooms, offices or workspaces. Personal environment modules (PEM) are micro-zone systems that allow each user to adjust the supply air temperature, velocity and direction at each work station. PEM systems are designed to fit under a typical office desk. In this system, a mixture of outdoor air and recirculated indoor air is delivered to each personal environment module from the main duct or under-floor plenum. PEM systems reduce energy consumption by using occupancy sensors to turn off the system when the workspace is unoccupied. They also minimize the energy required for cooling and heating because they provide thermal control to individual spaces versus the entire building or floor area.

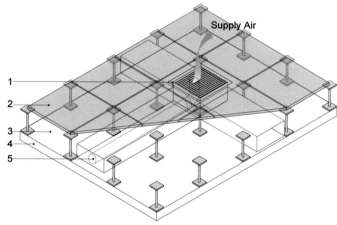

1. Air Outlet
2. Raised Floor
3. Floor Plenum
4. Floor Slab
5. Supply Air Duct

Fig. 4.3-42 Under-Floor Distribution

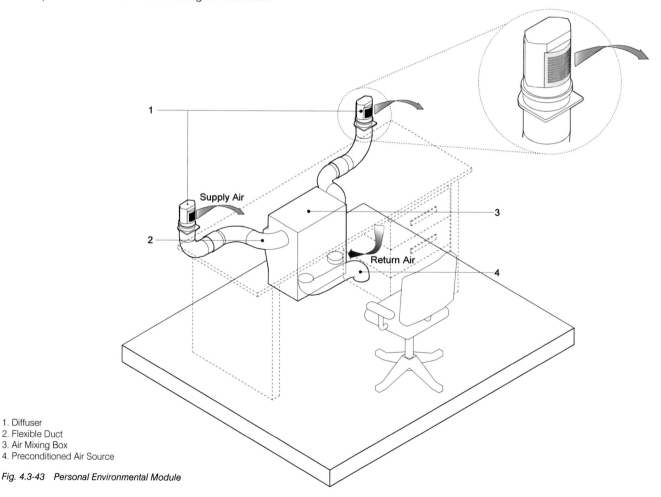

1. Diffuser
2. Flexible Duct
3. Air Mixing Box
4. Preconditioned Air Source

Fig. 4.3-43 Personal Environmental Module

Active Systems

FAN COIL UNIT A fan coil unit is typically located under windows and consists of a fan that blows room air across the surface of a coil filled with chilled or hot water. The water flow that passes though the coils is regulated by a thermostat to provide heating or cooling. Fan coil units utilize a four-pipe, three-pipe or two-pipe system to circulate the water. A four-pipe system consists of two pipes for hot supply and return water and two other pipes for cold water supply and return. In this system, either heating or cooling is possible at any time of the year. A two-pipe system circulates hot water during the winter and cold water during the summer, providing only heating or cooling during each season. A three-pipe system circulates hot, cold and return water. A three-pipe system is not as efficient because it circulates hot and cold return water through the same pipe. Fan coil units come in many shapes and sizes that allow flexibility. They can also be located above windows, in small closets, or above a suspended ceiling.

INDUCTION SYSTEMS Induction systems utilize a constant volume of fresh air supply, preconditioned at the central system and delivered to each induction terminal, typically located below windows or above suspended ceilings. In the terminal unit, fresh air is forced through an opening while room air is induced to mix with the incoming stream of fresh air. About 20 to 40 percent of fresh air is mixed with room air and is blown over the surface of coils filled with chilled or warm water for heating or cooling. The flow of cold/warm water and the flow of fresh air are directly controlled by local thermostats generally located within the terminal units.

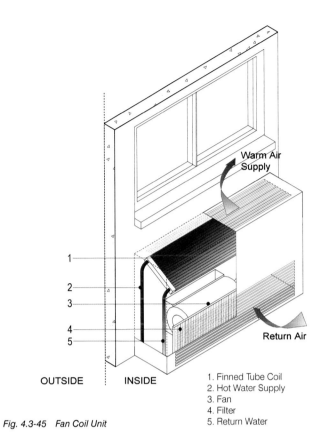

1. Finned Tube Coil
2. Hot Water Supply
3. Fan
4. Filter
5. Return Water

Fig. 4.3-45 Fan Coil Unit

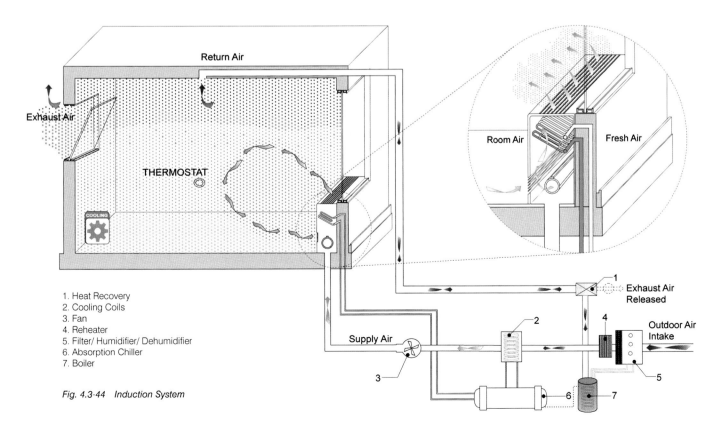

1. Heat Recovery
2. Cooling Coils
3. Fan
4. Reheater
5. Filter/ Humidifier/ Dehumidifier
6. Absorption Chiller
7. Boiler

Fig. 4.3-44 Induction System

4. Climate Control

FAN COIL WITH SUPPLEMENTARY AIR This air-supplement system is closely related to the induction system, but it uses a fan at each unit to circulate the mixture of air throughout the unit. A fan coil unit is a simple device consisting of a heating or cooling coil and a fan that moves the air mixture. In this system, a constant volume of preconditioned fresh air from the central system is delivered to the fan coil unit through air ducts. The fan draws room air through a filter and moves it across the surface of the coil filled with warm or chilled water that heats or cools the supply air. As in induction systems, the unit's output is controlled by a local thermostat with a manual switch. Fan coils with supplementary air units are typically used in buildings that have many thermal zones, such as schools, hotels, apartments and office buildings.

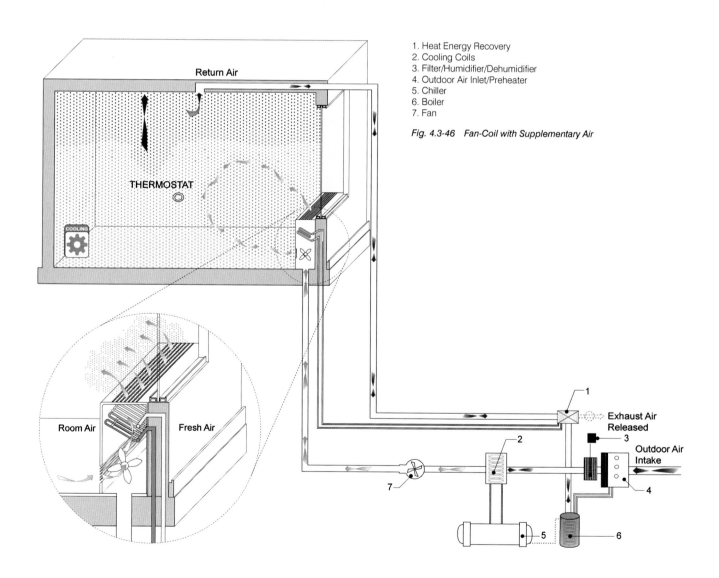

1. Heat Energy Recovery
2. Cooling Coils
3. Filter/Humidifier/Dehumidifier
4. Outdoor Air Inlet/Preheater
5. Chiller
6. Boiler
7. Fan

Fig. 4.3-46 Fan-Coil with Supplementary Air

Active Systems

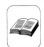

RADIANT PANELS WITH SUPPLEMENTARY AIR In this air-water system, the terminal unit is replaced by a large surface of radiant ceiling or wall panels that contain the cooled and heated water. Radiant panels can be used for both heating and cooling with chilled or hot water. Conditioned water is circulated through a finned tube mounted horizontally within the radiant panels. A constant volume of fresh air is brought into the space and cooled or warmed as it passes over the hot/cold surface of the panels. Radiant systems are highly effective in spaces exposed to large influxes of outside air such as warehouses. They can accommodate many building configurations.

REFERENCES

1. Markuss Kottek, Jurgen Grieser, Beck Christoph, Franz Rubel and Bruno Rudolf, Map of the Köppen-Geiger climate classification updated, Meteorologische Zeitschrift, Publisher E. Schweizerbart'sche Verlagsbuchhandlung, Volume 15, No. 3, June 2006, pp. 259-263(5).

2. Fanger, P. O. "Thermal environment — Human requirements." The Environmentalist. 6. no. 4 . http://dx.doi.org/10.1007/BF02238059.

3. Jank R. Volkswohnung GmbH, GovEnergy, "Net Zero and Low Energy Buildings:Theory and European Practice." Last modified January 17th, 2008. http://www.annex46.org/kd/cache/files/645BB562D756407F95B9E4E8FE5CC5DD.pdf.

4. Passive House Institute. http://www.passiv.de/07_eng/index_e.html.

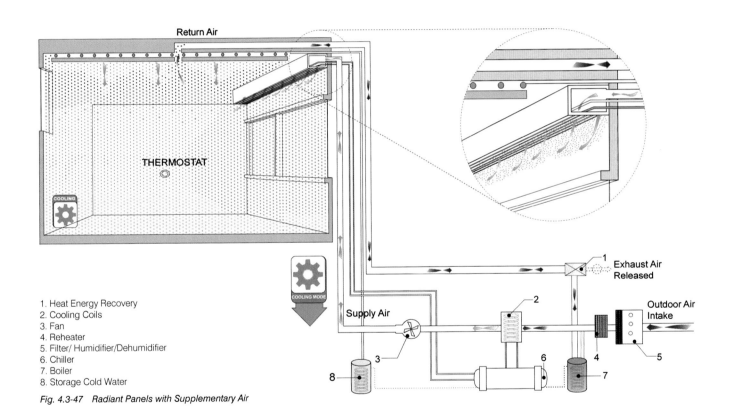

1. Heat Energy Recovery
2. Cooling Coils
3. Fan
4. Reheater
5. Filter/ Humidifier/Dehumidifier
6. Chiller
7. Boiler
8. Storage Cold Water

Fig. 4.3-47 Radiant Panels with Supplementary Air

Renewable Energy

Fossil fuels are nonrenewable. Use of fossil fuels draws on finite resources that are diminishing. These fuels are becoming increasingly more expensive and their extraction produces irretrievable damage to the environment. In contrast, renewable energy resources are constantly replenishing themselves. Their capacity to replace conventional fuels is significantly increasing on a global scale. In their various forms, renewable resources include sunlight, wind, and geothermal energy. Energy harnessed from these sources can be used to produce electricity and heating and cooling energy for building operations.

5. Renewable Energy

5.1 Energy Sources and Storage

Solar Energy

The sun is the most significant source of renewable energy. Most renewable energy comes either directly or indirectly from the sun. Sunlight or solar energy can be used directly for heating, daylighting, solar cooling and generating electricity. There are two main approaches utilized to harness solar energy: solar thermal conversion and the photovoltaic effect. Solar thermal conversion is utilized to convert solar energy to thermal energy while the photovoltaic effect is utilized to convert solar energy to electricity.

SOLAR THERMAL CONVERSION The most important component of a solar thermal conversion system is the solar collector. Solar collectors are heat exchangers designed to capture and store solar radiation for conversion into thermal energy or heat. They operate by absorbing sunlight to generate large amounts of heat. There are several types of solar collectors, including flat plate, solar concentrators, and heat pipe. Solar collectors mounted on roofs must be firmly constructed and attached to avoid leaks and internal corrosion, and be able to withstand unfavorable weather conditions. They can also be mounted on a tracking system to continuously face the direction of solar radiation.

FLAT-PLATE COLLECTORS Flat-plate collectors are generally comprised of a layer of glazing, an absorber plate, insulation, and a transferring fluid. The glazing admits approximately 90 percent of the solar radiation while reducing the upward loss of heat. The absorber plate generally has a dark surface which collects much of the radiation transmitted through the glass, and stores heat. The heat is then removed by the continuous flow of the transferring fluid.

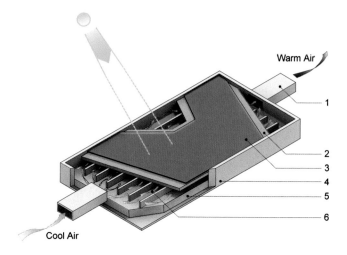

1. Air Duct
2. Absorber Plate
3. Glazing
4. Metal Frame
5. Insulation
6. Air Passage

Fig. 5.1-2 Flat-Plate Collector (Air)

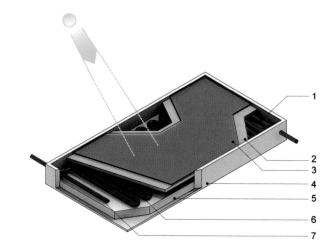

1. Cold Liquid Inlet/Insulated Pipe
2. Absorber Plate
3. Glazing
4. Metal Frame
5. Insulation
6. Copper Flow Tubes
7. Hot Liquid Outlet

Fig. 5.1-3 Flat-Plate Collector (Liquid)

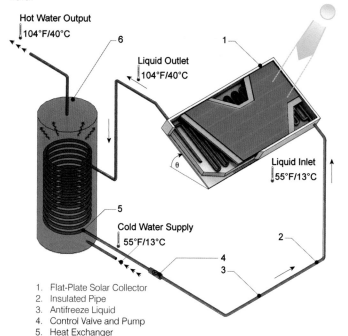

1. Flat-Plate Solar Collector
2. Insulated Pipe
3. Antifreeze Liquid
4. Control Valve and Pump
5. Heat Exchanger
6. Storage Device

Fig. 5.1-1 Flat-Plate Solar Collector Cycle

Energy Sources and Storage

SOLAR CONCENTRATORS Solar concentrators operate similarly to flat plate collectors, but have a larger area for receiving solar radiation. They utilize optical concentrators such as reflecting mirrors and refracting lenses to concentrate sun rays in the absorber plate to allow the transferring fluid to reach higher temperatures of approximately 930°F (500°C). Solar concentrators provide higher efficiency, but require continuous adjustment to solar orientation.

VACUUM TUBE SOLAR COLLECTORS Heat pipe collectors consist of hollow tubes inside vacuum-sealed tubes. The vacuum envelope reduces convection and conduction, allowing the system to operate at higher temperatures. Each hollow tube is filled with liquid at a specific pressure that undergoes an evaporating-condensing phase change. As the liquid is heated by the sun, it evaporates and travels to a heat sink area where it condenses and releases latent heat. This cycle is repeated as the fluid returns to the solar collector where the sun starts to heat it again. Heat pipe collectors are capable of creating large amounts of heat.

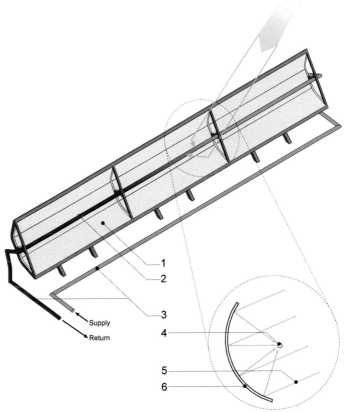

1. Reflector
2. Insulated Absorber Tube
3. Insulated Solar Field Piping
4. Absorption Tube
5. Sunlight Rays
6. Parabolic Reflector

Fig. 5.1-5 Solar Concentrator

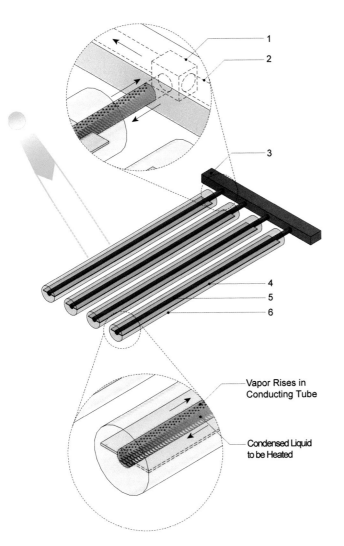

1. Condenser
2. Heat Exchanger Tube
3. Thermal Insulation
4. Selectively Coated Absorber
5. Conducting Tube
6. Impact-Resistant Solar Glass Tube

Fig. 5.1-4 Vacuum Tube Solar Collectors

155

5. Renewable Energy

Photovoltaic Systems

Direct conversion of sunlight into electricity can be achieved by the use of energy conversion devices called solar or photovoltaic (PV) cells. PV cells can be classified into three major categories: monocrystalline, polycrystalline, and thin-film silicon products. Crystalline cells are the most efficient and the most expensive cells. They are generally used for window and façade applications. Thin-film cells have a lower efficiency than crystalline cells with lower costs per square foot. Thin-film modules are most commonly used in industrial building façades and roof elements. PV systems do not need engines and operate quietly. They generate electricity only when the sun is shining and require an unobstructed exposure to sunlight for maximum efficiency.

PV systems can be mounted on roofs. They can also be incorporated in the cladding system of a building. In this case, building integrated photovoltaics (BIPV) are used. BIPVs can replace conventional roofing, siding, glazing, overhangs, and shading devices to generate a significant portion of the required electricity. BIVPs are composed of modules that come in many sizes, finishes and colors. PV modules can be combined to form panels, which are further combined to form an array. The amount of electricity generated by a PV array varies depending on solar exposure, the size of the system, the building location, and orientation.

ROOF CLADDING WITH PV SYSTEMS PV systems integrated into the roof should be located on south-facing slopes to generate the maximum amount of electricity. When integrated with roofs, the underside of the PV system needs to be ventilated during the summer to avoid overheating. In winter, the warm air under the PV system can be collected to heat the building.

When utilized on flat roofs, PV systems require a support structure that provides the appropriate orientation and tilt for the system. The optimal tilt is based on the time of year that maximum power is required. In hot climates, the peak energy demand is during the summer for air conditioning. In cold climates, the peak energy requirement is during the winter for heating.

PV FAÇADES PV systems that are integrated into the building façades can generate significant amounts of electricity. The optimal condition for energy production occurs when the PV modules are oriented perpendicularly to the beam of solar radiation. The south façade provides the maximum collection of solar energy, while the east and west façades produce up to 60 percent of the optimal south output. PV systems should be integrated only on the upper portion of the façade if lower areas of the building are shaded.

TYPE OF PV CELL	ENERGY PRODUCED*	EFFICIENCY RANGE(%)**	COST***
Monocrystalline	12 watts	16-25	$1.50/watt
Polycrystalline	10 watts	14-17	$1.25/watt
Thin-Film	5 watts	7-12	$1.15/watt

*Energy Produced may vary depending on the system's orientation and tilt angle.
**Efficiency Range: The sunlight-to-electricity conversion rate.
***Actual costs may vary depending on the modules' specific features.

Source: Solarbuzz, an NPD Group Company, "Solar Market Research and Analysis." Accessed March 16, 2012. http://solarbuzz.com/.

Fig. 5.1-6 *Photovoltaic Systems Performance Metrics*

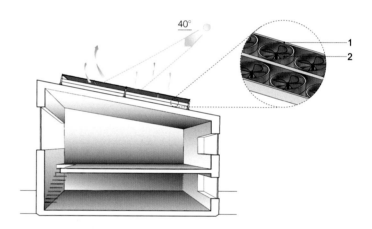

1. Active Ventilated Frame
2. Array of Fans

Fig. 5.1-7 *Actively Ventilated Photovoltaic Module*

Energy Sources and Storage

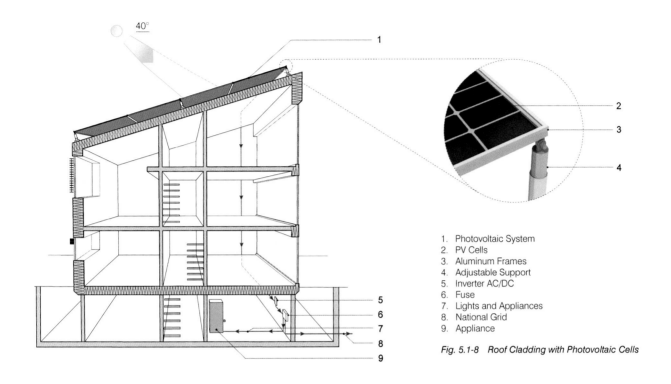

1. Photovoltaic System
2. PV Cells
3. Aluminum Frames
4. Adjustable Support
5. Inverter AC/DC
6. Fuse
7. Lights and Appliances
8. National Grid
9. Appliance

Fig. 5.1-8 Roof Cladding with Photovoltaic Cells

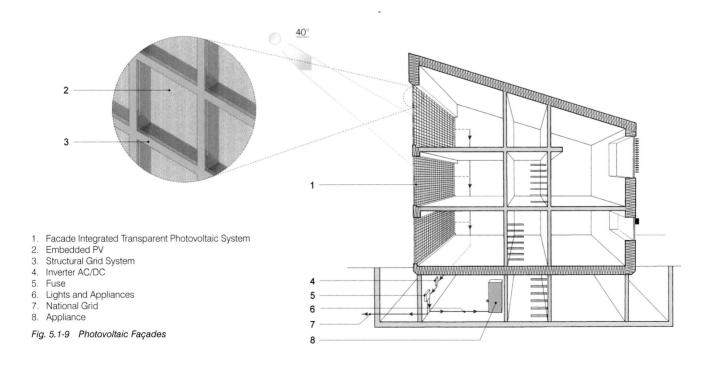

1. Facade Integrated Transparent Photovoltaic System
2. Embedded PV
3. Structural Grid System
4. Inverter AC/DC
5. Fuse
6. Lights and Appliances
7. National Grid
8. Appliance

Fig. 5.1-9 Photovoltaic Façades

5. Renewable Energy

Wind Energy

A small portion of solar energy is converted to wind. Because the amount of the sun's heat absorbed or reflected by the earth varies with topography and the differences in day and night temperatures, the atmosphere warms at a different rate. The warm air rises and cool air is drawn to replace it, thus producing air currents or wind. The wind's kinetic energy can be captured and transformed into electricity or other forms of energy. This type of energy has the lowest environmental impact.

Wind energy conversion can be accomplished through small- or large-scale conversion systems using turbines. Small-scale wind conversion systems have potential as distributed energy resources. Distributed energy resources refer to a variety of small, modular power-generating technologies that can be combined to improve the operation of the electricity delivery system. Large-scale wind conversion systems, known as "wind farms" or "wind power plants," are more economical and can be expanded easily because they are modular. The electricity generated by large-scale systems is often collected and transferred to utility power lines, where it is delivered to specific locations.

Wind energy power generators are classified based on their rotational axes: the horizontal axis system and the vertical axis system. Both of these systems can be utilized on rooftops where there is adequate height and wind speed. Rooftop turbines can create vibration on the roof and to the structure, which can be avoided by raising the turbine above the roofline.

HORIZONTAL AXIS WIND-GENERATOR SYSTEMS Horizontal axis wind turbines are most commonly used. They consist of two or three blades revolving around the horizontal axis, a gear box, an electrical generator, and other electrical equipment. As the wind blows, it turns the blades of the turbine which are connected to the main shaft. The shaft spins the generator to create electricity. Wind turbines are usually mounted on a tower or on top of a building at one hundred feet or more above the ground. At this level, the turbines take advantage of faster wind speeds to generate the most energy.

VERTICAL AXIS WIND-GENERATOR SYSTEM Vertical axis systems consist of vertically oriented blades revolving on the vertical axis. These turbines have a greater surface area for capturing more energy and are multidirectional, which means they do not have to face the wind directly. They have a simpler design than the horizontal axis systems and therefore are easier to maintain. In addition, they can be placed in more locations, including parking lots and highways. Because vertical axis systems operate at lower speeds, birds do not get caught in the blades. New research in design and construction of vertical axis turbines shows a great potential for increasing their efficiency in the near future.

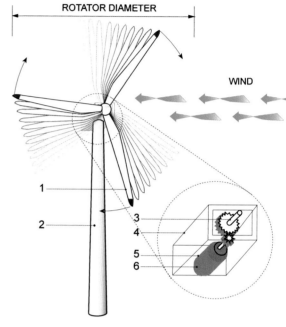

1. Rotor Blade
2. Tower
3. High-Speed Shaft
4. Gear Box
5. Generator
6. Low-Speed Shaft

Fig. 5.1-10 Horizontal Axis System Wind Turbine

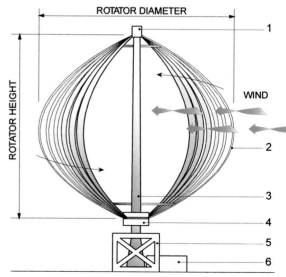

1. Upper Hub
2. Rotor Blade
3. Tower
4. Lower Hub
5. Gear Box
6. Generator

Fig. 5.1-11 Vertical Axis System Wind Turbine

Energy Sources and Storage

Geothermal Energy

Geothermal energy is heat obtained from the earth. This heat is produced by the geothermal activity or the decay of naturally radioactive materials such as uranium and potassium located deep in the earth. Geothermal energy can be accessed by capturing the heat from hot rocks, in the form of steam or hot water, located a few miles or deeper below the earth's surface. Geothermal energy concentration varies based on geographical location and is not available everywhere. In some areas, adequate concentration produces heat flow to shallower depths which makes it easier to access. This type of geothermal energy is often referred to as geothermal power. It has the potential for generating significant amounts of electric power.

Another type of geothermal energy refers to the contained energy in shallow ground. This energy can be accessed by shallow heat pumps. It can be an efficient source for cooling and heating of individual buildings. These systems are discussed in Section 4.3.

GEOTHERMAL POWER Geothermal power plants are installed where a geothermal site has been identified. In these plants, hot water and steam from the geothermal activity are directed to the surface utilizing deep pipes placed in the earth. The hot water and the steam are then redirected to drive steam turbines that run generators, producing electricity. The cycle of energy is renewed because steam returns to its liquid state in condensers. Most of the residual heat evaporates, and the remaining hot water is reinjected into the reservoir.

Biomass, Hydropower and Hydrogen Energy

In addition to solar, wind, and geothermal energy, the use of other sources of renewable energy, such as biomass, hydrogen energy, and hydropower, are becoming more widespread. Biomass is the solar energy stored in organic matter such as plants, animal waste, and aquatic vegetations. This energy is released as heat when the organic matter is burned or converted. Energy released from biomass is used to produce power and fuel. Hydrogen is found in many organic compounds, as well as water. Hydrogen is an abundant element, however it does not occur naturally as gas. It is always combined with other elements. Once hydrogen is separated, it can be burned as fuel or converted into electricity. Hydroelectric power or hydropower is the energy harnessed from moving water that can be converted to electricity. With the increasing cost of fossil fuel and improving production technologies, these renewable energy sources are becoming more efficient and economically viable solutions.

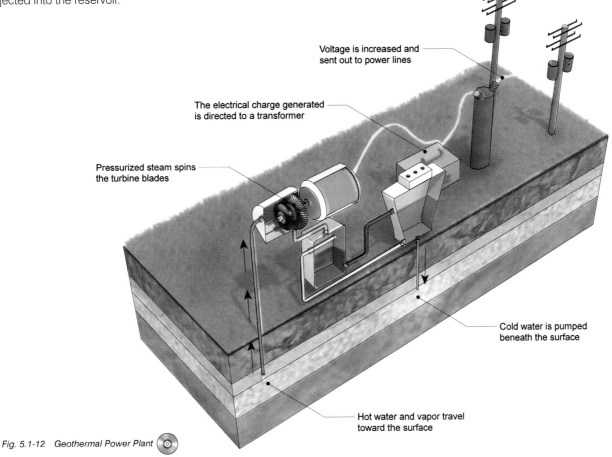

Fig. 5.1-12 Geothermal Power Plant

5. Renewable Energy

Energy Storage Systems

One of the greatest impediments to the more extensive use of renewable energy is the lack of adequate storage capability. Because the availability of solar and wind energy fluctuates both with the time of day and seasonal changes, adequate storage capacity is a critical component in providing a steady source of energy for buildings. Energy can be stored in thermal storage reservoirs or batteries. Thermal energy storage holds energy in thermal reservoirs such as large water tanks, concrete slabs, or phase-change materials for later use. Thermal storage can be used to balance energy demand between daytime and nighttime to avoid power outages due to high peak demand. Battery storage systems use the same electrochemical reactions used in car batteries, but have a much greater storage capacity and can supply power for longer periods.

COOL THERMAL STORAGE (CHILLER TANKS) Cool thermal storage or chiller tanks offer storage for sizable amounts of cool thermal energy to be used for building operations. These storage systems are typically composed of a large tank filled with water (or another medium) that may have several smaller containers filled with phase-change material (PCM) (see Section 2.1). During the off-peak demand period, the chiller produces cool water that flows to the tank, solidifying the PCM. Because the PCM has a lower temperature than that of the building's chilled water temperature, it drops the storage tank's temperature.[1]

In general, the selection of the storage medium and distribution of the stored energy will determine the size of the storage tank and the configuration of the cooling systems. The choice of storage medium includes chilled water, ice, and phase-change materials, or eutectic salts (salts with low melting points) which are typically cooled by refrigeration compressors.

HEAT THERMAL STORAGE (SOLAR TANKS) Hot water collected from solar panels can be stored in thermal tanks. The stored water can be used for domestic water or space heating. Most practical active solar heating systems can store a few hours to a day's worth of heat. There are also a growing number of seasonal large-scale thermal storages used to store summer heat for space heating during winter or summer cooling for space cooling during the hot season.

REFERENCE

1. Kurt Roth, Robert Zogg, and James Brodrick, "Cool Thermal Energy Storage," Emerging Technologies, ASHRAE Journal Vol. 48, September 2006. http://www.tiax.biz/publications/cool_thermal_energy_storage.pdf

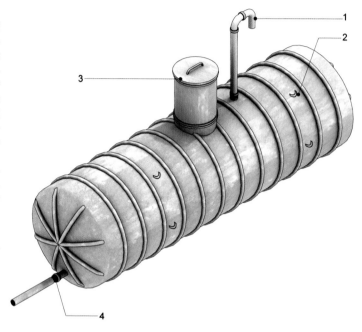

1. Upper Hub
2. Rotor Blade
3. Tower
4. Lower Hub
5. Gear Box
6. Generator

Fig. 5.1-13 Insulated Cool Thermal Storage Tank (Axonometric)

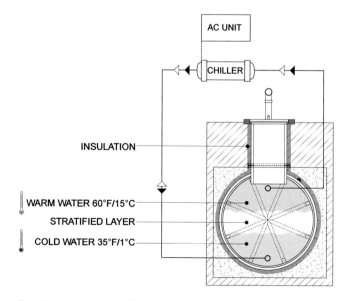

Fig. 5.1-14 Insulated Cool Thermal Storage Tank (Section)

Energy Sources and Storage

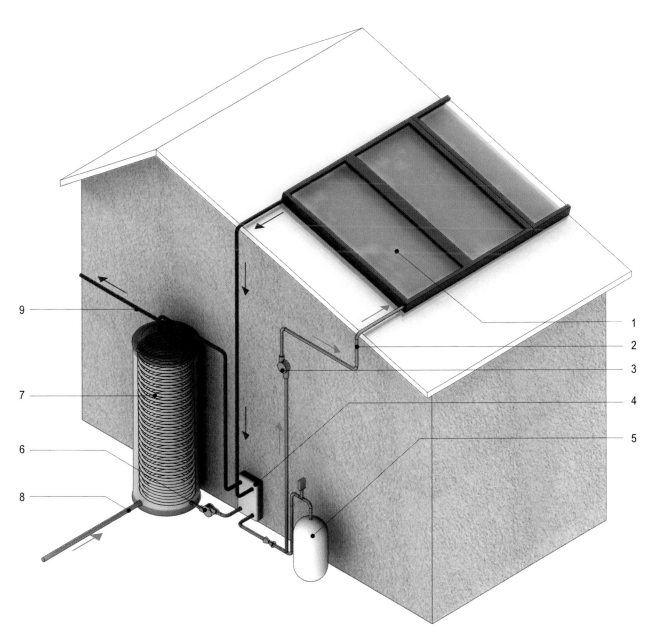

1. Solar Collector
2. Insulated Pipes
3. Collector Circulation Pump
4. Heat Exchanger
5. Expansion Tank
6. Storage Circulation Pump
7. Storage Tank
8. Return from Heating Energy Source
9. Supply to Heating Energy Source

Fig. 5.1-15 Heat Thermal Storage (Solar Tank)

Lighting

Prior to the invention of electricity, natural lighting was the only abundant light source for illuminating buildings. As a result, the orientation and form of buildings, openings on façades, size and placement of windows, and the location of rooms were guided by the availability of daylight. The building form and façade/room relationships changed dramatically with the invention of artificial lighting. Today, the use of artificial lighting in a building accounts for a significant portion of the building's electric energy consumption.

As sustainability of the built environment is becoming critical, the use of natural lighting is being reconsidered and is gaining in significance. Many technologically advanced buildings are now designed to harness natural light for illumination and to use artificial lighting only as an auxiliary system. Innovative lighting strategies, such as utilizing sensor technology, efficient lighting systems, and lighting control devices, are also making it possible to reduce the use of artificial lighting to sustainable levels.

A naturally lit and bright living or workspace can improve quality of life, improve user productivity and reduce the building's life-cycle cost, while minimizing adverse impacts on the environment. The following sections will discuss some basic concepts and strategies that utilize natural and artificial lighting in a sustainable and energy-efficient way.

6. Lighting

6.1 Concepts

An understanding of how light influences our visual perception, needs, and experience of the environment is essential for lighting design in buildings. The effect of lighting on interior space arrangement and identifying the visual needs of occupants for specific tasks are also important to acknowledge. In addition, the designer should consider the value of physiological and psychological effects of brightness, color patterns and aesthetics on visual acuity, particularly in spaces occupied for extended periods.

Measuring Light

Only a small portion of the electromagnetic spectrum in the approximate range of 380–780 nanometers (nm) is visible to the human eye. Visible light is perceived in a variety of colors, from the longest visible wavelength of red (700 nm) to shorter wavelengths of orange, yellow, green, blue, and violet (400 nm). Although white light has an equal mixture of all the wavelengths, black is a result of no light.

LUMINANCE AND BRIGHTNESS Luminance (L) or luminous intensity (LI) is the measurement of light brightness emitting from an object or surface. Luminance also refers to the human perception of the brightness sensation that is reflected off the surface. Brightness is a function of the object's actual luminous intensity, including the reflections of adjacent surfaces and objects. Luminance can be objectively measured by a light meter or photometer. However, the human perception of brightness has individual limitations based on the relative perceiver's physiological and psychological conditions and the influence of colored or reflective surroundings. Luminance units are expressed in candelas or candlepower per square foot (cd/f^2) or per square meter (cd/m^2).

IILUMINANCE Illuminance (E) describes the incident and density of light per unit area hitting a given surface or plane. Illumination is commonly known as light level and is measured in foot-candle (fc) or lux (lx). Foot-candle is the U.S. standard unit measuring the illumination of one candlepower or one candela per one square foot of a surface that is one foot away from the light source. Lux is the metric unit (SI) that indicates the illumination of one lumen per square meter that is one meter away from the light source. One lux equals 0.093 foot-candles.

LUMEN OR LUMINOUS FLUX Luminous flux is the monochromatic light portion of the electromagnetic spectrum that is perceived as light

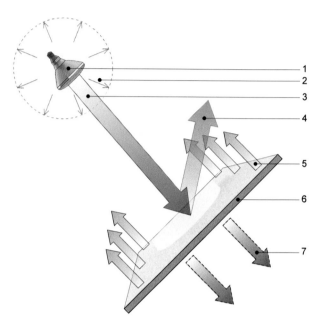

1. Light Source
2. Luminous Flux (Lumen)
3. Luminous Intensity (Candela or Candlepower)
4. Reflected Luminance at Specific Angle (Candela per Square Foot)
5. Illuminance (Foot-Candle or Lux)
6. Translucent Surface
7. Transmitted Luminance at Specific Angle (Candela per Square Foot)

Fig. 6.1-1 Luminance and Brightness

Concepts

by the human eye. Luminous flux is also called luminous power or photometric power. The unit of luminous flux is the lumen (lm) in both SI and IP units. Lumens express the total light output of a light source and measure the intensity of light emitting or radiating out from a surface. A higher lumen rating indicates a brighter light, but the overall life span of the light source can be different. When using artificial lighting, lumens provide a base for comparing various lighting technologies in terms of their energy consumption, heat generation, overall life-cycle span and costs.

There are some limitations to the human's perception of luminous flux because many light sources are not monochromatic, but produce luminous intensity in different parts of the electromagnetic spectrum. Each light source or luminaire originates from a different location in the electromagnetic spectrum and has its own luminous efficiency rating in lumens/watt.

LUMINOUS EFFICACY Luminous efficacy is the term used to denote lighting efficiency. Luminous efficacy indicates the amount of lumens emitted per watt of electricity consumed. Luminous efficacy measures the perceived brightness of a specific light source in lumens per watt (lm/w). Lumens per watt can be also used to measure the intensity of natural light penetrating through glazing in buildings (depending on the glazing types and properties). Light sources with high luminous efficacy consume less energy while maintaining a high quality of light.

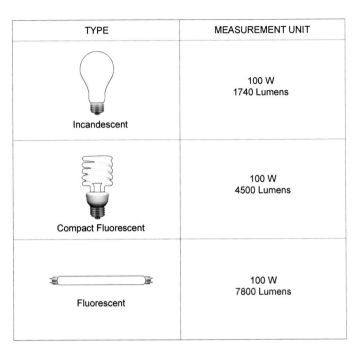

Fig. 6.1-2 Examples of Light Output from Different Light Sources

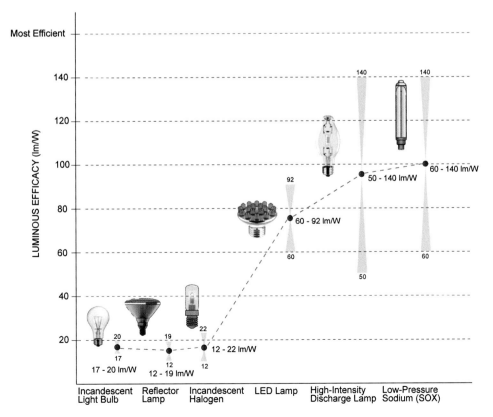

Fig. 6.1-3 Luminous Efficacy for Different Light Sources

6. Lighting

CANDELA Candela (cd) or candlepower (cp) is the SI unit of luminous intensity that measures the rate at which light leaves the incident light source. Candela indicates the amount of light produced by an object in a given direction at a precise frequency. Manufacturers of light sources provide candela distribution graphs, charts or tables for each of their luminaires to indicate the luminous intensity of their lighting products.

CHROMATICITY The color of illumination can be described by chromaticity or correlated color temperature (CCT). Chromaticity refers to the color appearance of a light source. A low CCT indicates a warm color temperature; a high CCT value indicates a cool color temperature. Lighting designers use chromaticity diagrams, spectral energy distribution (SED) or spectral power distribution (SPD) diagrams to determine the different color content and temperature of any light source. Quantifying chromaticity is an attempt of objective measurement of the color value independent of its luminance. Quantifying chromaticity not only involves the color characteristics of one object, but it also involves the various background effects with hue and saturation intensities from low

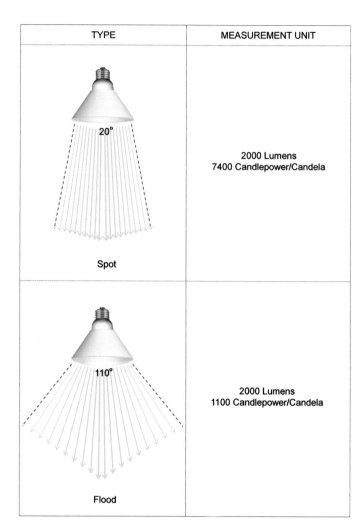

Fig. 6.1-4 Examples of Spot and Flood Light Luminous Intensity

Concepts

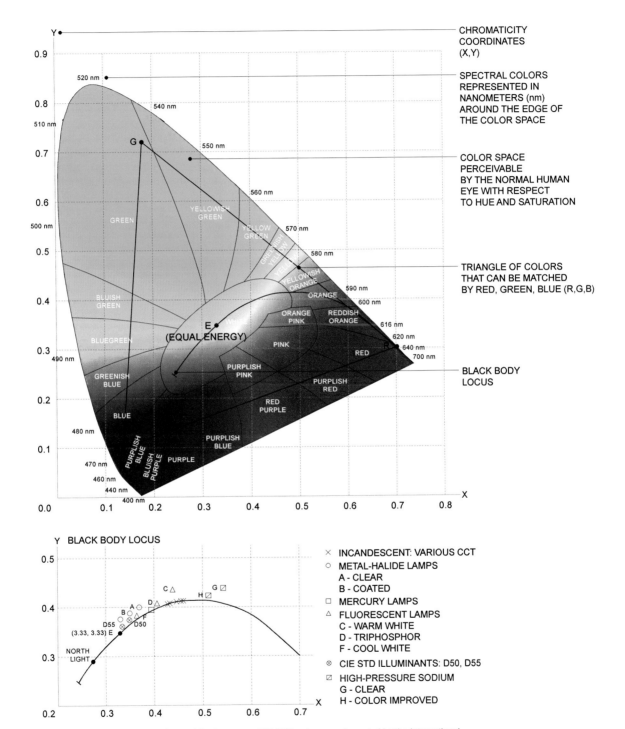

Fig. 6.1-5 Chromaticity Diagram

6. Lighting

Light Transmittance

Light rays travel in a straight line from a source at a specific wavelength until they strike a physical surface or a plane. When incident light encounters a medium, it may be transmitted, absorbed, reflected or refracted based on the material properties of that medium. A medium may be transparent, translucent or opaque.

VISIBLE TRANSMITTANCE The amount of light transmitted though glass is called visible transmittance (VT) or visible light transmittance. VT is expressed by a number between zero and one: zero indicating no light passing through and one indicating all the light passing through the glass. VT is influenced by the glass color, the inner and outer coatings and the number of glazing layers. Clear glass has the highest VT, but also produces glare, contrast, and unacceptable heat gain or loss. Adding a tint, or applying a color coating or a reflective film to a glazing surface can reduce the VT. Most glass treatments used for reducing VT also reduce heat gain or loss from the ultraviolet and infrared portion of the solar spectrum. Energy-efficient glazing of façade systems with double low-E (refer to Section 6.2) and triple-pane glazing varies between 0.30 and 0.70.

TOTAL ULTRAVIOLET TRANSMITTANCE Ultraviolet transmittance (UV) occurs between 280 and 380 nm and has potential effects on various glazing materials, objects and fabrics. As a result, an object's protective surface might fade and lose its original character or performance quality. The UV transmittance factor (UV tm) quantifies the ability of glass to reduce fading by measuring the effects of both transmitted UV and visible light. The total UV tm is regulated by the International Standards Organization in the category "Damage Weighted Transmittance (Tdw-ISO)" and by the International Commission on Illumination (CIE), an international authority on lighting and illumination.

TOTAL INFRARED TRANSMITTANCE The infrared transmittance (IR) segment of the solar spectrum encompasses wavelengths between 780 and 4000 nm and has a heat radiation impact on a range of transparent materials when surfaces are exposed to intensive IR light. According to the CIE, the IR radiation does not cause fading directly; however, the produced heat by the absorption of IR radiation can significantly influence the fading process. Infrared transmittance is regulated by the International Standards Organization to assess the potential effects of heat impact on glazing materials.

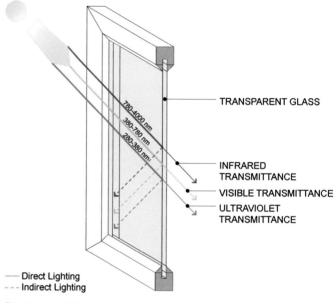

Fig. 6.1-6 Light Transmittance

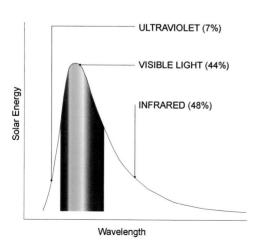

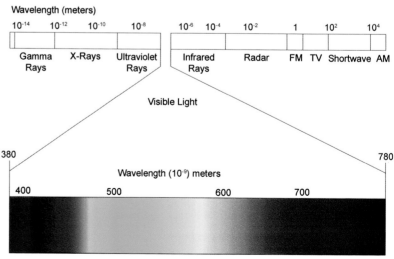

Fig. 6.1-7 Solar Spectrum

Concepts

REFLECTION When direct light strikes a surface, it bounces or reflects in different paths, depending on the texture of that surface. A highly polished object, such as a mirror, will reflect the light at the same angle as the incident light. This is called specular reflection. Diffused reflection is caused by matte surfaces and light is reflected in all directions. Uneven surfaces or surfaces with irregularities produce a spread reflection.

REFRACTION Light refraction occurs as light travels from one medium to another at different speeds. This causes light to bend and change its direction at the boundary between the two media. For example, when light passes through air (a transparent medium) and enters glass (another transparent medium) it is partially reflected and partially transmitted.

ABSORPTION Absorption refers to the energy from light that is absorbed in the volume of a material. It quantifies how much of the incident light is absorbed or reflected based on the properties of the material. Opaque objects absorb most of the light rays because light cannot pass through them. Opaque materials absorb and reflect all light waves.

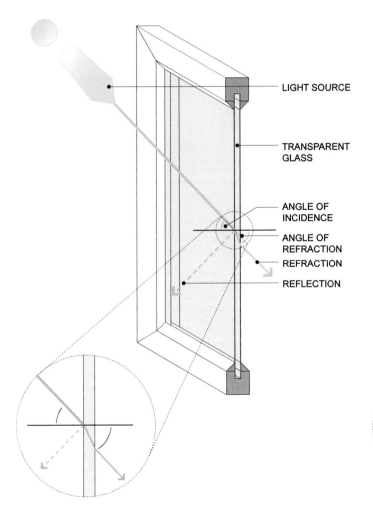

Fig. 6.1-8 Reflection and Refraction

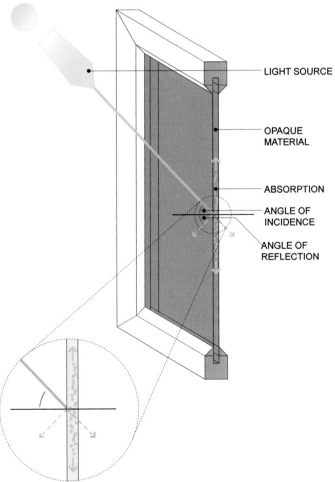

Fig. 6.1-9 Absorption

6. Lighting

Lighting Design

Lighting design demands an intricate balance of many competing requirements, such as providing visual comfort and acuity, and sense of orientation, meeting the building's programmatic and aesthetics needs, and minimizing energy consumption. Lighting distribution in a space should be appropriate and adaptable to the performed activities, to the time of day and to individual needs. A consideration of glare, reflectance, brightness, surface textures, color, and contrast is critical in lighting design to achieve visual age-based comfort, particularly in spaces occupied for extended periods.

GLARE Glare is one of the main factors in visual discomfort. Glare is produced by an excessively bright source of light within the visual field, either daylight or artificial light. Glare can also be created by a strong light reflection from surfaces in the space and in the surroundings such as windows and glass façades. Window openings and artificial light sources should be designed to minimize glare.

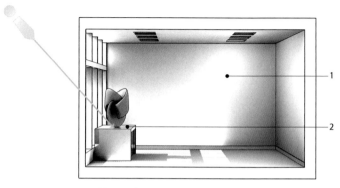

—— Direct Lighting

1. Glare Reflected into Interior
2. Reflective Surface

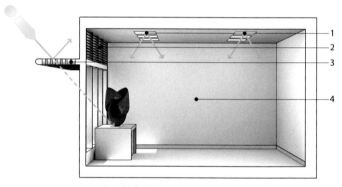

—— Direct Lighting
--- Indirect Lighting

1. Uniform Electrical Light Distribution
2. Sun Screen
3. Sun Shade
4. Reduced Glare

Fig. 6.1-10 Glare

Concepts

BRIGHTNESS Brightness is another factor that can contribute to visual discomfort. Brightness is dependent on how much light is emitted, reflected, or transmitted from an object. Brightness is a relative concept and becomes problematic when there are large differences between the brightness of various surfaces within a space. The brightness ratio consists of the ratio of the brightest surface to the least-bright surface in the field of vision. To avoid visual discomfort, the brightness ratio should not exceed 3:1.

CONTRAST Visual contrast refers to the relationship between the luminance of an object and its background. An object is distinguished from its background only if there is visual contrast. Some level of contrast may be desirable in a space for visual effectiveness, but excessive brightness contrast can cause visual discomfort. To reduce unwanted contrast, wall areas next to windows should be illuminated by another light source. In general, admitting light from multiple directions, rather than a single direction, will reduce contrast.

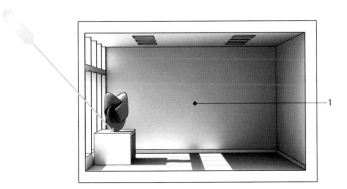

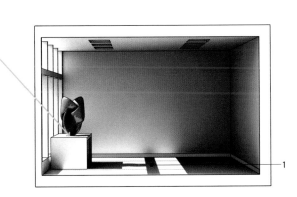

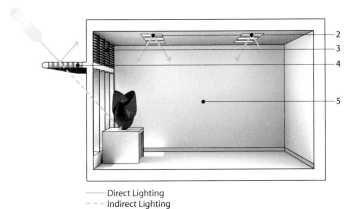

—— Direct Lighting
- - - Indirect Lighting

1. Irregular Natural Light Distribution
2. Uniform Electrical Light Distribution
3. Sun Screen
4. Sun Shade
5. Reduced Brightness

Fig. 6.1-11 Brightness

—— Direct Lighting
- - - Indirect Lighting

1. High Contrast
2. Uniform Electrical Light Distribution
3. Sun Screen
4. Sun Shade
5. Reduced Contrast

Fig. 6.1-12 Contrast

6. Lighting

6.2 Natural Lighting

Natural light provides ecological, psychological, and economical advantages by reducing the need for electric lighting. Illuminating buildings using natural light also provides interior spaces with visual comfort, stimulating environments, increased user productivity and improved operating and life-cycle cost. However, utilizing natural light properly is challenging in that it requires minimizing the adverse effects of sunlight, heat gain, glare, and excess contrast. Natural light can be utilized directly with carefully selected glazing types and coatings or indirectly through controlled shading, filtering and redirecting techniques as well as using the ambient light in cloudy skies.

Solar Radiation

The solar spectrum consists of approximately 4 percent of ultraviolet radiation with a wavelength range of 280 to 380 nm; 45 percent of visible radiation or natural light with a wavelength range of 380 to 780 nm; and 51 percent of infrared radiation (IR) with a wavelength range of 780 to 2500 nm . When using natural light for illumination, the solar spectrum producing light is accompanied by infrared long waves that produce a significant amount of heat energy. Eliminating or reducing solar radiation accompanied by natural lighting can be achieved by implementing a range of solar controls and strategies such as using various types of glazing, coatings, transparent insulating materials, controlled shading elements, light redirecting and deflecting devices.

SUNLIGHTING Solar orientation and access to direct light or sunlighting plays a significant role in the natural illumination of interior spaces. However, sole illumination through sunlighting is not always adequate or the best choice. For example, in the cold climate zones of the northern hemisphere where overcast skies are the prevalent condition, the access to direct sunlight may be extremely limited. Direct sunlighting in hot climate zones can also be problematic because direct sunlighting is often associated with significant heat gain. Redirecting or filtering devices avoids direct lighting and provides a viable alternative to direct sunlighting.

DAYLIGHTING AND APERTURE LOCATION In climates with predominantly overcast skies, reflective light from the sky dome can provide ample opportunities for natural illumination of the interior spaces. In these climates, utilizing large and high openings without shading devices will aid in illuminating the space more effectively. In general, admitting daylight from above brings light deeper into the space and provides better illumination. Increasing ceiling heights creates better light distribution and improves daylight utilization.

It is important to distinguish the view function of glazing from its natural light-delivery function. The provision of daylight alone, for example, through skylights or redirecting devices, will not automatically satisfy user desires for views of the sky, horizon, and ground. Windows placed above 7'-6" (231 cm) are considered to be daylight glazing. Glazing at this height is best to distribute light deep into the space, while windows located above 2'-6" (76 cm), but below 7'-6" (231 cm), are considered vision glazing.[1]

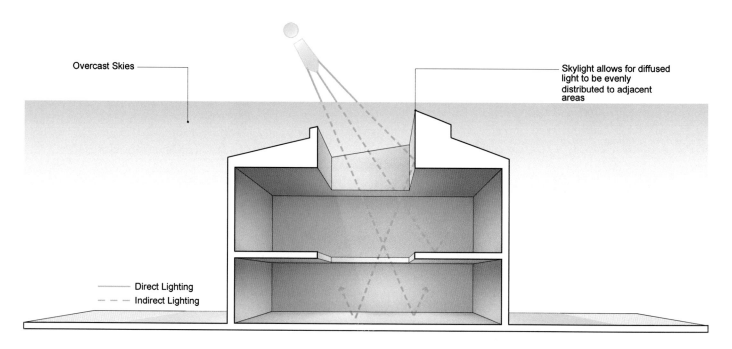

Fig. 6.2-1 Daylighting and Aperture Location

Natural Lighting

Climatic Zones and Sunlighting

The amount of sunlight received in a building is a direct effect of the specific angle at which sun rays strike the Earth's surface at the specific latitude, longitude, and altitude, and varies based on climatic zone and climate change throughout the year. The exact position of the sun in the sky in different latitudes can be studied from a sun-path diagram. During the summer season, the sun rises slightly south of east and sets slightly south of west in the southern hemisphere, while in the northern hemisphere, it rises considerably north of east and sets north of west. In cold climates, the solar heat energy is less intense because the sun rays are at a lower angle and extend over a larger area. In warm climates close to the equator, the sun angle is higher and the sun rays strike the Earth almost at a straight angle. The sun rays are concentrated on smaller areas and therefore produce much higher heat energy.

HOT AND HUMID ZONE The summer solstice angle in the hot and humid climate zones is close to 90° (solar radiation directly overhead on June 21st). Maximum sunshine with the highest altitude at noon occurs mostly in midsummer from June to August. To avoid excessive heat transfer, controlled shading and daylight-redirecting systems are necessary throughout the year. Horizontal systems should be located in the south façade; vertical systems should be located on the east and west façades due to lower sun angles. In these climates, exterior shading devices often work well to both reduce heat gain and to diffuse or redirect natural light before entering the building interior. Shading devices include fixed, dynamic or adaptable horizontal and vertical louvers, light shelves, overhangs, and dynamic tracking or reflecting systems.

HOT AND ARID ZONE Solar radiation is intense in the hot and arid climatic zones. Sun rays strike the Earth's surface at steep angles during the summer and at lower angles during the winter. The maximum amount of sunshine occurs from June to July. Similar to hot and humid climates, controlled shading and daylight-redirecting systems are critical for reducing solar heat gain on the east and west sides due to the lower sun angles. Depending on the latitude, in northern hot and arid climate zones such as the Mediterranean areas of Europe, northeast and northwest shading may also be required.

TEMPERATE ZONE The distribution of clear and cloudy days is almost uniform throughout the year in the temperate zone. The sun is never directly overhead and the maximum amount of sunshine occurs from June to September. Shading and daylight-redirecting and controlling systems are necessary for intense exposures during the hot climate on the east, northeast, west and northwest sides of buildings when the sun angles are the lowest and radiate directly on façades.

COLD ZONE Sun angles are very low in the cold climatic zones, striking the south face of a building at relatively direct angles. Sunlight is poorly distributed throughout the year. Too much solar radiation during the summer and not enough in winter makes passive solar heating and harnessing natural lighting challenging.

Carefully designed light shelves, horizontal louvers in the south and vertical louvers in the east, northeast, west and northwest, efficient light-reflecting materials, and fixed or automatic daylight tracking or redirecting systems help to increase daylight harnessing throughout all the seasons.

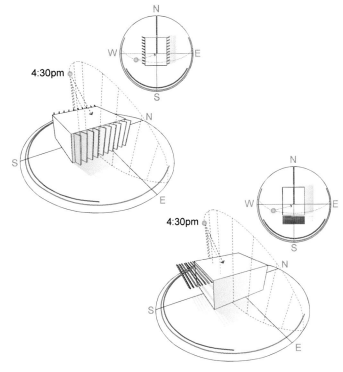

Fig. 6.2-2 Sun Path in Hot and Humid Zone (Miami, FL)

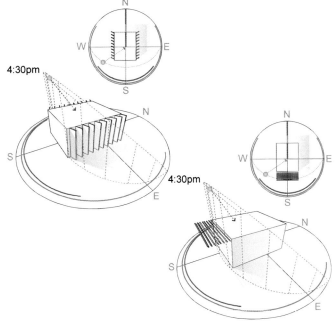

Fig. 6.2-3 Sun Path in Cold Zone (Minneapolis, MN)

6. Lighting

Glass

Solar radiation entails ultraviolet radiation, infrared radiation, and visible light. Glass for windows varies in transmission properties and capabilities and performs differently in each of the climatic regions. Clear glass has the highest rate of visible daylight transmittance and heat transfer. However, new and continuously emerging glazing technologies make it possible to produce a wide range of colored, coated, and insulated glazing that better controls daylight, glare, IR, UV, and contrast issues while reducing excessive heat transfer as well as reducing the need for artificial lighting.

GLASS THERMAL TRANSMITTANCE (U-VALUE) Thermal transmittance is the heat transfer or heat loss through glass due to the temperature difference between the exterior and the interior environment. Thermal transmittance is indicated by the U-value in units of Btu/ft^2/hr/°F or W/m^2/°k. A glass with a low U-value is more effective in reducing heat loss. Low U-values can be achieved by providing insulation between layers of glass (air space or a poor conductor such as krypton or argon gas) or by adding low-emissivity coating to block heat radiation between the layers of glass.

SOLAR HEAT GAIN COEFFICIENT (SHGC) The solar heat gain coefficient (SHGC) measures how well glass blocks heat caused by sunlight. The SHGC is the fraction of solar radiation that is admitted through glass and is expressed as a number between 0.0 and 0.87. Lower values indicate lower transmittances. Typical values of SHGC range from 0.25 to 0.80.

LIGHT-TO-SOLAR-GAIN RATIO The light-to-solar-gain (LSG) ratio, or glazing efficacy, is a quantitative measure of the capability of glazing to pass light into the building interior without excessive solar heat gain. LSG is a ratio of the SHGC to the visible transmittance value of the glass. In general, a greater LSG ratio indicates a more appropriate glazing for natural lighting in cold climatic zones.

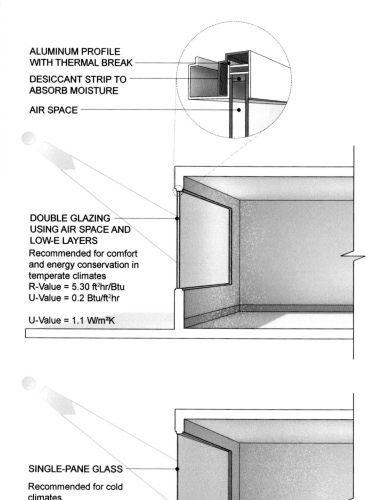

Fig. 6.2-4 Example of Glass Performative Values of Double Glazing

Fig. 6.2-5 Examples of R- and U-Values for Single and Double Glazing

Natural Lighting

Glass Types

Glass is manufactured to serve a wide range of specialized applications. Glass types include float glass, mirrored glass, security glass, and laminated glass. Glass referred to as smart glass can change its transmission properties based on an electric signal (electrochromic glass), the temperature (thermochromic glass) or the amount of available light (photochromic glass) to increase both its thermal and optical performance. Glass manufacturers offer a wide variety of tints, metallic and low-emissivity coatings, frittings, and holographic films. In addition, multipaned glazing systems filled with inert gases for improved thermal conductivity are readily available. In general, glass with a moderate-to-low shading coefficient and relatively high visible transmittance is recommended for daylighting of buildings in most climatic zones.

LOW-EMISSIVITY COATING Low-emissivity (low-E) coating is achieved by adding microscopically small metal or metallic oxides to the glass surface. Low-E coating is added to reduce solar heat gain by reflecting long-wave radiation while allowing short-wave radiation in the visible light range to pass through. Low-E coating is generally applied to the inner pane of glazing. Low-E glass is also referred to as spectrally selective glass.

INSULATING GLASS Insulating glass and multiple insulating glass units consist of two or more low-E glazing panes that enclose a sealed cavity space. The cavity space between glazing panes may have air or be filled with inert gasses such as argon or krypton with low thermal conductivity. Insulated glass improves façade performance by reducing heat loss, decreasing condensation, and providing soundproofing.

REFLECTIVE GLASS Reflective glass is a common type of float glass that is treated with a metallic reflective coating in order to reduce solar heat gain. The thin metallic coating produces a mirror effect, increasing the reflectivity of the glass and thus lowering the solar heat gain coefficient (SHGC). Reflective glass blocks some natural light from entering the interior space, which may lead to an increase in demand for artificial lighting. The mirror effect produced by the coating will reduce visibility from the outside into the building's interior.

ELECTROCHROMIC GLASS Electrochromic glass changes from a transparent appearance to a dark color, blocking solar heat transmission without impacting visibility. This type of gazing can alter its color and heat transmission property when subjected to a low-voltage current through a microscopic coating embedded on its surface. Activation of the current can be achieved directly by the user or by light sensors that are controlled by the building's management system. Electrochromic glass is an energy-efficient alternative to using window shades and blinds for blocking solar heat.

THERMOCHROMIC GLASS Thermochromic glass is a type of glass with embedded polymer layers that are sensitive to heat. As the temperature rises, the glass changes from clear to opaque, thus reducing transmission of solar radiation. Because the change in the glass opacity is reversible, changing opacity is an effective mechanism to control heat gain. Although changing the glass opacity does not need energy input, it can cause an increase in electric lighting cost because it blocks sunlight to limit solar heat gain. Another disadvantage of using thermochromic glass is the lack of user control to modify thermal control and visibility.

PHOTOCHROMIC GLASS Photochromic glass is a type of glass coated with a film of photochromic material. This film is composed of a UV-sensitive material that changes color by becoming darker in response to sunlight. This change in color is a result of a chemical reaction in the material and thus does not require energy input. Photochromic glass is not suitable for cold climatic zones because as it becomes dark when exposed to low sun rays, blocking heat gain along with sunlight. In addition, the manufacturing process for photochromic glass is sophisticated and currently cost prohibitive for use in buildings.

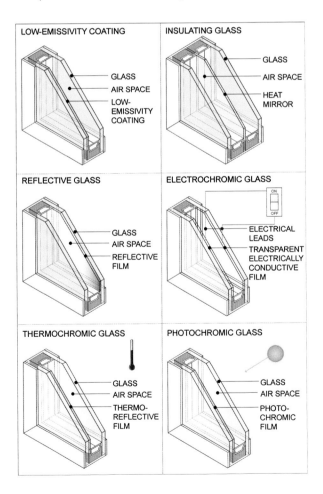

Fig. 6.2-6 Glass Types

6. Lighting

Design with Natural Lighting

Natural lighting can be used to illuminate interior spaces to provide visual comfort. Carefully designed shading devices and light-redirecting systems allow adequate daylight distribution and reduce unwanted heat gain while controlling uncomfortable brightness, contrast and glare. Natural lighting with the integration of automatic and artificial lighting controls, such as dimming and switching controls, provides efficient ambient illumination and adequate task illuminance. Combined natural and artificial lighting can also help to achieve energy savings and occupant satisfaction goals. The following sections explain some important factors in design with natural lighting.

DESIGN SKY ILLUMINANCE Design sky (Ds) illuminance values are used to assess the potential daylight levels outside the building that depend on the latitude of the location. The Ds illuminance levels for the design of natural lighting systems differ from around 12,000 lux to 15,000 lux at the equator down to about 3,000 lux to 4,000 lux at a latitude of ±60°. For example, Miami is located at 25° latitude and has approximated 9,100 lux, while Minneapolis is at 44° latitude with only 7400 lux of sky illuminance.[2]

Most daylighting and lighting energy software tools (such as Autodesk Ecotect, DAYSIM, Radiance, ADELINE, and AGi32) provide illuminance calculators to assist the designer with exterior illuminance values at specific latitudes. However, these values do not include the site-specific externally reflected components. These values have to be individually identified at the specific location through illuminance meters.

DAYLIGHT FACTOR Daylight factor (DF) is the ratio of the interior luminance on a given plane to the exterior luminance at a reference point under overcast sky conditions. The DF is always expressed as a percentage and is used to determine if a room has adequate daylight to satisfy user demands. The DF can be measured at a particular location or at a reference point in the interior space. This daylighting calculation methodology can be applied to approximate the DF for each room in relationship to the floor area, the visible transmittance (VT) of the window (or of translucent or transparent layers), and the geometry of the reflected components.

SOLAR ACCESS The location of the building's site within the natural, rural or urban environment can impact solar access for natural lighting as well as the thermal performance of buildings. To ensure solar access and prevent restrictions on utilizing natural light and solar energy, solar easements or solar right laws are placed in ordinances, codes, policies and master plans worldwide. These laws provide local governments with the authority to develop and enforce guidelines for proper zoning, street orientation, building height and setbacks that restrict shading neighboring building access to natural light and solar systems installation and operation.

TOPOGRAPHY Topography affects the availability of sunlight and the length of shadows cast from objects. In higher latitudes, the lower position of the sun in the sky results in longer shadows and more solar radiation. In general, south slopes are better for solar access, because in the lower latitudes sunlight hits the ground more perpendicularly, creating shorter shadows. In the lower latitudes, buildings can be placed closer together without obstructing solar access.

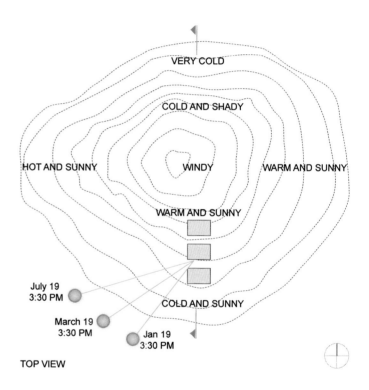

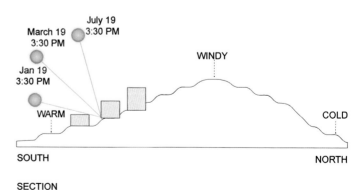

Fig. 6.2-7 Example of Sunlight Availability Based on Topography in Phoenix, AZ

Natural Lighting

URBAN CONDITIONS In an urban environment, adjacent structures can have a significant impact on the availability of direct sunlight and daylight. This can be an important consideration when designing in an urban environment because adjacent structures may block access to direct sunlight or daylight. Adjacent structures, especially with highly reflective surfaces, can create glare because direct light is reflected off surfaces. In addition, highly reflective surfaces can intensify the heat island effect and increase cooling loads in adjacent buildings.

SURFACE REFLECTANCE The reflectance of the various surfaces within a space is one of the most significant factors in the distribution of light. Reflectance should be kept as high as possible. Direct sunlight passing through a window only falls on a small portion of the total surface area of a room. The remaining surface area receives light through reflectance. Recommended surface reflectance for ceilings is more than 80 percent; walls, 50–70 percent; and floors,

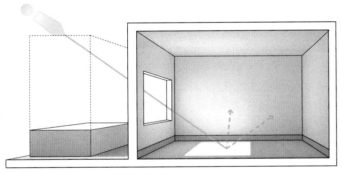

LOW ADJACENT STRUCTURE

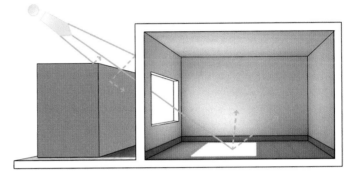

TALL ADJACENT STRUCTURE

Fig. 6.2-8 Adjacent Structure Conditions

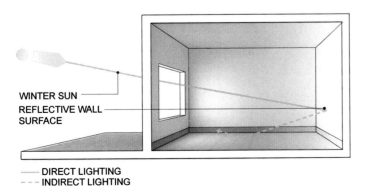

WINTER SUN
REFLECTIVE WALL SURFACE

— DIRECT LIGHTING
--- INDIRECT LIGHTING

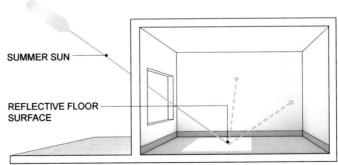

SUMMER SUN

REFLECTIVE FLOOR SURFACE

Fig. 6.2-9 Reflective Wall and Floor Surfaces

6. Lighting

about 20–45 percent.[3]

Side Lighting

Side lighting through windows is one of the primary methods of admitting light into a space. The optimal orientation of buildings and proper window openings require balanced considerations of daylighting and heat gain and heat loss through the window openings and glass. Size, geometry and window location are important factors for the quality of light and illumination of the space.

WINDOW SIZE Activity types occurring in a room should be considered when choosing window size and type. Some activities benefit from direct sunlight, while other activities are best performed in even, indirect light. When the reflectance of the interior surfaces remains constant, an increase in window size will increase the general illumination of a room.

WINDOW GEOMETRY The geometric configuration of a window can have a significant impact on the distribution of light within a space. When a narrow horizontal window is used, incoming light is reflected off the walls. Conversely, with a vertical window, light is reflected off the floor, ceiling, and walls. The least-effective distribution of light occurs with the conventional punched windows centered on the wall.

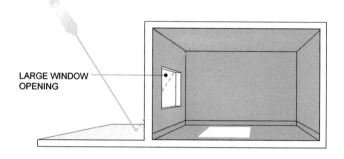
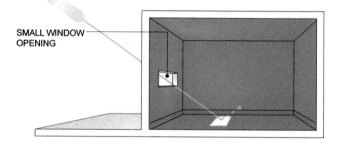

Fig. 6.2-10 Window Size Impact on the Illumination of a Room

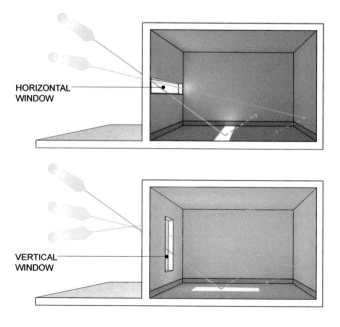

Fig. 6.2-11 Window Geometry Impact on the Illumination of a Room

Natural Lighting

WINDOW LOCATION Because most surfaces in a room receive reflected light, the darkest surface in a room is often the interior surface of the wall with the window. This surface is the least likely to receive reflected light because it is illuminated by light that has been reflected off two or three other surfaces. This situation can create a strong brightness contrast between the window and the interior wall with the window.

A window placed high on an exterior wall will distribute light deep into the space. However, there will be a strong brightness contrast with the lower portion of the wall. In addition, the room occupants will find themselves in direct sunlight without a view to the exterior landscape. A window placed low on the exterior wall will provide an even, albeit low, level of illumination throughout the room. With a window near the floor, brightness contrast is only a problem if the exterior ground surface is highly reflective.

CLEAR STORIES Clear stories are high windows that use light indirectly to illuminate the space. When located on the east face of the building, they collect morning light, while clear stories on the west side collect afternoon sun. On the south side, the clear stories collect more light from low sun angles than high sun angles. When placed on the north side, the clear stories are not as effective because they do not collect much sunlight.

CEILING HEIGHT An increase in ceiling height will often provide a more even distribution of light within a space, subsequently reducing brightness contrast. However, an expansive wall above a window can create a dark area on the interior of the wall, increas-

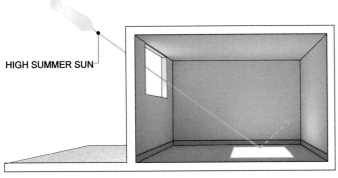

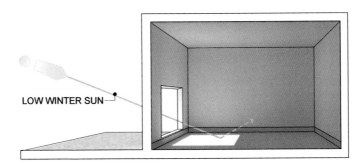

Fig. 6.2-12 Window Location and Light Distribution

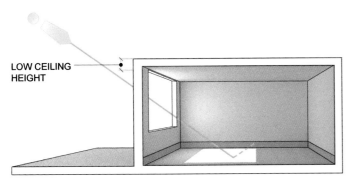

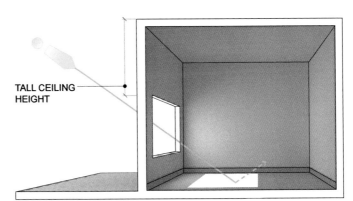

Fig. 6.2-13 Ceiling Height and Light Distribution

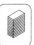

6. Lighting

ing brightness contrast when viewing out.

Light Shelves

Light shelves are an effective way to redirect direct sun rays and reduce heat gain. They are most effectively used on the southern face of the building located in areas with predominantly clear skies. Light shelves can help to distribute light evenly into the interior of a room by reflecting direct light on the ceiling plane. A highly reflective matte finish on the top surface of a light shelf allows light to be redirected deeper into the space. The light shelf projection to the room should be deep enough to block the high summer sun. It can also be projected beyond the building to block direct sunlight falling on the lower window. Too much projection will significantly reduce the light distributed within the space.

LIGHT SHELVES AND CEILING HEIGHT When light shelves are utilized, an increase in ceiling height can decrease the brightness contrast between the window wall and the portion of the room furthest from the window. Increasing the ceiling height will also reduce the bright spot on the ceiling plane directly above the window. However, increasing the ceiling height above an optimal level might reduce the effectiveness of the ceiling to reflect light onto the surfaces below.

ANGLED AND ROTATING LIGHT SHELVES A light shelf is most effective when positioned as a horizontal surface with a projection depth into the room to cut off the high summer sun. However, windows that are not oriented directly to the south may benefit by varying the angle of the light shelf and increasing the reflectance from exterior surfaces. Changing light shelf angle can provide the opportunity to project more light deeper into the interior space.

LIGHT SHELF POSITION Due to the angles of reflectance, the greater the distance between the light shelf and the ceiling plane, the deeper the light can be projected into the space and the more effective it will be in distributing light. However, other factors such as the effect on usable space and potential interference with views

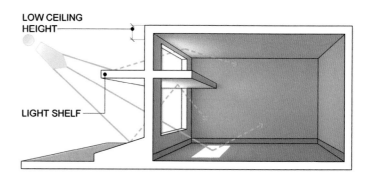

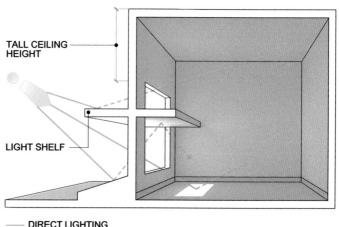

Fig. 6.2-14 Light Shelves and Ceiling Height

Natural Lighting

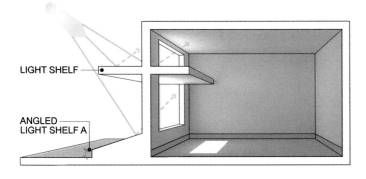

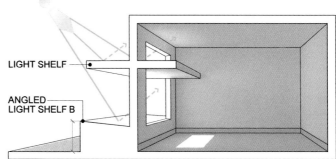

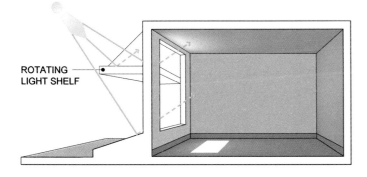

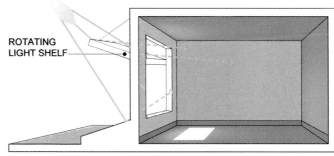

Fig. 6.2-15 Angled and Rotating Light Shelves

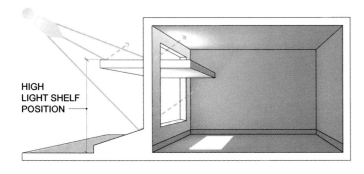

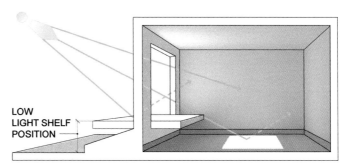

— DIRECT LIGHTING
--- INDIRECT LIGHTING

Fig. 6.2-16 Light Shelf Position and Light Distribution

6. Lighting

should be considered.

Top Lighting

Admitting daylight from the ceiling or the roof plane is called top lighting. In general, top lighting creates higher levels of illumination and more uniform lighting when compared to side lighting. Top lighting also reduces glare and penetrates deeper into the space. Because the location of the openings for top lighting can be independent of the building orientation, they can be oriented to capture more light with less impact on the building's solar heat gain.

TOP LIGHTING SIZE The amount of illumination provided by top lighting is directly related to the size of the opening. Top lighting is most effective for lighting vertical surfaces; therefore, selecting highly reflective wall surfaces can increase the general level of illumination within the space.

TOP LIGHTING AND SUN ANGLES As the sun moves into a position in which light is reflected on the adjacent wall, the illumination in the room increases significantly by the light reflected off the wall onto other surfaces.

TOP LIGHT TILT AND ORIENTATION Tilting the top light in the correct direction will improve the ratio of admitted light to heat gain. A high tilt will result in lower solar heat gains during the summer and higher heat gains in winter, which is desirable in cold and temperate climates. As a general rule of thumb, in order to optimize the top light tilt in various climatic zones, a slope equal to latitude of

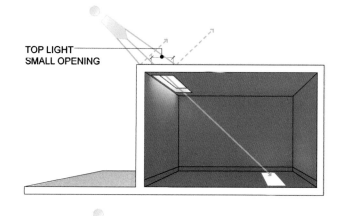
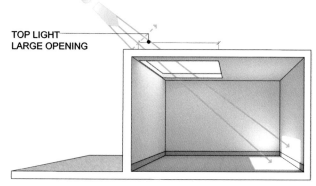

Fig. 6.2-17 Top Lighting Size Impact on the Illumination of a Room

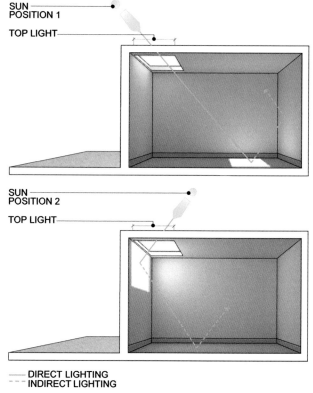

Fig. 6.2-18 Top Lighting and Sun Angle Impact on the Illumination of a Room

Natural Lighting

the location plus 5 to 15 degrees can be used.[4]

Natural Light Filtering and Redirection

Light-redirection systems are utilized to enhance the effectiveness of natural lighting. These systems work by changing the path of incident sunlight or indirect daylight to increase light penetration and produce a uniform illumination throughout the depth of the room. Daylight redirection technologies reduce the need for artificial lighting and minimize energy consumption while providing optimum daylight utilization.

Reflectors and Refractors

MIRROR REFLECTORS The amount of daylight penetration and distribution into a side-lit room decreases gradually toward the back of the room. Daylight reflection with mirrors allows an even distribution of light inside the space by redirecting incident sunlight into the depth of the room.

PRISMATIC SYSTEMS Prismatic systems are usually designed to reflect and refract incident sunlight. They are engineered to block certain angles of sunlight and refract and transmit others. Prismatic panels allow an effective use of daylight when used in conjunction with light reflectors on ceilings to increase daylight penetration into the depth of the room.

HOLOGRAPHIC SYSTEMS Holographic systems use the principle of refraction to redirect sunlight. They consist of films with three dimensional patterns attached to glazing which direct incident light

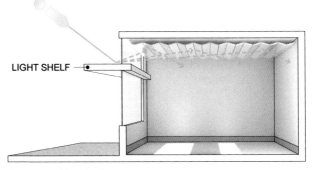

Fig. 6.2-19 Mirror Reflectors

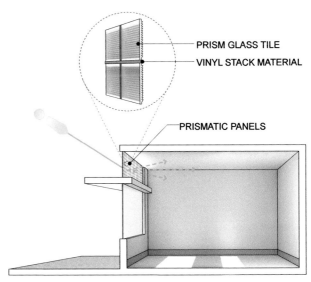

Fig. 6.2-20 Prismatic Systems

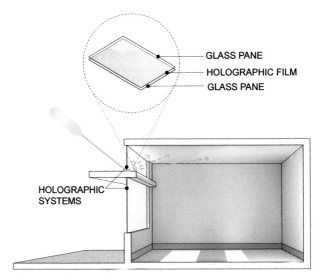

Fig. 6.2-21 Holographic Systems

6. Lighting

onto the ceiling to be reflected further back into the room.

LIGHT WELLS Light wells allow the penetration of deep ambient light into the building's interior. They provide indirect sidelight to adjacent spaces and top light to bottom spaces. High reflectance surfaces in light wells increase efficiency, providing significant illumination to the interior space.

SUNCATCHERS Suncatchers are vertical redirecting devices that are placed parallel to the building's façade. They can be used to capture low-angle sunlight on the east and west sides of the building and redirect light to adjacent walls or toward the ceiling. Suncatchers are also used in the north façade to capture incident sunlight and redirect it into the building's interior to increase illumination. Suncatchers can be used in conjunction with light shelves

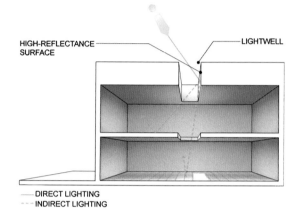

Fig. 6.2-22 Light Wells

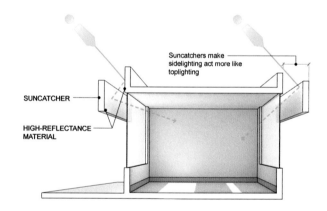

Fig. 6.2-23 Suncatchers

Artificial Lighting

6.3 Artificial Lighting

Appropriate selection of a building's interior lighting systems and luminaires can affect the physiological, psychological and productivity levels of the occupants. Energy-efficient light fixtures with long service life and minimal waste heat help to reduce electrical energy and excessive internal building heat loads. Integrating energy-efficient artificial lighting with natural light and advanced lighting-control systems provides comfortable and visually stimulating environments, reduces adverse impacts on the environment, and promotes health and work productivity. Facilities that combine natural lighting with energy-efficient artificial lighting also benefit from significant reduced operation cost.

Luminaires

Luminaires, commonly known as light fixtures, are optical devices that produce, control, and distribute light. They are complete lighting assemblies that consist of lamp(s), ballast(s), and auxiliary components that perform various functions, including redirecting and positioning light, protecting and shielding lamps, and connecting lamps to the power source.[5] Luminaires convert electrical power (watt) into luminous power (lumen), and the light yield is a general measure of efficiency (lumen/watt).[6] There are numerous variations of luminaires on the market, and each year new luminaires with higher efficacy, less environmental impact and a longer service life are produced and distributed.

LUMINAIRES TYPES There are many ways to categorize and select luminaires. Luminaires can be utilized for indoor and outdoor lighting in single, double, or multiple units. They can have direct, indirect or parabolic light distribution and may be used as symmetric or asymmetric installations. Luminaires can be mounted as pendants, suspended, and recessed or be portable. They may be equipped with glare control, various shielding elements, color-rendering intensity, and color temperature management capabilities. All exterior luminaires need to be resistant to moisture, water vapor, and corrosion, and should be protected from dust and insects. The most efficient luminaires are connected to space occupancy sensors and are dimmable using wireless controllers to save energy and respond to the occupant's lighting needs and comfort requirements.

LUMINAIRES PERFORMANCE METRICS Luminaire performance metrics and compliance reports are usually provided by lighting manufacturers and through independent industry standards and testing procedures managed by international and national lighting authorities. Luminaire performance compliance reports consist of the luminaire description, the luminaire or light-intensity distribution graphs, the correlation of light color and color temperature, heat mitigation, equipment and operation costs, maintenance, and life service.

LIGHTING AUTHORITIES The International Commission of Illumination is the leading global organization on light, illumination, and color. The International Association for Energy-Efficient Lighting (IAEEL), the International Organization for Standardization (ISO), and the International Electrotechnical Commission (IEC) are further informative resources on efficient lighting products, standards and techniques.

In the U.S., technical standards and guidelines are provided by the National Electrical Contractors Association (NECA) and the National Electrical Manufacturers Association (NEMA). All electrical lighting equipment must comply with the U.S. National Electrical Code (NEC) and must be certified by Underwriters Laboratories (UL) standards and the American National Standards Institute (ANSI). The American Society of Heating, Refrigerating, and Air Conditioning Engineers Inc. and the Illuminating Engineering Society of North America ASHRAE/IESNA 90.1-2011 and Energy Star Standards are responsible for energy use codes.

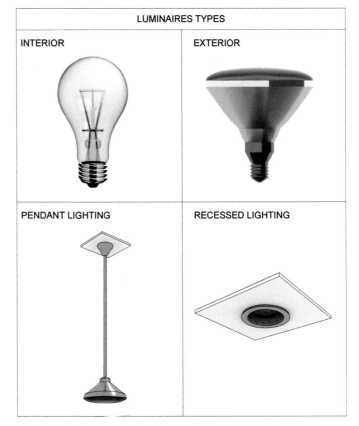

Fig. 6.3-1 Luminaires Types

6. Lighting

Light Sources

Most light sources utilize one of the three main technologies that generate light via electricity. These include incandescent sources that produce light by passing an electric current through a filament, gas discharge or fluorescent sources that produce light by passing electric current through a gas, and solid-state light (SSL) sources, that utilize semiconductor technology to convert electricity to directional light beams.

In the near future, SSL sources such as sodium- and mercury-free light-emitting diodes (LED) and organic light-emitting diodes (OLED) will become significantly more cost effective and competitive with incandescent and fluorescent lighting sources. SSL technology offers a considerably more efficient lighting source with much longer service life span, higher quality light, and a less adverse impact on the environment. According to the U.S. Department of Energy, "No other lighting technology offers as much potential to save energy and enhance the quality of our building environments, contributing to our nation's energy and climate change solutions."[7]

Incandescent Light Sources

Incandescent bulbs and incandescent halogen lamps are also called thermal luminescence lamps. These lamps have a yellowish light color with good color rendition capabilities and light up instantaneously. However, they have a very low efficiency (lm/W), very short service life span, and higher adverse environmental impact when compared to solid-state lighting sources. Many governments across the world have passed measures to completely phase out incandescent light bulbs and replace them with cold cathode compact fluorescent lamps or solid-state lighting technologies for general lighting purposes. Switzerland, Australia, Brazil, Venezuela and the European Union started to phase out incandescent bulbs in 2005. Russia, Canada and Argentina are scheduled to begin the phaseout in 2012. In the U.S., incandescent bulbs will be phased out by 2014 under the CLEAN Energy Act of 2007.

INCANDESCENT LIGHT BULBS The hot white color produced by an incandescent light bulb is a result of filament resistance to electricity and turning the electrical energy to heat. About 90 percent of the electricity used to power regular incandescent and halogen light bulbs is lost to heat, which triggers increased energy costs and resource use for cooling buildings, as well as greenhouse gas emissions. In addition, incandescent light bulbs have a considerably shorter life service span than newer light resources. As an example, a 60-watt incandescent light bulb has an average operational life span of 1,200 hours, whereas a 13–50 watt fluorescent lamp has a service life of 8,000 hours. These both fall significantly short of more than the 100,000-hour service life of a dimmable 6–8 watt LED.

According to the U.S. Department of Energy, the replacement of all 60-watt conventional light bulbs with efficient LED with less than 6–8 watts of power input, would provide an energy saving of 83 percent. The U.S. would save about 35 terawatt-hours of electricity or $3.9 billion in one year and avoid 20 million metric tons of carbon emissions.[8]

INCANDESCENT PARABOLIC ALUMINIZED REFLECTOR LAMPS Parabolic aluminized reflector (PAR) lamps consist of an incandescent light source with reflective aluminum coating and a parabolic lens that controls and improves light distribution. PAR lamps are commonly used in residential, commercial, and industrial applications for flood lighting. Like most incandescent lights, PAR lamps are in the process of being replaced by LED technology because they use less power, have higher lumens output, higher service life span, and produce a wide array of saturated colors without the use of color filters.

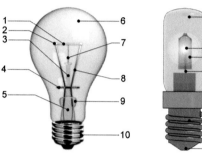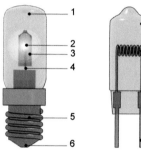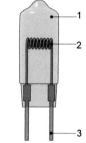

INCANDESCENT LIGHT BULB
1. Filament
2. Button
3. Stem
4. Heat Deflecting Shield
5. Exhaust Tube
6. Inert Gas
7. Support
8. Lead-in Wire
9. Pinch
10. Base

INCANDESCENT HALOGEN
1. Bulb
2. Filament
3. Inert Gas
4. Electric Circuit
5. Base
6. Contact

TUNGSTEN HALOGEN
1. Bulb
2. Filament
3. Electric Current

Fig. 6.3-2 Incandescent Light Sources: Incandescent Light Bulb (Left) Incandescent Halogen (Middle), Tungsten Halogen (Right)

Artificial Lighting

INCANDESCENT HALOGEN Incandescent light bulbs and tungsten halogen lamps (or quartz lamps) are made of fused silica (quartz) or aluminosilicate glass to withstand higher temperatures. Tungsten halogen lamps contain halogens with iodine, chlorine, bromine, or fluorine to slow the evaporation process of the tungsten.

Halogens produce whiter light and have a longer service life span compared to standard incandescent lamps. Dimmable halogens have better illumination beam control, color rendition, and object focus than incandescent bulbs. Most halogens operate at 12 volts and use an energy transformer, which requires a proper ventilation system due to the high waste heat generation.

Discharge Sources

Discharge lamps work by an electrical arc striking between two electrodes causing a filler-gas to produce light. These lamps require an extra device called a ballast that initially ignites the lamp with high voltage and then limits the electric current for its proper operation. There are three types of discharge lamps: low-pressure, high-pressure and high-intensity discharge lamps. Discharge lamps have higher efficiency and longer life spans than incandescent lamps. The color efficiency is dependent on the type of discharge lamp and can range from warm white, neutral white, and daylight white to different color renderings on the visible electromagnetic color spectrum.

LOW-PRESSURE DISCHARGE LAMPS Low-pressure discharge lamps include compact fluorescent lamps (CFL), cold cathode compact fluorescent lamps (CCFL), and inductive fluorescent lamps (IFL). CFLs are expected to be phased out and replaced by the four-times longer lasting CCFLs. The light source of CCFLs sends an electrical discharge through an ionized gas, which is called plasma. Unlike CFLs, the cold cathode of CCFLs does not burn up the igniter every time it is turned on. CCFLs are more compatible with photocells, occupancy sensors, timers, and dimmers and have a service life of approximately 50,000 hours. CCFLs can be used in recessed luminaires, wall- and ceiling-mounted fixtures, and track lighting, as well as task lighting. The diffused light from the fluorescent light source makes the CCFL a good alternative for down lighting and task lighting. CCFLs can deliver all types of light with moderate to very good color renditions. Most fluorescent lamps use argon, neon, krypton and xenon gas or a mixture of these gases. Unfortunately, most lamps are filled with additional elements, such as mercury, sodium, and metal halides, which are harmful to the environment.

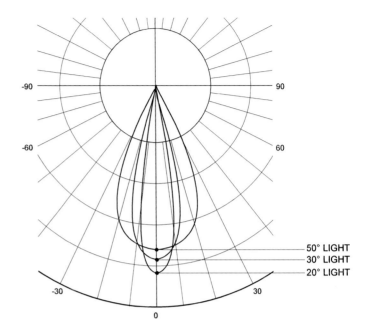

Fig. 6.3-3 Light Bean Spread Pattern of an Incandescent Parabolic Aluminized Reflector Lamp

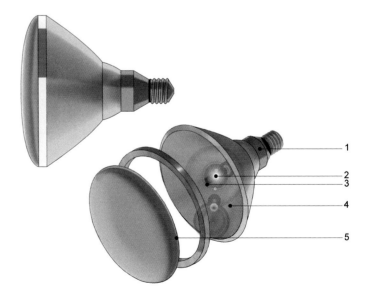

1. Base
2. Filament
3. Halogen Capsule
4. Reflector
5. Glass Lens

Fig. 6.3-4 Incandescent Parabolic Aluminized Reflector Lamp

6. Lighting

Inductive fluorescent lamps (IFL) are a type of electrodeless bulb that emits white light with good color temperature. IFLs use a small magnetic field generator to excite the phosphorus coating on the inside of the glass tube with an electrical current. These luminaires are more energy efficient and have a longer service life span than fluorescent bulbs. Induction bulbs also warm up much faster with less energy than other incandescent or sodium vapor bulbs. They are an excellent choice for illuminating bigger volumes and surfaces. However, environmental concerns regarding the use of toxic ballast technology has prevented the induction technology to excel and compete with solid-state lighting technology.

HIGH-INTENSITY DISCHARGE LAMPS High-intensity discharge lamps (HID) use mercury and metal halide gases to produce light. Once an HID lamp is turned on, it heats and evaporates the metal salts, increasing the intensity of illumination. HID lamps have higher overall luminous efficacy compared to fluorescent lamps because a greater proportion of their radiation is produced in the visible light range as opposed to wasted heat. Because HIDs produce intense light, they are often used for outdoor applications as well as large indoor areas such as sports arenas and gymnasiums. Various types of HID lamps use a different chemistry in the arc tubes to produce the required characteristics of light intensity, cor-related color temperature and color rendering, energy efficiency, and service life span. The lamp types are often labeled by the gas name contained in the bulb and include mercury vapor, metal halide and high pressure sodium (HPS) lamps. Metal halide lamps emit more colors from the visual spectrum while HPS lamps emit a bright yellowish-red light and produce between 97 and 150 lumens per watt with a lifetime between 16,000–24,000 hours. Metal halide bulbs appear more blue-white and produce 65–115 lumens per watt.[9]

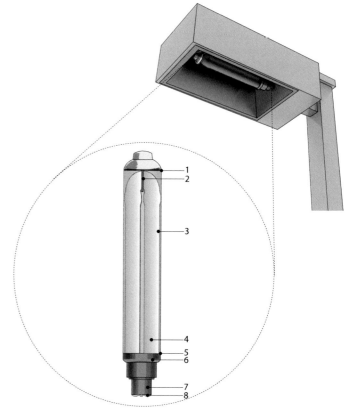

1. Metal Disc
2. Top Support
3. Discharge Tube
4. Cathode
5. Mica Disc
6. Stem
7. Cap
8. Solder

Fig. 6.3-5 Low-Pressure Discharge Lamp

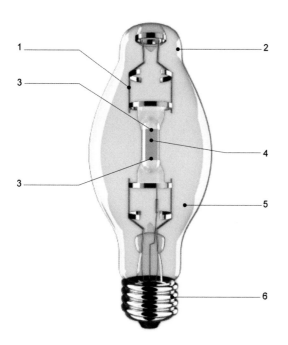

1. Nickel-Plated Steel Supports
2. Glass Bulb
3. Tungsten Electrode
4. Quartz Arc Tube
5. Special Fill Gases
6. Nickel/Brass Base

Fig. 6.3-6 High-Intensity Discharge Lamp

Artificial Lighting

Solid-State Lighting Sources

Solid-state lighting (SSL) utilizes semiconductor technology as the source of illumination instead of the electrical filaments or gas utilized in incandescent and fluorescent lamps. SSL sources produce visible light with less heat waste and are long-lasting versatile light sources. Although SSL sources are not currently cost-competitive with their conventional counterparts, they are a most promising artificial lighting technology because they offer an energy-efficient alternative with a long service life and minimal environmental impact.

LIGHT-EMITTING DIODES Light-emitting diodes (LED) produce light when an electric charge moves through a semiconductor device called a diode and activates the flow of electrons. LEDs are significantly more efficient than incandescent or fluorescent light bulbs. An incandescent or fluorescent bulb emits light and heat in all directions, whereas LEDs emit light in a specific direction and do not heat up. In addition, LEDs do not require a ballast or a starter feature, which is essential for incandescent and fluorescent lamps. LEDs are currently available for a wide variety of lighting applications such as bulbs, spotlights, track lights, street lights, and many others. LEDs are available in many colors of the spectrum, including warm white and cool white. LED technology is sodium- and mercury-free, thus eliminating the need for special disposal or handling, and has a long service life of more than 100,000 hours.

ORGANIC LIGHT-EMITTING DIODES Organic light-emitting diodes (OLED) are LEDs comprised of emissive thin layers of organic film that glow when subjected to an electrical current. Because OLED are flexible and have transparent components, they offer great potential for architectural lighting. Some OLED applications in architecture include illumination of multimedia building façades and screens, interior wall panels, and ceilings. OLEDs produce a warm white color temperature, comparable to incandescent light sources. They are durable, power-efficient, lightweight, and flexible. However, when compared to LEDs, at the current development stage, OLEDs typically emit less light per unit area.

POLYMER LIGHT-EMITTING DIODES Polymer light-emitting diodes (PLED), also called light-emitting polymers (LEP), are another emerging technology that function similar to OLEDs, but they use organic and flexible polymers diodes that illuminate when stimulated with electrical currents. PLEDs are used as a thin film for full-spectrum small-scale color displays, in particular on building façades and for information systems. PLEDs are ideal for any lightweight, ultra-thin multimedia video display. They also have low-power consumption, low heat waste, and excellent readability of visual features.

1. Epoxy Encapsulation
2. Flat Spot
3. Base

Fig. 6.3-7 Light-Emitting Diodes (LED)

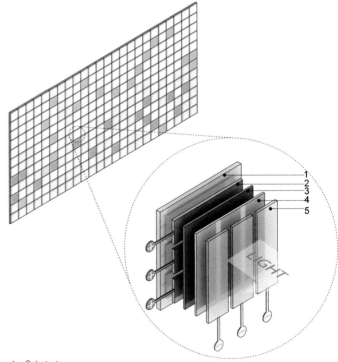

1. Substrate
2. Anode
3. Conductive Layer
4. Emissive Layer
5. Cathode

Fig. 6.3-8 Organic Light-Emitting Diodes (OLED)

6. Lighting

LUMINAIRE	PRODUCT DESCRIPTION	LUMINAIRE SPECIFICATIONS	TYPICAL LUMINOUS INTENSITY DISTRIBUTION
(LED array)	Light-emitting diodes (LED) produce light when an electric charge moves through a semiconductor device called diode and activates the flow of electrons. LEDs are significantly more efficient than incandescent or fluorescent light bulbs.	*Efficiency (lumens/watts):* 60-92 *Lifetime (hours):* 50,000-100,000 *Color Rendition Index (CRI):* 70-90 *Color Temperature:* 5000 (cold) *Usage:* Indoor and Outdoor	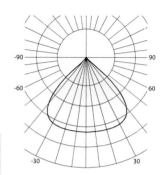 **Wide beam spread** (light is evenly distributed by prismatic lens)
(SOX lamp)	Low pressure sodium lamps (SOX) are primarily for use in remote general lighting applications where good efficiency and long life with no color rendering requirements are desired.	*Efficiency (lumens/watts):* 60-150 *Lifetime (hours):* 12,000-18,000 *Color Rendition Index (CRI):* -44 (poor) *Color Temperature:* poor color rendition *Usage:* Outdoor	
(HID lamp)	High intensity discharge lamps have higher overall luminous efficacy compared to fluorescent lamps because a greater proportion of their radiation is produced in the visible light range as opposed to wasted heat.	*Efficiency (lumens/watts):* 50-140 *Lifetime (hours):* 16,000-24,000 *Color Rendition Index (CRI):* 25 *Color Temperature:* 2100 (warm) *Usage:* Outdoor	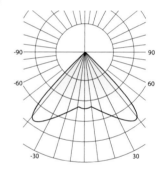 **Batwing beam spread** (light is concentrated to sides between zones of direct glare and reflected glare)
(Halogen lamp)	Incandescent halogen lamps are made of fused silica (quartz) or aluminosilicate glass to withstand higher temperatures. They produce whiter light and have a longer service life span compared to standard incandescent lamps.	*Efficiency (lumens/watts):* 12-22 *Lifetime (hours):* 2000-4000 *Color Rendition Index (CRI):* 98-100 *Color Temperature:* 2900-3200 (warm) *Usage:* Indoor and Outdoor	
(PAR lamp)	Parabolic aluminized reflector lamps consist of an incandescent light source with reflective aluminum coating and and a parabolic lens, which controls and improves light distribution.	*Efficiency (lumens/watts):* 12-19 *Lifetime (hours):* 2000-3000 *Color Rendition Index (CRI):* 98-100 *Color Temperature:* 2800 (warm) *Usage:* Indoor and Outdoor	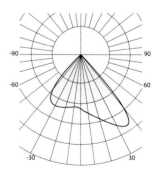 **Directional beam spread** (light is directed to side) Note: Manufacturers supply luminous intensity distribution graphs for each of the lighting fixtures.
(Incandescent lamp)	Incandescent lamps consist of a filament sealed within a light-transmitting bulb that is either evacuated or filled with an inert gas. Lead-in wires from the ends of the filament may be connected to a source of electricity.	*Efficiency (lumens/watts):* 10-17 *Lifetime (hours):* 750-2500 *Color Rendition Index (CRI):* 98-100 *Color Temperature:* 2700-2800 (warm) *Usage:* Indoor and Outdoor	

Source: U.S. Department of Energy, "Energy Efficiency & Renewable Energy."
http://www.energysavers.gov/your_home/lighting_daylighting/index.cfm/mytopic=12030#led.

Fig. 6.3-9 Luminaires Performance Metrics

Artificial Lighting

LED BARS AND MARKER LIGHTING LED light bars and LED marker lighting consist of flexible luminaires used to highlight paths and provide signal lighting for retail facilities, museums, exhibitions, and transportation and educational facilities where display and orientation systems need to be emphasized with compelling illuminations. These systems offer many advantages over conventional lighting, including heat-free illumination, and less ultraviolet light that causes fading of materials, as well as shadow-free illumination.

Lighting Control Systems

Lighting control systems are energy management devices that can be digitally programmed to switch on or dim lights in various spaces of a building. Utilizing light and motion sensors, the lighting control system can reduce the output of luminaires and adjust the required task lighting, based on the programmed codes for illumination when natural light is present. The sensors can measure the amount of natural light or the occupancy level in a room and control when and for how long the lights should stay on. There are many types of lighting controls and sensors that can save between 40 to 70 percent of energy consumption.

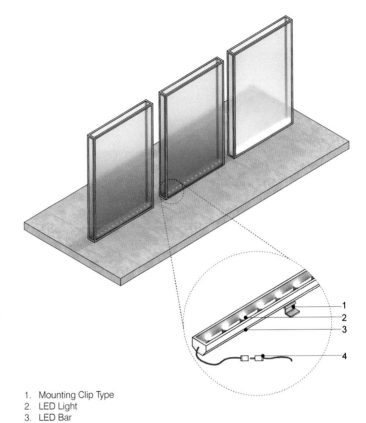

1. Mounting Clip Type
2. LED Light
3. LED Bar
4. Adapter 24V DC

Fig. 6.3-10 LED Bars and Marker Lighting

REFERENCES

1. U.S. Green Building Council, LEED—EB for Existing Buildings: Reference Guide, 2nd ed. (U.S. Green Building Council, 2006)

2. Ecotect Software, Design Sky Calculator Based on Tregenza's equations: http://naturalfrequency.com/Tregenza_Sharples/Daylight_Algorithms/intro.htm

3. U.S. Department of Energy, "Energy Savers." http://www.energysavers.gov/your_home/windows_doors_skylights/index.cfm/mytopic=13700?print

4. Mark Stanley Rea, *The IESNA Lighting Handbook: Reference and Application*, 9th Ed. (New York: Illuminating Engineering Society of North America, 2000)

5. Mark Stanley Rea, *The IESNA Lighting Handbook: Reference and Application*, 9th Ed. (New York: Illuminating Engineering Society of North America, 2000) P. 7-1

6. Ernst Neufert, Peter Neufert, Bousmaha Baiche and Nicholas Walliman, *Architects Data*, Third Edition. (Oxford: Blackwell Science, 2000) P. 141

7. The Green Atom, "Solid State Lighting, Energy Efficiency through LED Technology." http://www.solidstatelighting.org/.

8. L Prize. U.S. Department of Energy, "DOE Announces Philips as First Winner of the L Prize Competition." http://www.lightingprize.org/philips-winner.stm.http://www.lightingprize.org/philips-winner.stm

9. U.S. Department of Energy, Energy Savers, http://www.energysavers.gov/your_home/lighting_daylighting/index.cfm

Landscape

The design of landscape elements and systems is a significant component of effective sustainable building design. Through the appropriate use and integration of landscape elements, remarkable reductions in energy and resource consumption can be realized. Landscape elements can provide such benefits to buildings as shielding them from the sun, protecting them against wind, providing opportunities for natural ventilation, and facilitating passive cooling. Significant freshwater conservation can be achieved by incorporating hydrologically sensitive landscape design solutions into building and site design. Furthermore, landscape strategies can be utilized to develop ecological habitats for wildlife, clean the air and water, absorb floodwaters, provide added recreational amenities, and improve aesthetics. With the potential benefits that can be achieved through proper landscape design, its consideration is essential to a holistic and sustainable approach to the design and construction of the built environment.

7. Landscape

7.1 Concepts

Understanding the possibilities of landscape design requires more than an aesthetic eye for placing plants around a site. In order to establish an appropriate design process that tackles issues of sustainability in an effective manner, it is necessary to understand a variety of associated topics. For instance, the selection of proper plant material requires knowledge of concepts such as growth habits, origin, species' adaptations, and plant biological processes. In addition to specific knowledge relating to the plant materials themselves, it is also important to have a comprehension of contextual topics, including local and global hydrologic systems, precipitation, seasonal temperature fluctuations, wind, and geography. The following sections discuss some of the critical concepts and topics necessary for understanding landscape design as it relates to sustainable building design.

Plant Classification

There are a variety of characteristics by which to describe or classify plants and distinguish them from one another. Among these, growth habit, seasonal persistence, and ecological origin are particularly important with regard to sustainability.

GROWTH HABIT Based on their growth habit, plants can be classified as trees, shrubs, groundcovers, or vines. The boundaries between these growth habit types are not always distinct, nor consistent. A plant species may fall into several categories depending upon the conditions of a particular site or its maintenance regime. In addition, a plant may not fall neatly into any of these common categories. Despite the shortcomings of this classification system, it is widely used in landscape design and associated industries as a point of general reference.

Trees

A tree is a perennial plant (a plant that lives over multiple years) that has a large woody trunk(s) supporting a branching structure that carries foliage. These branches and foliage are typically clear of the ground.

Trees are the largest plant elements used in landscape design. While defining a tree in terms of its size is not always accurate, it can generally be defined as a plant which is taller than 10 feet (3 m). As a further subclassification, trees measuring 10 to 20 feet (3 to 6 m) in height can be classified as "small trees," trees 20 to 30 feet (6 to 9 m) can be considered as "medium trees," and trees taller than 30 feet (9 m) can be considered as "large trees."

Shrubs

A shrub is a woody perennial plant with several major stems, lacking a single main trunk. A shrub typically has foliage growing from its base to its top in its natural growth condition. Shrubs are relatively smaller plants than trees. They can be defined as being larger than 2 feet (0.6 m), but less than 10 feet (3 m) in height. A group of shrubs used in a border or row, either clipped or unclipped, is commonly called a "hedge." It is also possible to maintain some tree species in a shrub-like form with the use of trimming. However, this application may require frequent maintenance, which may not align with sustainability goals.

Groundcovers

Groundcovers are low-level understory plants that are grown over and cover an area of ground, acting as a base layer in a planting design. A groundcover is utilized to provide protection from erosion and drought and to improve the aesthetic appearance of a landscape by filling areas between large plants and trees. Plants used as groundcovers typically grow to less than 2 feet (0.6 m) tall or are maintained at that height.

Vines

A vine is a plant that spreads extensively along the ground, over other plants and objects, or up vertical surfaces through runners. Vines utilize other objects to lend them support for growth rather than investing energy in developing supportive tissue. This allows vines to reach sunlight with less energy expenditure than most other plants. Vines climb surfaces using various growth techniques varying by species. Some vines grow through twining, in which they wrap themselves around objects as support. Others use leaning techniques in which the vine grows upward, resting on objects that can give additional support, or grasping techniques in which they sprout roots, thorns, or tendrils, which attach to surfaces and structures.

Landscape Concepts

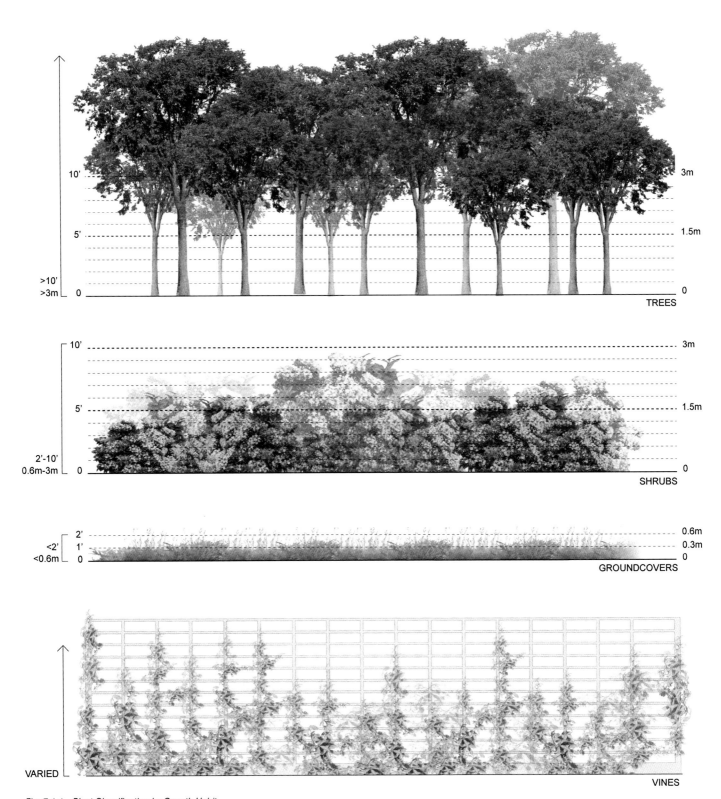

Fig. 7.1-1 Plant Classification by Growth Habit

7. Landscape

SEASONAL FOLIAGE PERSISTENCE The term seasonal foliage persistence describes plant species' annual retention of foliage (leaves or needles). Some plants periodically drop their foliage during a portion of the year as an adaptation to adverse seasonal climate conditions, while other plants keep their foliage throughout the year. The differences between plant species' foliage retention patterns can have significant impact on their functionality in shielding sun and wind. Therefore, foliage persistence is an important consideration in the selection of plants on a site.

Deciduous Plants

Deciduous plants are those which completely, or significantly, shed their foliage during the winter or dry season and remain bare for a period of time, followed by the growth of new leaves in the next growing season, typically spring. Deciduous plants are found in various climates and conditions worldwide from cold weather zones to tropical zones. The shedding of leaves by deciduous plants allows them to avoid cold damage and to conserve more water during dry periods. During the process of leaf shedding, known as abscission, the leaves of the deciduous plants can merely dry up and drop off or they may display a wide array of colors before they are shed. Depending on the species, the leaves may turn a bright yellow, a dark burgundy, or one of a variety of tones. Deciduous species include trees such as maple, birch, most oak, and poplar trees; shrubs such as serviceberry and azaleas; groundcovers such as wild ginger and stonecrop; and vine species such as Virginia creeper and wisteria.

Evergreen Plants

In contrast to deciduous plants, evergreen plants retain foliage throughout the year. Where evergreen plants exist in the same ecology as deciduous plants and endure the same climate conditions, they have special leaves that are resistant to cold and/or moisture loss. Evergreens may continue to photosynthesize during the winter or dry period in which nearby deciduous trees have shed their leaves as long as they have enough water. However, the process may slow down substantially.

The color of the foliage of an evergreen plant is not necessarily green, as might be suspected by the name. Foliage colors vary widely and include yellows, reds, purples and silvers. Evergreen plants include most conifer species, such as pines, cedars, spruces and hemlocks, along with tropical species like eucalyptus, many rainforest species, palms, and cycads.

Despite appearances, evergreen plants may actually shed leaves in certain seasons. While the overall plant retains its foliage, the individual foliage elements (leaves or needles) may be shed, varying in persistence from a few months to decades. Some evergreen species grow leaves constantly during the same period that old leaves are simultaneously shed. Due to this phenomenon, some species can be classified as semi-evergreen or semi-deciduous. Some oak species can be included in this category.

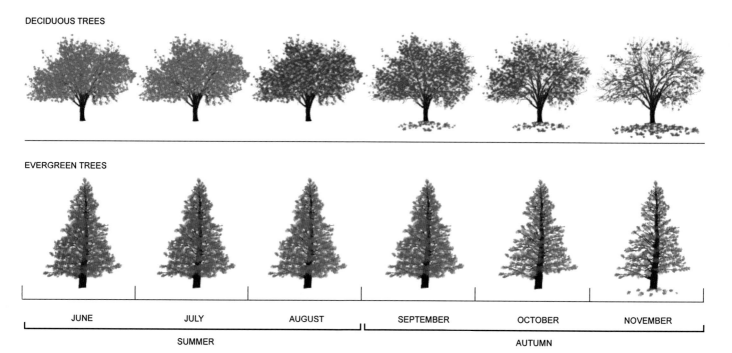

Fig. 7.1-2 Annual Cycle: Deciduous Trees (Top), Evergreen Trees (Bottom)

Landscape Concepts

ECOLOGICAL ORIGIN AND ADAPTATION The ecological origin of a plant is typically considered to be the location from which a plant species originated, relative to a given local ecology. A plant that originates from the local ecology is called native or indigenous. A plant that is not from the local ecology is non-native and is introduced. Introduced plants can also fall under the category of invasive if they crowd out or threaten the survival of native plant species in their host ecology.

Native Plants

Native, or indigenous, plants are considered to be plants that naturally exist in a geographic location and were not introduced to that location in the modern era by humans. In North America, the term often refers to plants found growing in a region prior to the arrival of settlers of European descent. However, a native ecology is not a static entity and this definition is somewhat shortsighted. As an alternative, the concept "native" could more appropriately be defined as referring to a plant that is adapted and ecologically integrated into a host habitat, which in turn has integrated the plant to the extent that symbiotic and balanced relationships have developed between the plant and the habitat. This definition more accurately describes the actual condition of "native" ecologies, which are continually being altered in adaptation to shifting climate conditions. However, it should be stressed that most natural changes in ecologies occur slowly, over hundreds, thousands, or even millions of years.

Because native plants are well adapted and integrated into their native ecologies, they tend to be supportive of those ecologies. Native plants can be the food source for native insects that are the food source of native birds that might also be the food source of a higher order predator. Using native species in a landscape also tends to consume fewer resources because the native plants typically don't require much maintenance or irrigation relative to non-natives. The use of non-native plants in a landscape design is unlikely to contribute to the native ecology and in some instances may hinder or cause damage to it.

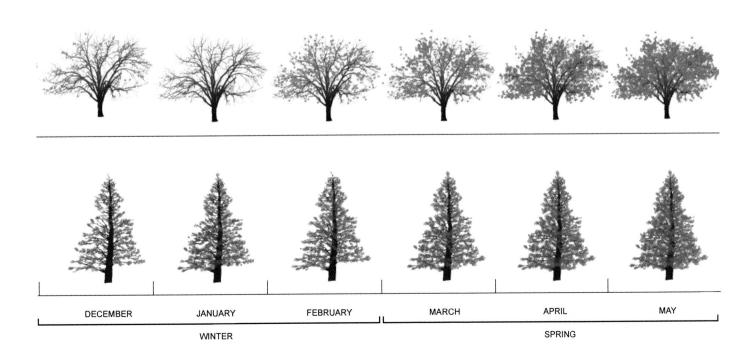

7. Landscape

Introduced Plants and Invasive Plants

Introduced plant species live within a host ecology, but their recent origins lay outside that ecology. These plants often arrive at the new ecology through human activities, either deliberately or accidentally. Subsequent range expansion of an introduced species may or may not involve human activity. An introduced plant may adapt well to a host ecology or may require a level of maintenance to survive over a long period of time.

Some introduced plants that adapt extremely well to a host ecology and have no natural controls can push out native species and become what is termed "invasive." An invaded host ecology may have little to no natural limits for a newcomer species from an entirely different ecology. An aggressive plant, which might otherwise be limited within its own native ecology, is freed from its natural environmental pest and disease constraints.

The problem of invasive plants is not their "non-nativeness," as it is sometimes assumed, but their significant negative impact on established and balanced ecosystems. Invasive plants can significantly harm or permanently alter an existing and functioning native ecology by dominating whole areas and displacing species that may perform vital ecological functions. Invasive plant infestations can be extremely expensive to control once they are underway. Controlling the entry and spread of invasive plant species before they become major problems is essential to stopping them and protecting native ecologies.

STAGE 1
1. Introduction of Invasive Exotic Plants
2. Still Healthy Connection of Natural Plant Communities

STAGE 2
1. Expansion of Invasive Exotic Plants
2. Displacement of Native Species
3. Disruption of Native Ecology

STAGE 3
1. Connection of Invasive Exotic Communities
2. Further Crowding Out of Native Species
3. Further Disruption of Native Ecology
4. Further Expansion of Invasive Exotic Species

STAGE 4
1. Rapid Expansion of Invasive Exotic Species
2. Severe Crowding Out of Native Species
3. Severe Disruption and Isolation of Native Ecology
4. Domination of Invasive Exotic Species

Fig. 7.1-3 Stages of Invasive Plant Subjugation

Landscape Concepts

Plant Processes

Some of the most valuable aspects of plants are in the microscopic processes they perform. Understanding these processes and properly utilizing them in landscape design can enhance energy savings within buildings and improve environmental health in significant ways. Harnessing some of the most beneficial processes can yield such gains as reductions in cooling costs, reductions in water consumption, and the removal of water and air pollutants. The focus here is to introduce some of these important processes for further discussion of their potential role in sustainable design solutions.

EVAPOTRANSPIRATION Evapotranspiration is a combination of two processes. It is the sum of water evaporating from the Earth's surface and the water vapor generated by plants through the process of transpiration. The processes of evaporation and transpiration both have a cooling effect on local air temperatures. The process by which water changes from liquid to gas requires the addition of heat energy. This heat energy is absorbed by the water during evaporation in the form of latent heat and is carried away with the water vapor. The rate and quantity of evapotranspiration can be affected by such factors as plant species, ecological conditions, weather conditions, available water, and humidity levels.

The transpiration component of evapotranspiration is created by a biological process in plants by which leaves open their stomata (small holes found on the surface of leaves) to absorb carbon dioxide, which is an important component in the process of photosynthesis. This process also releases water vapor to the atmosphere in order to maintain a level of hydrostatic pressure and pull water and nutrients from the root zone up into the plant. Levels of transpiration can vary greatly between different species of plants. In general, woody plants such as trees, generate more transpiration due to their large amount of foliage. Also, plants with deep and extensive root systems are able to pull more water from the soil for release into the atmosphere. Close to 10 percent of all of the moisture found in the atmosphere is released by plants through transpiration.[1]

The evaporation portion of evapotranspiration is also affected by the presence of plants. A large quantity of water during rain events is caught and held by the foliage of plants. Most of the captured water evaporates back into the air. Leaves also capture humidity from the air as condensation in the form of dew, which also later evaporates back into the air.

PHOTOSYNTHESIS Photosynthesis is the internal chemical process by which plants create sugars for growth and sustenance. Photosynthesis takes place within the leaves of a plant through the biomolecule chlorophyll, which is also responsible for the green pigmentation found in most plants' foliage. The process captures energy from sunlight and converts it to a chemical energy or fuel. The plant then uses this chemical energy along with water and carbon dioxide to synthesize sugars used for sustenance. Much of the sunlight energy received by a plant is absorbed through the photosynthesis process. An additional important by-product of the photosynthesis process is oxygen.

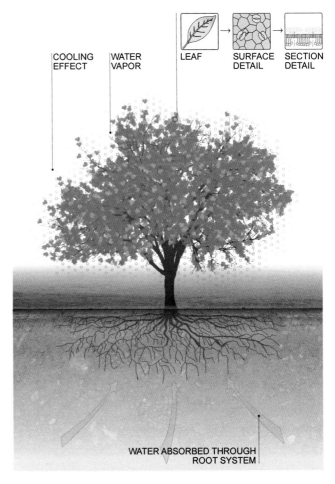

Fig. 7.1-4 *Evapotranspiration*

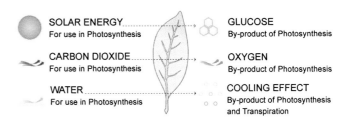

Fig. 7.1-5 *Photosynthesis*

7. Landscape

PHYTOREMEDIATION Phytoremediation is the use of biological processes connected to plant materials to mitigate pollutants in contaminated soils, water, or air. Some plant materials, through their natural life processes, are able to contain, degrade, or eliminate pesticides, solvents, explosive material, metals, crude oil and its derivatives, and many other contaminants.

Phytoremediation processes can be classified into four types. These are accumulation, dissipation, degradation, and immobilization. The process utilized in a particular contamination situation is based upon the desired or necessary outcome for a given site and is also dependent upon the plant species that are available for a particular pollutant type. In some instances, multiple plant species may be employed in a simultaneous or consecutive manner that utilize varying phytoremediation process types to remove pollutants.

Accumulation

Accumulation processes are those phytoremediation processes in which plants uptake and contain contaminants. With accumulation, plants absorb a contaminant, but do not break it down. After uptake of the contaminants, the plants may need to be removed for disposal. Accumulation can occur in two forms. In the first form, phytoextraction (or phytoaccumulation), plants absorb and accumulate contaminants in above-ground plant tissues. Contaminants are taken up into the plant with the nutrients and water it pulls from the soil (or water) and held within the plant's shoots and leaves. Phytoextraction is available primarily for the removal of heavy metals, such as lead, from soils and water. After uptake of pollutants, the plant material can be harvested and either smelted for potential metal recycling/recovery or disposed of as a hazardous waste.

The second form of accumulation is rhizofiltration. Rhizofiltration is primarily used in the treatment of water pollutants and is typically utilized in a greenhouse condition with plants growing in hydroponic systems or in an artificial soil medium, such as sand mixed with perlite or vermiculite. Contaminated water is pumped to irrigation tanks beneath the plants. The selected plants trap and accumulate the contaminants within their root zones. As the roots become saturated with contaminants, they can be harvested for disposal.

Dissipation

A dissipation process is one by which plants decrease contaminant concentrations by transferring them to the atmosphere via transpiration. Dissipation occurs via a single process method called phytovolatization. Under phytovolatization, water-soluble contaminants are absorbed by plants through their roots and are carried into the upper portions of the plant and into the leaves. Through transpiration, contaminants are released from leaves to the air. Contaminants can be transferred to the atmosphere as the

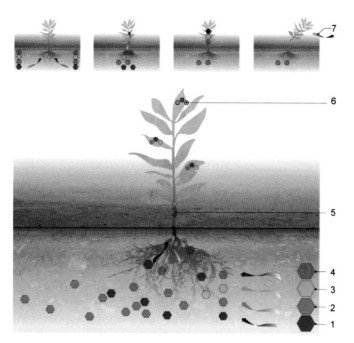

1. Metal Contaminants
2. Organic Contaminants
3. Water
4. Plant Nutrients
5. Transfer to Plant Stem and Leaves
6. Accumulation in Stem and Leaves
7. Harvest or Disposal of Leaves and Shoots

Fig. 7.1-6 Accumulation: Phytoextraction

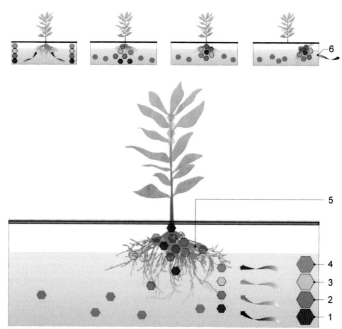

1. Metal Contaminants
2. Organic Contaminants
3. Water
4. Plant Nutrients
5. Transfer to Plant Root Systems
6. Harvest or Disposal of Plant with Roots

Fig. 7.1-7 Accumulation: Rhizofiltration

Landscape Concepts

same substance or they may be modified or degraded in form while passing through the plant and then transferred to the atmosphere. In order for the process to be an effective method of phytoremediation, the substance released into the atmosphere should ideally be less toxic than the initial contaminant drawn from the water or soil being mitigated. In some cases, contaminant transfer to the atmosphere can allow more effective natural degradation processes to occur. Phytovolatization is utilized with both organic and inorganic contaminants.

Degradation

Degradation processes are those phytoremediation processes by which plants effectively destroy or alter a contaminant. Degradation processes are typically available for the mitigation of organic pollutants. Using a degradation process, plants are selected to absorb a contaminant and break it down into benign substances through biological processes within the plant in order to eliminate the contaminant. Degradation can occur in two forms. The first form, rhizodegradation, takes place below ground in the root zones of plants. Rhizodegradation is accomplished by microorganisms associated with the plant, but outside of it. The second form of degradation is phytodegradation, in which the plant metabolizes an absorbed contaminant directly. Phytodegradation can take place above or below ground, but is within the plant's roots, stems, or leaves.

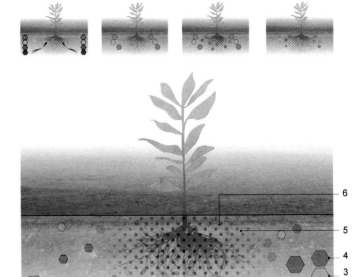

1. Metal Contaminants
2. Organic Contaminants
3. Water
4. Plant Nutrients
5. Release of Nutrients of Microorganisms into Soil
6. Enhancement of Degradation Using Microorganisms

Fig. 7.1-9 Degradation: Rhizodegradation

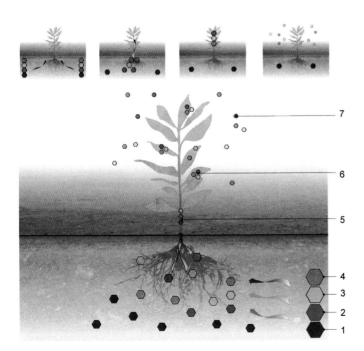

1. Metal Contaminants
2. Organic Contaminants
3. Water
4. Plant Nutrients
5. Transfer of Particles to Plant Stem and Leaves
6. Accumulation of Particles in Stem and Leaves
7. Release of Contaminants into Air Through Leaves

Fig. 7.1-8 Dissipation: Phytovolatization

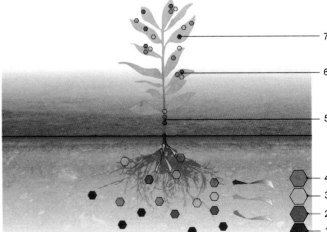

1. Metal Contaminants
2. Organic Contaminants
3. Water
4. Plant Nutrients
5. Transfer of Particles to Plant Stem and Leaves
6. Accumulation of Particles in Stem and Leaves
7. Degradation of Contaminants through Internal Plant Processes

Fig. 7.1-10 Degradation: Phytodegradation

7. Landscape

Immobilization

Immobilization processes are those by which plants are used to reduce or restrict the movement of contaminants within soil to achieve a level of containment. They are used in cases of organic, inorganic, and metal contaminants. Immobilization processes may be used in conjunction with other phytoremediation processes to achieve removal of contaminants, if necessary. Immobilization occurs in two forms. In the first form, hydraulic control, plants with high levels of water uptake are used to influence the movement of ground and soil water. The plants act as natural hydraulic pumps, pulling water toward the surface. Hydraulic control is typically used to decrease the migration of contaminants from surface water into the groundwater and drinking water supplies.

The second form of immobilization is phytostabilization, which utilizes plants that trap contaminants in their root zones. In phytostabilization, chemical compounds produced by the plant hold the contaminants. The process does not degrade contaminants, but merely holds them. Phytostabilization is useful at sites with shallow and relatively low levels of contamination. Plants that can accumulate heavy metals in their root zone are typically effective at depths of up to 24 inches (61 cm). In cases where toxic contaminants such as heavy metals are readily transferred to plant foliage, the applicability of phytostabilization may be limited due to the potential for adverse effects on the food chain.

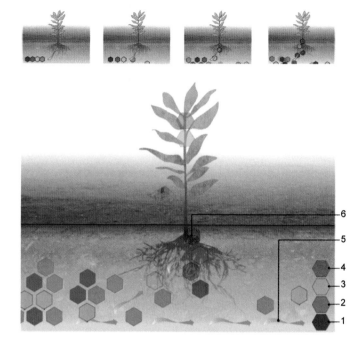

1. Metal Contaminants
2. Organic Contaminants
3. Water
4. Plant Nutrients
5. Subsurface Water Flow
6. Absorption of Contaminants

Fig. 7.1-11 Immobilization: Hydraulic Control

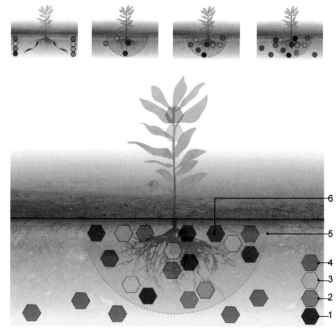

1. Metal Contaminants
2. Organic Contaminants
3. Water
4. Plant Nutrients
5. Accumulation of Contaminants in Roots
6. Immobilization of Contaminants in Roots

Fig. 7.1-12 Immobilization: Phytostabilization

Landscape Concepts

Hydrology

Water is a key resource for the function of life on Earth. The wise use and conservation of water resources is vital for an environmentally sustainable future. In order to promote conservation and the wise use of water resources, it is important to understand the water cycle and the impacts that the built environment can have on its proper function. The built environment can often significantly limit the natural cycling processes of water or alter it in detrimental ways. The following concepts are useful in a discussion of hydrological processes.

HYDROLOGICAL CYCLE The hydrological cycle, or water cycle, describes the continuous movement of water above and below the surface of the Earth and through its atmosphere. It includes the flow of water over land surfaces and underground through soils and also the transformation of water molecules through various states and systems. The Earth's water cycle is driven by the energy from sunlight. Water from the Earth's surface is transformed into water vapor through evapotranspiration processes. It then rises into the atmosphere to form clouds of water vapor. These clouds are carried to other geographical locations through air currents. With changes in pressure and temperature, the water vapor clouds turn back into liquid or solid-state water that falls back to the earth as rain or snow. After reaching the Earth's surface, some of the fallen water re-evaporates back into the atmosphere. The rest flows into bodies of water, such as rivers, lakes, and streams, or seeps into the earth where it might be absorbed by plants or join groundwater reservoirs. This process is continuous, keeping the water resources of the Earth in constant movement and transformation.

Of particular significance during the hydrological cycle, is that in the transformation process of water molecules between the states of solid, liquid, and gas, an exchange of heat energy occurs. This happens in two ways: first, through the release of heat energy into the environment during water condensation, and second, by absorption of heat energy from the environment during evapotranspiration. These heat energy exchanges have significant impacts on temperature and climate. Thus, the hydrological cycle has a major influence on the climate of the Earth.

The hydrological cycle also helps to maintain ecosystems on the Earth by purifying water during the cycling process, replenishing the soil with freshwater, and transporting different minerals, carried by water, to different parts of the earth. An understanding of the hydrological cycle is crucial to understanding the movement of nutrients and pollutants across systems and within a site. The treatment of landscape can have significant impacts on the hydrological cycle locally as well as on regional and global scales through cumulative effects. Site design that fails to take hydrology into account can reduce infiltration and increase runoff, leading to soil erosion, sedimentation, and the spread of pollutants.

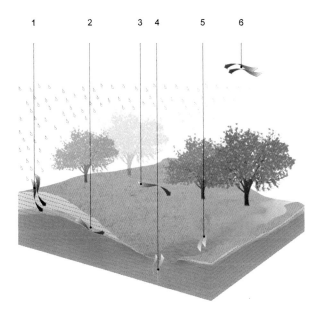

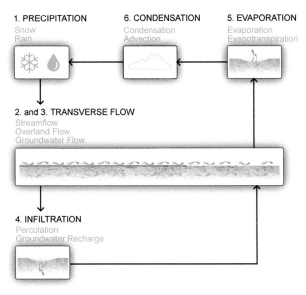

Fig. 7.1-13 Hydrological Cycle

7. Landscape

SURFACE RUNOFF Surface runoff is stormwater generated by fallen precipitation that is not absorbed into the earth or by a body of water, but flows away over the ground surface. Excessive amounts of runoff can cause flooding, erosion, and the spread of unfiltered pollutants. On undeveloped sites, soils and plants absorb significant amounts of precipitation. Additionally, stability has been achieved over time by the creation of landforms, which effectively absorb or convey precipitation to established water bodies, streams, and rivers.

In an urban condition, impermeable surfaces such as paved roads, parking lots, driveways, building roofs, and compacted soils replace existing, more permeable surfaces and established systems. Thereby, water infiltration into the ground is significantly reduced and quantities of surface runoff are increased. In these conditions, during rain events, precipitated water quickly flows off of surfaces and then accumulates in other areas where soil can be washed away. Paved surfaces also typically carry accumulated pollutants, such as oil and grease, chemicals, and bacteria, which are spread with the increased runoff. The polluted stormwater can ultimately end up spreading into local lakes, rivers and streams.

GROUNDWATER RECHARGE Groundwater is an important source of freshwater for many cities and communities. Groundwater recharge is the process by which water moves downward from the earth surface to replenish groundwater quantities. Recharge can occur both naturally, through the water cycle, and by artificial means in which rainwater or reclaimed water is routed or forced to the subsurface. Groundwater is recharged naturally by precipitation and melted snow and to a smaller extent by surface waters such as rivers and lakes. Groundwater recharge is an important element in sustainable groundwater management.

Groundwater recharge in urban areas can be impeded by paved surfaces that are impervious to water flow and increase surface runoff. Overuse of groundwater, especially for irrigation, may also result in depleted water tables that may exacerbate reductions in recharge.

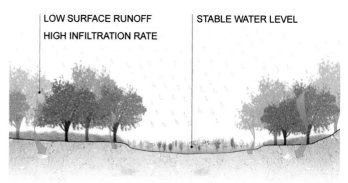

Fig. 7.1-14 Surface Runoff: Natural

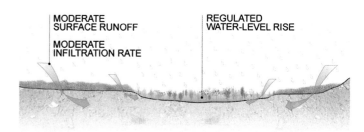

Fig. 7.1-15 Surface Runoff: Rural

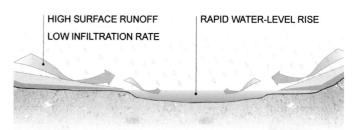

Fig. 7.1-16 Surface Runoff: Urban

Landscape Concepts

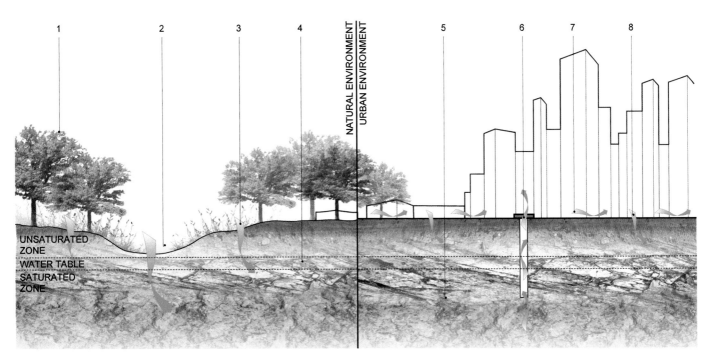

NATURAL ENVIRONMENT
1. Vegetation
2. Stream
3. High Infiltration Level
4. Stable Groundwater Supply

URBAN ENVIRONMENT
5. Decreasing Groundwater Supply
6. Wells Remove Water from the Ground for Consumption
7. Increased Surface Runoff
8. Low Infiltration Level

Fig. 7.1-17 Groundwater Recharge

7. Landscape

Climate

Climate is a key consideration for the selection of plants and hardscape materials. The following sections cover the connections between climate conditions and landscape design.

HARDINESS AND HARDINESS ZONES Hardiness refers to a plant's tolerance of temperature conditions. Hardiness zones are geographic regions, which have a similar range of average annual minimum temperatures. The zone delineation is used to determine which kinds of plant materials can survive in specific geographical locations. The United States Department of Agriculture (USDA) produces hardiness zone maps for the United States. Recently a Canadian based organization, Aden Earth, has developed the first World Plant Hardiness Zone Map.

In real-world conditions, temperature is only one factor that influences a plant's ability to survive in a specific location. Several other factors, such as overall temperature patterns, water supply, wind and sun exposure, and a plant species' genetic makeup, can also influence how well a plant survives in a given location. Therefore, hardiness zone designations can be somewhat limited in the information they provide.

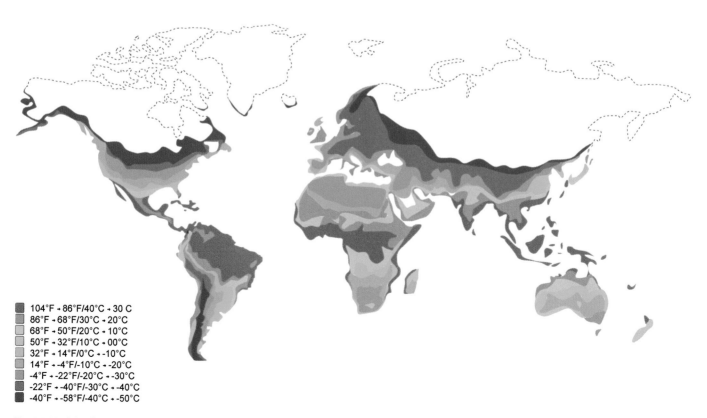

104°F ‑ 86°F/40°C ‑ 30 C
86°F ‑ 68°F/30°C ‑ 20°C
68°F ‑ 50°F/20°C ‑ 10°C
50°F ‑ 32°F/10°C ‑ 00°C
32°F ‑ 14°F/0°C ‑ -10°C
14°F ‑ -4°F/-10°C ‑ -20°C
-4°F ‑ -22°F/-20°C ‑ -30°C
-22°F ‑ -40°F/-30°C ‑ -40°C
-40°F ‑ -58°F/-40°C ‑ -50°C

Fig. 7.1-18 Aden Earth World Plant Hardiness Zone Map

Landscape Concepts

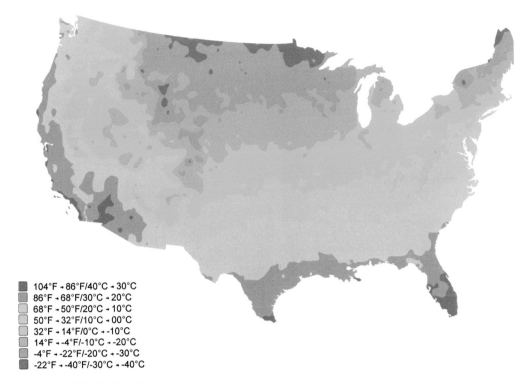

104°F → 86°F/40°C → 30°C
86°F → 68°F/30°C → 20°C
68°F → 50°F/20°C → 10°C
50°F → 32°F/10°C → 00°C
32°F → 14°F/0°C → -10°C
14°F → -4°F/-10°C → -20°C
-4°F → -22°F/-20°C → -30°C
-22°F → -40°F/-30°C → -40°C

Fig. 7.1-19 USDA Hardiness Zone Map

Fig. 7.1-20 Sample Plant Palette for Different Hardiness Zones

7. Landscape

CLIMATIC REGIONS Classifying geographic areas into climatic regions may present a better picture of the vegetation types that might grow in a specific area. In addition to temperature differences, climatic regions are differentiated by factors such as humidity, precipitation, prevailing winds, atmospheric pressures, sun exposure, cloud types, and cloud coverage. Some of the broader, more common regional climate types are described here with some examples of associated plant species.

Hot and Humid

Hot and humid climate regions include tropical and subtropical ecosystems. They are generally hot and humid but may experience an extensive dry season. Tropical climates have year-round growing seasons and are without freezing temperatures. Plants that grow in tropical climates include gumbo limbo, macadamia, banana, eucalyptus, and philodendrons. Subtropical climates generally maintain temperatures well above freezing throughout the year, but may experience mild winters with some chilling and rare freezing. Plants that grow in subtropical areas include citrus, palms, figs, and olives.

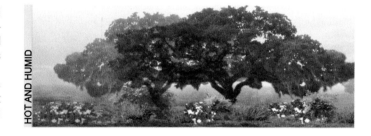

Hot and Arid

Hot and arid or semi-arid climates include desert and low precipitation regions. Such climate regions are dry and can only support specialized plants that can survive long periods without moisture. Semi-arid climates may support some hardy tree species such as desert willow, desert apple, and many acacias. In the driest areas, plants such as cacti, succulents, tough shrubs, and grasses that can withstand extremely harsh climatic conditions are dominant. When it does rain in hot and arid or semi-arid climates, the rain may come in high intensity bursts that can cause flooding.

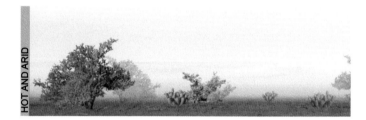

Temperate

Temperate climates are mid-latitude climates that have distinct seasonal variations moving from very warm to freezing temperatures. Plant types living in temperate climate zones must be adapted to surviving this flux in temperatures, including periods when temperatures are considerably below the freezing point. Deciduous trees that lose their foliage during the winter period can dominate in temperate climates, but evergreens are also prevalent (typically with needle-type foliage). Examples of species that are found in this climate type are maples, oaks, pines, and cottonwoods.

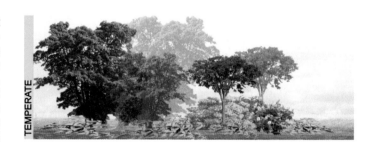

Cold

Cold climate regions exist in upper latitudes and in high-elevation mountainous regions. They tend to have extended dry periods. In this climate, plants must be adapted to a growing season that is much shorter relative to other climate types. Evergreen trees, such as spruce and pine, are typically the dominant species, but deciduous trees, such as aspen, are also found in areas where the cold weather is less severe. In the coldest regions, with the shortest growth season and heavy snowfall, larger plants and trees have less of an advantage. In such regions, low and quick-growing plants, such as grasses and wildflowers, tend to be the dominant plants.

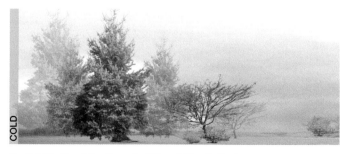

Fig. 7.1-21 Vegetative Cover for Different Climatic Regions

Landscape Concepts

MICROCLIMATE Microclimate describes a small and local climate zone that can be differentiated from the dominant climate of the surrounding area. A microclimate zone may refer to an area as small as a few square feet or as large as several square miles. Microclimate differences can occur for many reasons and can have significant impacts on the local conditions of a site.

The slope or aspect of an area can be a significant factor in microclimate. South-facing slopes in the Northern Hemisphere and north-facing slopes in the Southern Hemisphere are exposed to more direct sunlight than opposite slopes and are therefore warmer for longer periods of time. Land located on water bodies can have significantly milder temperatures than land located inland due to the temperature retention of water. A local climate can be affected by many factors, both natural and man-made, to create a microclimate.

URBAN HEAT ISLAND An urban heat island refers to a microclimate phenomenon of increased temperatures in urban areas, contrasting to areas located immediately outside of the urban context or to what might otherwise exist in the urban location if it were covered in a more natural state of vegetation. The heat island effect is mainly generated by the materiality of the urban environment and by human activity. Urban areas are generally constructed of concrete, stone, brick and other similar materials, which have high levels of absorption of solar energy. The absorbed energy accumulated by these materials is slowly released as heat to the surrounding environment, which produces and maintains higher air temperatures. Increasing the effect (the reduction or elimination of vegetated areas) that typically accompanies the construction of urban areas, reduces the cooling effects of evapotranspiration that would otherwise help to counteract higher temperatures.

Along with the urban materiality, waste heat is also a significant contributor to the urban heat island effect. Significant waste heat is generated by many urban activities, including mechanical heating-cooling, lighting, transportation, and machinery. The urban heat island effect can generate average temperatures 5°F to 9°F (2.8°C to 5°C) warmer in the urban core than the rural or open areas outside the urban context.[2]

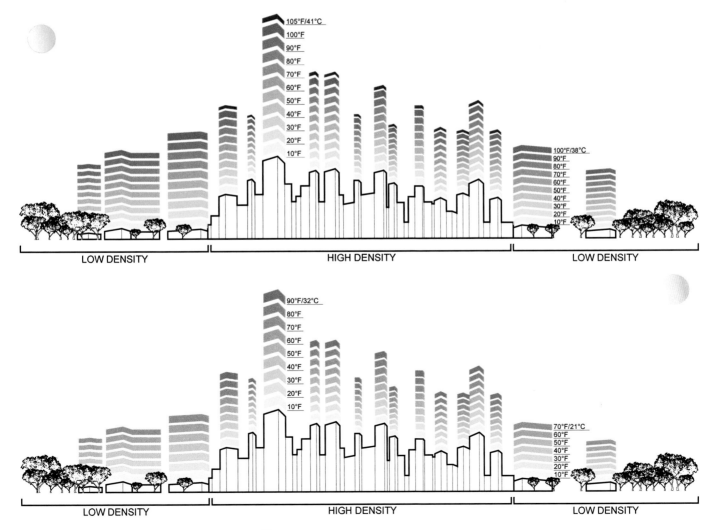

Fig. 7.1-22 Urban Heat Island: Day (Top), Night (Bottom)

209

7. Landscape

7.2 Thermal Efficiency

The typical building's high reliance on nonrenewable energy sources is in significant conflict with the goals of environmentally sustainable design. The total U.S. energy consumption in 2010 by buildings was about 40 quadrillion British thermal units, which was close to 41 percent of the nation's total energy consumption.[3] The sum of energy spent for heating and cooling in residential and commercial buildings accounts for the most significant portion of buildings' total energy consumption.[4] Combining sustainable landscape design strategies with passive environmental climate controls can be highly effective in reducing dependence on mechanical systems, leading to significant energy savings. Simple strategies utilizing landscape planting elements such as trees, shrubs, groundcovers or vines in key locations and in proper quantities can greatly reduce energy consumption. More complex landscape systems, such as green roofs and green walls, can also be added to achieve even greater energy efficiencies, particularly on larger buildings.

Solar Heat Moderation

Solar radiation has significant impact on buildings. The extent of this impact is dependent upon several factors, including building orientation, architectural form, and materiality, along with site condition aspects such as climate, geography, and seasonal changes. Without proper consideration, particularly in hot weather conditions, solar radiation can heighten building temperatures to undesirable levels and increase the need for mechanical cooling. Appropriately utilized landscape elements and systems can deflect and diffuse sunlight or dissipate solar heat energy to moderate thermal loads and reduce requirements for mechanical cooling.

CANOPY SHADING Shading of a building's surfaces during periods of the most intense solar radiation, particularly in hot climates and seasons, can be highly effective in reducing excessive thermal heat loads on the building. Important to the effectiveness of canopy shade is the proper location of trees and shrubs on a site. The most effective shading arrangement for reducing maximum air temperatures and hastening early evening cooling is by shading a building's roof and its southwest- and west-facing walls and windows (in the Northern Hemisphere).

In geographical locations with a winter season, deciduous trees and shrubs can be used to block summer sunlight and also allow winter sunlight to reach the building, thus taking advantage of solar radiation when it is beneficial and protecting against it when it is not. Planting tall trees with elevated branching structures, or trimming up branches, will also allow more winter sunlight to reach a building as the sun is crossing the sky at a lower angle. Shading other portions of a building and its adjacent site can also help to reduce ambient air temperatures around the building as well as indoor temperatures to some degree. Trees planted at distances too far to shade a particular building's façade surfaces may also help reduce the air and ground temperatures surrounding the building, thereby reducing indirect impacts from solar radiation. Site planting can also help to diminish the light reflected toward a building from surrounding surfaces.

In addition to the locations of trees on a site, the impact of canopy shade on moderating heat load is affected by other factors. Tree height and canopy spread significantly affect the amount of area that will be shaded. Foliage density and foliage development patterns, which control the amount of incident sunlight prevented from passing through the canopy, are also significant factors. Large-canopy shade trees will typically block 80 to 90 percent of light transmission. The amount of light prevented from passing through a given species canopy can be expressed as its shade factor. A factor of 0.00 represents full light transmission (0 percent). A factor of 1.00 represents a complete blockage of all light transmission (100 percent).[5]

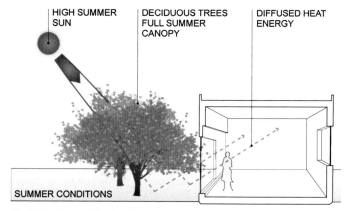

Fig. 7.2-1 Canopy Shading: Summer

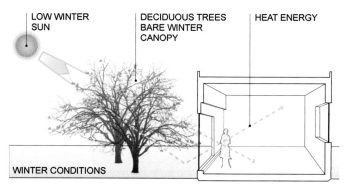

Fig. 7.2-2 Canopy Shading: Winter

Thermal Efficiency

ROUND/OVAL

Dense Foliage
Medium Texture

20'-30'/6m-9m
Moderate Spread (20yrs)

35'
11m
Moderate Height (20yrs)

Acer rubrum Red Maple
North American Native

Shade Factor: 0.83

SPREADING

Moderate Foliage
Fine Texture

30'-40'/9m-12m
Large Spread (20yrs)

20'
6m
Moderate Height (20yrs)

Albizia julibrissin durazzini Silktree
North American Native

Shade Factor: 0.83

PYRAMIDAL

Dense Foliage
Medium Texture

20'-30'/6m-9m
Small Spread (20yrs)

40'
12m
Great Height (20yrs)

Quercus palustris Muenchh. Pin Oak
North American Native

Shade Factor: 0.77

CONICAL

Dense Foliage
Medium Texture

10'-20'/3m-6m
Small Spread (20yrs)

40'
12m
Great Height (20yrs)

Populus tremuloides Michx. Quaking Aspen
North American Native

Shade Factor: 0.74

VASE

Dense Foliage
Medium Texture

30'-40'/9m-12m
Large Spread (20yrs)

50'
15m
Great Height (20yrs)

Ulmus americana L. American Elm
North American Native

Shade Factor: 0.87

COLUMNAR

Dense Foliage
Medium Texture

40'-50'/12m-15m
Large Spread (20yrs)

80'
24m
Great Height (20yrs)

Populus deltoides Eastern Cottonwood
North American Native

Shade Factor: 0.85

Fig. 7.2-3 Shade Factors for Various Tree Species During Summer
Source: David I. Nowak, "Estimating Leaf Area and Leaf Biomass of Open-Grown Deciduous Urban Trees." Forest Science 42, no. 4 (1996), P. 506.

7. Landscape

In addition to the direct effect of canopy shade in lowering air temperatures, tree coverage, and plant materials in general, can moderate increased temperatures caused by ambient solar heat through evapotranspiration processes. The result of this is that the cooling effect of shade from plant materials is almost always better than the shade from constructed shading structures, which have the potential to absorb solar energy and reradiate it downward onto a building as heat.

SITE PLANTING COVERAGE Paved surfaces tend to absorb solar energy and therefore generate heat that is then radiated back into the immediate environment, contributing to the urban heat island effect. Temperatures over asphalt or concrete may be as much as 15°F to 25°F (8.3°C to 13.9°C) higher than surrounding nonpaved areas.[6] Replacing hardscape surfaces with adequate planting coverage around the base of a building and over its larger site can lead to substantial reductions in solar heat generation affecting the building. Most significantly, site planting reduces solar heat gain through the cooling effects of evapotranspiration. In addition, because planted areas present irregular surfaces (in contrast to a flat surface like concrete), reflected sunlight from those surfaces becomes greatly diffused. With extensive planting coverage, the overall effect can be significant. Adding taller groundcovers with larger leaf surfaces can increase this cooling effect to a greater extent.

VEGETATED SURFACE SYSTEMS Vegetated surfaces on the façades and roofs of buildings offer protection from solar heat in several ways. First, they form a buffer between building surfaces and direct sunlight, similar to canopy shade, which can greatly reduce absorption of solar heat by conductive building materials. Second, the evapotranspiration process reduces the building's surface temperatures. Third, like site plants, the texture of the foliage on vegetated walls or roofs don't present smooth, flat surfaces to receive solar radiation, reducing the effects of solar rays on heating.

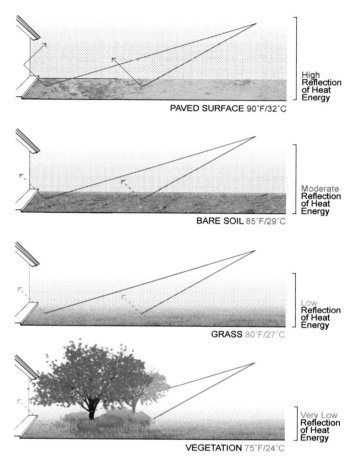

Fig. 7.2-4 Site Planting Coverage

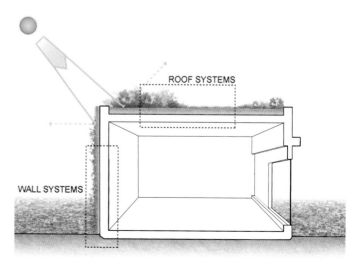

Fig. 7.2-5 Vegetated Surface Systems

Thermal Efficiency

Vine-Covered Walls

Vine-covered walls can be a relatively simple and a low-cost method of adding a vegetated surface to a building. Vines typically require a less-complicated growing infrastructure than living walls or green roof systems. Vines may be grown on the ground level or in planters that can be attached to a building at elevated points to reach higher levels. In selecting the proper plant material for a vine covering, an understanding of the local climate plays a significant role. In cold climates of the Northern Hemisphere, deciduous materials should be grown on south- and east-facing walls, which will help in blocking sun in the summer and let sun through during the winter to reduce heating costs. In hot climates of the Northern Hemisphere, evergreen vines located on the west and south walls can reduce mechanical cooling needs.[7] Care should be taken in utilizing vine covering, as vines adhered directly to a wall can sometimes undermine the integrity of wall materials over time. Utilizing a trellis system can help to overcome this issue.

Living Wall Systems

Living walls are more complex than vine coverings, but they offer a level of increased design control and can be instituted more extensively and more selectively than vine coverings. Living walls are engineered systems, typically composed of many individual plants that are planted on a vertical support structure. They can be wall-mounted or freestanding systems. The support structure of the wall may contain planting containers with a growing medium or fabric planter pockets that contain plants in a soilless hydroponic system. Living walls also typically have an irrigation system. A living wall's vegetation can be composed of evergreen or deciduous plant species. However, the use of deciduous plants may expose the underlying structure of the living wall, which may not be desirable for aesthetic reasons. Like vine coverings, living walls have the potential to reduce the energy needed for heating and cooling through the benefits from shading and evapotranspiration. For maximum benefit, living walls should be located in a manner similar to that outlined for vine-covered walls.

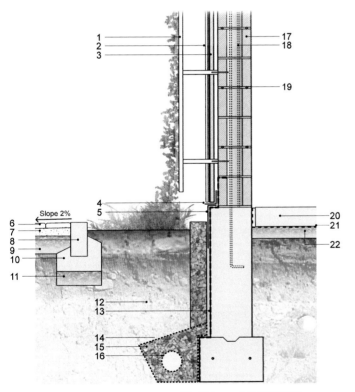

1. Trellis Structure
2. Stucco-on-Metal Lath
3. Rigid Insulation
4. Flashing
5. Protective Membrane
6. Pavers
7. Sand Setting Bed
8. Concrete Paving Edge
9. Granular Base
10. Concrete
11. Granular Base
12. Soil Backfill
13. Waterproofing Membrane
14. Filter Fabric
15. Coarse Gravel
16. Perforated Drain Pipe
17. CMU Wall
18. Vertical Reinforcement Bars
19. Ladder Type Joint Reinforcement
20. Concrete Slab
21. Vapor Barrier
22. Coarse Gravel

Fig. 7.2-6 Vine-Covered Wall

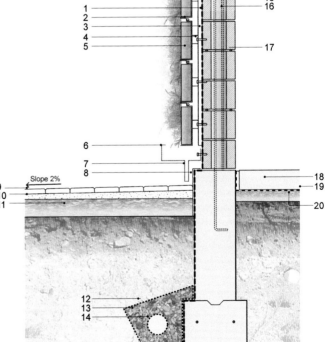

1. Waterproofing Membrane
2. Irrigation Drip Line
3. Stainless Steel Frame
4. Stainless Steel Anchor
5. Modular Panels with Planting Medium
6. Irrigation Catch Basin
7. Drain Pipe
8. Protective Membrane
9. Pavers
10. Sand Setting Bed
11. Granular Base
12. Filter Fabric
13. Coarse Gravel
14. Perforated Drain Pipe
15. CMU Wall (Void Must Be Filled)
16. Vertical Reinforcement Bars
17. Ladder Type Joint Reinforcement
18. Concrete Slab
19. Vapor Barrier
20. Coarse Gravel

Fig. 7.2-7 Living Wall

7. Landscape

Green Roofs

Green roofs, or living roofs, are engineered, vegetated rooftop systems. On a green roof, vegetation is planted in a growing medium laid over a waterproof membrane separating the system from the roof and the building below. A green roof may also contain additional layers to provide root barrier protection, irrigation, and drainage.

The vegetation on a green roof can be composed of low groundcovers or may contain large trees and shrubs, depending upon the system's construction. Green roof systems with 6 inches (15.2 cm) of growing medium or less are commonly known as extensive systems. They can support relatively smaller-sized plant materials. Because of their limitations with plant material sizing, this green roof type is more commonly used where weight loads are a limiting factor, such as in cases involving conversions of existing conventional roofs. Where large weight loads can be accommodated, an intensive system can be utilized in which the growing medium exceeds 12 inches (30.5 cm) in depth. For intermediate applications of 6 to 12 inches (15.2 to 30.5 cm) of growing medium, the semi-intensive green roof can be used. Intensive and semi-intensive systems can accommodate larger plants species, including trees. In general, roofs with greater soil depth can better retain moisture and maintain more stable soil temperatures, thereby offering a more stable ecosystem for plant materials and accommodating a broader range of species. Intensive and semi-intensive green roofs are typically favored in newly constructed buildings over extensive systems.

Green roofs are built as an alternative to conventional roof systems due to their economic, environmental, and aesthetic benefits. Among their most significant benefits is the moderation of solar heat. Many conventional roof materials absorb and accumulate solar heat, contributing to higher heat loads on buildings. On a green roof, evapotranspiration processes from plants absorb most solar radiation. This leads to cooler temperatures on the rooftop, reducing the heat load on the building. In addition to the effects of evapotranspiration, the plants on a green roof offer a buffer for the building from incoming solar energy and also an irregular and diffusing surface for solar rays to strike. Along with the direct benefits to the buildings on which they are constructed, green roofs reduce the urban heat island effect, making cities more comfortable and less dependent on mechanical cooling.

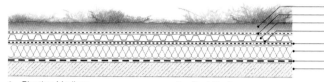

1. Planting Medium
2. Filter Fabric
3. Drainage and Reservoir Layer
4. Moisture Retention Layer
5. Root Barrier
6. Thermal Insulation
7. Waterproofing Membrane
8. Structural Roof Deck

Fig. 7.2-8 Extensive Green Roof

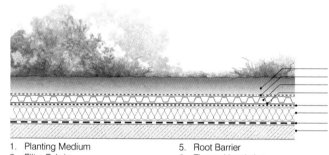

1. Planting Medium
2. Filter Fabric
3. Drainage and Reservoir Layer
4. Moisture Retention Layer
5. Root Barrier
6. Thermal Insulation
7. Waterproofing Membrane
8. Structural Roof Deck

Fig. 7.2-9 Semi-Intensive Green Roof

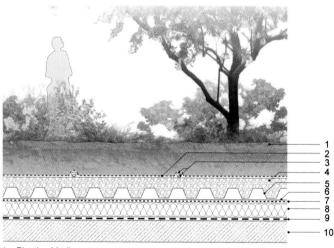

1. Planting Medium
2. Filter Fabric
3. Irrigation Drip Line and Slotted Sleeve
4. Granular Drainage Medium
5. Reservoir Layer
6. Moisture Retention Layer
7. Root Barrier
8. Thermal Insulation
9. Waterproofing Membrane
10. Structural Roof Deck

Fig. 7.2-10 Intensive Green Roof

Thermal Efficiency

Thermal Insulation

Effective insulation can significantly decrease the amount of energy required to heat and cool a building, thereby reducing energy costs and decreasing negative environmental impacts. In addition to traditional building insulating methods, landscape elements and systems can be utilized to greatly improve the insulation of a building.

VEGETATED SURFACE SYSTEMS A living wall on a façade or a green roof can potentially offer an additional insulating layer to a building, helping to maintain the temperatures inside. Living walls or green roofs are typically constructed with base layers that have the effect of reducing or blocking direct contact between outdoor air and building surfaces, providing a buffer to exterior temperatures. In addition, many living walls and green roofs contain a significant amount of growing medium, which can be a very effective thermal insulator, adding additional protection. Moreover, the plants grown on living walls and green roofs can also improve the insulation of a building further, by reducing air infiltration as well as creating insulating still-air spaces next to buildings that can help reduce conductive heat loss or gain.

The effectiveness of green roofs in providing insulation has been studied extensively and well documented. The effect of living walls on heat gain and heat loss has been less studied, but some early studies indicate significant insulating properties that can generate improvements of 3.6°F to 19.8°F (2°C to 11°C) in temperature over walls composed of conventional construction materials.[8]

EARTH SHELTERING In an earth-sheltered building design, earth (soil) is a major component of the building's construction and insulation, covering a portion of the building or its entirety. Proper use of earth sheltering can substantially reduce a building's energy consumption for heating and cooling. This is due to two reasons. First, earthen barriers have a high thermal mass, which means they have a high capacity for heat absorption and a low level of conductivity. This results in a temperature lag between the earth and outside air. Thus, earth sheltering has the capacity to absorb extra heat from a building in hot weather or insulate it in cold weather, reducing both heating and cooling requirements. Second, earth barriers have a high density, which makes them highly effective at reducing air (and heat) leakage, or drainage, between the outside and inside of a building.

The climatic conditions of a geographical area will determine whether earth sheltering can be an effective strategy for energy savings. Some studies have shown that earth-sheltered buildings are more effective in climates that have significant temperature extremes and low humidity, such as the climates found in the Rocky Mountains and northern Great Plains in North America. There are three basic technical design configuration types for earth sheltering. These are elevational design, penetrational design, and atrium-style design.

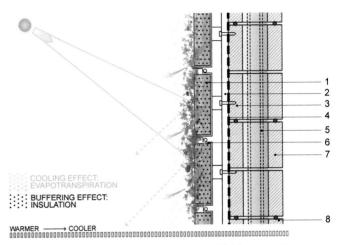

1. Modular Panels with Planting Medium
2. Stainless Steel Frame
3. Stainless Steel Anchor
4. Waterproofing Membrane
5. Vertical Reinforcement Bars
6. Irrigation Drip Line
7. CMU Wall
8. Ladder Type Joint Reinforcement

Fig. 7.2-11 Thermal Insulation: Living Wall

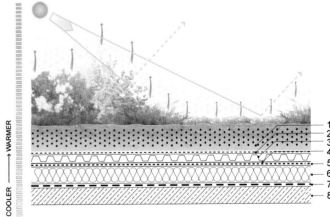

1. Planting Medium
2. Filter Fabric
3. Drainage and Reservoir Layer
4. Moisture Retention Layer
5. Root Barrier
6. Thermal Insulation
7. Waterproofing Membrane
8. Structural Roof Deck

Fig. 7.2-12 Thermal Insulation: Green Roof

7. Landscape

Elevational Design

An elevational design configuration is typically used on hillside sites. Utilizing the topography of the sloped site, much of the building is covered with earth with the exception of one façade facing outward from the hill, left entirely exposed to the exterior air. The earth-covered sides of the building protect and insulate the building. The exposed side, which typically faces south, provides solar access for natural lighting and heating. Although the building can be built to varying depths, deeper construction can limit the internal air circulation and reduce daylight access in the most interior portions of the building. However, skylights and venting systems can alleviate these problems.

Penetrational Design

In a penetrational type design, earth covers the roof and all façades of the building, except where it is removed for window and door access. The building structure is usually built at ground level or above grade, and earth is built up or bermed over the top. With properly placed openings on more than one side, this earth-sheltering design type can allow cross-ventilation opportunities and greater access to natural light than other methods.

Atrium-Style Design

An atrium-style earth-sheltered building is built entirely below ground level on a flat site. At the center of the building, there is an open central outdoor courtyard. Exposed walls facing the courtyard interior are made of glass to provide light, solar heating, and outdoor views. Access to the ground level is via stairway in the courtyard. The courtyard is hardly visible from ground level and barely interrupts the landscape. The design provides excellent protection from the winter winds and offers a private outdoor space. In developing an atrium-style earth-sheltered building, climate is a very significant consideration. In hot-humid climates, the courtyard may become overheated because the design can prevent significant natural air movement. Methods to draw air down into the courtyard must be employed. In wet climates, proper drainage needs to be carefully considered. In cold climates, snow removal must be addressed.

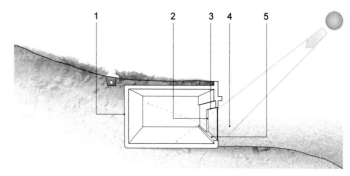

1. Structure Built into Hillside
2. Limited Natural Ventilation
3. Limited Access to Natural Lighting
4. Views of Immediate and Distant Surroundings
5. South-Facing Entrance

Fig. 7.2-13 Earth Sheltering: Elevational Design

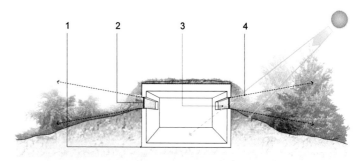

1. Structure Built at Ground Level Using Berms
2. Opportunity for Cross-Ventilation
3. Access to Natural Lighting
4. View of Immediate Surroundings

Fig. 7.2-14 Earth Sheltering: Penetrational Design

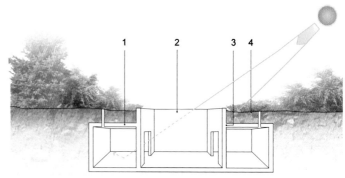

1. Structure Built Below Grade
2. Access to Natural Lighting from Courtyard
3. Reduction of Winter Winds and Noise
4. Seamlessly Blends into Landscape

Fig. 7.2-15 Earth Sheltering: Atrium-Style Design

Thermal Efficiency

Wind Protection and Control

Wind can have profound effects on climate. It can bring soothing relief from high air temperatures or additional bitter cold in low temperatures. Wind can impact the temperatures of a building in two significant ways. First, wind blowing across the surfaces of buildings can impact those surfaces in ways similar to its impacts on human skin and body temperature. Wind brings building surfaces into contact with a greater number of air molecules, causing increased heat exchange. A relatively cool wind blowing across a warmer surface will absorb some of the surface heat and carry it away. Second, air movement from wind creates pressure differences around a building, causing air to circulate. This creates air infiltration, bringing outside air into the building through doors, windows, cracks, and crevices, which also in turn forces an equal amount of interior air out of the building. This is referred to as *air drainage*. In cold weather conditions, air drainage can result in heated air being drawn out of the building while cool air is pulled in, leading to unwanted heat loss. In warm weather conditions, such an exchange could be beneficial. Cooler air could be brought into an overheated space in order to reduce the excess heat. Maintaining control over this heat exchange is desirable.

Given the impact of wind on temperature, harnessing its benefits and defending against its detriments can help achieve significant energy savings. Employing a number of landscape strategies can be effective in controlling wind and its impacts on buildings.

LANDSCAPE WINDBREAKS Windbreaks, also known as shelterbelts, are strategically placed clusters or rows of trees and shrubs that are planted to reduce wind speed or redirect wind movement. They can be beneficial on any site where wind is a considerable factor. In a cold climate, a properly located and effective windbreak can decrease air infiltration and heat loss by reducing wind velocity near the building, thus saving up to 20 to 40 percent of heating costs.[9] Additionally, in climates with considerable snowfall, windbreaks can act as catches for drifting snow, reducing snow related damage as well as reducing the energy expenditures related to snow removal.

An effective windbreak in a cold climate is comprised of a variety of plant species with varying growth characteristics in order to maintain a sufficient density at all heights over a period of years. Diversity of plant species also improves a windbreak's wildlife habitat value. Plant species selected for a windbreak should be able to withstand the desiccating effects of winter winds. Evergreen species should constitute a significant portion of the windbreak composition because they retain wind-blocking mass in winter when it is most needed. Trees or shrubs in a windbreak should be closely spaced to provide a continuous barrier to winds.

Windbreaks can reduce winds up to a distance of 30 times the height of their tallest row, downwind.[10] The effective distance of a windbreak is usually expressed in terms of a windbreak height multiplier, which is measured from the center of the outermost row of planting, downwind, along a line following wind direction. The typical optimum distance for placement of a windbreak from a structure for reducing wind velocity is about one to three times the windbreak height. However, a windbreak can provide a high level of protection at a distance of up to six times its height.[11] The length of the windbreak, perpendicular to wind direction, should be at least ten times its height and extend beyond the width of the area being protected in order to reduce the effects of wind flow around the ends of the windbreak.[12]

Dense windbreaks can stop a greater amount of wind, but density is not always the most efficient strategy for efficient protection. With a more solid and impermeable windbreak, wind is deflected up and over. Low pressure created by the windbreak on the downwind side will draw back the wind quickly a short distance from the windbreak, reducing the protection area size. Developing a more permeable windbreak will reduce the low-pressure build-up and result in a larger area of protection. Windbreak permeability should allow 20 to 50 percent of wind to pass through to maximize the effective distance.

Although permeability can increase the efficiency of windbreaks, gaps (vertical and horizontal) in an otherwise dense windbreak will create areas in which wind is funneled with increased speed due to the *Venturi effect*. The Venturi effect is a phenomenon in which wind, when channeled or forced to flow through a narrower space, increases in velocity.

Trees and shrubs dying or failing to establish can result in the creation of significant gaps in a windbreak. Establishing new planting in such gaps can be difficult. Therefore, planting multiple rows of trees and shrubs in a windbreak at initial installation protects against the formation of gaps. If a tree dies, the windbreak can still remain intact and effective.

WINDBREAK DESIGN There are many ways to construct a landscape windbreak. Site constraints, budget, aesthetics, and also functional aspects can influence the choice of a windbreak's design. The following are some of the basic design options.

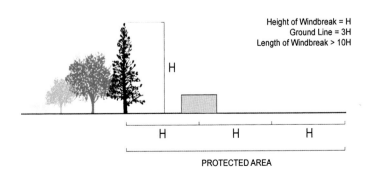

Fig. 7.2-16 Landscape Windbreaks: Optimal Protected Area Formula

7. Landscape

One-Row Windbreaks

A one-row windbreak is composed of a single linear row of trees or shrubs. A one-row windbreak uses the least land area among windbreak design types. It is typically used for agricultural field protection or in urban settings with limited space. To be effective, the one-row windbreak should utilize densely planted evergreens that will retain their lower limbs and foliage. If deciduous trees are to be used, they should be densely planted and have narrow crowns. One-row windbreaks have some limitations that make them less than ideal in most situations. The most significant limitation is that they can be considerably weakened if a single member tree (or shrub) in the row dies or fails to grow properly. In addition, with regard to wildlife value, one-row windbreaks typically offer less benefit in terms of biological diversity and available shelter. An effective mixture of several plant species can improve circumstances.

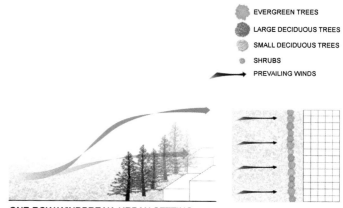

ONE-ROW WINDBREAK: URBAN SETTING

Two-Row and Twin-Row Windbreaks

Two-row and twin-row windbreaks are comprised of two linear rows of trees or shrubs. They are typically utilized for agricultural field applications or in suburban settings with sufficient space. A two-row windbreak is made up of two distinct rows of trees or shrubs spaced apart at a consistent distance. A two-row windbreak can be composed of a single species, a set of two species (one each row), or a mixture of species. To be effective, each row of the windbreak should be densely planted as is done in a one-row windbreak. A twin-row windbreak is composed of two rows of trees or shrubs, but planted adjacent to one another in an alternating pattern to form a single mass of planting. A twin-row windbreak is more typically composed of a single species, but could be made up of a plurality of species. Planting should be of evergreen-type trees or shrubs.

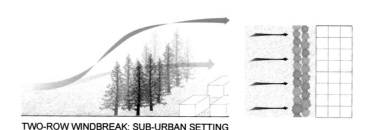

TWO-ROW WINDBREAK: SUB-URBAN SETTING

Three-Row Windbreaks

Three-row windbreaks are comprised of three rows of trees or shrubs. The three rows should consist of at least one dense row of evergreen trees. The other rows can be deciduous or evergreen plantings. There can also be a frontline row of shrubs for catching snow if necessary. The rows are spaced at a standard and consistent distance from one another. This type of windbreak is typically used for farmstead protection. A three-row windbreak can have considerably more wildlife value than a single or double-row windbreak with its additional sheltered spaces and the possibility of a greater diversity of plant species. With the addition of food-bearing shrubs, it can be improved further.

THREE-ROW WINDBREAK: FARMLAND SETTING

Four-Row Windbreaks

The use of four or more rows in a windbreak can provide an even greater level of protection. Additional rows allow for greater flexibility in the design and in the diversity of species. Four or more rows in a windbreak will use a considerably large portion of land and therefore should only be used where extensive land is available, typically in a rural setting. One or two of the rows should consist of evergreen planting. The windbreak can also include one or more rows of deciduous plants and small shrubs for snow catch, if necessary.

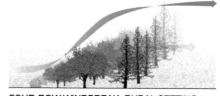

FOUR-ROW WINDBREAK: RURAL SETTING

Fig. 7.2-17 Landscape Windbreak Types

Thermal Efficiency

FOUNDATION PLANTINGS Foundation plantings are a continuous line of evergreens along the length of the foundation and around the corners of a building, approximately five feet (1.5m) out from the outer walls. They can be utilized to achieve considerable heating and cooling energy savings in a low-rise building or the lower levels of a taller building. Like windbreaks, foundation plantings are used to reduce wind speed around the building. However, they are also used to create a buffer of "dead air space" around the building with slower circulating air, which acts as an additional insulating layer. This still air has much less cooling potential than circulating or wind-driven air, which greatly decreases heat loss through walls at the ground level. In the summer, this still air space provides a shade buffer to the building, creating a cooler space of insulating air. Energy savings of more than 20 percent can be achieved in a building landscaped to minimize air infiltration versus a building without such landscaping.[13]

In the development of an effective foundation planting scheme, the plants should never be allowed to grow much closer to the building than five feet (1.5m) in order to be sufficiently effective. In addition, planting too close to a building can create problems with mildew, fungi, humidity, and insects.

WIND DEFLECTORS AND WIND CHANNELS Wind deflectors are short rows of trees or shrubs, fences, or earth berms used to deflect wind. Depending on their placement, they can direct wind into or away from an area. They are most effective at deflecting wind in a small vicinity. They are not intended to act like a windbreak, which can protect an entire building or a piece of land from wind. An effective use of wind deflection would be planting a row of trees to the northeast of a building to capture and direct a southerly summer breeze toward the north side of the building.

In hot climates, during warm seasons, there is a greater desire to utilize the cooling effect of wind rather than defend against it. Just as cold winter wind can be blocked and redirected, cool breezes can be "funneled" toward living spaces to bring relief from heat. Trees and shrubs planted in a V-shaped pattern that tapers as it nears a structure, can collect and funnel cool breezes toward a building or usable outdoor space. This arrangement not only redirects wind, but also increases its speed, due to the Venturi effect.

Plantings for a wind channel should be dense with overlapping branches between adjacent plants. The channel can be comprised of both evergreen and deciduous trees or shrubs. Foliage should extend to the ground to maximize the channeling effect. However, trees with thick and lifted canopies can also be used to increase the ground level breeze by forcing air downward.

The benefits derived from increasing airflow around a building during warm seasons are generally not as substantial as the benefits of decreasing airflow in cold seasons. In winter, the difference between a desired building temperature and the outside air temperature can be significantly large. In warmer weather, the difference between a building's desired temperature and the outside air is usually relatively smaller, making the impact of wind on surface temperatures considerably less. However, where cooling winds are available, the use of landscape to channel wind can move away excess heat and bring significant relief, even if only a few degrees. In addition, transpiration from trees and shrubs in landscape wind channels can cool passing wind, helping to decrease temperatures. Warm wind blowing over a leaf surface passes some of its heat to water secreted by the leaf via transpiration. The heat is absorbed when the water evaporates, leaving behind cooler air and a cooler breeze.

In developing a landscape wind channel, consideration must be given to the ability of the chosen plant species to withstand wind.

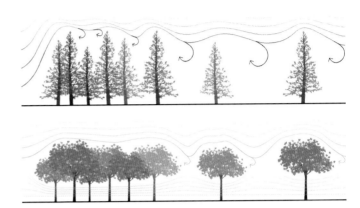

Fig. 7.2-18 Wind Patterns through Vegetation

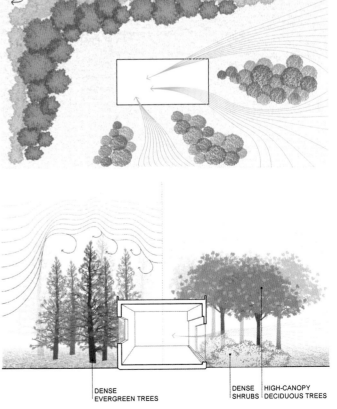

Fig. 7.2-19 Wind Deflectors and Channels: Plan (Top), Section (Bottom)

7. Landscape

Prototypical Designs for Climatic Regions

The following design cases show prototypical comprehensive design strategies for the various climate types. These design cases strictly address landscape solutions for solar, thermal, and wind control and are based on climate types in the North American continent. In addition, these landscape solutions are more applicable in addressing low-rise buildings. However, these design prototypes illustrate some general principles that can be a guide for applications elsewhere.

HOT AND HUMID CLIMATE STRATEGIES Maximizing shade throughout the year and encouraging air movement are the main objectives for a landscape design in a hot and humid zone. Plant materials should provide shade to the building and outdoor living spaces whenever possible. Significant shade structures such as wide trellises with deciduous vines on the north and south sides of a building can provide additional help for solar protection and form comfortable outdoor areas. Utilizing high-canopy deciduous trees on the east and west sides of the building can increase solar protection in the morning and afternoon, and allow air movement underneath the canopies. It is also important to keep low vegetation away from the building to allow breezes through and to prevent dampness. To maximize air movement, it is important to channel prevailing winds with wind channeling and deflection techniques. Light-colored paving materials around the building can help to reduce glare and heat absorption.

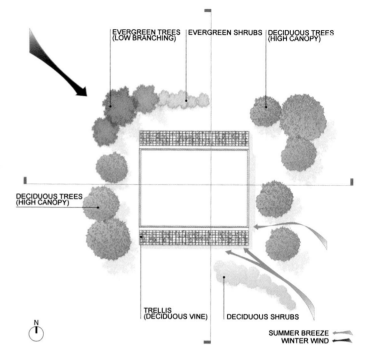

Fig. 7.2-20 Hot and Humid Climate Strategies: Plan

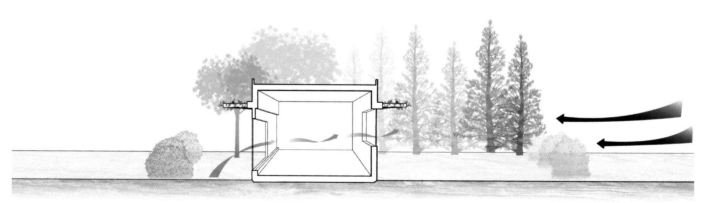

Fig. 7.2-21 Hot and Humid Climate Strategies: North-South Section

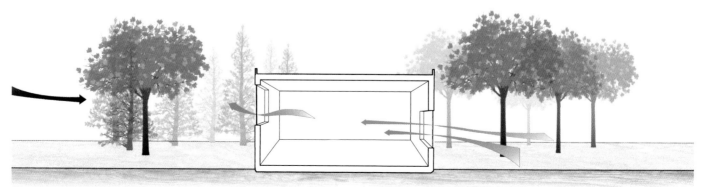

Fig. 7.2-22 Hot and Humid Climate Strategies: East-West Section

Thermal Efficiency

HOT AND ARID CLIMATE STRATEGIES The key objective of landscape design in a hot and arid zone is to maximize shade, especially during the late morning and late afternoon hours. Locating shade trees to the east and west of the building can help with this. Also, due to the high altitude of the sun in the sky during hot summer months, it is advantageous to locate high-canopy deciduous trees immediately adjacent to the building to maximize shading of the roof. However, care should be given to closely monitor tree roots in order to avoid foundation damage when using this strategy. Additional shade trees or a trellis structure with vines on the southern side of the building can help prevent solar heating of the south walls.

Protecting the east and west sides of the building with climbing vines growing on vertical structures will help to reduce heat gain in the morning and afternoon as well as cooling the air immediately adjacent to the building through transpiration processes. In addition, adding water features is another useful landscape strategy to cool a building in a hot and arid zone. Hot, dry winds channelized across a water body can produce a cooling effect for the building, and also deliver needed moisture, taking advantage of quick evaporation in the dry air.

With regard to site hardscape, it is preferable to reduce the amount of paving and cover the ground with vegetation as much as water resources allow. This significantly reduces the potential for heat absorption by the paved surface and also reduces glare. In areas where paving is necessary, use of light-colored surface materials can help to reduce negative effects.

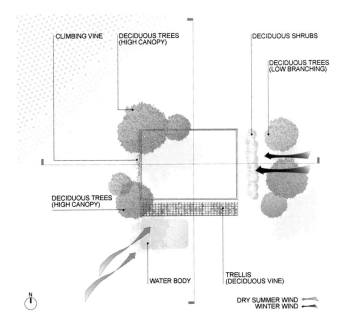

Fig. 7.2-23 Hot and Arid Climate Strategies: Plan

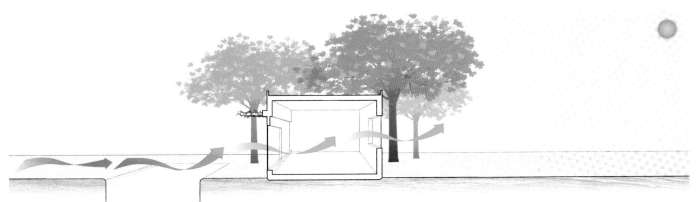

Fig. 7.2-24 Hot and Arid Climate Strategies: North-South Section

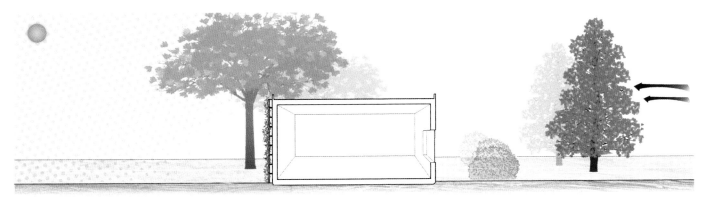

Fig. 7.2-25 Hot and Arid Climate Strategies: East-West Section

7. Landscape

TEMPERATE CLIMATE STRATEGIES To best accommodate the climatic conditions of temperate regions, it is necessary to consider more substantial seasonal variations. It is advantageous to maximize the warming effect of solar radiation and develop buffers against the colder outdoor air in the winter and yet maximize shade and capture cool breezes during the summer. A prototypical landscape design for this region could include the use of high-canopy, high-branching deciduous trees on the east and west sides of the building. This would allow penetration by the warming rays of the low winter sun, but protect the building from the high summer sun with a full summer canopy. Low-branching evergreen tree clusters could be utilized to help block cold northwest winds during the winter. In addition, the use of dense evergreen shrubs on the north and west sides can form an insulating air space between the building and the planting, which would help to reduce heat loss during winter months. Also, it is advantageous to funnel prevailing summer breezes into the building during hot summer days using landscape wind-channeling techniques.

Utilizing an overhead trellis adjacent to the southern façade of the building with deciduous vines can provide additional shade to the building and create a shaded outdoor space for use in the summer. Similar to the situation in hot climatic zones, the use of outdoor paving materials with light colors will lower heat absorption on site and help maintain cooler air temperatures around the building in warmer weather periods.

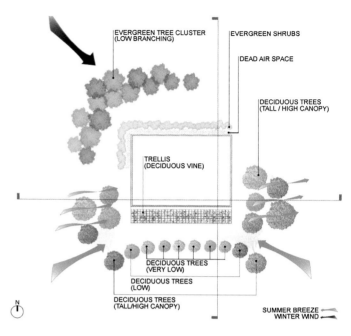

Fig. 7.2-26 Temperate Climate Strategies: Plan

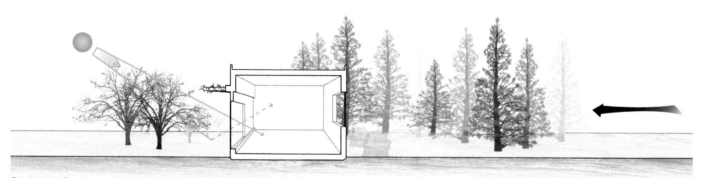

Fig. 7.2-27 Temperate Climate Strategies: North-South Section

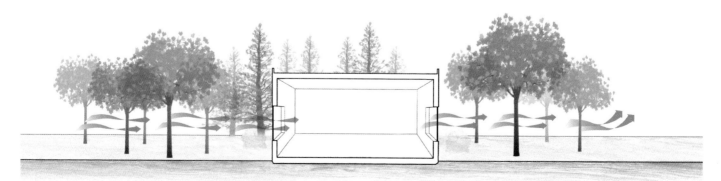

Fig. 7.2-28 Temperate Climate Strategies: East-West Section

Thermal Efficiency

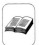

COLD CLIMATE STRATEGIES In cold climate regions, it is very important to protect the building from northern winter winds. Forming an earthen berm on the north and northwest sides of the building and planting dense rows of evergreen trees and shrubs will help to break the speed of the cold winter wind and create a trap for blowing snow. Additional dense evergreen shrubs adjacent to the northern sides of the building can help to create insulating airspaces, providing insulation during both winter and summer months. Earth sheltering may also be an effective solution in cold climates. If the building site is located on a south-facing slope that receives sufficient sunlight, an elevational earth sheltering design can be utilized effectively.

Using deciduous shrubs and trees on the south side of a building can provide some summer shading when needed, but admit low winter rays. In addition, deciduous, high-canopy trees on the east and west sides of a building will allow warm winter rays, provide summer shade, and promote summer breezes under their canopies. To further capture low winter sun and reflect its warmth to building interiors, a sunken terrace with a light-colored reflective material can be incorporated into the design on the southern side of the structure. Furthermore, darker paving materials may also be used on site to capture warmth and promote snowmelt.

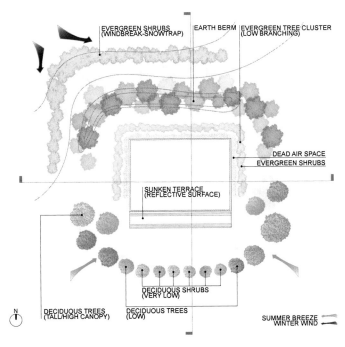

Fig. 7.2-29 Cold Climate Strategies: Plan

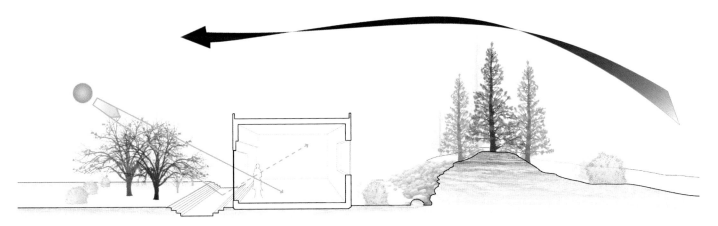

Fig. 7.2-30 Cold Climate Strategies: North-South Section

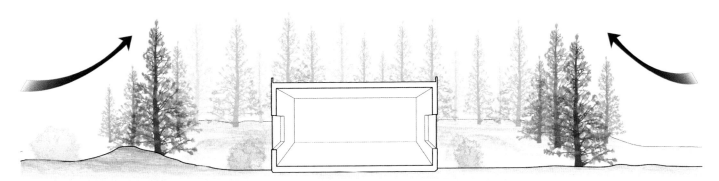

Fig. 7.2-31 Cold Climate Strategies: East-West Section

7. Landscape

7.3 Hydrological Efficiency

Water is an essential life element. However, usable supplies are diminishing as the world's demand for water resources is increasing at a significant rate. Human overconsumption, poor conservation, pollution, and the effects of climate change are threatening the ability to supply basic water needs. Unless current behaviors and present trends are altered, clean and safe water will become an expensive commodity, unaffordable to many. The following sections examine specific tools and methods available for the utilization of landscape design to promote sustainable use of water resources.

Water Conservation

Water conservation is the most effective method available for ensuring affordable water supplies into the future. If clean water supplies become scarce, there will be a need to utilize resources that require increased costs for extraction, transport, treatment, and storage. Developing strategies for the efficient use of water in the present reduces future costs by stretching the use of current water supplies and aiding the development of methods that can be used in the long run to keep water usage at sustainable levels.

In addition to the direct and up-front costs of water usage, significant costs can be associated with the treatment of resulting wastewater. Every gallon of water that is conserved in use produces less wastewater that needs treatment. This produces a substantial impact for water conservation that goes beyond what might be immediately perceptible when looking at water use alone. Employing proper landscape design strategies plays a significant role in conserving water and reducing the demand on potable water supplies. The use of low-irrigation plant materials, efficient irrigation systems, and the expanded use of treated wastewater or harvested rainwater for irrigation can help to achieve significant reductions in water use.

LOW IRRIGATION PLANT MATERIALS The selection of plant materials is a significant component of developing a landscape design that is resource conscious and sustainable. Many plants used in man-made landscapes consume significant amounts of water (along with other resources) to remain healthy. Turf lawns, in particular, can be large consumers of water resources and they also require a great amount of maintenance. Merely substituting a lawn with a properly chosen herbaceous plant cover can drastically reduce water use and maintenance in many instances.

Large trees, once established, can also considerably reduce the irrigation needs of a landscape in two ways. First, many trees are able to tap water sources in the soil far deeper than the roots of smaller plants and therefore survive longer periods of drought without irrigation. Second, trees can lend shade to plants below and protect them from intense heat generated by the sun, reducing evaporation, and thereby the water needs of those plants.

The best strategy for reducing plant irrigation is to use native plants ideally suited to a site's conditions, including precipitation levels. Generally, species native to the locality of a site do not require much, if any, irrigation beyond what might be needed for establishment. Many non-native plant species, in contrast, may require significant amounts of irrigation and extra care to keep them alive and healthy. Strategies which seek to minimize or eliminate water use in landscaped areas by using plants needing little to no irrigation should be applied to conserve water, particularly in regions where water resources are the most limited.

EFFICIENT IRRIGATION MECHANISMS The amount of water that landscape irrigation consumes can be a significant portion of a building's overall water usage. Therefore, there is much potential for substantial reductions in water consumption through the use of technologies and methods that increase the efficiency of landscape irrigation.

Using appropriate technologies can easily improve water-use efficiency in any irrigation system. Automatic irrigation timers with controllers can ensure that plants are watered only the necessary amount. The addition of rain and soil moisture sensors will also reduce unnecessary watering when natural precipitation provides the adequate irrigation quantities.

Utilization of proper irrigation strategies for specific site conditions can also provide significant water savings. In heavy clay soils, water should be applied slowly for long periods of time, with substantial time between waterings. Lighter sandier soils may require more frequent irrigation at higher application rates to keep roots from drying out. Overall, plants that have been watered deeply and less frequently will develop deeper root systems and will need less water than those watered frequently and at shallow depths. Therefore, watering deeply and infrequently should be the dominant strategy for irrigation everywhere to the extent possible.

For the most extensive water savings, microirrigation should be employed. Microirrigation is an irrigation method by which small quantities of water are delivered to plant material through frequent applications on or below the soil surface as drops, tiny streams, or low-level spray delivered through emitters or applicators placed along a water delivery line. The most common application methods for microirrigaton are drip (or trickle) and subterranean irrigation.

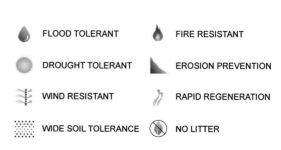

Fig. 7.3-1 Plant Material Selection Symbol Key

Hydrological Efficiency

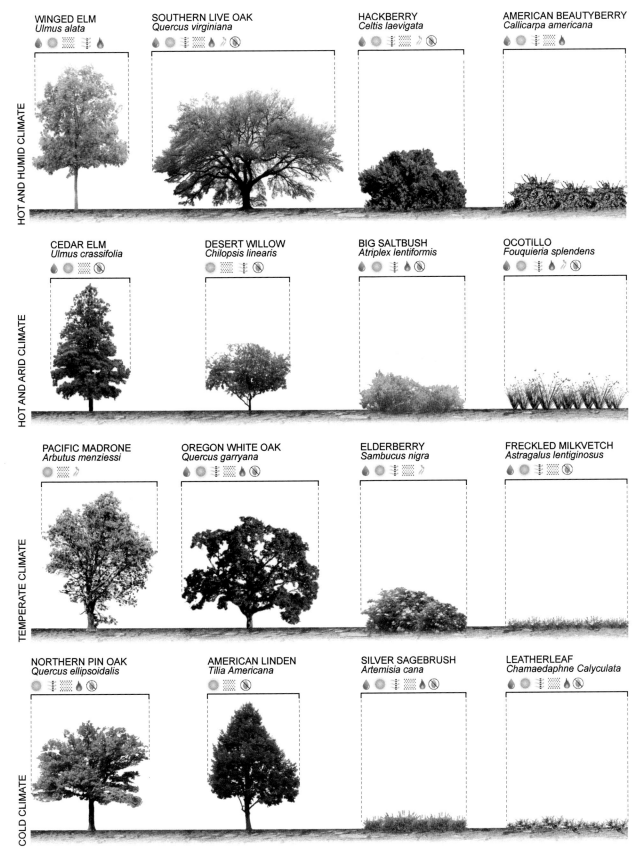

Fig. 7.3-2 *Plant Material Selection*

7. Landscape

Drip Irrigation

Technically referred to as low-volume irrigation, drip irrigation systems deliver water directly to the root zones of plants at very low pressure and rates of flow. A drip irrigation system consists of main water lines and small microtubing spurs that deliver water to individual plants. Water is applied to the soil surface as drops or tiny streams through emitters on the microtubing spurs. The system can be modified as plants grow or have established themselves and no longer require irrigation. Drip systems are ideal for trees, shrubs, groundcovers, and vines. Lawns are typically better off with standard sprinkler systems due to coverage requirements. Drip irrigation is estimated to save 30 to 50 percent of the water required over conventional irrigation methods.[14]

Subterranean Irrigation

Like drip irrigation systems, subterranean systems utilize low flow and low pressure to minimize water use. Also, like drip systems, the application of water is through emitters, with discharge rates generally in the same range as drip irrigation. However, unlike drip systems, the water lines and delivery system of subterranean irrigation systems are buried. Subterranean systems are designed to deliver water directly to the root zones of plants. Installation costs for subterranean systems are more than drip, due to line burial, but the system offers the advantage of supplying a more even delivery of water, making it usable in lawn applications. In addition, the hidden lines offer a better aesthetic look.

ALTERNATIVE WATER SOURCES FOR IRRIGATION Using alternative sources to potable water in building and site functions can conserve water supplies. Recycling the water within a site and using captured rainwater are two economical and practical strategies to conserve water supplies. Harvested rainwater can be directly used for irrigation, typically without any additional cleaning processes. Minimally treated graywater from buildings on a site can easily be used for landscape irrigation as well.

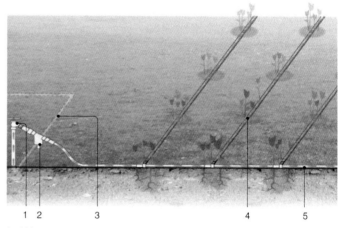

1. Valve
2. Filter
3. Water
4. Emitter
5. Drip Tubing

Fig. 7.3-3 Drip Irrigation

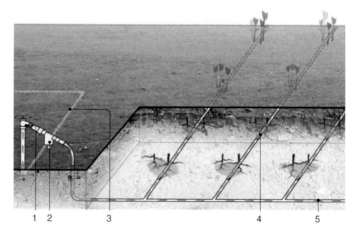

1. Valve
2. Filter
3. Water
4. Emitter
5. Drip Tubing

Fig. 7.3-4 Subterranean Irrigation

Hydrological Efficiency

Runoff Mitigation and Pollution Control

Surface runoff (or stormwater runoff) is the uncaptured and unabsorbed water from precipitation events that flows over land surfaces. Surface runoff is a naturally occurring phenomenon, but the development of impervious surfaces, including parking lots, compacted earth, rooftops and other man-made surfaces, can create excessive volumes and increase peak loads. This can overwhelm natural and man-made drainage systems and cause significant erosion in some circumstances, such as when the terrain has a significant slope or has inadequate plant coverage.

Impervious surfaces also prevent natural infiltration into the soil, thereby preventing the filtration and purification of water and reducing the potential to replenish ground water supplies. In addition, surface runoff is the main conveyor of nonpoint source (NPS) pollution. NPS pollutants are comprised of fertilizers from agricultural fields, industrial contaminants from work sites, and oil and discarded waste materials in parking lots, streets, roofs, etc. These pollutants become mixed with the runoff water, which can easily end up in freshwater reservoirs, above and below ground, contaminating them. NPS pollution has continually been one of the largest sources of water-quality problems in the U.S. It is the main reason that approximately 40 percent of surveyed rivers, lakes, and other water bodies in the U.S. are not clean enough to meet basic uses such as fishing or swimming.[15]

Along with the problems posed by NPS pollutants, some municipalities have combined sewer systems where surface runoff directly drains into wastewater systems. Excessive storm surges causing significant runoff can overload the system and associated wastewater treatment plants. This can create a situation in which raw sewage is discharged directly into rivers and streams because the system is overwhelmed.

The construction of buildings and associated amenities can be significant sources of increased runoff when formerly undeveloped sites are built upon and converted to impervious surfaces. The cumulative effects of multiple and expansive developments can pose problems on a regional scale. During the development of building sites, many of the problems associated with surface runoff can be mitigated in the design stage by using strategies that reduce runoff volumes and peak loads. Primary strategies tend to focus on increasing the infiltration capabilities of the site or by slowing runoff flows.

REDUCING IMPERVIOUS SURFACES Urbanized areas are often extensively covered by paved surfaces that form an impermeable layer over the underlying soils, substantially increasing surface runoff and its associated problems. Minimizing impervious surfaces can decrease runoff by allowing more water to infiltrate into the earth. The best ways to minimize impervious surface area are through more efficient land use practices and by the preservation of undeveloped natural places where pervious surfaces allows more water to infiltrate into the soil.

Proper site development can have a significant impact on the amount of impervious surfaces created on a site. Grouping multiple buildings more closely together can create efficiencies that reduce impervious surfaces. For instance, closely grouped buildings will allow for shared parking, access roads, and walkways. On community and regional scales, grouping various land uses together can also reduce paved surface requirements. When shopping, workplaces, and residences are located close enough to one another to allow walking in between them, parking and roadways can be shared, and built less extensively.

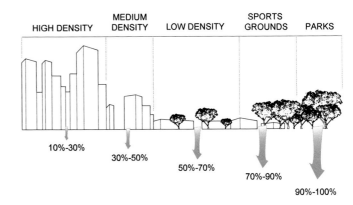

Fig. 7.3-5 Water Infiltration with Different Land Uses

7. Landscape

PERVIOUS PAVING The use of conventional paving materials can also contribute to increased stormwater runoff along with its associated problems. Using pervious (or permeable) paving materials that allow water to pass through, in substitution for conventional paving materials, can help to decrease the negative impacts of paved surfaces on stormwater runoff and also facilitate increased groundwater recharge.

Various materials and methods for the construction of pervious paving are available. Materials available for the paving layer include pervious concrete, porous asphalt, paving stones, precast pavers composed of various materials, single-sized aggregate, and resin bound paving. Below the paving layer, in a pervious paving system, there are several additional layers including an aggregate subbase that can extend 6 inches (15.2 cm) or more below the surface. This subbase allows the system to hold excess water for a period of time before it infiltrates or drains off.

The construction of the subbase is generally one of three types: full exfiltration, partial exfiltration, or tanked system (no exfiltration). The selection of a construction type depends upon the permeability of the soil below the paving system. In full exfiltration systems, all stormwater is expected to fully pass through to the underlying soil. Overflow pipes at the top of the subbase can provide secondary drainage if needed. Partial exfiltration systems are designed so that a portion of the captured water infiltrates into the underlying soil. Overflow piping, perforated piping, or other devices drain off the remaining water. Tanked systems are used where the underlying soil has low permeability and low strength or where there are water quality concerns. The subbase in a tanked system acts as a detention layer. It is enclosed with an impermeable liner and water is removed at a controlled rate through a conveyance system.

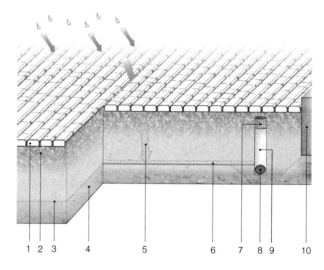

1. Permeable Pavers
2. Aggregate Subbase
3. Geotextile Fabric
4. Soil Subgrade
5. Partial Water Infiltration
6. Perforated Pipe
7. Steel Screen
8. Outlet Pipe
9. Overflow Pipe
10. Curb/Edge Restraint

Fig. 7.3-7 Pervious Paving: Partial Exfiltration

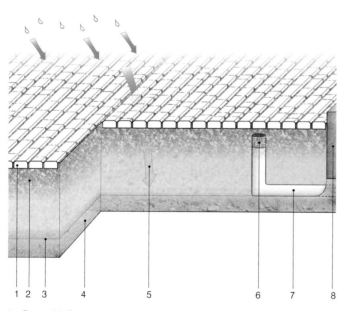

1. Permeable Pavers
2. Aggregate Subbase
3. Geotextile Fabric
4. Soil Subgrade
5. Water Infiltration
6. Steel Screen
7. Overflow Pipe
8. Curb/Edge Restraint

Fig. 7.3-6 Pervious Paving: Full Exfiltration

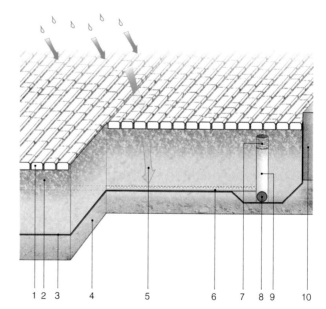

1. Permeable Pavers
2. Aggregate Subbase
3. Impermeable Barrier
4. Soil Subgrade
5. Water Held in Subgrade
6. Perforated Pipe
7. Steel Screen
8. Outlet Pipe
9. Overflow Pipe
10. Curb/Edge Restraint

Fig. 7.3-8 Pervious Paving: No Exfiltration (Tanked System)

Hydrological Efficiency

GREEN ROOFS AND STORMWATER In addition to their thermal benefits, as outlined in the Thermal Efficiency (Section 7.2), green roofs can also mitigate the impact of stormwater runoff. Typically, conventional roof materials present an impervious surface to precipitation. Virtually all rainwater falling on a conventional roof becomes surface runoff, which is collected by rooftop conveyance systems that concentrate the water and deliver it to the ground level. Such a system increases peak runoff loads and can strain natural and man-made systems. The plants and soil that compose a green roof are able to both slow down surface runoff and absorb some of the precipitation that falls on the roof. Just as plants and soil on the ground have a holding capacity for water, so do the plants and soil of green roofs. Some of the water that falls onto a green roof is taken up by the plants on the roof or is held in the soil. In low-quantity precipitation events, a green roof may be able to hold the entire amount of water falling on the roof. The holding capacity of a green roof depends upon its construction. Roofs with more growing medium and larger plant types can hold more water. In addition to the holding capacity of the plants and soil, a green roof may also have retention storage at its base layer to hold additional water.

In precipitation events that exceed a green roof's water holding capacity, the impacts of high volumes of runoff are reduced as the water passes through and is slowed by the roof layers. This decreases the overall peak impact of a site's surface runoff and reduces the need for additional infrastructure to handle higher peak runoff loads. In addition, the runoff from a green roof can be harvested for site irrigation or for applications within the building, such as toilet flushing.

In urban areas, rooftops represent approximately 40 to 50 percent of all impermeable surfaces.[16] As a result, there is great potential for green roofs to play a significant role in reducing surface runoff.

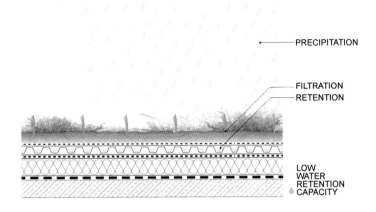

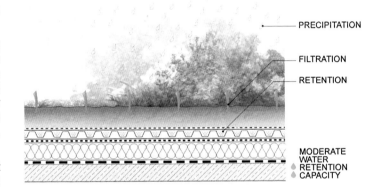

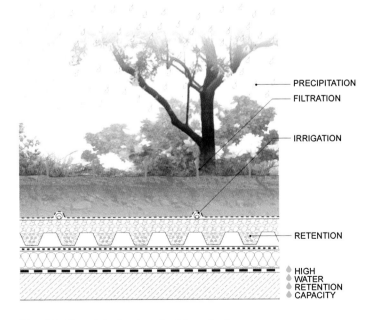

Fig. 7.3-9 Water-Retention Capacity of Green Roofs:
Extensive Green Roof (Top)
Semi-Intensive Green Roof (Middle)
Intensive Green Roof (Bottom)

7. Landscape

STORMWATER PLANTERS Stormwater planters are small, contained bioretention systems that collect and treat stormwater from streets and parking lots. They are often found in parking lot islands, buffer zones, and landscape medians adjacent to streets. Bioretention systems collect and filter stormwater through layers of mulch, soil, and plant root systems where pollutants such as bacteria, nitrogen, phosphorus, heavy metals, oil and grease can be degraded or absorbed by natural processes, or simply retained.

Depending upon the state of the water having passed through the planter, it can be treated in one of two ways. First, if the water is fairly clean after passing through the planter, the water can be allowed to infiltrate down into the soil below through an open bottom. A planter with an open bottom is called an infiltration planter. If letting the water infiltrate into the soil is not possible, or appropriate, then the planter can be enclosed at its base and the water filtered through the planter can be drained into a traditional stormwater drainage system through piping. Such a planter is called a filtration planter or a flow-through planter. Both systems can reduce strains on existing stormwater systems.

Stormwater planters can be a low-cost solution to stretch capacities in conventional stormwater systems. In addition, they do not require large amounts of space and can add aesthetic appeal and wildlife habitat to city streets, parking lots, and commercial and residential properties. Stormwater planters typically contain native plants, which include a selection of hydrophilic (water-loving) flowers, grasses, shrubs, and trees.

BIOSWALES Bioswales are drainage swales that are designed to capture and slow down surface runoff and to also remove sediments and pollutants from runoff water by mimicking natural watercourse systems. Bioswale design typically uses extensive planting along with elements such as a meandering course, gentle slopes, and check dam elements (boulders and other riprap) to slow the flow of water. Slower water flow allows floating and captured pollutants to settle out. The slow flow also facilitates water infiltration into the soil underlying the swale. In addition to slowing the water flow, the obstructions in a bioswale, such as plants and riprap, capture pollutants and sediments carried by the water. Some plant species can also be used in the swale that can take up and break down some chemical pollutants in the water through phytoremediation.

Bioswales present a simple and inexpensive solution to alleviating stormwater issues when there is available space for their implementation. In addition, they can be designed to significantly add to the aesthetics of a site.

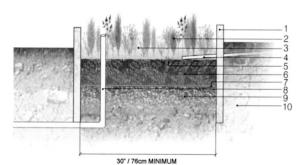

1. Structural Walls
2. Plant Material
3. Water
4. Downspout
5. Gravel Splash Pad
6. Growing Medium
7. Filter Fabric
8. Overflow Pipe
9. Drainage Rock
10. Existing Soil

Fig. 7.3-10 Stormwater Planters: Infiltration

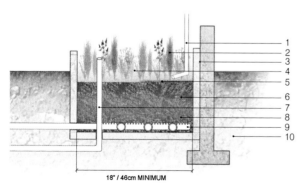

1. Downspout
2. Plant Material
3. Structural Walls
4. Water
5. Gravel Splash Pad
6. Growing Medium
7. Overflow Pipe
8. Drainage Rock
9. Perforated Pipe
10. Existing Soil

Fig. 7.3-11 Stormwater Planters: Filtration

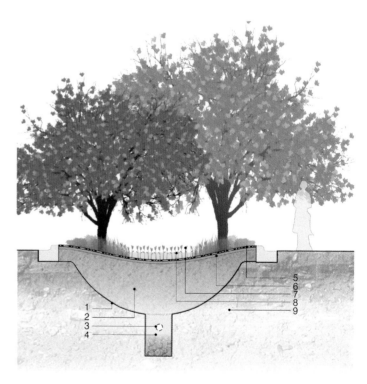

1. Non-Woven Geotextile Fabric
2. Bioswale Planting Mix
3. Perforated Drainage Pipe
4. Exfiltration Trench
5. Erosion Control Blanket
6. Mulch
7. Plant Material
8. Ponding Area
9. Noncompacted Subgrade

Fig. 7.3-12 Bioswale

Hydrological Efficiency

RAINGARDENS Raingardens are small bioretention cells that are built to capture and treat stormwater runoff. The raingarden specifically responds to rainfall and stormwater runoff through its design and plant selection. It is designed to withstand the extremes of moisture and concentrations of nutrients, particularly nitrogen and phosphorus that are found in surface runoff. Typically, a raingarden will be sited close to a source of runoff such as a parking lot or building. Runoff is drained to the raingarden where it is detained. The captured water is then allowed to infiltrate into the ground, or released slowly into other drainage systems, reducing the possibility of erosion or stress on conventional infrastructure. Raingardens are typically designed to fully drain within four hours after a 1-inch (2.5 cm) rain event.

Plants with deep fibrous root systems tend to adapt well in raingardens and typically provide the most cleaning and filtration benefits to the environment. Ideally, plant types chosen for raingardens should be local natives or native cultivars of herbaceous perennials, woody shrubs, and trees. Plants that are adapted to local weather conditions, that provide animal habitat, and that have lower maintenance requirements are preferable to plants chosen based solely on seasonal aesthetics and color effects.

There are two basic design types for raingardens: self-contained and under-drained. Selecting the proper design is based upon a balance of expected water volumes, existing soil conditions, available space, and budget.

Self-contained Raingardens

Self-contained raingardens are designed to capture and hold all stormwater conveyed to them. They have no additional drainage beyond a possible overflow pipe. Self-contained raingardens typically do not retain surface water, but the underlying soil can remain saturated for extended periods of time after rain events, particularly in the lowest areas of the garden. Plants selected for this type of raingarden need to be able to tolerate inundation in their root zones for an extended period of time.

Surface soils in raingardens are amended with a very porous planting media, minimally to a depth of 8 inches (20.3 cm) and ideally to a depth of 2 to 3 feet (0.6 to 0.9 m). This allows quicker infiltration of water at the surface, preventing erosive runoff that might remove the topsoil. Use of less soil amendment when a garden is built will limit the use of plant species to only those that are best adapted to prolonged periods of saturation. Also, upper portions of a raingarden, which tend to drain more quickly than the lower areas, need plants that can withstand drier conditions.

Under-drained Raingardens

In cases where water infiltration is undesirable, an under-drain raingarden might be chosen. In an under-drained system, a drainpipe at the garden subbase removes water before it can infiltrate into the soil below. Under-drained systems are used in cases where the base of the garden has less than 4 feet (1.2 m) of clearance to the seasonal mean high water table or in instances where adjacent soil is contaminated and water from the garden could become contaminated by coming into contact with the soil.

Under-drained raingardens are typically designed to completely drain within two hours of a storm event. Similar to a self-contained raingarden, highly porous planting media is used near the surface. Along with the drainage below, this allows the runoff water to be carried away from the garden relatively quickly. The plants selected for the under-drained raingarden do not need to tolerate the same levels of saturation required in the self-contained raingarden. However, they do need to be able to withstand the extremes of both flooding and drought. Also, as in the case of self-contained raingardens, plants on the upper portions of the under-drained raingarden need to be able to withstand somewhat drier conditions than the plants in lower areas.

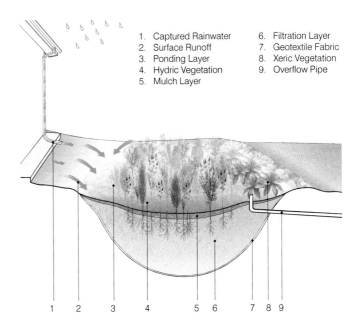

Fig. 7.3-13 Self-Contained Raingarden

Fig. 7.3-14 Under-drained Raingarden

7. Landscape

STORMWATER IMPOUNDMENTS Stormwater impoundments, or basins, allow for the mitigation of larger stormwater volumes. They are typically designed to slow and absorb surface runoff and possibly treat it for sediments and pollutants on-site in the same way as smaller bioretention systems. There are two types of stormwater basins: detention and retention.

Detention Basin

A detention basin is a low-lying area that is designed to temporarily hold a set amount of stormwater. Water is captured and held in the basin and allowed to slowly flow out into natural or man-made conveyance systems or to infiltrate into the soil below. The basins are mainly used for flood control situations. During most periods, the detention basin does not contain any water and is typically designed to drain within 72 hours after a rainstorm. An emergency spillway is included in the design for cases of excessive precipitation and runoff. Water is drained through the spillway into natural systems or into subsequent detention basins or raingardens.

Retention Basin

A retention basin is designed to hold a specific amount of water indefinitely, usually for aesthetic purposes. The retention basin typically has an additional capacity above the designed water level for handling runoff loads and sediment removal. In storm events when added water volumes enter the basin, the pond expands to accommodate the extra volume. The extra volume is then slowly released into the natural environment or into another location, such as a raingarden or detention basin for infiltration. As in the case for detention basins, retention basins typically have at least two types of outlets: a principle spillway and an emergency or overflow spillway. A standpipe is also often utilized to maintain water levels at the designed level.

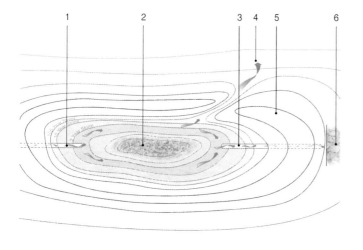

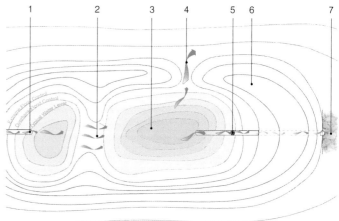

1. Inflow Pipe
2. Wetland Vegetation
3. Outflow Pipe
4. Overflow Spillway
5. Embankment
6. Outfall

1. Inflow Pipe
2. Overflow Spillway
3. Wet Pool
4. Overflow Spillway
5. Riser
6. Embankment
7. Outfall

Fig. 7.3-15 Detention Basin: Plan (Top), Section (Bottom)

Fig. 7.3-16 Retention Basin: Plan (Top), Section (Bottom)

Hydrological Efficiency

Wastewater Management

Wastewater can be described as water that has been contaminated through human usage. This includes water contaminated by industrial and agricultural uses, along with water contaminated by general urban functions, including building related consumption and direct human usage. Wastewater is typically separated into two general classifications: graywater and blackwater.

Graywater is wastewater generated through a building's general functions, with the exception of water from the toilets, kitchens, or sources contributing significant organic wastes. Graywater includes the wastewater generated by bathing, laundry, and non-kitchen sinks. Graywater contains few pathogens or organic materials. Therefore, it has the potential for easy reuse in some nonpotable applications with little to no treatment. Its reuse can help reduce overall water consumption and waste significantly.

Blackwater is generated from sources such as toilets, garbage grinders, and dishwashers. Blackwater can potentially contain high levels of bacteria, pathogens, and organic materials. Therefore, it requires considerable treatment before reuse. Blackwater quantities can be reduced through water conservation and alternative means of waste removal. The following sections introduce wastewater-cleaning processes that employ various landscape strategies.

CONSTRUCTED TREATMENT WETLANDS Constructed treatment wetlands are artificially created wetland water-treatment systems that mimic the water-cleansing properties of naturally occurring wetlands. They can be utilized as biological filters for wastewater to remove sediments and pollutants such as nutrients from agricultural slurries, toxic chemicals, and heavy metal from industrial waste. Constructed treatment wetlands are used to treat both stormwater runoff and gray and black wastewater. They rely on phytoremediation and filtering processes to absorb or degrade the pollutants.

Constructed treatment wetlands in conjunction with other treatment systems can be used to treat contaminated water close to a drinkable quality. Besides their water-cleansing function, the constructed treatment wetlands often serve as habitat for wildlife by creating ecosystems, which attract many different animal and insect species. The wetlands can also help with flood protection, provide educational and recreational opportunities, and enhance the aesthetic qualities of open spaces. In addition, in comparison with conventional wastewater treatment techniques, constructed wetlands seem to offer significantly lower costs over the total lifetime of a system.

Constructed treatment wetlands can be classified into two different types based upon the water movement and retention techniques they employ. These two types are surface-flow wetlands and subsurface-flow wetlands.

Scurpus pungens
BULRUSH

Elodea candensis
WATERWEED

Typha latifolia
CATTAIL

Phragmites australis
COMMON REED

Phalaris arundinacea
REED CANARY GRASS

Pontederia cordata L.
PICKERELWEED

Fig. 7.3-17 Wetland Plant Species

7. Landscape

Surface-Flow Wetlands

In surface-flow (or free-flow) wetlands, wastewater being treated flows above the ground surface and is exposed. The wastewater slowly moves above a layer of peat soil and through a densely planted shallow water basin or channel. A barrier layer prevents seepage of the wastewater into the native soils below. Plant species such as cattails, sedges, reeds, and rushes are widely used in surface-flow wetlands due to their high tolerance to continuously saturated soil conditions. Because the wastewater is open to the atmosphere and can come into direct contact with human and animal species, surface-flow wetland systems are predominantly utilized for the treatment of stormwater runoff or low-contaminate wastewater. The typical water depth is less than 1.3 feet (0.4 m) and the typical hydraulic loading rates are between 0.3 to 2 inches (0.7 to 5 cm) per day.[17] In the U.S., the number of surface-flow wetlands is almost double the number of subsurface-flow wetlands because they are much easier and cheaper to design and construct. However, subsurface-flow systems require less land area to achieve the same amount of pollution reduction.

Subsurface-Flow Wetlands

Unlike surface-flow wetlands, water in subsurface-flow wetlands is kept inaccessible, typically below ground level. In subsurface-flow wetlands, the wastewater slowly moves through soil beds composed of a porous medium, such as sand, gravel, and rocks on which plants are rooted. Similar to the case of a surface-flow wetland, a seepage barrier contains the system. Subsurface-flow systems minimize the exposure of the wastewater being treated to human and animals, thus allowing for the treatment of highly contaminated water and sewage. Another major benefit of a

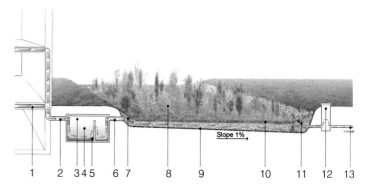

1. Waste Water
2. Inlet Pipe
3. Septic Tank
4. Effluent
5. Sludge
6. Outlet Pipe
7. Drainfield Rock
8. Wetland Plants
9. Impermeable Liner
10. Pea Gravel
11. Drainfield Rock
12. Water Level Control (Accessible)
13. Treated Water

Fig. 7.3-19 Subsurface-Flow Wetland: Horizontal

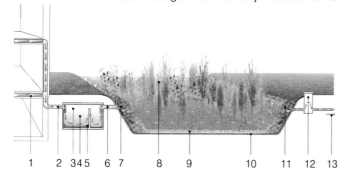

1. Waste Water
2. Inlet Pipe
3. Septic Tank
4. Effluent
5. Sludge
6. Outlet Pipe
7. Drainfield Rock
8. Aquatic Plants
9. Peat Soil
10. Impermeable Liner
11. Drainfield Rock
12. Water Level Control (Accessible)
13. Treated Water

Fig. 7.3-18 Surface-Flow Wetland

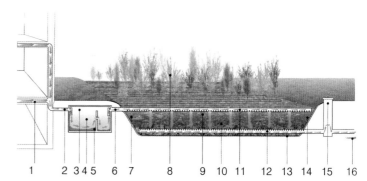

1. Waste Water
2. Inlet Pipe
3. Septic Tank
4. Effluent
5. Sludge
6. Outlet Pipe
7. Drainfield Rock
8. Wetland Plants
9. Pea Gravel
10. Compost
11. Perforated Pipe - Distribution
12. Perforated Pipe - Collection
13. Impermeable Liner
14. Drainfield Rock
15. Water Level Control (Accessible)
16. Treated Water

Fig. 7.3-20 Subsurface-Flow Wetland: Vertical

Hydrological Efficiency

subsurface-flow treatment system is that has reduced mosquito problems, which may occur in the slow-flowing water bodies of surface-flow wetland systems.

In subsurface-flow systems, the wastewater may move either horizontally or vertically. Based on the flow path of the water as constructed, these wetlands are specified as horizontal-flow wetlands or vertical-flow wetlands, respectively. In horizontal-flow wetlands, the wastewater flows through the wetland parallel to the surface from one side to the other along a slope. The flow of wastewater into the wetland is continuous in such a system. In the vertical-flow system, the wastewater filters down through the wetland from top to bottom. The water starts at the top planted layer and passes down through the subsoil and out through a drain. A pump regulates the flow.

INTENSIVE BIOREMEDIATION SYSTEMS An intensive bioremediation system, commonly known as a "living machine," is a complex wastewater-treatment system that utilizes a linked series of reactor tanks and constructed ecosystems, including constructed treatment wetlands, to purify wastewater. An intensive bioremediation system can offer ecological and economical alternatives to conventional wastewater treatment plants that consume significant amounts of energy, resources, and chemicals. An intensive bioremediation system is able to break down wastewater contaminants through the use of sunlight and natural organisms, including aquatic plants and trees, fungi, fish, clams, snails, and bacteria. Specifically ordered and combined living communities of flora and fauna are able to extract nutrients from the wastewater for their growth, while leaving cleaner water that is suitable for reuse in irrigation or toilet flushing.

An intensive bioremediation system typically includes a series of enclosed tanks, open treatment tanks, and outdoor wetland gardens. The construction of the outdoor gardens does not allow for human contact with contaminants and the gardens are odor free. Therefore, intensive bioremediation systems can be located in urbanized areas and employed as aesthetic amenities.

With current technology, intensive bioremediation systems are most appropriate for corporate and institutional use or use by small communities. For a single-residential use, these systems are not appropriate due to their prohibitive cost and significant space requirement. This system would occupy about the area of a two-car garage for use by a three-bedroom home.[18]

The water-treatment process in a typical intensive bioremediation system employs five steps:

1. Anaerobic settling tank: The wastewater is collected in a closed tank that does not contain any oxygen. In the tank, suspended solids settle while the zero oxygen condition promotes the growth of anaerobic and facultative bacterial populations that consume some biomass. Settled solids are stored for later removal.

2. Closed aerobic reactor: The wastewater flows into a closed-top reactor where dissolved organic materials in the wastewater are reduced. Fine bubble diffusers introduce oxygen for treatment and keeping the contents mixed. A filter system is used to reduce odorous gases.

3. Open aerobic reactors: The wastewater is exposed to aeration and to the roots of specific plant species growing on floating racks in the reactor. The roots provide surfaces to host beneficial organisms, which consume microbial biomass and reduce the sludge volume.

4. Clarifier: The clarifier is a settling tank for the remaining suspended solids in the wastewater. Solids are removed by gravity separation.

5. Constructed wetland: Planted wetland beds help with the final treatment of the wastewater. The surfaces of plant roots and stones in filter beds provide excellent locations for microbial treatment organisms to inhabit. These organisms along with filtering materials remove the remaining organic pollutants and suspended solids.

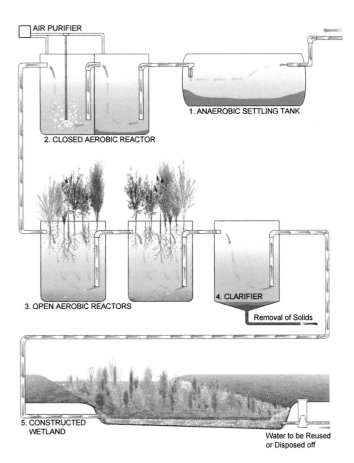

Fig. 7.3-21 Intensive Bioremediation System

235

7. Landscape

7.4 Case Studies

This section introduces case studies illustrating landscape strategies for sustainable buildings. Each case study examines an exemplary project that has successfully utilized landscape elements to achieve sustainable design goals. The first project, Council House 2, in Australia, uses vine-covered trellises on the building façade to improve passive cooling in order to reduce reliance on mechanical systems. The vines are also an integral aesthetic component of the building. The second project, California Academy of Sciences, in San Francisco, uses a large green roof to generate heating and cooling energy savings. The roof also serves as a valuable landscape amenity and a habitat for local birds and insects. The third project, Sidwell Friends School, in Washington D.C., utilizes an intensive bioremediation system, with associated treatment wetlands, to treat building generated wastewater for reuse on-site, creating a significant reduction in water consumption. The system is also an educational component utilized by the school and provides animal and insect habitat.

Council House 2

Council House 2 (CH2), designed by the City of Melbourne with Design Inc. Melbourne, is an award-winning office building located in Melbourne, Australia. In 2005, the building received the highest possible award for sustainable building design given in Australia, a six-star rating from the Green Building Council of Australia. This is equivalent to an LEED (Leadership in Energy and Environmental Design) Platinum certification in the U.S.

The building is equipped with several highly sophisticated technological systems that create significant efficiencies. Among these technologies are a sewer mining treatment plant that treats up to 26,417 gallons (100,000 liters) of wastewater per day for reuse in the building, 516.7 square feet (48 square meters) of solar panels for hot water heating, 279.9 square feet (26 square meters) of photovoltaic cells generating 3.5 kWh of solar electricity, and energy-efficient lighting fixtures and computers.[19]

In addition to its many advanced technological features, the building also incorporates landscape elements to further increase energy efficiency. The most significant of these elements is the shade trellising system constructed for the windows on the north façade of the building (equivalent of the south façade in the Northern Hemisphere). By shading the most direct sunlight from the windows, the trellising system significantly reduces the mechanical cooling costs of the building. The trellises are composed of stainless steel mesh and are covered with a growth of vines. They extend the entire height of the building, and extrude from the building face 3.9 feet (1.2 m) adjacent to the window openings. The trellises, along with additional horizontal shading elements, help the building achieve more than 95 percent shade coverage over the windows from 8 a.m. to 5 p.m. during the summer.[20]

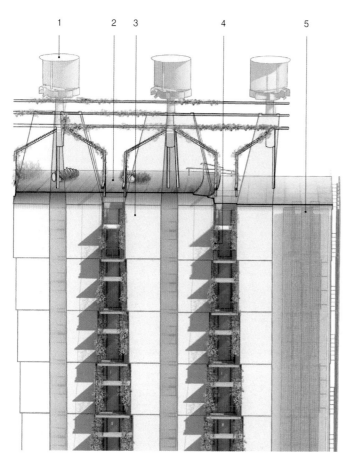

1. Energy-Harvesting Wind Turbines
2. Roof-Top Gardens
3. Tapered Façade
4. Window-shading Vine Trellises
5. Wood Louvers

Fig. 7.4-1 Council House 2: Façade

Fig. 7.4-2 Council House 2: Context

Case Studies

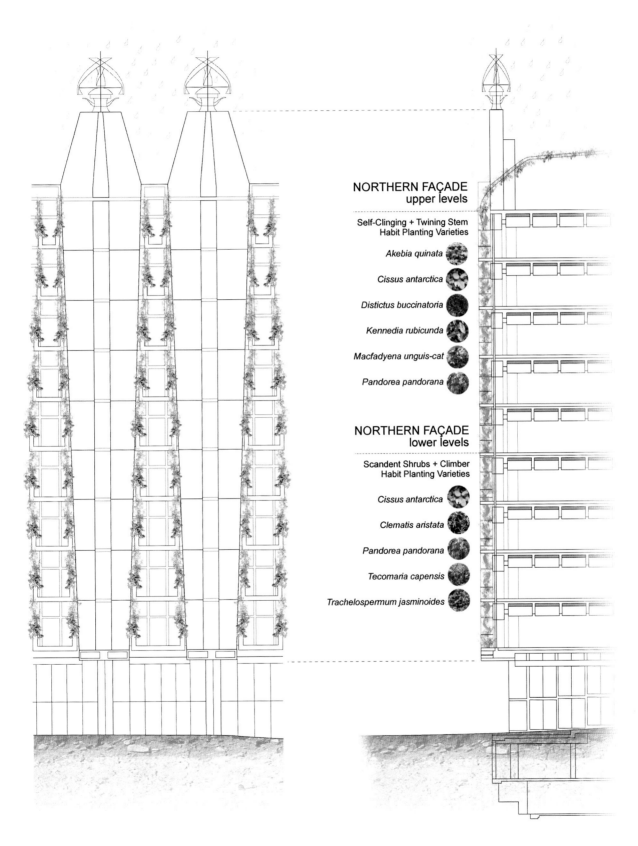

Fig. 7.4-3 Council House 2: Plant Palette

7. Landscape

The vines grown on the trellises are planted in special planter boxes on balconies. The planter boxes are filled with Fytogen flakes, a soil additive that looks similar to polystyrene flakes, but store a large amount of water and air. Within each planter box there is a subterranean irrigation system with a switching mechanism that functions similar to a conventional toilet cistern. When the water supply is used up and the flakes are dry, a float triggers the refill of water. The combination of this device and the Fytogen flakes provides excellent soil conditions for the plants to thrive. The irrigation system and Fytogen planting medium save up to 20 percent in water consumption versus a conventional irrigation system.[21] In addition to the water-efficient irrigation, all vines are native, hardy species to keep maintenance and irrigation requirements to a minimum. Furthermore, the entire water supply needed to irrigate the vines is sourced from the wastewater-mining system within the building.

The shade trellises of CH2 present an effective use of landscape elements as a component of the building's sustainability approach. The trellises provide passive cooling of interior spaces. They are also designed with minimized maintenance requirements. In addition, as a highly visible design element of the building, the shade trellises promote connectedness between the natural environment and built systems.

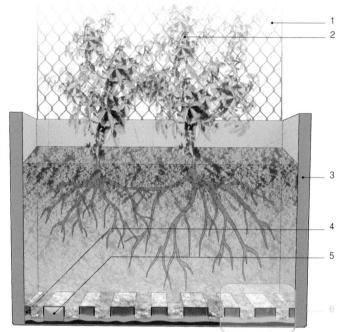

1. Stainless Steel Trellis Mesh
2. Climbing Vines
3. Planter Shell
4. Water Supply
5. Water Valve
6. Subirrigation Detail (Fig 7.4-5)

Fig. 7.4-4 Council House 2: Planter Section

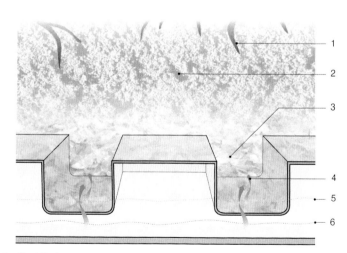

1. Plant Roots
2. Planting Mix
3. Fytogen Flakes
4. Capillary Action
5. High Water Level
6. Low Water Level

Fig. 7.4-5 Council House 2: Subirrigation Detail

Case Studies

California Academy of Sciences

The California Academy of Sciences museum in San Francisco's Golden Gate Park is an award-winning sustainable building project that was designed by a team that included architects Renzo Piano Building Workshop with Chong Partners (now Stantec Architecture); landscape architects SWA Group; and biological consultant Rana Creek. The science museum was developed as a replacement for the California Academy's previous cluster of buildings in the same location, which were damaged in the 1989 earthquake affecting San Francisco.

The project was awarded a LEED Platinum certification (LEED's highest award) for its design and construction utilizing strategies such as: the use of recycled materials (more than 90 percent of the demolition waste from the old academy was recycled), natural lighting (at least 90 percent of regularly occupied spaces have access to daylight), natural ventilation (about 40 percent of the academy utilizes natural ventilation), a perimeter canopy of photovoltaic cells (providing at least 5 percent of the building's power), and a graywater collection system.[22] However, the most significant component of the building's design is its green roof. The roof is designed to appear as an undulating plane laid over the top of the building structure. The spherical forms of a planetarium and a rainforest terrarium appear to push up the surface of the roof plane from the interior of the building below, creating hill-like forms on the rooftop. The hills, composed of two large mounds along with five smaller mounds, are meant to evoke the seven hills of the city of San Francisco's landscape. The undulating hills of the roof make it visible from the ground level, overcoming the visibility problem of many green roofs. The roof is also an educational component of the building, which is partially accessible and is integrated into the program of the museum.

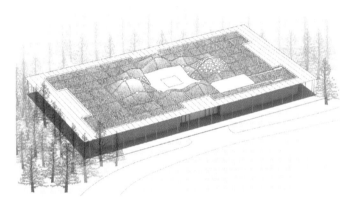

Fig. 7.4-6 California Academy of Sciences: Context

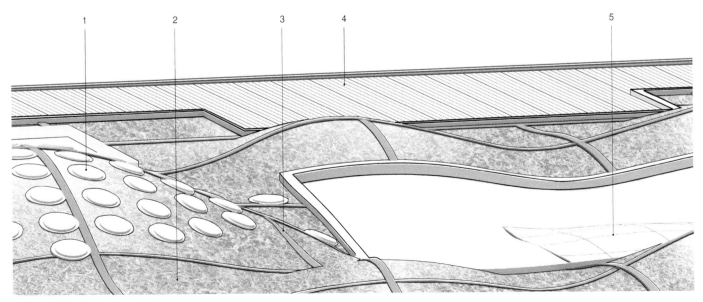

1. Dome Skylights
2. Plant Material
3. Gabion Grid
4. Solar Panels
5. Central Skylight

Fig. 7.4-7 California Academy of Sciences: Roof Perspective

7. Landscape

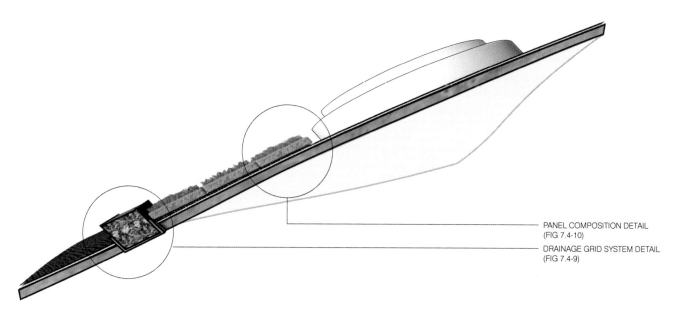

Fig. 7.4-8 California Academy of Sciences: Extensive Green Roof Section

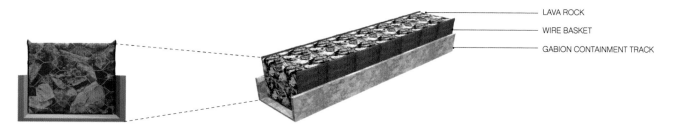

Fig. 7.4-9 California Academy of Sciences: Drainage Grid System Detail

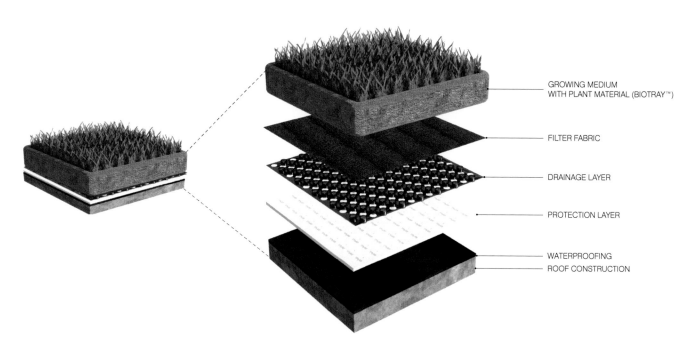

Fig. 7.4-10 California Academy of Sciences: Panel Composition Detail

Case Studies

The area of the roof is 2.5 acres (0.8 ha) and contains 1.7 million plants composed of 9 native species installed using a specially produced component system called BioTray™. The established roof serves as a wildlife habitat that attracts pollinating animals, such as hummingbirds, bumblebees, and butterflies. In order to minimize irrigation and maintenance, the roof-planting palette relies on native plants because of their adaptation to the Bay Area's seasonal rainfall cycle. In addition to the intentional planting choices, birds and bees have deposited foreign pollens and seeds on the site, bringing new species of plants. Depending on how these species interact with the existing roof habitat, they are allowed to remain or are removed by maintenance workers. Such flexibility demonstrates a great level of interaction and connectedness to local ecosystems in a building design.

In addition to providing a habitat for plant and animal species, the roof also maintains a connection with local hydrology. Most of the rainwater falling onto the roof is captured for the irrigation needs of the roof's plant materials in panelized reservoirs along the roof's surface underneath their growing medium. The water quantities exceeding irrigation needs are siphoned off the roof by a crisscrossing system of gabions to an underground water table recharge system. Filtered through sand and gravel, the collected rainwater is held in a recharge chamber, which allows percolation into the soils and down to the water table of Golden Gate Park.

Beyond its connections to natural systems, the green roof serves as an important component of the operational systems of the building. The steep slopes of the roof mounds create a natural ventilation and cooling system, which reduces the use of mechanical cooling. Outdoor air cooled by the vegetated roof surface is funneled into the entry plaza whose mechanically operable skylights open to allow the cooled air to flow into the building interior. The roof also helps to regulate indoor temperatures by creating a thermal buffer for the spaces below. The 7 inches (17.8 cm) of soil substrate on the roof, acting as natural insulation, maintains the building's interior at an average of 10°F (5.5°C) cooler than a standard roof would in hot weather.[23]

The green roof of the California Academy of Sciences illustrates an effective use of landscape design as an important component of the building's sustainability strategy. The roof contributes to sustainable design through its energy savings, water conservation, habitat function for wildlife, and advancement of a healthy site hydrology. In addition, its visibility and access as a museum exhibit also promote an understanding of sustainable design principles for museum visitors.

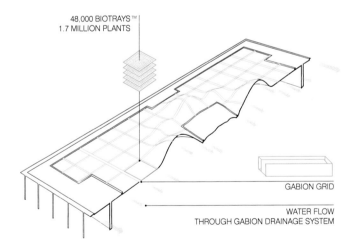

Fig. 7.4-11 California Academy of Sciences: Gabion Drainage System

7. Landscape

Sidwell Friends School

Sidwell Friends School in Washington, D.C., designed by Kieran Timberlake Architects with Andropogon Landscape Architects, and consultants Natural Systems International, provides an excellent example of landscape design that promotes the sustainable use of water resources in a building. Sidwell is a school founded on the Quaker philosophy of human beings as stewards of the Earth. During an expansion in 2007, the school chose to strengthen the link between this philosophy and the curriculum by integrating it into the design of the new school facility.

The project earned an LEED Platinum certification for its design. The project's environmental credentials are numerous and include strategies such as light shelves, a green roof, operable skylights, solar chimneys for passive cooling, photovoltaic cells for generating electricity, and use of recycled building materials. Such strategies pursued together have reduced energy demands by 60 percent when compared to other similar-sized schools.[24] The building's design also incorporates landscape design elements to further its sustainability goals. The best example of this is the school's use of an intensive bioremediation system for the reuse and recycling of wastewater.

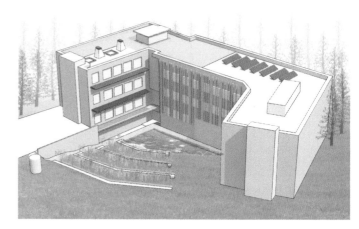

Fig. 7.4-12 Sidwell Friends School: Context

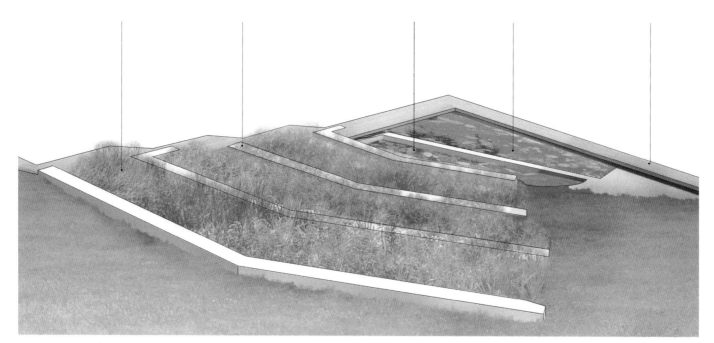

1. Native Wetland Species
2. Wetland Terraces Retaining Walls
3. Raingarden
4. Biology Pond
5. Walkway

Fig. 7.4-13 Sidwell Friends School: Perspective of the Constructed Wetlands

Case Studies

The intensive bioremediation system is utilized to process and treat the building's wastewater for reuse in the school's toilets and cooling towers. The treatment process begins with the primary treatment of wastewater in underground tanks that utilize bacteria to help cleanse the water. The water is then circulated through a series of reed beds in a designed wetland in the school's main courtyard. Within the wetland, microorganisms attached to gravel in the planting medium, in conjunction with the roots of the plants, break down contaminants in the water. Trickle and sand filters provide further treatment. The overall system can treat up to 3000 gallons (11,356 liters) of wastewater per day. During the wintertime warm wastewater entering the system prevents the wetlands in the courtyard from freezing, making the system viable year round.[25] Overall, the system achieves a water savings of 92 percent for the school.[26] Additionally, using biological processes to treat wastewater is energy efficient and produces significantly less sludge waste than conventional treatment processes. Furthermore, the terraced wetlands component of the treatment system has created habitat for local insects, birds and small animals. The wetlands' planting design follows the range of plant communities that would occur along the soil within each given moisture gradient, creating habitats that could naturally exist on the site.

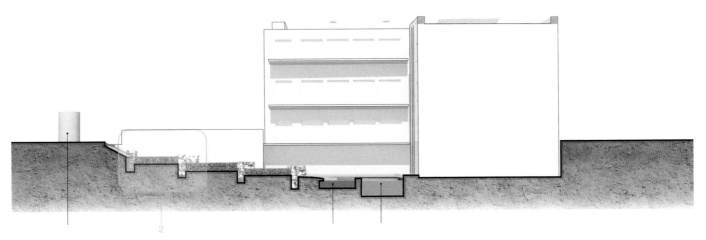

1. Trickle Filter
2. Constructed Wetland Detail (Fig 7.4-15)
3. Raingarden
4. Biology Pond

Fig. 7.4-14 Sidwell Friends School: Constructed Wetland Section

1. Compacted Subgrade
2. Barrier Liner
3. Granular Subgrade
4. Dry Laid Retaining Wall
5. Top Soil
6. Reed Bed

Fig. 7.4-15 Sidwell Friends School: Constructed Wetland Detail

7. Landscape

Along with treating wastewater through wetlands, the school also captures rainwater from the roof to aid its irrigation needs and supply a biological education pond in the school's courtyard. During seasons of high precipitation, rainwater directly supplies the needs of the pond. Excess rainwater is stored in an underground cistern, which is then used to supply the pond during dry seasons when its levels are low.

The school's green roof, although somewhat limited in its extent, is a great example of the use of landscape in sustainable building design. A notable function of the green roof is its inclusion of a vegetable and herb garden where students grow some of the food that is used in the cafeteria.

The treatment of the school grounds is a primary component of a larger strategy within the school that fosters connections between the students and the natural environment. Learning about the building, its systems, and its connections to natural processes is a key component of the educational curriculum. The use of the courtyard wetlands for the school's wastewater treatment system is an important part of this. The wetlands are also an excellent example of an effective use of landscape systems as an integral component of the building's sustainable design strategies.

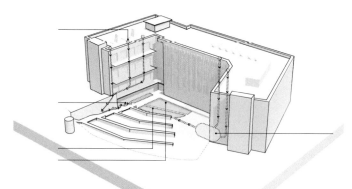

1. Water Collection
2. Cascade
3. Raingarden
4. Biology Pond
5. Rainwater Basin

Fig. 7.4-16 Sidwell Friends School: Rainwater Circulation

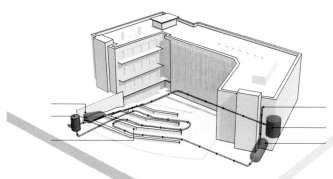

1. Wastewater Collection
2. Settlement Tank
3. Constructed Wetlands
4. Trickle Filter
5. Sand Filter
6. Grey Water Storage Tank

Fig. 7.4-17 Sidwell Friends School: Wastewater Circulation

Case Studies

REFERENCES

1. "The Water Cycle: Transpiration," July 1, 2010. http://ga.water.usgs.gov/edu/watercycletranspiration.html

2. Ginny Meade and David L. Hensley, "Using Trees to Save Energy," February 1998. http://www.ctahr.hawaii.edu/oc/freepubs/pdf/L-5.pdf

3. "How much energy is used in buildings in the United States?" June 24, 2011. http://www.eia.gov/tools/faqs/faq.cfm?id=86andt=1

4. "2008 Buildings Energy Data Book," March 2009. http://buildingsdatabook.eren.doe.gov/docs%5CDataBooks%5C2008_BEDB_Updated.pdf

5. David I. Nowak, "Estimating Leaf Area and Leaf Biomass of Open-Grown Deciduous Urban Trees." *Forest Science* 42, No. 4 (1996): 504–507.

6. Joan Bradshaw and Linda Tozer, "Enviroscaping," October 2003. http://sfrc.ifas.ufl.edu/urbanforestry/Resources/PDF%20downloads/Bradshaw_Enviroscaping_2003.pdf

7. E. Gregory McPherson, "Planting Design for Solar Control," in *Energy-Conserving Site Design*, Ed. E. Gregory McPherson. (Washington: American Society of Landscape Architects, 1984), 156.

8. Graeme Hopkins and Christine Goodwin, *Living Architecture: Green Roofs and Walls*. (Collingwood: CSIRO Publishing, 2011), 33.

9. "Farmstead Windbreaks: Planning," August 1997. http://www.extension.iastate.edu/publications/pm1716.pdf

10. Gary O. Robinette and Charles McClennon, Eds., *Landscape Planning for Energy Conservation* (Melbourne: Van Nostrand Reinhold Company, Inc., 1983), 34.

11. L. Walker and S. Newman, "Landscaping for Energy Conservation," March 2009. http://www.ext.colostate.edu/pubs/garden/07225.pdf

12. Bijay Tamang, Michael G. Andreu, Melissa H. Friedman, and Donald L. Rockwood, "Windbreak Designs and Planting for Florida Agricultural Fields," August 2009. http://edis.ifas.ufl.edu/pdffiles/FR/FR28900.pdf

13. L. Walker and S. Newman, "Landscaping for Energy Conservation," March 2009. http://www.ext.colostate.edu/pubs/garden/07225.pdf

14. Robert L. Thayer Jr. and Thomas Richman, "Water-Conserving Landscape Design," in *Energy-Conserving Site Design*, Ed. E. Gregory McPherson. (Washington: American Society of Landscape Architects, 1984), 205.

15. Environmental Protection Agency, "Nonpoint Source Pollution: The Nation's Largest Water Quality Problem," 1996. http://water.epa.gov/polwaste/nps/outreach/point1.cfm

16. Graeme Hopkins and Christine Goodwin. *Living Architecture: Green Roofs and Walls*. (Collingwood: CSIRO Publishing, 2011), 42.

17. Nancy V. Halverson, "Review of Constructed Subsurface Flow vs. Surface Flow Wetlands," September 2004. http://sti.srs.gov/fulltext/tr2004509/tr2004509.pdf

18. Patricia L. Brown, "Eco-Privy: Bringing Outdoor Plumbing Indoors," October 12, 1995. http://www.nytimes.com/1995/10/12/garden/eco-privy-bringing-outdoor-plumbing-indoors.html?sec=andspon=andpagewanted=all

19. Dominique Hes, "CH2 Setting A New World Standard in Green Building Design-Design Snapshot 01: Introduction." http://www.melbourne.vic.gov.au/Environment/CH2/DesignDelivery/Documents/CH2_Snapshot1.pdf

20. Advanced Environmental Concepts Pty Ltd, "Melbourne City Council North Façade Analysis," April 2003. http://www.melbourne.vic.gov.au/Environment/CH2/DesignDelivery/Documents/Facade_North_Analysis.pdf

21. Dominique Hes, "CH2 Setting A New World Standard in Green Building Design-Design snap shot 09: Water Initiatives." http://www.melbourne.vic.gov.au/Environment/CH2/DesignDelivery/Documents/CH2_Snapshot9.pdf

22. Stephanie Stone, "Press Release: New California Academy of Sciences Receives Highest Possible Rating from U.S. Green Building Council: LEED Platinum," October 8, 2008. http://www.calacademy.org/newsroom/releases/2008/leed_platinum.php

23. Stephanie Stone, "Press Release: Dramatic Living Roof Installed Atop New California Academy Of Sciences, Making It The "Greenest" Museum Ever Constructed," June 7, 2007. http://www.calacademy.org/newsroom/releases/2007/living_roof_release.php

24. American Institute of Architects, "AIA Cote Top Ten Green Projects 2007,"2007. http://www.aia.org/aiaucmp/groups/aia/documents/pdf/aias077513.pdf

25. Liat Margolis and Alexander Robinson, *Living Systems: Innovative Materials and Technologies for Landscape Architecture*. (Berlin: Birkhauser Verlag AG, 2007).

26. American Institute of Architects, "AIA Cote Top Ten Green Projects 2007,"2007. http://www.aia.org/aiaucmp/groups/aia/documents/pdf/aias077513.pdf

Bibliography

"2008 Buildings Energy Data Book," March 2009. http://buildingsdatabook.eren.doe.gov/docs%5CDataBooks%5C2008_BEDB_Updated.pdf

Aric Chen, "Teaching Tools." Metropolis Magazine, July/August, 2007, P. 106–111.

Advanced Environmental Concepts Pty Ltd, "Melbourne City Council North Façade Analysis," April 2003. http://www.melbourne.vic.gov.au/Environment/CH2/DesignDelivery/Documents/Facade_North_Analysis.pdf

Ahmadul Ameen, *Refrigeration and Air Conditioning*, illustrated ed. (New Delhi: PHI Learning Pvt. Ltd., 2006)

American Institute of Architects, "AIA Cote Top Ten Green Projects 2007,"2007. http://www.aia.org/aiaucmp/groups/aia/documents/pdf/aias077513.pdf

American National Standards Institute (ANSI), http://www.ansi.org

American Society of Agricultural Engineers, "Design and Installation of Microirrigation Systems," February 2003. http://www.geoflow.com/Flushing/An2%20-%20ASAE%20EP405.1%20Feb%202003.pdf

American Society of Heating, Refrigerating and Air-Conditioning Engineers (ASHRAE) and Illuminating Engineering Society of North America, Energy Standard for Buildings Except Low-Rise Residential Buildings, ANSI/ASHRAE/IESNA Standard 90.1-2007. (Georgia: American Society of Heating, Refrigerating and Air-Conditioning Engineers, 2007).

Andrea Deplazes, *Constructing Architecture: Materials, Processes, Structures: A Handbook*, (Basel: Birkhäuser, 2008).

Arthur A. Bell, *HVAC Equations, Data, and Rules of Thumb*, 2nd illustrated ed. (New York: McGraw-Hill Professional, 2007).

Arthur R. Lyons, *Materials for Architects and Builders*. 3rd ed. (Oxford: Elsevier, 2007).

ASHRAE, American Society of Heating, Refrigerating and Air-Conditioning Engineers (2011), http://www.ashrae.org

ASHRAE Design Guide Special Project 200, EPA, USGBC, BOMAI:" Indoor Air Quality—Best Practice for Design, Construction and Commissioning," 2009

Barbara Erwine, "Lighting design lab," Glazing: Which Glass Should I Use? Sorting It All Out, http://www.lightingdesignlab.com/articles/glazing/glazing.htm

Bijay Tamang, Michael G. Andreu, Melissa H. Friedman, and Donald L. Rockwood, "Windbreak Designs and Planting for Florida Agricultural Fields," August 2009. http://edis.ifas.ufl.edu/pdffiles/FR/FR28900.pdf

Brad Putman, "Porous Pavements: An Overview," May 18, 2011. http://www.clemson.edu/public/carolinaclear/consortiums/flodar_home/downloads/pp_overview.pdf

Bruce Haglund and Kurt Rathmann, "Thermal Mass in Passive Solar and Energy-Conserving Buildings, Vital Signs." http://arch.ced.berkeley.edu/vitalsigns/res/downloads/rp/thermal_mass/mass-sml.pdf

"BubbleDeck Structure Solutions, CI/SfB, (23) Eq4. Part 1 (September 2008), http://www.bubbledeck-uk.com/pdf/Product%20Information%20_final_20070219.pdf.

"Building Strategies Architecture 2030." http://www.architecture2030.org/regional_solutions/materials.html.

Centre for Building Performance Research, "Embodied Energy Coefficients," Victoria University of Wellington, http://www.victoria.ac.nz/cbpr/documents/pdfs/ee-coefficients.pdf

Chartered Institution of Building Services Engineers, http://www.cibse.org National Electrical Contractors Association, http://www.necanet.org

Christian Schittich, *Glass Construction Manual*, (Basel: Birkhäuser, 2007)

Christian Schittich, *Building Skins: Concepts, Layers, Materials*, Volume 2 (Basel: Birkhäuser, 2008)

Christian U. Grosse, *Advances in Construction Materials*. (Berlin: Springer, 2007).

CIBSE Journal, "The CIBSE Journal CPD Programme: Gas-absorption heat pumps", http://www.cibsejournal.com/cpd/2010-10/

City of Portland, Oregon, "Building Integrated Photovoltaics." http://www.portlandonline.com/bps/index.cfm?a=115264andc=42115

Commission Internationale de l'Eclairage Standardization of luminance distribution on clear skies, Paris: Commission Internationale de l'Eclairage, 1973

Darco Underground Tankage, "Thermal Storage," http://www.thermal-storage-tanks.com/thermal-storage.html

David I. Nowak, "Estimating Leaf Area and Leaf Biomass of Open-Grown Deciduous Urban Trees." *Forest Science* 42, No. 4 (1996): P. 504–507.

Dominique Hes, "CH2 Setting a New World Standard in Green Building Design-Design Snapshot 01: Introduction." http://www.melbourne.vic.gov.au/Environment/CH2/DesignDelivery/Documents/CH2_Snapshot1.pdf

Dominique Hes, "CH2 Setting a New World Standard in Green Building Design-Design Snapshot 09: Water Initiatives." http://www.melbourne.vic.gov.au/Environment/CH2/DesignDelivery/Documents/CH2_Snapshot9.pdf

Dominique Hes, "Setting a New World Standard in Green Building Design. Design Snapshot 15: Phase Change Material." http://www.melbourne.vic.gov.au/Environment/CH2/DesignDelivery/Documents/CH2_Snapshot15.pdf

Ducan Erley and Martin Jaffe, Site Planning for Solar Access: A Guidebook for Residential Developers and Site Planners. (Chicago: Diane Publishing, 1997)

E. Gregory McPherson, "Planting Design for Solar Control," in *Energy-Conserving Site Design*, Ed. E. Gregory McPherson. (Washington: American Society of Landscape Architects, 1984), P. 141–164.

Eckhard Reyer, *Kai Schild and Stefan Völkner, Kompendium der Dämmstoffe* (Verlag: Fraunhofer IRB-Verl, 2000).

Ecotect Software, Design Sky Calculator Based on Tregenza's Equations: http://naturalfrequency.com/Tregenza_Sharples/Daylight_Algorithms/intro.htm

Educypedia-Electronics, http://www.educypedia.be/electronics/pled.htm

EIA Independent Statistics and Analysis, U.S. Energy Information Administration, "Energy Units and Calculators Explained." http://www.eia.gov/energyexplained/index.cfm?page=about_degree_days

Energy and Resources Institute, *Sustainable Building Design Manual: Sustainable Building Design Practices*, illustrated ed. (New Delhi: TERI Press, 2004).

Energy Star, "Energy Star Qualified Homes Thermal Bypass Inspection Checklist." June 2008. http://www.energystar.gov/ia/partners/bldrs_lenders_raters/downloads/ThermalBypass_Inspection_Checklist.pdf

Energy Star, "Furnaces Key Product Criteria." http://www.energystar.gov/index.cfm?c=furnaces.pr_crit_furnaces

Energy Star, "9. Heating and Cooling," http://www.energystar.gov/index.cfm?c=business.EPA_BUM_CH9_HVAC#S_9_2

Energy Star, "Heat Pumps Air-Source for Businesses and Operators." http://www.energystar.gov/index.cfm?fuseaction=find_a_product.showProductGroupandpgw_code=EP

Energy Star: Learn About LEDs. http://www.energystar.gov/index.cfm?c=lighting.pr_what_are

Environmental Protection Agency, "Nonpoint Source Pollution: The Nation's Largest Water Quality Problem," 1996. http://water.epa.gov/polwaste/nps/outreach/point1.cfm

Ernst Neufert, Peter Neufert, Bousmaha Baiche and Nicholas Walliman, *Architect's Data*, Third Edition. (Oxford : Blackwell Science, 2000)

European Commission–Joint Research Centre–Institute for Environment and Sustainability, "Life Cycle Thinking and Assessment." http://lct.jrc.ec.europa.eu/

Fanger, P. O. "Thermal Environment — Human Requirements." The Environmentalist. 6. no. 4 . http://dx.doi.org/10.1007/BF02238059.

"Farmstead Windbreaks: Planning," August 1997. http://www.extension.iastate.edu/publications/pm1716.pdf

Ferrell M. Bridwell, *Landscape Plants, Their Identification, Culture and Use*, (New York: Delmar Pub. Co.,1994).

Gary O. Robinette and Charles McClennon, eds., *Landscape Planning for Energy Conservation* (Melbourne: Van Nostrand Reinhold Company, Inc, 1983), P. 34.

Gary O. Robinette and Charles McClennon, Eds., *Landscape Planning for Energy Conservation* (Melbourne: Van Nostrand Reinhold Company, Inc., 1983), P. 66–78.

Geo4VA, "Heat Pump Mechanics." http://www.geo4va.vt.edu/A3/A3.htm

Geoff Hammond and Craig Jones, "Inventory of Carbon and Energy (ICE)," Sustainable Energy Research Team (SERT), Department of Mechanical Engineering, University of Bath, UK, 2008. http://people.bath.ac.uk/cj219/

Georgia State University, "HyperPhysics - The C.I.E. Color Space." http://hyperphysics.phy-astr.gsu.edu/hbase/vision/cie.html.

Gerd Lütjering and James Case Williams, *Titanium: Engineering Materials and Processes*. 2nd ed. (Heidelberg: Springer Verlag, 2007).

Gerhard Hausladen, Michael de Saldanha, and Petra Liedl, *Climate Skin: Building-skin Concepts that Can Do More with Less Energy*. (Basel: Birkhäuser Verlag, 2008).

Ginny Meade and David L. Hensley, "Using Trees to Save Energy," February 1998. http://www.ctahr.hawaii.edu/oc/freepubs/pdf/L-5.pdf

Glass on Web, "Glass Manual." http://www.glassonweb.com/glassmanual/

Graeme Hopkins and Christine Goodwin, *Living Architecture: Green Roofs and Walls*. (Collingwood: CSIRO Publishing, 2011), 33-42.

Graham Treloar, Michael McCormack, Laurence Palmowski and Roger Fay, "Embodied water of construction," BEDP Environment Design Guide Vol. GEN 58, pp.1–8, Royal Australian Institute of Architects, Melbourne (2004–2005)

"Green over Gray: Living Walls and Design," 2009. http://www.greenovergrey.com/green-wall-benefits/energy-savings.php

Green Roofs for Healthy Cities, "2008 Awards of Excellence: California Academy of Sciences," 2008. http://www.greenroofs.org/index.php?option=com_contentandtask=viewandid=1039andItemid=136

Greenspec, "About Materials." http://www.greenspec.co.uk/insulation-oil-derived.php

Grondzik, Walter T., *Air-conditioning System Design Manual*. (Burlington: Butterworth-Heinemann, 2007).

Günter Pfeifer, Rolf Ramcke, Joachim Achtziger and Konrad Zilch, *Masonry Construction Manual* (Basel: Birkhäuser, 2001)

Guardian Industries Corp, Guardian SunGuard, "Advanced Architectural Glass." http://www.na.en.sunguardglass.com/SpecificationsResources/FAQs/index.htm

Gustaaf A. van der Hoeven, "Energy Efficient Landscaping," November 1982. http://www.urbanforestrysouth.org/resources/library/energy-efficient-landscaping/file

Hank Becker, "*Phytoremediation: Using Plants to Clean Up Soils*." Agricultural Research 48, no. 6 (2000): P. 4.

Harald Mehling and Luisa F. Cabeza. *Heat and Cold Storage with PCM: An Up to Date Introduction into Basics and Applications*, illustrated ed. (Berlin: Springer, 2008).

Bibliography

Herb Kneirman, GLUMAC engineers for a sustainable future. "Shedding the Light on Photovoltaics." http://www.glumac.com/greenResources/GR_Shedding_Light_Photovoltaic.html

Holger Koch-Nielsen, *Stay Cool: A Design Guide for the Built Environment in Hot Climates*, illustrated ed. (London: James and James, 2002).

"How much energy is used in buildings in the United States?" June 24, 2011. http://www.eia.gov/tools/faqs/faq.cfm?id=86andt=1

H. R. Viswanath, Jurek Tolloczko, J. N. Clarke and Concrete Society, Multi-Purpose High-Rise Towers and Tall Buildings: Proceedings of the Third International Conference "Conquest of vertical space in the 21st century", illustrated ed. (Oxford: Taylor and Francis, 1997).

IAP Fraunhofer Institute, http://www.oled-research.com/oleds/oleds-lcd.html

IES Calculation Procedures Committee Recommended Practice for the Calculation of Daylight Availability, Journal of the Illuminating Engineering Society of North America 13 (4) 381–392 (1984)

International Aluminum Institute, "Life Cycle Assessment." http://www.world-aluminium.org/?pg=97

International Code Council, "2009 International Building Code." http://www.iccsafe.org/GR/Pages/adoptions.asp

International Commission on Illumination (CIE). http://www.cie.co.at/

International Energy Agency (IEA), "Combined Heat and Power", IEA Publications, France, February 2008, http://www.localpower.org/documents/reporto_iea_chpwademodel.pdf

International Energy Agency (IEA), "DHC District Heating and Cooling." http://www.iea-dhc.org/index.php

International Organization for Standardization (ISO). http://www.iso.org/iso/

International Organization for Standardization (ISO), 81.040.20: Glass in Building (Tdw-ISO) and ISO 9050:2003, http://www.iso.org/iso/search.htm

International Commission of Illumination (CIE). http://www.cie.co.at/

International Dark Sky Association. http://www.darksky.org

International Electrotechnical Commission (IEC). http://www.iec.ch/

Jank R. Volkswohnung GmbH, GovEnergy, "Net Zero and Low Energy Buildings:Theory and European Practice." Last modified January 17th, 2008. http://www.annex46.org/kd/cache/files/645BB562D756407F95B9E4E8FE5CC5DD.pdf.

James R. Simpson and E. Gregory McPherson, "Potential of Tree Shade for Reducing Residential Energy Use in California." Journal of Arboriculture 22, no. 1 (1996): P. 10-18.

James Zanetto. " *Master Planning,*" in *Energy Conserving Site Design*, ed. E. Gregory McPherson. (Washington: American Society of Landscape Architects, 1984), P. 95.

Jan Knippers, Jan Cremers, Markus Gabler and Julian Lienhard. "Construction Manual for Polymers + Membranes," Edition Detail, Basel: Birkhäuser, 2011. http://www.detail.de/AtlasPolymers/blaetterkatalog/index.html

Jan F. Kreider, Handbook of Heating, Ventilation, and Air Conditioning, illustrated ed. (Boca Raton: CRC Press, 2001)

Jank R. Volkswohnung GmbH, GovEnergy, "Net Zero and Low Energy Buildings: Theory and European Practice." Last modified January 17th, 2008. http://www.annex46.org/kd/cache/files/645BB562D756407F95B9E4E8FE5CC5DD.pdf.

Joan Bradshaw and Linda Tozer, "Enviroscaping," October 2003. http://sfrc.ifas.ufl.edu/urbanforestry/Resources/PDF%20downloads/Bradshaw_Enviroscaping_2003.pdf

Karen E. Steen, "Green Architecture's Grand Experiment," Metropolis Magazine, September 2008, P. 109–114.

Ken Yeang, *The Green Skyscraper: The Basis for Designing Sustainable Intensive Buildings* (New York: Prestel, 1999). P. 207, 210, 227–229.

Klaus Daniels, *The Technology of Ecological Building: Basic Principles and Measures, Examples and Ideas*. (Basel: Birkhäuser Verlag, 1997).

Klaus Daniel and Ralph Hammann. *Energy Design for Tomorrow*, (Stuttgart: Edition Axel Menges, 2009).

Kurt Roth, Robert Zogg, and James Brodrick, "Cool Thermal Energy Storage," Emerging Technologies, ASHRAE Journal Vol. 48, September 2006. http://www.tiax.biz/publications/cool_thermal_energy_storage.pdf

Kwok, Alison G. and Walter T. Grondzik. *The Green Studio Handbook: Environmental Strategies for Schematic Design*. illustrated, annotated ed. (New York : Architectural Press, 2007).

L. Walker and S. Newman, "Landscaping for Energy Conservation," March 2009. http://www.ext.colostate.edu/pubs/garden/07225.pdf

Lal Jayamaha, *Energy-efficient Building Systems: Green Strategies for Operation and Maintenance*, illustrated ed. (New York: McGraw-Hill Professional, 2006)

Lang Werner and Thomas Herzog, "Using Multiple Glass Skins to Clad Buildings," Architectural Record, July 2000, http://archrecord.construction.com/features/green/archives/0007edit-1.asp

L Prize. U.S. Department of Energy, "DOE Announces Philips as First Winner of the L Prize Competition." http://www.lightingprize.org/philips-winner.stm.http://www.lightingprize.org/philips-winner.stm

Liat Margolis and Alexander Robinson, *Living Systems: Innovative Materials and Technologies for Landscape Architecture*. (Berlin: Birkhauser Verlag AG, 2007).

Luna B. Leopold and Walter B. Langbein, "A Primer on Water," 1960. http://eps.berkeley.edu/people/lunaleopold/(064)%20A%20Primer%20on%20Water.pdf

LUTRON. http://www.lutron.com/Products/WholeBuildingSystms/EcoSystm/Pages/Overview.asp

Manfred Hegger, Matthias Fuchs, Thomas Stark and Martin Zeumer, *Energy Manual: Sustainable Architecture*, Detail Edition, (Basel: Birkhäuser, 2008)

Marian Keeler and Bill Burke, *Fundamentals of Integrated Design for Sustainable Building*, illustrated ed. (Hoboken: John Wiley and Sons, 2009)

Markuss Kottek, Jurgen Grieser, Beck Christoph, Franz Rubel and Bruno Rudolf, Map of the Köppen-Geiger climate classification updated, Meteorologische Zeitschrift, Publisher E. Schweizerbart'sche Verlagsbuchhandlung, Volume 15, No. 3, June 2006, pp. 259-263(5).

Markus Erb, editor, "Vacuum Insulation, Panel Properties and Building Applications, HiPTI-High Performance Thermal Insulation." (2005). http://www.ecbcs.org/docs/Annex_39_Report_Summary_Subtask-A-B.pdf.

Matheos Santamouris, *Environmental Design of Urban Buildings: An Integrated Approach*, illustrated ed. (London: Earthscan, 2006).

Matheos Santamouris, *Solar Thermal Technologies for Buildings: The State of the Art*, illustrated ed. (London: Earthscan, 2003)

Mark Stanley Rea, *The IESNA Lighting Handbook: Reference and Application*, 9th ed. (New York: Illuminating Engineering Society of North America, 2000)

Maureen Puettmann. WoodLife, "Carbon Footprint of Renewable and Nonrenewable Materials." October, 18, 2009. http://www.corrim.org/presentations/2009/Puettmann_WEI.pdf

M. David Egan and Victor W. Olgay, Architectural Lighting, 2nd ed. (New York: McGraw-Hill, 2002).

Michael A. Dirr, *Manual of Woody Landscape Plants: Their Identification, Ornamental Characteristics, Culture, Propagation and Uses*, 5th ed. (Champaign: Stipes Publishing, 1998).

Mike Gruntman, *Blazing the Trail: The Early History of Spacecraft and Rocketry*. illustrated ed. (Reston: American Institute of Aeronautics and Astronautics, 2004).

Mike Kuhns, "Windbreak Benefits and Design," May 2010. http://forestry.usu.edu/files/uploads/NR_FF/NRFF005.pdf

Nadine M. Post, "San Francisco Museum's Green Redo Keeps Team on Slippery Slopes," June 18, 2008. http://enr.construction.com/features/buildings/archives/080618a-1.asp

Nancy J. Todd and John Todd, *From Eco-Cities to Living Machines: Principles of Ecological Design*. (Berkeley: North Atlantic Books, 1994).

Nancy V. Halverson, "Review of Constructed Subsurface Flow vs. Surface Flow Wetlands," September 2004. http://sti.srs.gov/fulltext/tr2004509/tr2004509.pdf

Nigel Dunnett and Andy Clayden, *Rain Gardens: Managing Water Sustainably in the Garden and Designed Landscape*. (Portland: Timber Press, 2007).

"NOAA Satellite and Information Service," National Oceanic and Atmospheric Administration, August 20, 2008. http://www.ncdc.noaa.gov/oa/climate/online/ccd/avgwind.html.

"NOAA National Weather Service," Climate Prediction Center, "Degree Days Statistics." http://www.cpc.ncep.noaa.gov/products/analysis_monitoring/cdus/degree_days/

Norbert Lechner, *Heating Cooling, Lighting: Sustainable Design Methods for Architects*, 3rd ed. (Hoboken: John Wiley and Sons, 2009).

NREL National Renewable Energy Laboratory of the U.S. Department of Energy, "Solar Photovoltaic Technology." September 29, 2009. http://www.nrel.gov/learning/re_photovoltaics.html

Passive House Institute. http://www.passiv.de/07_eng/index_e.html

Patricia L. Brown, "Eco-Privy: Bringing Outdoor Plumbing Indoors," October 12, 1995. http://www.nytimes.com/1995/10/12/garden/eco-privy-bringing-outdoor-plumbing-indoors.html?sec=andspon=andpagewanted=all

Piia Sormunen, Tuomas Laine, Juhani Laine and Mikko Saari "The Active Utilization of Thermal Mass of Hollow-Core Slabs," Proceedings of Clima 2007 Well Being Indoors, VTT Technical Research Centre of Finland Espoo, Finland (2007). www.rehva.eu/projects/clima2007/SPs/D04B1190.pdf.

Pilkington NSG Group. http://www.pilkington.com/the+americas/usa/english/default.htm

Robert H. Kadlec and Scott D. Wallace, *Treatment Wetlands*. 2nd ed. (Boca Raton: CRC Press, 2008).

Robert L. Thayer Jr. and Thomas Richman, "Water-Conserving Landscape Design," in *Energy-Conserving Site Design*, Ed. E. Gregory McPherson. (Washington: American Society of Landscape Architects, 1984), p. 185-213

Robert Cassidy, "Green Buildings + Water Performance," November 2009. http://www.lafargenorthamerica.com/BDandC%20White%20Paper%202009.pdf

Roger W. Haines and C. Lewis Wilson, *HVAC Systems Design Handbook*, illustrated 4th ed. (New York: McGraw-Hill, 2003)

Sam Kubba, *LEED Practices, Certification, and Accreditation Handbook*, illustrated ed. (Oxford: Butterworth-Heinemann 2009)

"Schock Innovative Building Solutions." http://www.schoeck.co.uk/upload/files/download/100113_TI_IK_GB_rz_web_EBA_type_K_5B2736_5D[2736].pdf.

SCHOTT, "Special Glass and Glass Ceramic for Architecture". http://www.us.schott.com/2009_architecture/english/index.html

Schott Glass Made of Ideas. http://www.us.schott.com/lightingimaging/english/lighting/products/index.html

Shahin Vassigh and Jason Chandler. *Building Systems Integration for Enhanced Environmental Performance* (Fort Lauderdale: J. Ross Publishing, 2011). P. 56, 97.

Bibliography

Simmler, Hans, Samuel Brunner, and Ulrich Heinemann. "Vacuum Insulation Panels—Study on VIP-Components and Panels for Service Life Prediction of VIP in Building Applications." HiPTI—High Performance Thermal Insulation IEA/ECBCS Annex 39. no. September (2005). http://www.ecbcs.org/docs/Annex_39_Report_Subtask-A.pdf.

Simon Roberts and Nicolò Guariento, *Building Integrated Photovoltaics: A Handbook*, (Basel: Springer/Birkhäuser, 2009).

Solarbuzz, an NPD Group Company, "Solar Market Research and Analysis." Accessed March 16, 2012. http://solarbuzz.com/.

Stephanie Stone, "Press Release: Dramatic Living Roof Installed Atop New California Academy Of Sciences, Making It The 'Greenest' Museum Ever Constructed," June 7, 2007. http://www.calacademy.org/newsroom/releases/2007/living_roof_release.php

Stephanie Stone, "Press Release: New California Academy of Sciences Receives Highest Possible Rating from U.S. Green Building Council: LEED Platinum," October 8, 2008. http://www.calacademy.org/newsroom/releases/2008/leed_platinum.php

Steve Doty and Wayne C. Turner, *Energy Management Handbook*. Lilburn: The Fairmont Press, 2009.

Sto Corp, "Exterior Insulated Finish Systems (EIFS)." http://www.stocorp.com/index.php/component/option,com_catalog2/Itemid,1%2096/catID,1/catLevel,2/subCatID,15/

Structural Insulated Panel Association (SIPA), "Structural Insulated Panels." http://www.structall.com/residential/content/pages/sips/SIPA_article.htm

"Structural Steel Solutions," American Institute of Steel Construction. http://www.aisc.org/content.aspx?id=3792

Sukha R. Vishnoi and P. N. Srivastava, "Phytoremediation: Green for Environmental Clean." Proceedings of Taal 2007: The 12th World Lake Conference, (2008), 1016-1021. http://wldb.ilec.or.jp/data/ilec/wlc12/H-%20Constructed%20Wetlands/H-7.pdf.

Susan Weiler and Katrin Scholz-Barth, Green Roof Systems: A Guide to the Planning, Design and Construction of Building Over Structure. (Hoboken: John Wiley and Sons, Inc., 2009).

T. Kuppan, *Heat Exchanger Design Handbook*, illustrated ed. (New York: CRC Press, 2000)

Terrence C. Sankar, Robert Morris University, Pittsburgh PA, "The Case for Vertical Axis Wind Turbines." http://www.ftcenergy.com/VAWT.pdf

The Green Atom, "Solid State Lighting, Energy Efficiency through LED Technology." http://www.solidstatelighting.org/.

The Illuminating Engineering Society of North America (IESNA). http://www.iesna.org

The International Association for Energy-Efficient Lighting (IAEEL). http://www.iaeel.org/

"The Water Cycle: Transpiration," July 1, 2010. http://ga.water.usgs.gov/edu/watercycletranspiration.html

Thomas Spiegelhalter, "Innovative Building Integrated, Solar-Assisted Air-Water Space Conditioning Systems with Dehumidification, and Thermo-Active Cooling Systems for Hot and Humid Climates." ASES American Solar Energy Society, Phoenix, 2009.

Transit Green House Gas Emissions Management Compendium, U.S. Department of Transportation, Federal Transit Administration, p.104; http://www.fta.dot.gov/documents/GHGCompendGTv2.pdf

Treloar, G., McCormack, M., Palmowski, L., Fay, R. (2004) Embodied Water of Construction. In Royal Australian Institute of Architects. BDP Environment design guide (P.1-8). Royal Australian Institute of Architects

Underwriter Laboratories (UL). http://www.ul.com/global/eng/pages/

U.S. Department of Energy, "Building Energy Codes Resource Center." http://resourcecenter.pnl.gov/cocoon/morf/ResourceCenter/article//93

U.S. Department of Energy, "Energy Efficiency and Renewable Energy EERE." http://www.energysavers.gov/your_home/energy_audits/index.cfm/mytopic=11190

U.S. Department of Energy, "Energy Efficiency and Renewable Energy, Building Energy Software Tools Directory." http://apps1.eere.energy.gov/buildings/tools_directory/subjects_sub.cfm

U.S. Department of Energy, "Energy Efficiency and Renewable Energy, Ductless, Mini-Split Heat Pumps." http://www.energysavers.gov/your_home/space_heating_cooling/index.cfm/mytopic=12630

U.S. Department of Energy, "Energy Efficiency and Renewable Energy, EnergyPlus Energy Simulation Software." http://apps1.eere.energy.gov/buildings/energyplus/cfm/weather_data.cfm

U.S. Department of Energy, "Energy Efficiency and Renewable Energy, Energy Savers." http://www.energysavers.gov/your_home/energy_audits/index.cfm/mytopic=11190

U.S. Department of Energy, Energy Efficiency and Renewable Energy, "Heat Pump Systems." http://www.energysavers.gov/your_home/space_heating_cooling/index.cfm/mytopic=12610

U.S. Department of Energy, "Energy Efficiency and Renewable Energy." http://www.energysavers.gov/your_home/windows_doors_skylights/index.cfm/mytopic=13700.

U.S. Department of Energy, "Energy Efficiency and Renewable Energy, Wind and Water Power Program." http://www1.eere.energy.gov/windandhydro/wind_animation.html

U.S. Department of Energy, "Energy Savers." http://www.energysavers.gov/your_home/lighting_daylighting/index.cfm

U.S. Department of Energy, "Energy Savers." http://www.energysavers.gov/your_home/windows_doors_skylights/index.cfm/mytopic=13700?print

U.S Department of Transportation, "Transit Green House Gas Emissions Management Compendium", Federal Transit Administration, p.104. http://www.fta.dot.gov/documents/GHGCompendGTv2.pdf.

U.S. Green Building Council, *LEED—EB for Existing Buildings: Reference Guide*, 2nd ed. (U.S. Green Building Council, 2006)

Victor Olgyay and Aladár Olgyay, *Design with Climate: Bioclimatic Approach to Architectural Regionalism* (Princeton: Princeton University Press, 1963). P. 89

Vince Catalli and Maria Williams, "Designing for Disassembly," Canadian Architect, January 2001. http://www.canadianarchitect.com/news/designing-for-disassembly/1000149177/

Walter T. Grondzik, Alison G. Kwok, Benjamin Stein and John S. Reynolds, *Mechanical and Electrical Equipment for Buildings*, 11th ed. (Hoboken: John Wiley and Sons, 2010)

Whole Building Design Guide (WBDG), A Program of the National Institute of Building Sciences, "Heating, Ventilating, Air-Conditioning, and Refrigerating (HVACandR) Engineering." http://www.wbdg.org/design/dd_hvaceng.php

William Bobenhausen, *Simplified Design of HVAC Systems*, (New York: Wiley-IEEE, 1994)

Index

A

Absorption heat pumps, 126
Active climate control systems, 116–151
 chillers, 130–134
 distribution and terminal systems, 145–151
 distribution medium, 118–122
 district heating and cooling, 140
 evaporative cooling, 135–136
 heat energy-recovery systems, 143–144
 heat pumps, 125–129
 mechanical heating, 137–139
 refrigeration cycles, 123–124
 space conditioning, 116–117
 ventilation, 141–142
Aden Earth World Plant Hardiness Zone Map, 206
Adjacent structure conditions, 177
AHU. See Air-handling unit (AHU)
Air drainage, 217
Air extract system, 64
Air-handling unit (AHU), 141
Air-source heat pumps, 125
Air temperature, 106
All-air systems, 119
All-water systems, 120–121
Aluminum, 27
American Society of Heating, Refrigerating, and Air Conditioning Engineers (ASHRAE), 143
Aperture location/daylighting, 172
Artificial lighting. See also Light sources
 lighting authorities, 185
 lighting control systems, 191
 luminaires (light fixtures), 185
ASHRAE. See American Society of Heating, Refrigerating, and Air Conditioning Engineers (ASHRAE)
Atrium-style earth-sheltered building, 216

B

Beam post-tensioning, 74
Biomass, hydropower and hydrogen energy, 159
Bioswales, 230
BioTray, 241
BIPV. See Building integrated photovoltaics (BIPV)
Blackwater, 233
Boilers, 137
Brick enclosure materials, 25
Bubble decks (two-way system), 87
Buffer system, 65
Building envelopes, 17–69
 climate-response façades, 64–69
 concepts, 18–35
 generally, 17
 wall systems, 36–63
Building form, 3–15
 climatic concept, 8–15
 concepts, 4–5
 generally, 3
 plan shapes, 6–7
Building integrated photovoltaics (BIPV), 156
Building occupancy codes, 95–96
Building orientation, 4
Building thermal loads, 95, 96, 116–117

C

California Academy of Sciences, 239–241
 context, 239
 drainage grid system detail, 240
 gabion drainage system, 241
 green roof section, 240
 panel composition detail, 240
 roof perspective, 239
Candela (cd) or candlepower (cp), 166
Canopy shading, 210–212
Carbon footprint, 19, 71
Carbon-neutral design, 100–105
 low-energy buildings, 100, 101
 passive house, 100, 102
 plus-energy buildings, 103, 105
 sustainable buildings, 100
 zero-fossil energy buildings, 103, 104
Case studies, 236–244
 California Academy of Sciences, 239–241
 Council House 2, 236–238
 Sidwell Friends School, 242–244
Cavity wall, 36–40
 cavity, role of, 38
 cavity ties, 38
 construction/sustainability, 40
 exploded axonometric, 37
 exploded axonometric, with punched window, 38
 flashings, 40
 green/standard construction, compared, 40
 inner wythe, 36, 38
 insulation, 38
 interior finish, 40
 outer wythe, 38
 section of, with punched window, 38
 vapor barrier, 40
CCFL. See Cold cathode compact fluorescent lamps (CCFL)
CCT. See Correlated color temperature (CCT)
CDD. See Cooling degree days (CDD)
Ceiling height
 light distribution and, 179
 light shelves and, 180
CFL. See Compact fluorescent lamps (CFL)

Chillers, 130–134
 chilled-water air-conditioning system, 130, 131
 chilled-water coil, 133
 cooling tower, 134
 heat energy-recovery systems for cooling towers, 134
 water chillers, 130, 132
Chiller tanks, 160
CHP. See Combined heat and power (CHP)
Chromaticity, 166, 167
CIE. See Commission on Illumination (CIE)
Clay bricks, 25
Clear stories, 179
Climate, 206–209. See also Climatic zones
 generally, 94
 hardiness/hardiness zones, 206–207
 microclimate, 209
 urban heat island, 209
Climate control, 93–151
 active systems, 116–151
 concepts, 94–105
 generally, 93
 passive systems, 106–115
Climate-response façades, 64–69
 double-skin façades, 64–67
 photovoltaic (PV) façades, 69
 shading devices, 68
Climatic regions, 208. See also Prototypical designs for climatic regions
Climatic zones. See also Zone maps
 cold, 14–15
 hot and arid, 10–11
 hot and humid, 8–9
 sunlighting and, 173
 temperate, 12–13
CMU. See Concrete masonry unit (CMU) enclosure materials; Concrete masonry unit (CMU) wall
Coefficient of performance (COP), 125
Cold cathode compact fluorescent lamps (CCFL), 187
Cold climatic concept, 14–15
Columns, 88
Combined heat and power (CHP), 140
Commission on Illumination (CIE), 168
Compact fluorescent lamps (CFL), 187
Composite panel cladding systems, 52
Composites, 28
Concrete, 26, 48, 73. See also Reinforced concrete
Concrete frame (one-way system), 79
Concrete frames, generally, 91
Concrete masonry unit (CMU) enclosure materials, 25
Concrete masonry unit (CMU) wall, 44–47
 components, 44
 construction/sustainability, 44, 46

253

exploded axonometric, 45
exploded axonometric, with punched window, 47
green/standard construction, compared, 46
section of, with punched window, 46
structural materials, 75
Concrete wall, 48–51. *See also* Precast concrete wall
 components, 48
 construction/sustainability, 50
 exploded axonometric, 49
 exploded axonometric, with punched window, 51
 green/standard construction, compared, 50
 section of, 48
 section of, with punched window, 50
Conduction, 99
Constructed treatment wetlands, 233–235
 generally, 233
 subsurface-flow wetlands, 234
 surface-flow wetlands, 234–235
Convection, 99
Cooling degree days (CDD), 94
Cooling tower, 134
Cool thermal storage (chiller tanks), 160
COP. *See* Coefficient of performance (COP)
Correlated color temperature (CCT), 166
Council House 2, 236–238
C-plan, 7
Cross-ventilation, 111

D

Daylight factor (DF), 176
Daylighting/aperture location, 172
Degree days, 94
Design with natural lighting, 176–177
 daylight factor (DF), 176
 design sky (Ds) illuminance, 176
 solar access, 176
 surface reflectance, 177
 topography, 176
 urban conditions, 177
Detention basin, 232
DF. *See* Daylight factor (DF)
DH. *See* District cooling (DC); District heating (DH)
DHC. *See* District heating and cooling (DHC)
Direct evaporative cooler, 135
Direct heat gain, 109
Discharge lamps, 187–188
Distribution and terminal systems, 145–151
 double-duct systems, 147
 fan coil unit, 149
 fan coil with supplementary air, 150
 induction systems, 149
 personal environmental module (PEM), 148
 radiant panels with supplementary air, 151
 single-duct systems, 145–147
 underfloor distribution, 148
Distribution medium, 118–122
 all-air systems, 119
 all-water systems, 120–121
 refrigerant systems, 118
 thermo active building systems (TABS), 122
District cooling (DC), 140
District heating (DH), 140
District heating and cooling (DHC), 140
Double-duct systems, 147
Double-skin façades, 64–67
 air extract system, 64
 buffer system, 65
 hybrid system, 67
 twin-face system, 66
Drainage swales, 230
Drip irrigation, 226
Ds (design sky) illuminance, 176

E

E. *See* Illuminance (E)
Earth sheltering, 215–216
 atrium-style design, 216
 elevational design, 216
 generally, 215
 penetrational design, 216
Earth's water cycle, 203
EER. *See* Energy Efficiency Ratio (EER)
Electrochromic glass, 175
Electromagnetic spectrum, 168
Embodied energy, 18
Embodied water, 18–19
Enclosure materials, 24–29
 brick, 25
 glass, 28–29
 masonry products, 25
 metals, 27
 reinforced concrete, 26
 wood, 24
Energy Efficiency Ratio (EER), 125
Energy-plus building, 103, 105
Energy-recovery ventilators (ERVs), 144
Energy storage systems, 160–161
 cool thermal storage (chiller tanks), 160
 heat thermal storage, 160, 161
Engineered wood products, 24
Environmental impact, 18–19
ERVs. *See* Energy-recovery ventilators
Eutectic PCMs, 115
Evaporative cooling, 113, 135–136
Evapotranspiration, 199, 214

F

Fan coil unit, 149
Fan coil with supplementary air, 150
Fiber-reinforced concrete, 26
Flashings, 40
Flat plates and flat slabs (two-way system), 83
Flat-plate solar collectors, 154
Formwork, 48
Fossil fuels, 153
Foundation plantings, 219
Free-flow wetlands, 234
Furnaces, 138
Fytogen planting medium, 238

G

Geoexchange heat pumps, 127–129
Geothermal energy, 159
Glass
 enclosure materials, 28, 29
 natural lighting, 174
 types of, 175
Glass curtain wall, 41–43
 components, 41
 construction/sustainability, 42
 exploded axonometric, 43
 green/standard construction, compared, 41
 section of, 42
Graywater, 233
Green roofs. *See also* Vegetated surface systems
 benefits, 108
 at California Academy of Sciences, 239–241
 intensity levels, 214
 stormwater and, 229
 thermal insulation, 215
Groundwater recharge, 204, 205

H

Hardiness/hardiness zones, 206–207
 generally, 206
 plant palette, 207
 zone maps, 206, 207
HDD. *See* Heating degree days (HDD)
Heat energy-recovery systems, 143–144
 energy-recovery ventilators (ERVs), 144
 heat energy-recovery ventilators, 143
Heat flow, 99
Heat forms, 98
Heating. *See* District heating and cooling; Mechanical heating; Solar heating
Heating coil, 138
Heating degree days (HDD), 94
Heat island, 209
Heat pumps, 125–129
 absorption, 126

Index

air-source, 125
generally, 139
geoexchange, 127–129
mini-split, 126
water-source, 127
High-intensity discharge lamps (HID), 188
High pressure sodium (HPS) lamps, 188
Hollow-core slabs (one-way system), 82
Holographic systems, 183
Horizontal spanning systems, 76–87
　bubble decks (two-way system), 87
　composite steel frame (one-way system), 78
　concrete frame (one-way system), 79
　flat plates and flat slabs (two-way system), 83
　hollow-core slabs (one-way system), 82
　noncomposite steel frame (one-way system), 77
　one-way systems, 76
　pan joist or ribbed slab (one-way system), 80–81
　slabs with beams (two-way system), 84
　two-way systems, 76
　waffle slabs (two-way system), 85–86
Hot and arid climatic concept, 10–11
Hot and humid climatic concept, 8–9
HPS. See High pressure sodium lamps
Hybrid double-skin façade system, 67
Hydrogen energy, 159
Hydrological efficiency, 224–235
　runoff mitigation and pollution control, 227–232
　wastewater management, 233–235
　water conservation, 224–226
Hydrology, 203–205
　groundwater recharge, 204, 205
　hydrological cycle, 203
　surface runoff, 204
Hydropower, 159

I

IFL. See Inductive fluorescent lamps (IFL)
Illuminance (E), 164
Impermeable surfaces, 204
Impervious surfaces, reduction of, 227
Indirect evaporative cooler, 136
Indirect heat gain, 109
Induction systems, 149
Inductive fluorescent lamps (IFL), 187, 188
Infrared transmittance (IT), 168
Inorganic PCMs, 115
Insulating glass, 175
Insulation materials, 30–33
　other, 32–33
　rigid insulation, 30
　sound insulation, 32
　structured insulation panels, 30–31

synthetic insulation, 31
thermal insulation, 30
vacuum insulated panels, 31
Intensive bioremediation systems, 235
International Building Code (IBC), 95–96
Invasive/introduced plants, 198
Irrigation. See Water conservation
Isolated heat gain, 110
IT. See Infrared transmittance (IT)

L

Laminated veneer lumber (LVL), 24
Landscape elements, 193–245. See also Case studies; Hydrological efficiency; Thermal efficiency
　climate, 206–209
　climate control, 108
　generally, 193, 194
　hydrology, 203–205
　plant classification, 194–198
　plant processes, 199–202
Landscape windbreaks, 217–218
　generally, 217
　types, 218
Latent heat, 98
Leadership in Energy and Environmental Design (LEED), 236, 239, 242
LED. See Light-emitting diodes (LED)
LED bars/marker lighting, 191
LEED. See Leadership in Energy and Environmental Design (LEED)
LEP. See Light-emitting polymers (LEP)
LI. See Luminous intensity (LI)
Light-emitting diodes (LED), 186, 189
Light-emitting polymers (LEP), 189
Lighting. See also Artificial lighting; Measuring light; Natural lighting; Side lighting; Sunlighting
　authorities, 185
　generally, 163
　top, 182
Lighting design, 170–171
　brightness, 171
　contrast, 171
　glare, 170
Light shelves, 180–181
　angled and rotating, 180, 181
　ceiling height and, 180
　position of, 180, 181
Light sources, 186–191
　discharge sources, 187–188
　generally, 186
　incandescent, 186–187
　solid-state (SSL), 189–191
Light-to-solar gain (LSG) ratio, 174
Light transmittance, 168–169
　absorption, 169
　infrared transmittance (IR), total, 168
　reflection, 169

ultraviolet transmittance (UT), total, 168
visible transmittance (VT), 168
Lightweight concrete, 26
Light wells, 184
"Living machine," 235
Living roofs. See Green roofs
Living wall systems, 213, 215
Load-bearing walls, 89
Low-emissivity coating (low-E), 175
Low-energy buildings, 100, 101
Low irrigation plant materials, 224
Low-pressure discharge lamps, 187, 188
Low-volume drip irrigation, 226
L-plan, 7
LSG. See Light-to-solar gain (LSG) ratio
Lumens or luminous flux, 164–165
Luminaires (light fixtures)
　generally, 185
　performance metrics, 190
Luminance (L), 164
Luminous efficacy, 165
Luminous intensity (LI), 164
LVL. See Laminated veneer lumber (LVL)

M

Man-made masonry products, 25
Masonry products
　concepts, 25
　structural materials, 75
Mass and service core, 5
Material thermal properties, 20–23
Measuring light, 164–167
　candela (cd) or candlepower (cp), 166
　chromaticity, 166, 167
　illuminance (E), 164
　lumens or luminous flux, 164–165
　luminance and brightness, 164
　luminous efficacy, 165
Mechanical heating, 137–139
　boilers, 137
　furnaces, 138
　heating coil, 138
　heat pumps, 139
Metal enclosure materials, 27
Metal veneer wall, 52–55
　components, 52
　construction/sustainability, 54
　exploded axonometric, 53
　exploded axonometric, with punched window, 55
　green/standard construction, compared, 54
　section of, 52
　section of, with punched window, 54
Microclimate, 209
Microirrigation, 224
Mini-split heat pumps, 126
Mirror reflectors, 183

Mortar, 44

N

Native plants, 197
Natural climate control systems, 106–108
Natural lighting. *See also* Design with natural lighting
 climatic zones and sunlighting, 173
 concept, 5
 filtering/redirection, 183–184
 passive systems, 106
 solar radiation, 172
Natural unit: stone, 25
Natural ventilation, 5
Noncomposite steel frame (one-way system), 77
Nonpoint source (NPS) pollution, 227
NPS. *See* Nonpoint source (NPS) pollution

O

Occupancy codes, 95–96
Occupancy types, 95–96
OLED. *See* Organic light-emitting diodes (OLED)
O-plan, 7
Organic light-emitting diodes (OLED), 186, 189
Organic PCMs, 115
Orientation. *See* Building orientation
Oriented strand board (OSB), 24
OSB. *See* Oriented strand board (OSB)
Overflow piping, 228

P

Package unit system, 142
Pan joist or ribbed slab (one-way system), 80–81
PAR. *See* Parabolic aluminized reflector lamps
Parabolic aluminized reflector (PAR) lamps, 186
Passive climate control systems, 106–115
 natural systems, 106–108
 passive cooling, 110–113
 phase-change materials, 114–115
 solar heating, 109–110
Passive cooling, 110–113
 cross-ventilation, 111
 evaporative cooling, 113
 stack ventilation, 111
 thermal mass cooling with night ventilation, 112
Passive house, 100, 102
Passive ventilation, 106, 107
Passivhaus Standard, 100
PCMs. *See* Phase-change materials
PEM. *See* Personal environmental module
Perforated piping, 228

Personal environmental module (PEM), 148
Pervious paving, 228
Phase-change materials (PCMs)
 thermal materials, 34
 thermal storage behavior in buildings, 114
 types of, 115
Photochromic glass, 175
Photovoltaic (PV) cells, 156
Photovoltaic (PV) façades, 69, 156, 157
Photovoltaic (PV) systems, 156–157
Phytoremediation, 200–202
 accumulation, 200
 degradation, 201
 dissipation, 200–201
 immobilization, 202
Plan geometry, 4
Plan shapes, 6–7
Plant classification, 194–198. *See also* Wetland plant species
 deciduous plants, 196
 ecological origin and adaptation, 197
 evergreen plants, 196
 groundcovers, 194, 195
 growth habit, 194, 195
 introduced/invasive plants, 198
 native plants, 197
 seasonal foliage persistence, 196, 197
 shrubs, 194, 195
 trees, 194, 195
 vines, 194
Plant hardiness zone maps, 206–207
Plant material selection symbol key, 224
Plant processes, 199–202
 evapotranspiration, 199
 photostabilization, 202
 photosynthesis, 199
 phytoremediation, 200–202
Plastics, 28
PLED. *See* Polymer light-emitting diodes (PLED)
Plus-energy buildings, 103, 105
Plywood, 24
Pollutants, 204
Polymer light-emitting diodes (PLED), 189
Posttensioned concrete, 74
Precast concrete wall, 56–59. *See also* Concrete wall
 components, 56
 construction/sustainability, 56, 58
 exploded axonometric, 57
 exploded axonometric, with punched window, 59
 green/standard construction, compared, 58
 section of, 56
 section of, with punched window, 58
Prestressed concrete, 73–74

Pretensioned concrete, 73
Prismatic systems, 183
Prototypical designs for climatic regions, 220–223
 cold climate strategies, 223
 hot and arid climate strategies, 221
 hot and humid climate strategies, 220
 temperate climate strategies, 222
Psychrometrics/thermal content, 96–97
 human body, 96
 psychrometric charts, 96–97
 thermal comfort standards, 97
PV. *See* Photovoltaic (PV) cells; Photovoltaic (PV) façades; Photovoltaic (PV) systems

R

Radiant panels with supplementary air, 151
Radiation, 99
Raingardens, 231
Reflectance, 177
Reflective glass, 175
Reflectors/refractors, 183–184
Refrigerant systems, 118
Refrigeration cycles, 123–124
 absorpton cycle, 123
 compression cycle, 124
Reinforced concrete
 enclosure materials, 26
 structural materials, 73
Renewable energy, 153–161
 biomass, hydropower and hydrogen energy, 159
 energy sources and storage, 154–155
 energy storage systems, 160–161
 generally, 153
 geothermal energy, 159
 photovoltaic (PV) systems, 156–157
 solar energy, 154–155
 wind energy, 158
Retention basin, 232
Ribbed slab or pan joist (one-way system), 80–81
Roof cladding with PV systems, 156, 157
Runoff mitigation and pollution control, 227–232. *See also* Surface runoff
 bioswales, 230
 green roofs and stormwater, 229
 impervious surfaces, reduction of, 227
 pervious paving, 228
 raingardens, 231
 stormwater impoundments, 232
 stormwater planters, 230
R-value. *See* Thermal resistance (R-value)

S

SC. *See* Shading coefficient (SC)

Index

Seasonal Energy Efficiency Ratio (SEER), 125
Seasonal foliage persistence, 196, 197
SED. See Spectral energy distribution (SED)
SEER. See Seasonal Energy Efficiency Ratio
Self-contained raingardens, 231
Sensible heat, 98
Service core, 5. See Mass and service core
Shade trellising system, 236–238
Shading coefficient (SC), 22–23
Shading devices, 68
Shading/shade factors, 210–212
Shear walls, 90
SHGC. See Solar heat gain coefficient (SHGC)
Side lighting, 178–179
 ceiling height, 179
 clear stories, 179
 window geometry, 178
 window location, 179
 window size, 178
Sidwell Friends School, 242–244
 constructed wetlands, 242, 243
 context, 242
 rainwater circulation, 244
 wastewater circulation, 244
Single-duct systems, 145–147
 single-duct/multiple-zone system, 146
 single-duct/single-zone system, 145
 single-duct variable air volume (VAV), 147
Site planting coverage, 212
Slabs with beams (two-way system), 84
Solar access, 176
Solar concentrators, 155
Solar energy, 154–155
 flat-plate collectors, 154
 solar concentrators, 155
 solar thermal conversion, 154
 vacuum tube solar collectors, 155
Solar heat gain coefficient (SHGC), 22–23, 174
Solar heating, 109–110. See also Sun position/sun path
 direct gain, 109
 indirect gain, 109
 isolated gain, 110
 solar-assisted gas boiler, 137
Solar heat moderation, 210–214
Solar spectrum, 168
Solar tanks, 160, 161
Solar thermal conversion, 154
Solid-state lighting (SSL), 189–191
 LED bars/marker lighting, 191
 light-emitting diodes (LED), 189
 organic light-emitting diodes (OLED), 189
 polymer light-emitting diodes (PLED), 189
Sound transmission class (STC), 32
Space conditioning, 116–117
SPD. See Spectral power distribution (SPD)
Spectral energy distribution (SED), 166
Spectral power distribution (SPD), 166
Stack ventilation, 111
Stainless steel, 27
STC. See Sound transmission class (STC)
Steel
 frames, 92
 structural materials, 75
 types of, 27
Steel-reinforced concrete, 26
Stone panel wall, 60–63
 components, 60
 construction/sustainability, 60, 62
 exploded axonometric, 61
 exploded axonometric, with punched window, 63
 green/standard construction, compared, 62
 section of, 60
 section of, with punched window, 62
Stone products, 25
Stormwater
 impoundments, 232
 planters, 230
Stormwater runoff. See Runoff mitigation and pollution control
Structural frames, 91–92
 concrete frames, 91
 steel frames, 92
 wood frames, 91
Structural materials, 72–75
 masonry products, 75
 prestressed concrete, 73–74
 reinforced concrete, 73
 steel, 75
 wood, 72
Structure, 71–92
 generally, 71
 horizontal spanning systems, 76–87
 structural frames, 91–92
 structural materials, 72–75
 vertical spanning elements, 88–90
Stucco, 44
Subsurface-flow wetlands, 234–235
Subterranean irrigation, 226
Suncatchers, 184
Sunlighting
 natural lighting, 172
 sun path/climatic zones, 173
Sun position/sun path, 106. See also Solar heating
Surface area-to-volume ratio, 4
Surface-flow wetlands, 234
Surface reflectance, 177
Surface runoff, 204. See also Runoff mitigation and pollution control
Sustainable buildings, 100

T

TABS. See Thermo active building systems (TABS)
Temperate climatic concept, 12–13
Terminal units. See Distribution and terminal systems
Thermal bridging, 21
Thermal comfort standards, 97
Thermal conductivity, 20
Thermal efficiency, 210–223
 phototypical designs for climatic regions, 220–223
 solar heat moderation, 210–214
 thermal insulation, 215–216
 wind protection and control, 217–219
Thermal insulation. See Earth sheltering; Vegetated surface systems
Thermal loads, 95, 96, 116–117
Thermally driven absorption chiller, 132
Thermal mass
 cooling with night ventilation, 112
 thermal materials and, 34
Thermal materials, 34–35
Thermal resistance (R-value), 20, 174
Thermal transmittance (U-value), 20, 174
Thermo active building systems (TABS), 122
Thermochromic glass, 175
TI. See Transparent insulation (TI)
Titanium, 27
Top lighting, 182
Topography, 176
Transparent insulation (TI), 34, 35
Trees. See also Wind protection and control
 canopy shading, 210–212
 deciduous, 196
 evergreen, 196
 low irrigation plant materials, 224
 native/indigenous, 197
 plant classification, 194, 195
Trellising system, 236–238
Twin-face system, 66
Two-stage indirect-direct evaporative cooler, 136

U

Ultraviolet transmittance (UT), 168
Under-drained raingardens, 231
Under-floor distribution, 148
Urban conditions, 177
Urban environment
 groundwater recharge, 204, 205
 one-row windbreak, 218
 surface runoff, 204
 urban heat island, 209

USDA Hardiness Zone Map, 207
U.S. ENERGY STAR Qualified Homes Thermal Bypass Inspection Checklist, 21
UT. See Ultraviolet transmittance (UT)
U-value (thermal transmittance), 174

V

Vacuum tube solar collectors, 155
Vapor barrier for cavity wall, 40
Vapor compression chiller, 132
Variable air volume (VAV), 147
VAV. See Variable air volume (VAV)
Vegetated surface systems. See also Green roofs
 generally, 212
 thermal insulation, 215
Vegetation types, 208. See also Plant classification
Ventilation, 141–142. See also Heat energy-recovery systems; Natural ventilation
air-handling unit (AHU), 141
package unit system, 142
Venturi effect, 217
Vertical spanning elements, 88–90
 columns, 88
 load-bearing walls, 89
 shear walls, 90
Vines. See also Trellising system
 plant classification, 194
 vegetated surface systems, 212, 213
Visible transmittance (VT), 168
VT. See Visible transmittance (VT)

W

Waffle slabs (two-way system), 85–86
Wall systems, 36–63
 cavity wall, 36–40
 concrete masonry unit (CMU) wall, 44–47
 concrete wall, 48–51
 glass curtain wall, 41–43
 metal veneer wall, 52–55
 precast concrete wall, 56–59
 stone panel wall, 60–63
 vegetated surface systems, 212, 213
Waste heat, 209
Wastewater management, 233–235
 constructed treatment wetlands, 233–235
 intensive bioremediation systems, 235
Water chillers, 130, 132
Water conservation, 224–226
 alternative water sources for irrigation, 226
 efficient irrigation mechanisms, 224, 226
 low irrigation plant materials, 224
 plant material selection, 224, 225
Water cycle, 203
Water-source heat pumps, 127

Water tables, 204
Wetland plant species, 233
Wind energy, 158
Window. See Side lighting
Wind patterns, 106, 107
Wind protection and control, 217–219
 foundation plantings, 219
 landscape windbreaks, 217
 windbreak design, 217–218
 wind deflectors/wind channels, 219
Wood
 enclosure materials, 24
 structural materials, 72
World Plant Hardiness Zone Map, 206

Z

Zero-fossil energy buildings, 103, 104
Zero-net-energy building, 103, 104
Zinc, 27
Zone maps, 206–207. See also Climatic zones